COLLECTING AND USING
CLASSIC CAMERAS

COLLECTING AND USING
CLASSIC CAMERAS

IVOR MATANLE · With 320 illustrations

Thames & Hudson

© 1986 Ivor Matanle

First published in hardcover in the United States of America in 1986 by
Thames & Hudson Inc., 500 Fifth Avenue, New York, New York 10110

thamesandhudsonusa.com

First paperback edition 1992
Reprinted 2000

Library of Congress Catalog Card Number 91-75054
ISBN 0-500-27656-0

Printed and bound in Malta by Interprint Ltd

CONTENTS

Acknowledgments 6

Chapter 1 **It's harder. It takes longer. The results are no better. So why do you do it?** 7

Chapter 2 **How to buy classic cameras without getting egg on your face** 27

Chapter 3 **Reflex or rangefinder? Or TLR? Or folding camera?** 44

Chapter 4 **Emulating Cartier-Bresson. Classic Leica photography** 61

Chapter 5 **The other great rangefinder system – photography with a Contax** 82

Chapter 6 **Despite what the Germans say, not all classic cameras are European** 100

Chapter 7 **Who sold you that then? Out and about with a classic 35mm SLR** 112

Chapter 8 **Not every twin-lens reflex is a Rolleiflex** 131

Chapter 9 **And not every SLR takes 35mm film** 145

Chapter 10 **The delights of unfolding a medium-format camera** 160

Chapter 11 **Classic photography in your pocket – the 35mm folding camera** 174

Chapter 12 **The non-folding viewfinder classic – among the most reliable of all** 188

Chapter 13 **Getting the best from your classic camera** 201

Appendices

1 Some useful addresses 212
 (a) Classic-camera and photographic historical societies
 (b) Major auction houses which hold photographic sales
 (c) Specialist periodicals
 (d) Repairers and custom accessory manufacturers
 (e) Specialist classic-camera dealers

2 Film-speed conversion 215

3 Some frequently encountered classic-camera families of the wartime and post-war period 218

4 Bibliography 222

Index 223

For my wife and family, without
whose forbearance and co-operation
most of this book and many of the
pictures would not have been possible.

Acknowledgments

The author extends grateful thanks to the many
people who have provided information, pictures and
the loan of equipment needed for the researching
and writing of this book, and in particular would
acknowledge the indispensable assistance of Colin
Glanfield, who has acted as technical adviser. Others
whose help is gratefully acknowledged are:

Douglas Cole
Ricky Hood
Tony Hurst
Nirendragati Mustaphi
Vintage Cameras Ltd
Stein Falchenberg, of Teamwork
Tim Hawkins
Linhof Professional Sales Ltd, London
Malcolm Glanfield.

Except where otherwise stated in the captions, all
photographs are by the author.

Just once in a while, one sees in a crowd a photographer who stands out from the mass of camera enthusiasts who rush to seize imagined decisive moments with their motor drives and zoom lenses. He uses a separate hand-held exposure meter and takes his time. His camera does not make a repetitive noise like a duchess sneezing, nor clatter like a distant scrapyard when the shutter is fired. A discreet click is the only evidence of his having recorded the world about him on film.

The classic-camera user is a different kind of photographer, for whom the endless camera tests and articles on glamour photography that fill the middle sections of the popular photographic magazines have less appeal than the how-to-do-it sections on camera technique and the small ads full of intriguing old bargains towards the back. He enjoys his camera and his photography as one might enjoy great music, a fine wine or a good book: reflectively, uncompetitively, as a fulfilment of something not easy to define.

Photography is both art and science, both a technology and a means of communicating ideas. Like television, which similarly marries the arts and the sciences, photography is increasingly dominated by electronics, by automation, and by that regrettably boring certainty that very little can go wrong. As photography has become easier, and understanding of the technicalities has become less necessary, many more people throughout the developed world have become excited by the prospect of taking pictures, and have crowded into a fast-expanding market for cameras, lenses and accessories. Sadly, many become so enthralled by the electronic wizardry of the cameras themselves that they lose sight of the pleasures of photography, of making pictures, but in this they are no more than victims of the pressures of mass marketing. For, since the late sixties and early seventies, the camera industry that had previously seen itself as a source of fine (albeit mass-produced) instruments, has been obliged by the requirement to survive to serve a greatly larger market whose competitive thrust no longer permits fine craftsmanship.

The changes that ended the classic era

Faced in the late sixties with the need to produce ever greater numbers of cameras against increasing and better-financed competition, the camera industry around the world sought to develop new production techniques that would make possible reduced costs, while at the same time introducing marketable product features. The resurgent camera industry of Japan, almost as old as that of Germany but now risen phoenix-like from the ashes of World War Two,

It's harder. It takes longer. The results are no better. So why do you do it?

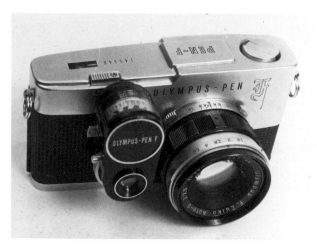

The **Olympus Pen F** half-frame single-lens reflex from Japan. This excellent mid-sixties design is not a European classic camera, but its appearance on the market foretold clearly the innovative spirit that was to push the Japanese camera industry to the fore.

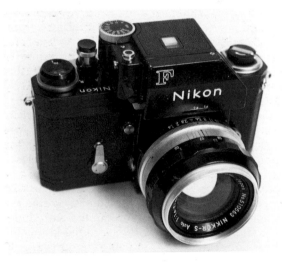

Probably the heaviest 35mm single-lens reflex camera ever made, the **Nikon F** (this late 1973 example has the Photomic FTn metering prism) and its lenses - here a 50mm f/1.4 Nikkor - established in the sixties a reputation for professional camera ruggedness that the Japanese industry had never had. Suddenly, photographers who wished to be thought successful wanted a Nikon rather than a Leica, and the writing was on the wall for the German camera industry.

proved more adept at finding new methods and adopting new skills than the deeply traditional camera manufacturers of Germany and the rest of Europe. Japanese manufacturers had, during the early sixties, been the first to introduce the instant-return mirror in a 35mm single-lens reflex, and had run a close race with Pignons of Switzerland, manufacturers of the beautifully engineered Alpa reflex cameras, to market the world's first camera with through-the-lens exposure measurement. **Olympus** of Japan had developed the half-frame format to a remarkable standard of sophistication with their **Pen F** series of single-lens reflexes and a battalion of non-reflex compact cameras. Yet the Japanese cameras of the sixties had continued to be manufactured by traditional engineering methods with the materials that precision was then seen to require – steel, brass and an abundance of glass. One has only to feel the weight of a late-sixties **Nikon F** with Photomic meter head and 50mm f/1.4 Nikkor to realize just how much glass and metal could be crammed into a single 35mm camera.

As the seventies began, so also did the revolution in materials and technology that was to complete the decline of the German camera industry, provide the foundation for total Japanese domination of camera manufacture, and, almost inadvertently, nourish the flourishing interest in classic cameras that has, by the eighties, become a significant feature of the photographic landscape. For, as the decade wore on, camera designers made vastly increased use of engineering plastics instead of metals for camera casings and film-transport gearing, installed electronically timed shutters of great accuracy and extended speed range instead of shutters timed by mechanical escapements derived from the watch industry, and devised electronic exposure-measurement systems to replace the electro-mechanical galvanometer-based meters that had been used in early in-camera exposure systems. All these developments greatly reduced the weight of the camera, dramatically increased the range of facilities it offered and functions of which it was capable, and, most significant of all, drastically reduced its real cost.

According to a 1970 issue of *Popular Photography*, from which I have obtained the US prices, and my invaluable Wallace Heaton Blue Book for 1970/71, which provided the UK figures, the price at that time of a Nikon F Photomic FTn with 50mm f/1.4 Nikkor was around $319.50 in the USA (where there was no retail price maintenance) and £311 17s. 11d. in Britain (where retail prices were firmly and, at that time, legally controlled by the importers). A Pentax Spotmatic with f/1.4 lens was $240 in the USA, and £171 3s. 6d. in Britain. Prices in West Germany and in other

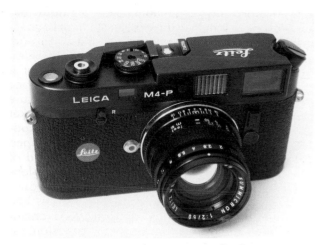

The **Leica M4-P** *and the more recent Leica M6 are in many eyes anachronisms; the last surviving truly classic high-precision 35mm coupled-rangefinder cameras. Lighter than the earlier Leica M2, M3 and M4, the M4-P lacks delay action and some of the 'feel' of the older cameras, but has features such as a 28mm built-in viewfinder that they lack. Still a current camera at the time of writing this book, the Leica M4-P is made in Canada. This example is fitted with a black 50mm f/2 Summicron of slightly earlier vintage than the camera.*

developed Western countries were broadly in line with these. Between 1971 and the mid-eighties, prices approximately quadrupled, so it would have been reasonable to expect a top-range professional Nikon with f/1.4 lens to cost about $1,300 in the USA and £1,200 in Britain in 1984. A top-of-range amateur Pentax might have been expected to cost $960 in the USA or £700 in Britain. But actual 1984/85 prices were just short of $479 and £500 for a Nikon F3 with f/1.4 Nikkor, and around $258 and £255 for a Pentax Super A with f/1.4. By 1994, the increasing complexity of both professional and amateur cameras, coupled with unfavourable exchange rates had once again increased the real cost of cameras, but still to only about half their real cost in 1971.

Obviously, to achieve such dramatic benefits to the consumer – to the photographer in the street – something has had to go. That something is engineering quality, ruggedness, 'feel', the silky smoothness of hand-crafted precision – the scarcely definable quality that is as characteristic of the classic camera as of the classic car or the antique clock. In the camera-manufacturing industry, the technician and scientist have, to a large extent, replaced the engineer and craftsman. The elements of many of even the most expensive Japanese lenses are now mounted in plas-

tics rather than metal. Some lower-cost lenses have plastics elements. The 'chrome' top-plate of many single-lens reflex cameras is, in fact, made of plastics materials. To their credit, most current camera designs perform extremely well, and modern computer-designed lenses outperform older classic lenses by almost any scientific standards, though not necessarily by the more subjective qualitative standards of the true photographer. If the reason for owning a camera were simply to take photographs of great sharpness and high contrast – and one could be forgiven for believing, after reading the magazines, that no other reason could exist – then nobody would look further than the top six or seven brands of Japanese single-lens reflex cameras and their huge ranges of lenses and accessories.

The last remaining classic marques

There remain, however, those photographers for whom the slight softness and roundness produced by lenses with a modicum of curvature of field and a few aberrations deliberately left intact are a positive asset; and they create a determined, though necessarily limited, market for new cameras in the classic tradition. Led by Ernst Leitz, manufacturers of the Leica camera since 1924/25, one or two great names of traditional camera engineering continue to satisfy that demand, albeit at a formidable price. A **Leica M4-P** rangefinder 35mm camera with 50mm f/2 Summicron costs almost twice as much as the Nikon F3, a Leica R4 reflex around one and a half times as much – the ratios may vary a little from country to country, but the principle remains sound. A 28mm lens for a Leica reflex camera costs almost three times as much as a comparable 28mm lens for Nikon. The **Linhof Technika 70** 6cm x 9cm technical camera, eminently usable as a hand-held coupled-rangefinder camera with Super Rollex rollfilm back, and hand-built to the last highly polished bolt, would have set you back some £2,190 with the standard 100mm f/2.8 Xenotar lens in the UK at the time that the model was discontinued in 1983. The Hasselblad 500CM, although arguably a professionals' camera in its concept, is nonetheless a modern classic in every respect and is widely used by relatively wealthy amateur photographers, despite the availability of significantly cheaper Japanese alternatives capable of scientifically indistinguishable results. One of the other great names of the German camera industry, Rollei, lives on, despite past financial difficulties, in the Rolleiflex SL66, still at the time of writing the only rollfilm single-lens reflex offering lens-panel movement to take the lens out of parallel with the film plane. West German Zeiss, whose name

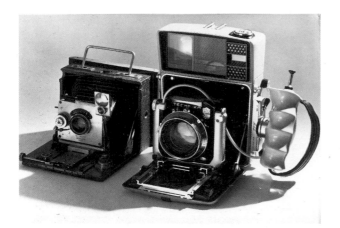

*The **Linhof Technika 70**, discontinued at the end of 1983, is an exceptionally beautifully made and very expensive combination of the rollfilm camera and the technical camera. It has full back movements and some front movements, and can be used with ground-glass film-plane focusing screen and double-cut film holders, much like a technical camera. But it also has coupled rangefinder, brightline viewfinders and built-in exposure meter in the manner of a high-quality folding rollfilm camera. Eminently usable in the hand, it is nonetheless capable of exacting studio work. Here the Technika 70 is beside one of the earliest Linhof plate cameras, made in 1903. Picture by courtesy of Linhof Professional Sales, London.*

ceased to be associated with camera manufacture more than a decade ago when Zeiss Ikon ended production of the Contarex single-lens reflexes, nonetheless continues to be represented by its magnificent West German Carl Zeiss lenses mounted as standard on the Hasselblad and Rolleiflex SL66 cameras. They also were available until a few years ago for Linhof technical cameras, which are now fitted with lenses by another great West German company, Schneider of Kreuznach. Even Pignons, the principal company of the Swiss camera industry, was still manufacturing its traditionally engineered **Alpa** 11Si during the eighties despite understandable efforts to capture a share of the lower-priced mass market with cameras imported from Japan and modified to Alpa specifications. The Alpa 11Si had during the mid-eighties the distinction of being the only 35mm camera offered in the British marketplace new at a price in excess of £1,000.

By comparison with the tremendous demand for mass-market single-lens reflex and high-quality compact cameras across the world, the sales of such new exotic examples of the camera designer's art to amateur photographers are very small, for the number of people able to afford to invest large sums of money in equipment for a spare-time interest is a tiny minority of the population. But nostalgia for the sheer joy of using a finely engineered camera, and the wish to perpetuate the standards and skills of photography in the pre-electronics age are felt in every country where the Leica, the Contax, the Rolleiflex, the Retina and the names of great manufacturers like Voigtländer, Ihagee and Zeiss were once the normal parlance of everyday photography. Fortunately, most of the classic cameras were built to last, and a significant number have succeeded in doing so despite the combined ravages of a world war, up to fifty years or so of hard use and, in many cases, a long-standing lack of spare parts. It is to this pool of classic cameras of the golden age of camera manufacture that the more impecunious lovers of fine engineering and traditional standards turn, and in which many of the less experienced sadly suffer great disappointment. For buying classic cameras of considerable age is fraught with problems that can be avoided if you know what to look for and what to guard against; and using classic cameras, even when they are in the first-

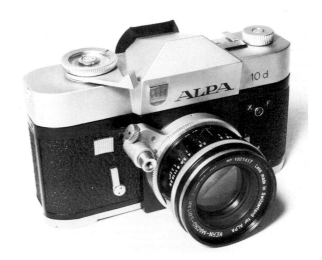

*The **Alpa** 10 and 11 series of 35mm single-lens reflexes were all manufactured using the same high-precision body and differ principally in the specifications of their exposure meters. The 10d, illustrated here, which was still available new in 1978 in Britain, had a conventional needle-centring exposure meter, whereas the 11el and 11Si have solid-state meters providing exposure indications by means of coloured lights visible in the viewfinder and, in the case of the 11el, in a repeater window on top of the camera. All have the distinctively Alpa crank leverwind which winds from the front of the camera to the rear, the reverse of the usual direction.*

class condition in which many can still be obtained, needs a different approach to photography and rather more subjective standards of qualitative judgment of results than are nowadays normal.

This book, therefore, is intended to help those who would like to enjoy the pleasures of collecting and using classic cameras without suffering too many of the pitfalls. It will guide you through the principal families, groups and types of camera that are to be found on the secondhand and collectors' markets, tell you which specific camera types are likely to be reliable and which are not, and help you to check cameras and establish their faults before you buy. Because this book is written as much for those who love to use fine old cameras as for those who wish simply to collect and display them, it will discuss the forms of photography for which each type is particularly suitable and show you examples of pictures taken with them – in some cases taken with the actual examples of the camera shown in the book. Because my own love affair with the classic camera has been going on since I was a boy in the mid-fifties (when I was to be seen photographing the school sports at Trinity School, Croydon, England, with a **twin-lens Contaflex** of a type now looked upon as a major collectible but then regarded by my father as a second camera) some of the pictures taken with classic cameras are from my own collection stretching back thirty years, and taken with cameras I no longer own. Much of the joy of classic-camera photography arises from that uniquely rounded image quality of the older lenses, which in many cases would not win any prizes in a photographic magazine camera-test feature of the eighties. I believe this quality to be apparent in many of my older pictures, so I make no excuse for including them.

The classic-camera period

There is no formal definition of a classic camera and no regulatory body to state categorically which cameras quality or do not qualify for the term. I am therefore in the happy situation of being able both to apply my own definition and to be reasonably immune from objective criticism of my choice. To me, and for the purposes of this book, a classic camera is not just an old camera, but a 35mm or rollfilm camera produced by one of the great manufacturers during the golden age of miniature-camera development, from the mid-twenties, when the first production Leicas arrived on the market, through to the late sixties, when the take-over of the hearts and pockets of the photographic public by oriental expertise in mass-production and electronics began.

The many excellent cameras produced by the leading manufacturers in Japan before the plastics and electronics revolution will also be discussed, although to me they are a class apart. Cameras of the Nikon rangefinder series, and the rangefinder cameras manufactured by Canon in the fifties, are well engineered and extremely usable, but are quite different in character from the great European classics. Similarly, we will include the products of the American camera industry, although there have been regrettably few cameras made by US manufacturers that genuinely merit being called classic cameras.

I would regard cameras of the pre-miniature technology and type – the Contessa Nettel hand and stand cameras, Voigtländer Bergheil and Avus models and

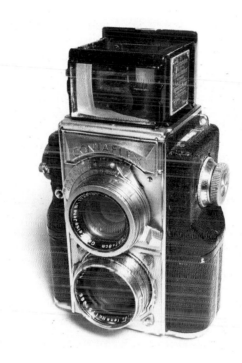

The remarkable **twin-lens Contaflex,** *probably in real terms the most expensive 35mm camera of all time, had a viewing (top) lens of 8cm focal length and a choice of standard taking lenses of 5cm focal length – this example is fitted with the 'top-of-the-line' 50mm f/1.5 Sonnar. The longer-focal-length viewing lens, which was mounted and geared so as to move further out from the reflex mirror than did the viewing lens from the film to focus at any given distance, provided a larger image for focusing than that received on the film. As a result, the camera is very easy to focus. A cell of a selenium photo-electric exposure meter, the first in the world to form a standard part of a camera, is mounted under the scutcheon bearing the camera name, which flips up when a button is pressed, and the needle is visible in the window to the left of the hood.*

the beautiful little 6cm x 9cm KW Etui cameras, for example – even those that were manufactured and sold extensively during the thirties, as being vintage cameras rather than classics, a distinction rather similar to that applying to vintage and classic cars. Most of those plate cameras can, in any event, now be used only with adaptation and distinct difficulty, because of the demise of the glass photographic plate, so would not fit easily into a book devoted to the usable classic camera.

For all these reasons, therefore, this book is about rollfilm and 35mm cameras from the great manufacturers across the world after the advent of the Leica. The predominance of European cameras and lenses throughout the book is inevitable, because European manufacturers dominated the world market for fine equipment throughout the classic-camera period, and is, for the same reason, a reflection of the interests of classic-camera enthusiasts in all parts of the world.

The creation of the European miniature-camera industry

Two major photographic events of the twenties, occurring within little more than a year of each other, did more to shape the European camera industry and its products through the pre-Second World War period than all else. The first was the imaginative and courageous decision in 1924 by Ernst Leitz II, the head of the Leitz family company, famed throughout the world for its microscopes and lenses, to go ahead with production of the revolutionary Leica camera designed by his close friend, the brilliant engineer Oskar Barnack. With hindsight, it seems an obvious decision to have made, but at the time it represented a substantial leap into the unknown – a major investment in an engineer's dream that had become a series of prototypes after more than eleven long years of development, albeit interrupted to some extent by the Great War. That decision initiated the photographic public's attachment to the 35mm camera and proved that the concept of 'small negative, big picture' was a practical and market-winning approach to photography. When the first fixed-lens Leica (the name was derived from LEItz CAmera) was shown at the Leipzig Fair of 1925, it was an immediate success, and within a year or two, as its sales and reputation gradually grew, it was having a considerable impact on the outlook of designers working for the other camera manufacturers.

Almost as important to the development of the classic cameras that form the subject of this book was the foundation of Zeiss Ikon, the other great force in the German camera industry of the thirties. In 1926,

during the latter part of a period of great financial instability and inflation in Germany, several of the camera manufacturers who fitted lenses manufactured by Carl Zeiss were simultaneously in financial difficulties. The Carl Zeiss Foundation was itself financially sound, and had no particular problems, but foresaw that its stability would be threatened if several of its important customers were allowed to go out of business. Zeiss therefore arranged a merger of no fewer than five major camera manufacturers – four initially in October 1926 (ICA, Goerz, Ernemann and Contessa-Nettel), plus a fifth (A.G. Hahn) in 1927. Together, the five companies became Zeiss Ikon AG, based in Dresden. The Zeiss Ikon merger brought together many of the best camera designers in Europe, and enabled one company to market a formidable array of cameras of the vintage era while the designers evolved their answer to the Leica, the Contax, and their new approach to rollfilm camera design, the Ikontas and the Super Ikontas.

The early 6cm x 9cm **Super Ikontas,** *taking eight pictures on 120 film, were finished in black with nickel plating to the bright parts, and usually had an f/4.5 Tessar (some a little later were f/3.8) in a Compur shutter with speeds from 1 second to 1/250th. The coupled rangefinder on the body worked in conjunction with a rotating wedge prism in the characteristic arm on the lens standard, and was very accurate. The Super Ikontas were well designed, strongly built, and more rigid than most folding cameras of their day, so maintained (and still maintain if well looked after) excellent parallelism between lens panel and film plane. The weak point is the bellows – always check them very carefully before buying. Picture by Colin Glanfield.*

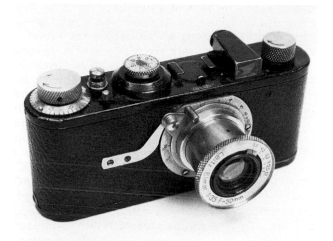 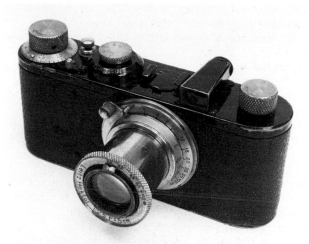

The **Leica I**, in its version with non-interchangeable lens, is usually known nowadays to collectors and those interested in camera history as the **Model A**, its American nomenclature. This Model A, number 28,437, has the close-focusing 50mm f/3.5 Elmar, which is common in examples found in Britain and less common elsewhere. It also has the 'low-profile' wind knob usually found on earlier cameras. Some Leica Model A cameras were fitted with the 50mm f/2.5 Hektor, a combination much sought after by collectors, and therefore likely to cost more than twice the price of a similar camera with Elmar, but best avoided by anyone actually planning to take photographs, since the f/2.5 Hektor is a poor lens by almost any standard.

In 1930, the fixed-lens Leica Model A gave way to the interchangeable-lens **Model C**, although some A cameras were manufactured after the C series began production. The first Model C Leicas were of non-standard lens-flange-to-film register, so each camera had to have its lenses individually matched to it. Later Model C cameras had the standard 28.8mm Leica register, and were marked with an 'O' at twelve o'clock on the lens flange. This particular example is fitted with the infamous f/2.5 Hektor – nice to collect, not so nice to use.

By 1930, the first folding Ikonta had appeared, initially in forms using the now long-discontinued 116 size film, soon afterwards supplied as cameras to take eight pictures 6cm x 9cm on what we would now term 120 film, or for twelve exposures 6cm x 6cm (known ever since to those brought up to measure in inches as 'two and a quarter square'). These were in no sense inexpensive cameras. As an example, a 6cm x 9cm Zeiss Ikonta 520/2 (a typical Zeiss catalogue number) with f/4.5 Tessar lens was listed in the 1932 Canadian catalogue at no less than $49.50 Canadian. Versions for sixteen exposures on 120 film (6cm x 4.5cm) were introduced, and there was also a Baby Ikonta, a tiny folding camera taking sixteen exposures on 127. The **Super Ikonta** with coupled rangefinder appeared in 1934, and began a whole era of sophisticated folding-camera photography.

The contenders for the market in the thirties

But by then the battle for the lead in the 35mm precision-camera market had been joined in earnest.

Leitz had followed up its success with the fixed-lens **Leica I** – usually now referred to by its American nomenclature, **Model A** – with a version of the Model I in which the lens could be unscrewed from the body and interchanged with specially matched wide-angle and long-focus lenses. This interchangeable-lens Leica I, the **Model C**, appeared in 1930, and was the first generally available 35mm camera with interchangeable lenses. By the beginning of 1931, the Model C Leica was available with a standardized lens mount, so that lenses no longer had to be individually matched to the camera; and at the Leipzig Spring Fair in 1932, Leitz launched the Leica II, with a convergent-image coupled rangefinder, enabling the user to set the focus of any of a range of interchangeable lenses. The Leica II almost, but not quite, stole the thunder of Zeiss Ikon's first 35mm camera, the Contax, now known as the **Contax I**. The Contax was larger, heavier and, with its rectangular lines, decidedly less elegant than the Leica II. It had also a significantly more complex mechanism than the Leica, as a result of Leitz patents having cornered the straightforward ap-

How the developing Leica and Contax lens ranges compared in the thirties

	1934		1938	
	Leica	Contax	Leica	Contax
28mm	None	28/8 Tessar	28/6.3 Hektor	28/8 Tessar
35mm	35/3.5 Elmar	None	35/3.5 Elmar	35/2.8 Biogon 35/4.5 Orthometar
40mm	None	40/2 Biotar	None	42.5/2 Biotar
50mm f/1.5	None	50/1.5 Sonnar	50/1.5 Xenon	50/1.5 Sonnar
50mm f/2	50/2 Summar (collapsible)	50/2 Sonnar (rigid)	50/2 Summar (collapsible)	50/2 Sonnar (collapsible)
50mm f/2.8	None	50/2.8 Tessar	None	50/2.8 Tessar
50mm f/3.5	50/3.5 Elmar	50/3.5 Tessar	50/3.5 Elmar	50/3.5 Tessar
60mm – 80mm	73/1.9 Hektor	None	73/1.9 Hektor	None
85mm – 90mm	90/4 Elmar	85/4 Triotar 85/2 Sonnar	90/4 Elmar	85/4 Triotar 85/2 Sonnar
90mm – 130mm	105/6.3 Elmar	None	None	None
135mm	135/4.5 Elmar 135/4.5 Hektor	135/4 Sonnar	135/4.5 Hektor	135/4 Sonnar
140mm – 195mm	None	180/6.3 Tele-Tessar (rangefinder cpld)	200/4.5 Telyt (reflex housing)	180/6.3 Tele-Tessar (rangefinder cpld) 180/2.8 Sonnar (reflex housing)
210mm – 400mm	None	300/8 Tele-Tessar (focus screen)	400/5 Telyt (reflex housing)	300/8 Tele-Tessar (reflex housing)
Over 400mm	None	500/8 Fern-Tessar (focus screen)	None	500/8 Fern-Tessar (reflex housing)

Note that in this table the common abbreviation 50/3.5 is used to represent 50mm f/3.5. Fuller discussion of the development of the Leica and Contax lens ranges will be found in Chapters 4 and 5.

Comparison of the Leitz and Zeiss lens ranges for the Leica and Contax cameras in 1934 and 1938 shows the extent to which Zeiss established and retained the initiative in the development and marketing of advanced objectives, thereby partially overcoming the price disadvantage of the Contax camera. The quality of Zeiss lenses was, in most cases, marginally higher than that of Leitz lenses prior to the Second World War. The exceptions were the outstanding 50mm f/3.5 Elmar, which in most cases outperformed the 50mm f/3.5 Tessar, and the 200mm f/4.5 Telyt.

proach to self-capping focal-plane shutter design, and was more expensive. But the Contax had, from the outset, two significant advantages which it was to retain until the mid-fifties: a longer-based and therefore more accurate rangefinder, and a set of decidedly superior lenses.

The various models of the pre-war Leica and Contax cameras that you are likely to find available will be discussed at some length in Chapters 4 and 5 respec-

tively, but this initial battle for ascendancy in a virgin market between two major companies with rival 35mm interchangeable-lens camera systems has an important place in the story of the classic camera, for it fuelled the enthusiasm of other manufacturers not only to join the fight for the 35mm camera market, which several did, but also to follow Zeiss Ikon's lead into the high-quality folding rollfilm camera market. During the first half of the thirties, a rash of folding

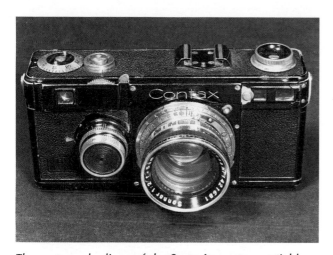

*The rectangular lines of the **Contax I** were appreciably less elegant than those of the Leica when it appeared in 1932, initially in a version without slow speeds, but there is no doubt that the longer base of the Contax rangefinder made focusing more accurate with wide-aperture lenses, and that the Zeiss lenses were substantially better than those produced by Leitz before the Second World War. This is a fairly late Contax I with slow speeds dating from about 1935, fitted with an f/2 'slip-ring' Sonnar in nickel finish. While the Contax I is a delightful camera, it is somewhat delicate in old age, and difficult to get repaired if it wheezes its last in your hands. Think twice, therefore, before buying one with the intention of using it at all frequently.*

later, of its less expensive cousin, the Rolleicord. Initially for six-exposure 117 film on a spool without flanges, the Rolleiflex was an instant success, and became the originator of the compact rollfilm twin-lens reflex design that is still available in the mid-eighties from Japan as the Yashica 124G. However, although the Rolleiflex was the first twin-lens reflex to be designed to use rollfilm, it was far from being the first camera to use the twin-lens reflex principle, there having been various twin-lens plate cameras available earlier. In 1931, the first 4cm x 4cm 'Baby' Rollei appeared, taking twelve square exposures on 127 VP film, and, by 1936, the 6cm x 6cm Rolleiflex had become established in its long-lasting twelve on 120 film (6cm x 6cm) format. The 'Standard Leverwind' version became one of the leading rollfilm cameras, particularly in demand among professional and portrait photographers. It was fast to focus, easy to wind with its large wind crank and had the feature, almost unique among rollfilm cameras of the time, of a self-cocking shutter. This meant that the shutter was cocked by the action of the winding crank. The

rollfilm cameras of quite advanced specification appeared on the European and American markets, most of them with lenses by Carl Zeiss, Meyer or Schneider, and with either simple 'everset' shutters, in which the depressing of the shutter release cocks the release spring, or more sophisticated Compur or Prontor shutters, typically with speeds from 1 second to 1/250th of a second.

Names like Voigtländer, Balda, Welta and Agfa were added to the familiar **Kodak** folding Brownies and the many Kodaks using 620 film, which were manufactured in their thousands to meet popular demand for folding snapshot cameras. Some of those folding rollfilm cameras – certainly the up-market Zeiss models, and some of the more expensive Welta and Voigtländer cameras – can reasonably be regarded as classics. But the quality of many left a great deal to be desired, and it could fairly be said that the proliferation of high-specification low-cost folding cameras in the mid-thirties was an early example of the sacrifice of quality to achieve market volume.

A further significant development was the advent in December 1928 of the Rolleiflex, and, a few years

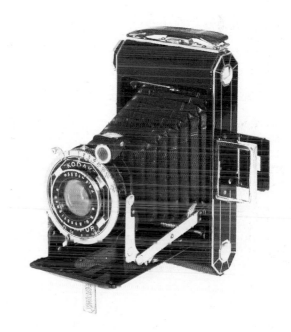

*There was during the thirties a vogue for cameras finished in the fashionable 'Art Deco' styling. This **Kodak Six-20** has a 10.5cm f/4.5 Anastigmat lens of good quality in a Compur shutter and, if the bellows are intact and lightproof, should be capable of producing excellent pictures once you have run to earth a supply of 620 film – which is the same as 120, but on spools with thin spindles and different fittings. Picture by Colin Glanfield.*

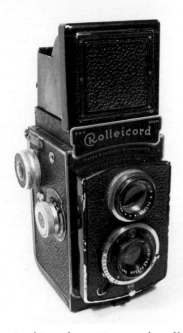

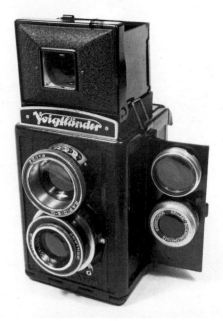

*The **Rolleicord** achieved great success by offering the amateur market the precision and quality of a well-engineered twin-lens reflex without the added cost of unnecessary refinements. This is a Rolleicord I; confusingly, however, it was not the first Rolleicord. That distinction is accorded to the 'metal-plated' Rolleicord, which had a distinctively 'diamond-patterned' metal front panel instead of the leathercloth covering. This example, like others of its kind, is fitted with a 75mm f/4.5 Triotar in Compur to 1/300th, not a first-quality lens, but one that lends itself to attractive 'old-fashioned' pictorial effects.*

*The circumferences of the mounts of the viewing and taking lenses of the Voigtländer Focusing **Brilliant** were cut as gears and meshed for focusing purposes. This worked well when the camera was new, and was a low-cost answer to the coupling problem, but the poor engineering of the camera rapidly caused play in the lens helixes to the extent that the gear teeth could ride one over the other, thereby destroying accurate focusing. As a result, these Brilliants are rarely effectively usable now – which is a pity, because the lenses are excellent.*

Rolleicord, with cheaper three-element lenses, simple knob-wind and manually cocked shutter, also had tremendous success among serious amateur photographers, and went on to be manufactured in some ten different versions, many with high-quality four-element lenses, before production ceased in the seventies.

Other twin-lens cameras appeared, notably the Voigtländer Superb, which was expensive, innovative and relatively unsuccessful commercially and is now therefore quite rare, and its low-cost brother, the Voigtländer **Brilliant**, a name applied to two quite distinct types of camera. The 'Focusing Brilliant' was a true twin-lens reflex, with its viewing and taking lenses coupled by means of meshed gears cut in the external circumferences of the lens mounts. The cheaper 'Brilliant' was not a reflex at all, the screen providing only a viewfinder image, and focusing being achieved by means of a scale on the lower taking lens. Neither Brilliant was well made and both are cameras to be avoided by those intending to take pictures. Zeiss had launched, concurrently with the Rolleiflex, its Ikoflex twin-lens reflex series of cameras, which continued well into the post-war era and which, in the more expensive forms, usually perform well to this day.

But the momentum of design innovation remained with the 35mm cameras. One of the most important was undoubtedly the Kodak Retina, which set a new standard of design and precision for the folding 35mm camera. In 1932, George Eastman's massive company had set out to buy an established and prestigious German camera manufacturer which would be prepared to make fine cameras with Kodak's name on

US prices in 1938 for different cameras compared (other years are in brackets where necessary)

	f/3.5 lens	f/2.8 lens	f/2 lens	f/1.5 lens
Leica II	$114.50	—	$159.50	$232.50
Contax I	$136.50	$147.00	$193.50	$293.50
Kodak Ektra (1942)	$304.00	—	$373.50 (f/1.9)	—
Kine-Exakta (35mm)	$150.00	$165.00	$230.00	—
Kodak 35 (1942)	$ 50.50	—	—	—
Retina I	$ 44.50	—	—	—
Retina II (1940)	—	?	$120.00	—
Super Baldina (1940)	$ 65.00	—	$ 99.00	—
Super Dollina (Tessar)	—	$ 87.50	—	—
Super Dollina (Xenar/Xenon)	—	$ 80.00	$ 95.00	—
Argus C3	$ 30.00	—	—	—
Rolleiflex (Standard Leverwind)	$115.00	—	—	—
Rolleiflex 4x4	—	$120.00	—	—
Rolleicord (f/3.8 Triotar)	$ 75.00	—	—	—
Voigtländer Superb	$ 69.50	—	—	—
Kodak Medalist (1942)	—	—	$176.00	—
VP Exakta B	$110.00	$125.00	$225.00 (f/1.9)	—
Super Ikonta C (1942)	$153.00	—	—	—

them and ship them both to the USA and to other major markets. Kodak quickly concluded a deal by which it bought Nagel Camerawerk in Stuttgart, and a year later, in 1933, Nagel began the task of designing the Retina.

When the new camera was launched in December 1934, Kodak announced with it one of the most significant developments for photography to emerge from the thirties – the mass-produced daylight-loading cassette that photographers everywhere have taken for granted ever since. Most Leica and Contax users prior to 1935 had bought their film as pre-cut lengths which the user was obliged to load into a Leica or Contax cassette in a darkroom before the cassette could be loaded into the camera, although spooled daylight-loading 35mm film refills with paper leaders had been available since the advent of the Contax,

and Agfa had introduced a felt-trapped 35mm cassette in a limited way in 1932. Kodak's newly acquired financial interest in the 35mm camera market inspired a felt-trapped cassette which made it possible for film to be bought, ready to load, straight from shops almost anywhere. Suddenly, the 35mm camera was suitable for the average photographer, and Kodak, whose Retina (in 1936) cost $44.50 in the USA and £10 10s. in Britain (when the Leica III with f/3.5 Elmar was priced at '$150 reduced to $114.50' in the USA, and £25 12s. 6d. in the UK), was well placed to take advantage of its innovation.

Real prices then and now

By 1936, both Leitz and Zeiss had extensive ranges of lenses and accessories for their Leica and Contax

cameras, and Zeiss had introduced its Contax II and III models and the twin-lens Contaflex, launched in 1935. This remarkable precision camera remains one of the few really successful 35mm twin-lens reflex cameras ever marketed. In 1936, the twin-lens Contaflex was priced at over £88 in Britain (the 1942 price in the USA was $399) at a time when the British average weekly wage was about £3. At 1994 prices, if one applies the ratio between average weekly wage and the price of the camera, the Contaflex would be priced at over £8,300 (about $12,500) – a not unfair comparison since, also in 1935, a Ford 8 family car was available in Britain for £100, little more than the price of the camera. Compare that with the Standard Leverwind Rolleiflex which was, in the same year, priced like the Leica at approximately £25 in Britain (1938 price $115 in the USA).

In 1936, Ihagee of Dresden, which had since 1934 been manufacturing its VP Exakta single-lens reflexes designed for 127 size film (eight exposures) launched what is usually credited with being the world's first 35mm single-lens reflex, a major landmark in camera development. According to a 1984 editorial in the British magazine *Amateur Photographer*, the Kine-Exakta, as it was then known to distinguish it from the rollfilm cameras, was not actually first, having been just preceded by a Russian camera known as the 'Sport'. However, recent (1994) research by the Exakta Circle, a specialist group within the Photographic Collectors Club of Great Britain has confirmed to most collectors' satisfaction that the Kine-Exakta was indeed the first 35mm SLR. The Kine-Exakta, available only with waist-level finder (the advent of the pentaprism had to await the Contax S of 1948), developed an enthusiastic following which continues to this day.

The Second World War

As the war approached, Leitz introduced the Leica IIIB, which for practical purposes was little different from the earlier IIIA, and Zeiss produced its Tenax and Nettax cameras, information on which can be found in Chapter 5, which goes into greater detail on the Contax family of cameras. Leitz was busy with a radical redesign, which emerged in 1939 as the Leica IIIC ('wartime' version) and continued with considerable amendment as the post-war IIIC in 1946; while the Zeiss team was apparently designing a top-quality single-lens reflex for the upper echelon of its range, revealed in patents filed between 1939 and 1941, and destined to appear after the war as the innovative, but poorly produced, East German Contax S.

The war period produced its own range of exotic collectibles, but nothing that was significant as a major advance in camera design other than the advent of

coated lenses. Wars, for all their ugliness, have a way of concentrating the minds of technologists, and from their efforts in the cause of victory emerge advances that may be extremely beneficial in peacetime. The coating of camera lenses was one such development. Although work on anti-reflection coating had been carried out years before the war, it was the demands of aerial reconnaissance with miniature cameras that brought lens coating to commercial and practical fruition.

Another marque brought to prominence by the needs of war was the Robot, a series of compact clockwork motorized cameras taking square 24mm x 24mm negatives, developed during the thirties for the photographic recording of the readings of scientific instruments, and tailor-made for mounting in aircraft to produce sequences of aerial-reconnaissance shots. Because the normal spring mechanism of the standard pre-war Robot did not provide power for long enough to fire more than six to eight frames of film, a special all-black 'long-spring Luftwaffen' Robot was developed – a camera that is not only interesting but is often usable if it should turn up in a sale. After the war, the Robot range was extended, first to the flash-synchronized Robot IIA, which was essentially a development of the wartime camera, then to the **Robot Royal** and Robot Royal 36, sophisticated and completely redesigned coupled-rangefinder cameras that are now of great desirability and, unfortunately, greatly inflated price, as a result of their interest to camera collectors. The Robot Royal 36 and its related sub-versions were the only Robots to adopt the 'standard' 35mm format of 24mm x 36mm.

Germany divided

After the war, the occupying powers were not slow to recognize the potential of the German camera industry. Dresden and Jena, then in East Germany, were of great interest to the USSR, whose ability to produce cameras and lenses of any quality or reliability had hitherto been extremely limited. By taking Dresden, the Russians had captured the works of both Ihagee and Zeiss Ikon, although many of the leading technicians had fled westwards. By capturing Jena, they found themselves in possession of the Carl Zeiss optical works. Much of the machinery of the Contax factory was taken to Kiev and set up in a camera works there for research which later produced the Kiev 35mm cameras, popular from the fifties until the end of the seventies and now increasingly sought after by collectors. These cameras and their lenses were clear derivatives of the pre-war and wartime Contax series. At Dresden, the **Contax S** pentaprism reflex,

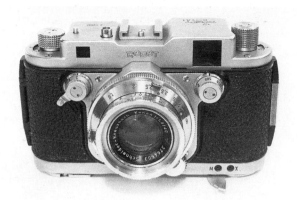

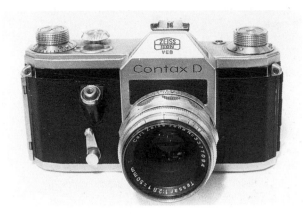

The *Robot* cameras were the originators of the concept of the 35mm camera with integral motor drive, and models with clockwork-spring motors were available before the Second World War. This is a post-war **Robot Royal**, which, like the earlier Robots, was designed to take square pictures 24mm x 24mm. This example is fitted with the desirable and very effective 40mm f/1.9 coated Xenon – note that a small red triangle on the lens bezel of a post-war Schneider lens indicated that it had been factory coated. The later Robot Royal 36 was the only Robot to adopt the standard 24mm x 36mm format. *Picture by Colin Glanfield.*

In 1948, the Zeiss Ikon works in Russian-occupied Dresden began producing a revolutionary camera called the **Contax S**, which was in fact the world's first single-lens reflex to be fitted with the now universal pentaprism. This is a Contax D, essentially the same camera but with mechanical improvements and a pre-set-diaphragm lens. *Picture by Colin Glanfield.*

based on the pre-war patents, was quickly put into production, but the speed of the camera's launch was not matched by its reliability, and examples which work well are comparatively scarce, even in the USA to which the majority of the cameras made were exported. Later, after a protracted trade-marks dispute with the new Zeiss Ikon established in Stuttgart, the cameras made at Dresden were renamed Pentacon, and lenses from Jena ceased to bear the name 'Zeiss', and were marked simply 'Jena'.

In the West, the Leitz factory was largely undamaged by the war, and was quickly back in production with the great commercial advantage of being able to continue an uninterrupted range of equipment. Zeiss Ikon, despite having to re-establish and re-equip itself in Stuttgart (with a new West German Carl Zeiss lens factory later set up at Oberkochen), was by 1948 producing Super Ikontas and Nettar folding cameras, by 1950 manufacturing a new range of Contax equipment, and had by 1953 offered the first of an extensive series of single-lens **Contaflex** cameras. The fifties were an innovative period at Zeiss Stuttgart, and a number of unusual cameras made their appearance, the folding Contessa being one of the most noteworthy. Other major marques were soon in full-scale production – Retinas in profusion, the Minox subminiature, a variety of Balda cameras, an abundance

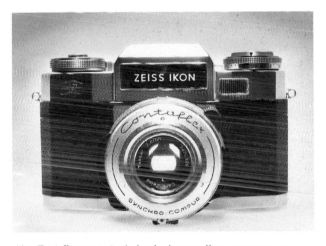

The **Contaflex** series of single-lens reflex cameras went through a variety of metamorphoses in the fifties to emerge as the butterflies of the Contax Super B, Super BC and Contaflex S only in the last few years of the existence of the line. This is a Contaflex Super B, with automatic exposure based on a selenium-cell exposure meter. The Super B and Super BC, which had a CdS (cadmium sulphide) exposure meter powered by a battery, are first-class cameras if they are in full working order, but watch very carefully for sluggish diaphragm operation after the shutter is fired. If the diaphragm does not close with a snap, do not buy it (unless it is very cheap), since cameras of the Contaflex Super series are extremely expensive to repair and service. *Picture by Colin Glanfield.*

of Agfa 35mm and rollfilm cameras, many of quite high quality and excellent performance, and some extremely interesting post-war Voigtländer designs.

The beginning of the end

By the sixties, the German camera industry was in decline, and only Leitz and (at that stage) Rollei were comparatively healthy. The production of Contax cameras ceased in 1962, and of Contaflex equipment in 1971. Only the success of the beautifully engineered Contarex series of cameras, particularly in the professional market of the time, and the acquisition of a financially troubled Voigtländer and its range of Icarex reflex cameras in the mid-sixties kept top-quality Zeiss camera production going, although a variety of progressively cheaper-looking compact viewfinder and coupled-rangefinder cameras was produced under the Contina and Contessa names. In 1971, even Contarex production came to an end under the onslaught of Japanese commercial success. Meanwhile, the other West German camera firms had one by one been taken over by Far Eastern interests or had gone out of business – only Leitz, Zeiss Ikon and Rollei remained. Zeiss manufactured only specialized cameras for military and scientific purposes, and the range of lenses for Hasselblad, Rollei and Linhof, and Rollei was to go through a succession of crises in the seventies. The golden age of the classic European camera was over.

A 1965 picture of one of my favourite child models, Rebecca Nicholson, taken with a Rolleicord V with f/3.5 coated Xenar. Note the pleasing roundness and slight softness of the image, which somehow complement the wistfulness of the little girl lost in her own thoughts. Shot on Ilford FP3.

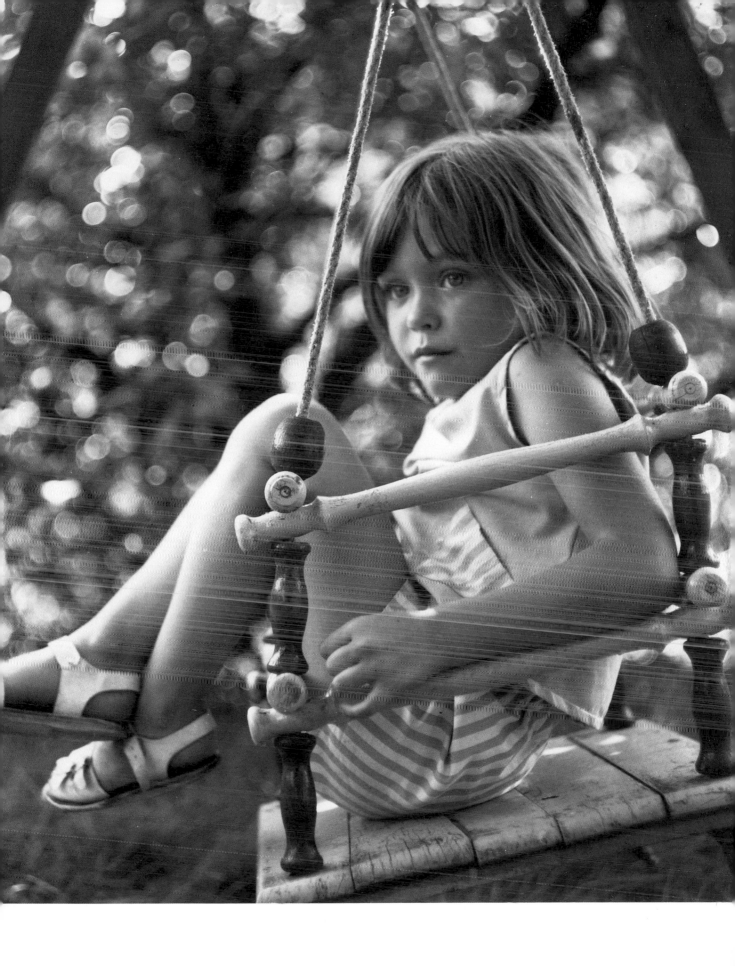

Above: One of those delightful unposed moments that children occasionally award to an alert bystander – in this case armed with a Leica IIIA with a late coated f/3.5 Elmar.

My father reading, as he always did, late at night.
The picture is interesting because it was shot at
1/10th second hand-held at f/2.8 with a Contax I
fitted with an uncoated f/2.8 Tessar by the sole
light of the standard lamp above him. The quality
of this picture, which dates from 1962, must be
regarded as excellent when one considers that
the camera and lens were made in 1934. A good
Contax can still do just as well thirty-odd years
on, and remains one of the easiest cameras
to hold still for lengthy exposures.

Not an advertising picture, although it could
almost have been, but a sixties near-abstract shot
in a London street with an Agiflex 2 6cm x 6cm
rollfilm single-lens reflex – a British copy of the
Reflex Korelle, which flourished in the Britain of
the fifties when import restrictions made German
cameras virtually impossible to buy unless you
were a professional photographer. The coated
80mm f/3.5 Agilux lens of the Agiflex (f/2.8 on
the later Agiflex 3) was capable of fine results.
Shot on Ilford HP3.

Opposite: *Static landscape photography is sometimes fashionable, sometimes not; this picture just appealed. Spotted on a hillside of what was once the garden of a great house in mid-Wales, the line of dead tree stumps, like a row of tombstones, leads the eye to the latest member of the family on the horizon. This shot should have been taken with a tripod, at f/32, with whatever.time exposure was necessary, so as to achieve maximum depth of field and get both the foreground stump and the distant tree perfectly in focus. As it was, I had no tripod with me (not a sign of a truly dedicated photographer) and was obliged to hand-hold at f/16. The camera was a Linhof Technika 70 fitted with 65mm f/8 Super Angulon and 6cm x 7cm Super Rollex rollfilm back.*

Who knows what thoughts pass through the head of a three-year-old boy as he contemplates the vastness of the Atlantic Ocean? This is a picture taken in 1973 with a pre-war Leica IIIA fitted with the much-maligned 50mm f/2 Summar lens. In the original print it is plain that very little was wrong with this particular Summar, albeit at f/11.

A candid taken during a downpour in Covent Garden market, London, in 1964 with a Reflex Korelle 6cm x 6cm single-lens reflex fitted with an uncoated f/2.8 Xenar. Uncoated lenses handle low-light situations like this very well, as there are no significant bright areas of light to cause flare. No records of the exposure survive, but I would guess by the light level and the lack of depth of field that the exposure was of the order of 1/50th at f/4 on Ilford HP3.

This shot was a candid taken in a friend's room at Magdalen College, Oxford, in 1959 with one of the original Model A Leica cameras. Notice how the flare of the uncoated f/3.5 fixed Elmar lens has created an attractive sunlight effect that modern coating technology has made almost impossible to achieve.

I was in France shooting pictures for a holiday brochure in 1977, and had a Hasselblad 1000F round my neck loaded with black-and-white for the fun pictures. Rounding a corner in the ancient Auvergne town of Besse en Chandesse, I found these fine old gentlemen contemplating their past. Picture shot from the waist with a 135mm f/3.5 Sonnar at about f/11 on 120 FP4.

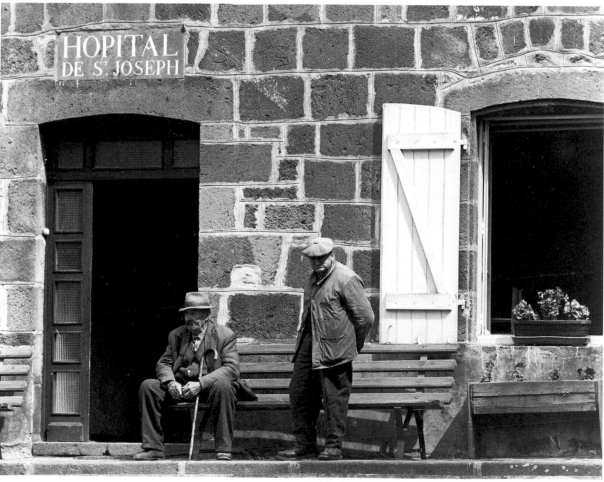

How to buy classic cameras without getting egg on your face

Just as there are few things more satisfying than a fine camera that reliably produces fine pictures, there are few experiences more frustrating than a prized acquisition that consistently lets one down and fails to produce much at all. Given care, good advice and a measure of luck when choosing a classic camera, there is no reason why you should experience anything more than the occasional minor breakdown, but simply rushing into the first camera store you see and buying anything that looks pre-Beatles is as likely to result in despair as in the joy of creative achievement.

It has to be realized that the period from the mid-twenties to the end of the sixties produced just as broad a range of cameras, good and bad, as has the last decade or so, and, indeed, probably a greater proportion of designs incapable of a long and trouble-free life. The trick is to know which designs were good and which bad; which can be repaired and which cannot. It is useful to remember that any camera made before the Second World War is by now old, and that only the best engineering and materials will have survived even modest and careful use. The advent of the Second World War during the period to which this book is devoted caused, between 1939 and 1945, an understandable reluctance among German manufacturers to supply spare parts for their products in Britain and the USA, and created conditions under which many cameras were destroyed or subjected to conditions of use for which they were not designed. Even in wartime Germany, especially in the latter part of the war, spares for cameras were unobtainable. As a result of this shortage, many pre-war cameras were repaired with non-standard or home-made parts, and retained these non-standard characteristics after the war. Such repairs are by now usually unreliable, even if the camera itself has managed to survive the years since the end of the war in Europe.

It therefore follows that, when buying pre-war cameras for use, it is important to look before all else for external evidence of non-standard or inexpert repair, such as accessory shoes that should not be there, flash-synchronization sockets added in curious places, unmatched screws or burred screwheads, and to treat with great caution cameras that show any of these characteristics. To be a thoroughly usable classic, a camera does not have to be in the 'mint condition' so earnestly sought by the collector, but it should be original, well-cared-for, and sound optically and mechanically. Later in this chapter, I will offer a little guidance on how to identify cameras that are in sound condition, for it is not always as easy as it seems. I would also suggest that nobody should embark upon buying and using classic cameras at all unless he or she is prepared for occasional failures and

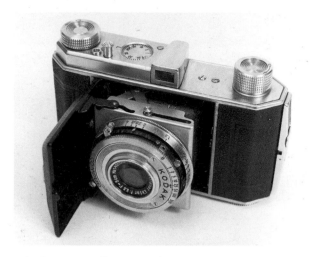

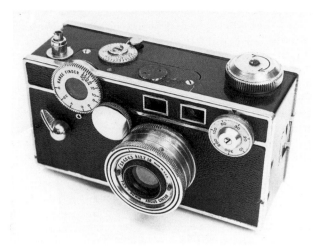

The **Retina I** *in all its many forms is a very pretty camera when found in good condition, and this particular 1939/40 model also works very well and has a beautifully silky feel to its controls. If you can find one like this, you are fairly lucky, for the Retinas prior to the 'a' series (the Ia and IIa) are subject to film-transport and shutter-interlock unreliability. This particular camera has a 50mm f/3.5 uncoated Ektar in Compur to 1/300th.*

The unbeautiful **Argus C3** *and its later brother the C33 were produced in vast quantities in the USA, and, with coupled rangefinder, an adequate-quality f/3.5 coated lens and ruggedness akin to a builder's wheelbarrow, performed tolerably well in their youth. Be warned, however, that they rarely perform well now, and are not to be recommended for taking pictures, although as a doorstop or paperweight they have much to recommend them.*

photographic disasters. As with classic cars, some of the appeal of using classic cameras is in the overcoming of inherent risks of failure.

Cameras that demand the exercise of caution

In many cases, manufacturers who were comparatively slow to follow Leitz and Zeiss into the miniature-camera market during the thirties did not achieve designs capable of long-term reliability until they had produced several sadly short-lived models. Other camera types which were successful at the time have subsequently proved to have design weaknesses which make them unreliable in old age. At the risk of having a contract on my life issued by the world-wide appreciators of the Retina marque, I have to recommend the exercise of the greatest caution (and perhaps insistence on a trial film) before buying a pre-war **Retina I** or **II** as a camera for long-term use in the eighties. A delightful collectible, and a camera capable of taking occasional pictures, an early Retina assuredly is, but its film transport and interlock system can be sorely troublesome nearly sixty years on, and perforated bellows that leak light are regrettably common. Similarly, the VP Exakta series of cameras, while advanced in design and excellently engineered when they were built between 1934 and the Second

World War, seldom fulfil their promise in practice today. The complex shutter mechanism, which in the VP Exakta B offers shutter speeds from 12 seconds to 1/1000th of a second, rarely sustains constant use, and, even if it does, is usually inaccurate after some sixty years of wear and tear. This is a great pity, because the VP Exakta, with its eight horizontal pictures 6cm x 4.5cm on a roll of 127 film, was and is a compact and versatile single-lens reflex capable of outstanding results.

Even early Rolleiflexes, while essentially simple cameras of basically sound design, must be checked very carefully before being bought as cameras to use. The 1936 Rolleiflex Standard Leverwind model, usually fitted with an f/3.8 Tessar in its Compur shutter, is given to occasional jamming of the film-transport mechanism in its old age, and, if you nurse a deep desire to make free with a pre-war twin-lens reflex, you may well do better to buy a Rolleicord of the same period, or the later first version of the Rolleiflex Automat, usually known as the 'single-bayonet' model because the taking lens only was fitted with the bayonet filter mount (size 1) that was later to become standard on both lenses of most Rolleiflexes and Rolleicords with f/3.5 lenses. The exceptions to this rule that f/3.5 Rollei lenses take size 1 filters are the late Rolleiflex 3.5E and 3.5F models with f/3.5 Planar or

Xenotar lenses, which take size 2 filters. Rolleiflexes with f/2.8 lenses take size 3 lens-mount accessories, and the scarce Wide-angle Rolleiflex takes size 4.

Even after the Second World War, import controls made it difficult not only to buy expensive cameras in many countries – notably Britain – but also to bring in the parts necessary to repair the ravages of the war. Shortages of raw materials and, in some cases, of appropriately trained and skilled technicians, resulted in some cameras being produced in the USA, in Britain and even in Germany to a standard far below that of the pre-war years. The omnipresent American **Argus** models were (and in some cases are) worthy if ugly cameras, but nobody could accuse them of being masterpieces of engineering. The British Corfield **Periflexes** and the **Corfield 66** of the fifties and early sixties were innovative and met a market need, but again have not proved able to withstand the test of time. Even twenty-five and thirty years on, few Periflexes could be classed as reliable. The great exception to this pattern among British cameras was the **Reid**, a near-copy of the Leica IIIB manufactured in Leicester, England, by Reid and Sigrist, and fitted with an excellent 2'' (roughly 50mm) f/2 Taylor-Hobson lens that looked much like the pre-war Leitz Summar and performed appreciably better. The Reid was, until the beginning of the eighties, comparatively common as classic cameras go in Britain, but has been bought in considerable numbers by collectors in other countries. This has made the camera both scarce and comparatively expensive everywhere. Nevertheless, as with the Leica from which it was copied, the Reid remains one of the classic cameras upon which the user can rely.

The impact of post-war production problems

In Germany, manufacturers such as Leitz, based in Wetzlar, and Rolleiwerke, with its factory in Brunswick, emerged from the war less damaged than did Zeiss, which had to start from scratch in the West after losing its facilities in the East; Ihagee, which was irretrievably under the Russian yoke; and Voigtländer, whose camera production had, in any case, since the twenties been of very variable quality after being acquired by a film manufacturer whose sole interest was in producing as many film-using machines as possible.

Thus, whereas early post-war Leicas (Leica IIICs with numbers above 400,000 and early Leica IIIFs with black synchronization dial) are sound and reliable cameras, and early post-war Rolleiflexes are for the most part a safe buy, the earliest post-war Zeiss Super Ikontas, Voigtländer Vito I and II 35mm folding cameras prior

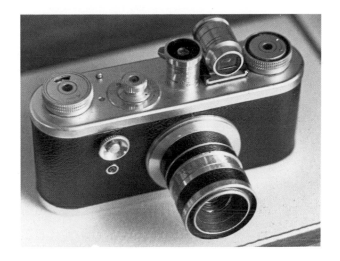

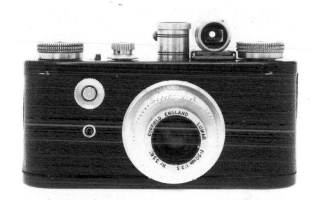

The **Periflex I** *was an innovative and clever design of the fifties by a British designer named Kenneth Corfield (now Sir Kenneth) who, like AGI (makers of the Agiflex and Agimatic) and Reid and Sigrist (producers of the Reid) sought to fill the UK market vacuum created by post-war import controls in Britain. The Periflex, like the Reid, was of Leica thread and register, but had no rangefinder. Instead, one pushed an inverted periscope down into the film chamber against spring pressure by using the lever on the side of the 'lighthouse' on top, and focused a small magnified part of the image. The picture was then framed through the direct vision finder. The chrome camera (top) has a later-type Periflex lens; the earlier black one has the original lens. Lower picture by Colin Glanfield.*

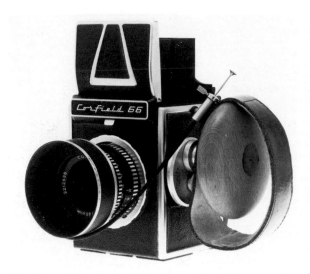

*Another of the Corfield designs of the fifties was this 6cm x 6cm single-lens reflex, the **Corfield 66**. Relatively few were sold, and it is uncommon even in Britain. Elsewhere, collectors seek it eagerly, and, as a result, many have been exported and prices for the camera are higher than its usefulness as a functional camera merits. Less than reliable after forty years, the Corfield 66 has a 95mm interchangeable lens. Picture by Colin Glanfield.*

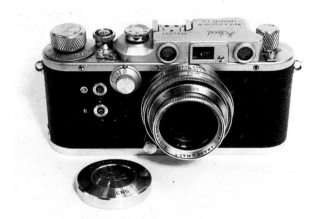

*Undoubtedly the best of the many copies spawned world-wide by the classic screw Leica, the British **Reid III** is essentially similar in design to a Leica IIIB, although relatively few parts are actually interchangeable. The excellent 2" f/2 lens by Taylor Hobson has a Leica screw mount, and Leica lenses normally fit and couple well to the camera. A Reid in good condition rates alongside the post-war Leicas, Contax models and Contarex as one of the most reliable classics capable of results of the highest standard. This is a Reid III – there was a Reid I without rangefinder, which is similar to a Leica Standard and is much scarcer than the Reid III. Picture by Colin Glanfield.*

to the IIA, and the early post-war folding rollfilm **Bessas** and twin-lens Brilliants can be diabolically and frustratingly unreliable. The lower-priced Voigtländer cameras, both pre- and post-war, were in any case often poorly engineered bodies supporting superb lenses (a Voigtländer Heliar will hold its own with many modern optics), a fact which brought their price down well below their competition and made it possible for Voigtländer models to be imported freely into Britain in the late forties and early fifties, when apparently similar models were subject to restrictive licences.

By the mid-fifties, the engineering quality of cameras from both East and West Germany had dramatically improved. The various models of the Voigtländer Prominent, Vito B and Vitessa are fine examples of the classic camera that can give first-class service in the nineties. So too, provided a good example is found, are the Exakta IIA and IIB single-lens reflexes from East Germany, and the **Super Ikonta** 532/16 and **533/16** (with exposure meter) 6cm x 6cm folding rollfilm cameras made after about 1951.

As trade and import restrictions in the various countries with which West Germany traded began to be eased, a flood of new camera models appeared to capture the enormous market that waited to be satisfied, and many of these were of such poor quality as not to have survived in any numbers. There cannot be many examples of the **Finetta 88**, the Lordomat or the **Futura** left in good reliable order. Similarly, the engineering standards of the early **Paxettes**, **Ilocas**, Edixa viewfinder cameras and Regulas left much to be desired, and one rarely sees them now, except in magazine advertisements of the fifties.

Classics of the fifties

Alongside these indifferent examples of camera mass-production, there also appeared new genuine classics – the Zeiss folding Contessa and Continas; the Agfa Silette and Super Silette, Solinette and Super Solinette, and their rollfilm cousins the Isolettes and Super Isolette; the Voigtländer Vitos, Vitessas and Prominents; the Zeiss Contaflex single-lens reflexes; and the beautiful Retina IA and IIA and their later B and C series successors. Towering above them all were the Leica models, particularly the new 'M' series Leicas that appeared with the advent of the M3 in 1954, and the Zeiss **Contax IIA** and IIIA. These two great rangefinder marques continued to dominate the top-quality market, which at that time was within the financial reach of very few enthusiasts. Among rollfilm cameras, the Rolleiflex and Rolleicord remained dominant, but a new name, Hasselblad, had appeared in

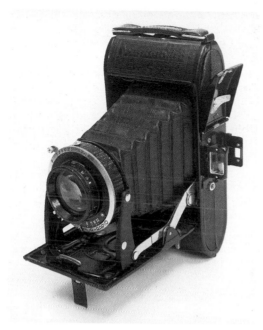

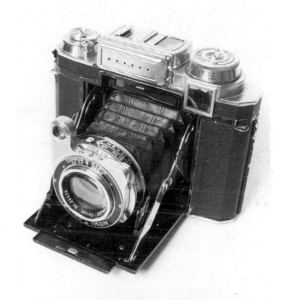

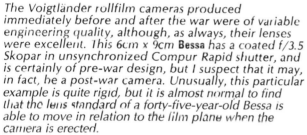

The Voigtländer rollfilm cameras produced immediately before and after the war were of variable engineering quality, although, as always, their lenses were excellent. This 6cm x 9cm **Bessa** *has a coated f/3.5 Skopar in unsynchronized Compur Rapid shutter, and is certainly of pre-war design, but I suspect that it may, in fact, be a post-war camera. Unusually, this particular example is quite rigid, but it is almost normal to find that the lens standard of a forty-five-year-old Bessa is able to move in relation to the film plane when the camera is erected.*

The pre-war **Super Ikonta** *design was heavy, magnificently engineered and capable of long trouble-free service. The same design was produced after the war, but the engineering standards, or possibly the available materials, seem not to have been so good, for it is more common to find an inoperative Super Ikonta 532/16 (without meter) or* **533/16** *(with meter, like this one) of early post-war date than of pre-war manufacture. This 533/16 with 80mm f/2.8 coated Opton Tessar has seen better days and is no longer usable. A later, very similar, version of the camera, normally with Synchro Compur shutter, has a lower-profile meter, and is usually found in much superior condition.*

the professional market since the war and was about to topple the Rolleiflex from its professional studio perch.

Assessing shutter function in cameras with focal-plane shutters

The Leica camera, from its inception as a production model in 1925, apart from Leitz's brief fling with the Compur-shuttered Leica Model B, had a focal-plane shutter. For the uninitiated, it should be explained that a focal-plane shutter consists of two blinds, usually of chemically treated lightproof fabric, or of thin flexible metal, which are normally positioned immediately in front of the film at the plane of focus of the lens, and which cover the film and protect it from light. When the shutter is fired, the first blind parts from the second and is rolled up from the other side of the film aperture, leaving a gap which exposes the film to the image from the lens. After a fraction of a second, the length of which is determined by the timing mechanism of the shutter, the second blind follows the first, closes the gap, ends the exposure and 'caps' with the first blind to form once again a continuous lightproof curtain. When the camera is wound after the exposure, both first and second blinds are wound together back to the tensioned start position at the same time as the film is wound to the position for the next exposure. In fact, most classic miniature focal-plane shutters open totally – that is, with the whole surface of the film exposed to light at the same time – only when set to speeds of 1/25th or 1/50th of a second or longer; the exact time varies with the design of the shutter and the make of the camera. It is this fact that determines the highest speed at which electronic flash can be synchronized

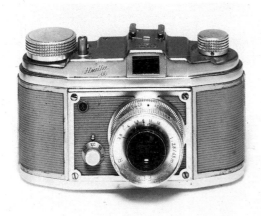

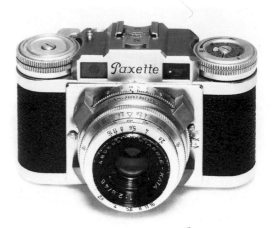

*One of the less successful cameras of the fifties in engineering terms, although in fact it sold quite well, was the Finetta, a German camera which was available in two versions: the **Finetta 88**, shown here, and a similar-looking model with built-in motor drive, much like a Robot, known as the Finetta 99. The lens was interchangeable with a screw thread.*

*While it would be entirely wrong to label all **Paxette** cameras as being cheap and nasty – the late models and the Paxette Reflex are capable of high-quality results and are reasonably reliable – the early Paxettes have poor lenses and mechanisms. This is one of the middle generation, dating from about 1957, the earlier models being recognizable by having no 'hump' for the accessory shoe above the camera name. Picture by Colin Glanfield.*

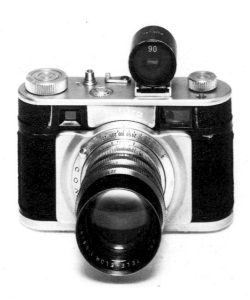

*The **Futura**, here shown fitted with its 90mm lens, possibly claims the distinction of being the least desirable camera of the fifties. Its engineering standard and quality of materials were very low, and lens mounts and focusing mechanisms are virtually always worn out. Picture by Colin Glanfield.*

with shutters that have flash synchronization – the duration of an electronic flash being so short that the film must be totally exposed by the shutter at the point when the flash is fired. At higher speeds, the second shutter blind starts its travel across the film before the first blind has reached the other side of the shutter aperture, effectively creating a travelling slit which progressively exposes the film across its width or length. At the highest speeds, this slit may be only a few millimetres wide. The actual speed of travel of the blind across the film remains constant, whatever shutter speed is set on the camera dial.

Thus it can readily be seen that the crucial requirements are that the shutter be light-tight when it is closed, and that it open appropriately when it is fired, staying open throughout the travel of the slit across the film. It must also be properly capped and light-tight when being rewound across the film aperture.

Before carrying out any mechanical checks on the condition of a focal-plane shutter, examine the blinds carefully with the camera lens removed. Fabric blinds should have an even, taut and unwrinkled appearance, and the sewing of the fabric at the point where the shutter caps should be even and in good condition. Beware shutter blinds that look cracked, or which appear to have bituminous or black adhesive materials spread on them. These will probably be

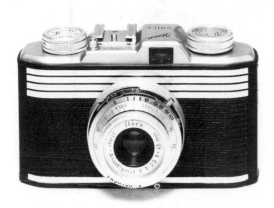

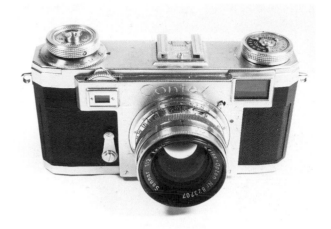

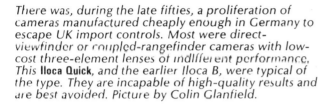

There was, during the late fifties, a proliferation of cameras manufactured cheaply enough in Germany to escape UK import controls. Most were direct-viewfinder or coupled-rangefinder cameras with low-cost three-element lenses of indifferent performance. This **Iloca Quick**, and the earlier Iloca B, were typical of the type. They are incapable of high-quality results and are best avoided. Picture by Colin Glanfield.

The post-war **Contax** 'A' series cameras – this is a late **IIA** – are excellent cameras to use and capable of superb results. However, the shutter repays constant use, and those that have been idle for an extended period frequently need a service, which can be expensive. So check the shutter as described in the text. Ensure also that the rangefinder prism is not defective and watch for play in the standard lens-focusing mount, which in the Contax is a part of the camera body.

porous, so will leak light, and may also be incapable of providing consistent shutter speeds. Shutter blinds can usually be replaced by competent repairers, but the job entails a full shutter overhaul and is expensive.

Metal shutter blinds should be smooth and un-rumpled and should never show signs of corrosion, which cannot be eliminated other than by replacement of the blinds, and may in any event be an indication that corrosion is present elsewhere in the camera.

With almost any camera that has a focal-plane shutter, other than a screw-mount Leica or a Leica copy, it is possible to remove or open the back to expose the blind of the focal-plane shutter from the film-chamber side. To check the shutter quickly and approximately in a shop, or in a vendor's home, remove the camera lens and the back, and first set the highest speed that the shutter offers – usually 1/1000th of a second, or 1/1250th on most Contaxes. Hold the camera to an even light source – a daylight sky is ideal – and fire the shutter several times. Your eye should be left after each passage of the shutter with an impression of the whole rectangular area of the film aperture. If you find that your retained image is of less than the full area of light, with a 'soft' or blurred edge on the side towards which the shutter travels, then the shutter is 'tapering' – that is to say, the

second blind is travelling fractionally more quickly than the first and is closing the slit between the blinds before the first blind reaches the end of the aperture. Some manufacturers' shutter designs are more prone to this fault than others; one that suffers badly from the problem is the Alpa shutter. On average, one Alpa 9d (or 6c) in every two will have a tapering shutter, unless it has been serviced during the preceding two or three years.

Tapering is usually simply rectified by any qualified repairer, but it will cost you a shutter overhaul, which can be expected to amount to a significant part of the value of the camera. If you see no light at all through the shutter during its travel at the highest speed, meaning that the shutter is failing totally to open (a common fault at the 1/1250th setting on post-war Contax shutters), then set the next longer speed, 1/500th, and try that. This will usually, in shutters that do not open at 1/1250th or 1/1000th, prove to be tapering as above. If the shutter does not open at 1/500th, try 1/250th – but there may be much more significant problems if the shutter is not opening at these lower speeds, and you should ask to be allowed to get a repairer's estimate before committing yourself. I would normally be prepared to buy an otherwise attractive camera whose shutter was tapering without further ado, provided I could reduce the

This Leica IIIA is in a considerably worse state than it looks in the photograph. For some reason, the Leica IIIA, which vies with the IIIC to be the commonest of all Leicas, seems to have led a harder life than other models, and a great many of them are in comparatively poor condition. This one has a flash-synchronization point that has been added through the front panel, which may or may not indicate further internal meddling, and some balsam separation of the elements of the 50mm f/2 Summar lens, which does not actually show in the picture. Leicas in this condition will nonetheless normally take quite reasonable pictures if the shutter is working properly, but are obviously less desirable (and less expensive) than good ones in original condition.

open and shut, not flop into action as pre-war Contax and VP Exakta shutters often do. They should look and sound clean, and there should be no loose oil or grease in evidence. Get to know the smell of that universal lubricant WD 40, and sniff for it when buying focal-plane cameras, particularly Leicas. This is because knowledgeable and unscrupulous individuals can, with care and know-how, get a 'sleepy' shutter going apparently normally for a short time by the judicious application of a tiny squirt of this remarkable lubricant in the right place.

If the camera is flash-synchronized, set the shutter to the fastest speed at which it synchronizes – sometimes indicated on the camera, or else guess at 1/50th or 1/25th – place the lens aperture at the front of the camera (without the lens fitted) over the lens of an electronic flashgun, plug the flash into the synchronization socket, and look through the shutter at the back as you fire it. You should be dazzled by the flash. If you are not, the shutter is not synchronizing with the flash. This may be, on elderly cameras that have had just one synchronization point fitted after manufacture, because the shutter has been synchronized for bulb flash. If you have such a thing as a bulb flashgun in working order, you could try the same test with that, given adequate safety precautions against the danger of the hot bulb both to person and camera, although you will not be able to judge visually whether synchronization with the peak light output of

price by about twenty per cent (typically) to cover the repair costs.

Next, try the slow speeds – those that use a mechanical escapement to delay the release of the second blind and thereby give exposures of 1 second, ½ second and so on. These should run with a clean, even buzz, and give the same exposure each time the same speed is run. Old Leica shutters, particularly those in models prior to the IIIC, are particularly prone to irregular slow speeds for no apparent reason, so wind and fire Leicas at 1 second or ½ second a number of times before committing yourself. A further useful indication of shutter condition with screw Leicas is a check whether the 1/8th second setting works – in many hard-used Leica III and IIIA cameras, it gives 1/20th second every time. If there is a delayed-action mechanism, try that, and not only at full delay but at half delay too. Finally, wind and fire the shutter at each of the speeds in turn and check that, on a rough-and-ready basis, each successive faster speed appears faster than the last. Focal-plane shutters should snap

This close-up of the speed dials of the Leica IIIA of the previous picture shows the setting that should yield the 1/8th-second exposure. It is the non-operation of this that is frequently a sign of a need for servicing. The main speed dial on the top of the camera should be set to 1/20th, the slow-speed dial on the front to 8.

the bulb has been achieved. In any event, if the camera has a synchronization point and fires the flash successfully, it should not be difficult for a good repairer to adjust the synchronization – but make an allowance for the cost of the work when calculating the price you are prepared to pay.

If the camera you are checking is a screw Leica, you will not have been able to check the shutter visually at the top speed, because the back cannot be removed. However, all is not lost. Take off the base of the camera and insert a piece of white paper where the film would normally go, between the shutter housing and the back of the camera. Set the shutter to its highest speed, remove the lens and fire, watching to see if you gain a visual impression of the whole of the film aperture (which will appear white because of the paper) or only part of it. You can also check the flash synchronization rudimentarily by pointing a flashgun into the camera lens aperture in a darkish room, and seeing whether, when the shutter speed is correctly set for flash synchronization, the light of the flash illuminates the whole of the white surface of the paper in the film aperture. You should also check that the flash synchronization works at all speeds below 1/30th, as well as at that speed. I have had the experience of checking a Leica IIIF and finding that the flash fired at one speed only. But by far the best test for a screw Leica is to load it with a fine-grain film, shoot pictures in appropriate conditions at all the shutter speeds, including some (if it is a synchronized camera) with flash, and process the film. Any tapering or shutter bounce – the term for the second blind bouncing back at the end of its travel to expose a narrow strip of film for a second time – will show clearly on the negatives. Shooting actual pictures will also reveal whether another of the problems occasionally encountered with screw Leica cameras is present. This is light leakage through the points where the body shell and the top-plate meet. Inexpert amateur repairers sometimes reassemble a Leica body with inadequate light-trapping. Although the camera may work well on non-photographic test, a developed film will reveal light-fogged streaks across the negatives.

Once you have checked the shutter, if the camera is a 35mm model, make sure the camera has a take-up spool (particularly with Zeiss cameras such as the Contax, Contaflex, Contarex, Super Nettel, etc.), check that the pressure-plate is smooth and springy, make sure the film path is smooth and will not scratch the film, and take a look to ensure that the film-advance sprockets move when the wind knob is advanced. If everything seems satisfactory, replace the back, and move on to checking the focusing mechanism and lens – but before we go through that,

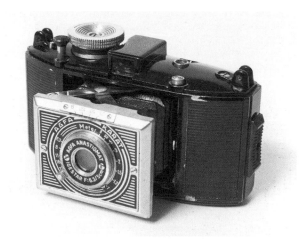

Agfa's earliest entry into the 35mm-camera market was with its pre-World War Two series of Karat cameras, ranging from this humble model with a three-element f/6.3 front-cell focusing Igestar lens through an f/4.5 version to quite sophisticated models with f/3.5 four-element Solinar with Compur shutter. All took twelve exposures 24mm x 36mm on 35mm film in special Karat cassettes, which re-emerged as 'Rapid' cassettes, and are still available. An f/6.3 Karat like this was my first 35mm camera when I was thirteen years old. They are sadly unreliable and should not be bought as cameras to use.

we should discuss how the checking of cameras with between-lens and behind-lens shutters differs from the procedure with focal-plane shutters.

How to check a leaf shutter

A leaf shutter of the Compur or Prontor type is usually positioned between the elements of a fixed-lens camera, or in some cases is behind the interchangeable lens of cameras like the Retina Reflex, single-lens Contaflex, Voigtländer Bessamatic or Prominent. It operates and exposes the film in quite a different way from a focal-plane shutter. The biggest differences are, firstly, that progressively higher shutter-blade velocities and shorter periods of opening (i.e., shutter speeds) are achieved by increasing spring tension, and, secondly, that, with a leaf shutter, there is always a point at any shutter speed when the shutter is fully open for flash synchronization.

The first check to make when examining a leaf shutter is simply visual. Look for the slightest sign of corrosion or free oil on the shutter blades, looking through the lens from front and back in the case of

between-lens shutters, and taking the lens out first in the case of behind-lens shutters. Corrosion is a bad sign, not only of possible poor shutter performance, but also of the likelihood that the camera has been kept or used in adverse conditions that may have affected other functions or created corrosion under the leather body covering that will later cause those tell-tale bumps in the leather finish. Free oil is usually a sign of inexpert servicing or repair and virtually always indicates a need for a thorough overhaul. Having a Compur or Prontor shutter serviced is itself less expensive than having work carried out on most focal-plane shutters, but beware the repairer's problem in reaching the shutter with cameras like the Retina Reflex, Contaflex or Bessamatic. Because so much dismantling is necessary, shutter work on these between-lens and behind-lens shuttered cameras can be as expensive as, or more expensive than, repairs to focal-plane shutters, and I have had the experience of a Retina Reflex being returned to me by an otherwise excellent repairer with a note saying that he 'would not work on one of these horrors' even at twice the usual rate. It must be said that the Retina Reflex models should be regarded with caution, even when they are working well.

If, on the other hand, the camera you are checking is a folding camera like a Retina or a Nettar, or a rigid viewfinder camera like an Agfa Silette or a Contina, the shutter can be reached with minimal dismantling, and the job should be relatively inexpensive. Nonetheless, because these types of camera, while excellent for taking photographs, are not worth very much money, it may well be that your best course is simply to avoid buying one that requires servicing. Even a modest shutter job may cost as much as the camera.

Once you are sure that the shutter looks clean and uncorroded, wind, cock and fire the shutter on all its speeds, making sure, as with the focal-plane shutter, that the slow speeds and delay action, if they are fitted, work smoothly and consistently. Uneven or inconsistent slow-speed or delay-action escapement operation is usually due to congealed grease or dirt. Older shutters, typically those made before about 1954, require separate cocking with a lever on the shutter barrel. The shutters of later cameras of the era of the Retina B and C series are cocked by the winding of the film-advance lever. But there is a catch. In many cases – the Voigtländer Vitos are the classic example, but there are many others – the shutter is not cocked by the wind-lever action itself but by the film turning the sprockets of the film transport as it is pulled through by the take-up spool. As a result, winding the camera does not cock the shutter unless there is a film in the camera. The simple answer to the problem of check-

When checking the condition of folding rollfilm cameras of almost any make or type, it is essential to look carefully at the mechanism by which the shutter release on the body of the camera triggers the shutter. This close-up shows the arm, bottom left, which is actuated towards the right of the picture on an Ensign Selfix 820. Make sure that the two arms meet correctly, work smoothly one against the other, and that there is no unnecessary play between the actuating arm and its bearing. A loose actuating arm can cause the shutter to fail to fire, or to jam.

ing such equipment is always to carry a cassette of useless film in your pocket which can be used to load and reload cameras whenever necessary. As you check the speeds of a leaf shutter, make sure the blades themselves close fully after the shutter has fired. A common problem with ageing shutters whose mainspring needs replacing is a failure to close totally. A pin-hole is left in the centre of the shutter, which of course lets in light and fogs the film. This can usually be dealt with by a good repairer, subject to the spares for the particular shutter being available, but will cost the full price of a shutter overhaul.

Many rollfilm cameras have interlock mechanisms which prevent the shutter being fired by the body

release unless the film-transport mechanism has been advanced one frame; but in these cases it is usually possible, without risk of harming the camera, to fire the shutter by depressing, with the tip of a pencil, the arm protruding from the shutter barrel around the lens, which is normally actuated by the shutter button on the body of the camera.

A rudimentary check of flash synchronization is much like that for a focal-plane shutter, but if, as in the case of many Compur and Prontor shutters (the **Synchro Compur**, Prontor SV and **Prontor SVS** shutters particularly), the shutter has settings marked X and M, the X setting is for electronic flash and the M setting is for bulb flash. Having set the lever to X, place an electronic flashgun beyond the lens, set the shutter to the highest speed – 1/300th or 1/500th – and fire. Again, if the synchronization is approximately right, you will be dazzled by seeing the flash through the open shutter.

Obviously, these are tests that help you to assess, rather than test, a camera in a shop or in somebody else's home. Readers of an engineering turn of mind can doubtless devise more effective tests of exact synchronization, and of shutter speeds.

A classic trick for shutter-speed testing is to mount a camera above a record turntable revolving at a known speed in a darkened room, with a bright-point light source on the turntable. At 33 rpm, the turntable takes 1.82 seconds to describe a circle, or 360 degrees. Hence a 1 second exposure should produce an arc of 198 degrees, a 1/2 second exposure 99 degrees, and so on. Other readers may simply prefer, once they have established the probability that a camera is in reasonable order, to buy their find and take it to a repair workshop to be checked on electronic instruments.

Checking the other functions

So far, we have discussed only the routine for checking whether shutters perform as they should. Other parts of the camera that are just as important are the lens, the focusing mechanism and the exposure meter, if one is fitted. One of the first things to do with any detachable lens is to remove it from the camera and gently shake it. If it rattles, be very suspicious! I have encountered many fairly modern lenses with displaced or loose internal elements or mechanical parts, but fortunately very few of the classic era, when lenses were assembled by craftsmen. Nonetheless, make sure that nothing is loose inside.

Next, check that the diaphragm opens and closes without undue effort on the one hand or slackness on the other, and that the aperture scale indicates full aperture when the diaphragm reaches its widest practical opening. This last point should be approached with a degree of flexibility, since some pre-war lens designs require their diaphragms to be apparently less than fully open when the lens is genuinely delivering its stated full aperture. This is particularly true of early wide-aperture lenses for 35mm cameras. Having checked diaphragm operation, open the diaphragm wide, and make sure there are no black specks of dried lubricant scattered around between the elements of the lens. This often happens to cameras that have spent some time in a hot, dry climate (and especially to the Leitz Summar, which has a complex curved diaphragm). There is seldom any problem for a repairer in cleaning the lens and relubricating the mechanism, but having the work done is a cost to be taken into account when deciding whether to buy the camera. Check the front and rear surfaces of the lens for scratches, digs and abrasions, and try to avoid buying lenses that are scratched, unless you have another overriding reason for wanting that camera or lens. Minor marks to the anti-reflection coating, while unsightly and unsettling to perfectionists, do not usually make sufficient difference to the performance of the lens to matter in practical use. Similarly, lenses (usually Zeiss lenses) with small, apparently reflective, mirror-like patches visible within their structure, caused by balsam (adhesive) failure between cemented elements, usually

*Most **Synchro Compur** and **Prontor SVS** shutters on the better-quality between-lens and behind-lens shuttered cameras of the fifties and sixties have a 'VXM' setting lever like this one, which is on a Voigtländer Vito B. 'M' is the setting for bulb-flash synchronization, 'X' is for electronic flash, and 'V' is the setting for delayed-action tripping of the shutter.*

function normally for practical photographic purposes, although you should take heed that the balsam fault will gradually get worse, is very expensive and usually uneconomic to repair, and that the lens will be difficult to resell. The logical conclusion is that you buy lenses with visible balsam failure only when the lens is of a scarce type, when you feel it to be unlikely that you will find another, when you are not likely to wish to resell the objective, and when you can obtain a reasonable reduction of the normal market price. If you must use a lens that is scratched, or has evidence of balsam failure, use a lens hood to minimize flare.

The next stage is to check the infinity focus of the camera. For this you need ideally to have a small piece of ground glass cut by your local glass dealer to a size slightly larger than the film aperture of the camera you are checking. But first, if the camera has a coupled rangefinder for focusing, as has a Leica, a Contax, any of the Retina II or III series or a Voigtländer Vitessa, check that the images of the rangefinder converge precisely when a 'true infinity' subject is focused. Even with a 50mm lens, such a subject needs to be at least half a mile away, and ideally twice that, to achieve a reliable test. This is not always easy in urban areas, but do your best! Make sure that the images not only come together in the horizontal plane, but also that they are not vertically separated. If they are, your reaction should depend on the camera you are checking. In the case of Leica cameras and their copies, such as the aforementioned Reid, the vertical alignment of the rangefinder is easily adjusted, and misalignment is no more than a nuisance. At the other extreme, vertical misalignment in a Contax is non-correctable, and is moreover an indication that the rangefinder prism is becoming unbalsamed. Since this prism is unobtainable, except by pillaging another camera, the fault in a Contax is serious, and you would be well advised never to buy such a camera.

In the case of reflex cameras, you should similarly check that the image of an infinity subject on the screen is sharply in focus when the focusing mechanism is set precisely to infinity. You should then, in either case, produce your piece of ground glass, open the back of the camera, position the glass where the film would be and view the subject on the ground glass through a 7x or 8x magnifier, with the shutter open at the 'B' setting, the diaphragm wide open, and the camera on a tripod. If the image is anything less than perfectly focused, a servicing job is required.

Simpler cameras without rangefinder or reflex focusing aids, which are focused simply by setting a scale on the lens or baseboard to an estimated distance, must be checked with the ground glass from the outset. If they are out of adjustment, having them

reset is a simple matter and should cost very little. Whichever sort of camera you are checking, make sure that the focusing helix of the lens runs smoothly without tight spots or slackness, and that the focusing head of the lens is not loose enough to rock within the focusing mount. If it does, this may or may not be correctable, depending on the design, manufacture and condition of the mount – ask your repair man.

Finally, check the exposure meter, if there is one. It is often requiring too much of a classic camera, particularly a pre-war camera, to expect its meter both to function and to be accurate. All selenium cells eventually become less active, and the meter cell of a pre-war Contax III, or of a Super Ikonta 533/16 folding rangefinder camera, while it may work, will almost certainly be inaccurate, although it will probably give consistently inaccurate results throughout its range. Some repairers are prepared to cut new cells to replace these, and can thus put early meters back in first-class working order, but this service should not be expected of any but a specialist. More reasonable is the expectation that the meter in a 1950s-era Contessa, Bessamatic or Contaflex should perform properly, which it usually does. Check for smooth, consistent movement of the meter needle, and try it with the camera held at different angles, to make sure that the mechanism is not out of balance. Take a reading of an evenly lit subject that fills the viewfinder, such as a brick wall, at about six feet, and then compare the suggested exposure with the reading from a meter of known accuracy – I take my Lunasix. However, one should beware the fact that the sensitometric bases upon which the emulsion speed of films is calculated have changed since the fifties, which inevitably results in a fifties meter that has not been recalibrated giving readings that will underexpose film rated by modern standards.

Finally, if you have the opportunity to do so, there is no better test for any camera than to load it with a film, to take as many different pictures as circumstances and the film length permit and to process it before you buy the camera. I have known Leica cameras that looked like new but leaked light, intermittent faults in focal-plane shutters that only occurred once in every thirty pictures or so, and Rolleiflexes whose film-counter 'feeler' roller was badly set and caused the loss of several pictures. There is nothing so effective as a thorough test.

Above all, when you set out to obtain a classic camera to enjoy, make sure you are buying a camera that will satisfy your aspirations and enable you to achieve the kind of results that you want. If you are likely to want the benefits of wide-angle and long-focus lenses, then opt for a system that offers inter-

changeable lenses, like the Contax, the Leica or the Exakta. If you want to do a lot of close-up work, then think about the Contarex with its superb close-focusing lenses, or the Alpa reflexes with their f/1.8 or f/1.9 Macro Switar lenses. If small size and pocket-ability are important, consider the top- quality folding cameras – the late Retinas, the Contessa, the Super Solinette – or settle for one of the screw Leica models. A Leica IIIC with a collapsible f/3.5 Elmar remains a formidable picture-making tool that nonetheless fits in a pocket or handbag.

Remember to budget for repairs, because, by the nature of using elderly cameras, repairs will be necessary from time to time. If you can afford it, try to own two identical classics, partly to provide a reserve camera if one goes wrong, but also to enable you to carry separate cameras for colour and black-and-white photography. Many of the later classic cameras with coated lenses are capable of superb colour rendition, and one should not accept without question the oft-repeated statement that 'old' lenses like the Tessar are no good for colour. You might also consider the investment potential, for it remains true that, while classic cameras have not appreciated greatly in the early years of the eighties, they have a recent history in most Western countries of at least holding their value against inflation, which is more than can be said for any new camera.

So which type of camera should you choose? The next chapter goes into greater detail on that point, and will help you to decide what classic equipment will best suit the photography that interests you.

Opposite: *Children's sports are always fun to photograph, but the subjects are no respecters of cameramen, and one has to be both fast on the button and nimble on the feet. This picture was taken in 1980 with – believe it or not – a 6cm x 9cm Linhof Technika 70 fitted with a 100mm f/2.8 Xenotar, 6cm x 7cm Super Rollex rollfilm back and anatomical grip, and hand-held using the coupled rangefinder. I find it hard to justify such a choice for this type of photography, but succeeding with it was certainly gratifying. Both girls are airborne, and the picture is sharp enough for the gymnastics award badge on the nearer girl's shorts to be read on the original print. Shot at 1/500th at f/8 on Ilford FP4.*

This portrait of Mr Robert Cox was taken in 1974 to mark his fifty years of service to his company. The camera was a 1936 Contax III fitted with a 50mm f/1.5 uncoated Zeiss Sonnar, and shows perfectly the curious characteristic of defined yet slightly unsharp detail that makes the optical quality of classic lenses so attractive.

All devotees of classic cameras derive pleasure from testing their latest acquisition to see what quality can be achieved from it. This picture of a sawn log end was taken about fifty feet from the back of my house with a newly acquired Contarex 'Cyclops' fitted with the usual standard 50mm f/2 Planar. As the picture shows, a Contarex in good order can deliver results equal to those of any top-quality current camera, the f/2 Planar being one of the most universally satisfactory lenses I know. Perhaps unfortunately, the camera that it fits is an acquired taste.

The unacceptable face of British housing, surprisingly shot, not in the US Depression of the thirties, but in Sussex, England, in 1977. The owner had just died, and the house was due to be demolished, so I paid a visit armed with an original Hasselblad Superwide – there was very little space for the shot to be taken, and only a very wide-angle lens made it possible.

This must rate as one of life's less promising subjects – a hospital boilerhouse in Scotland – but if one must photograph such things, one might as well attempt to make the resulting picture attractive. I took this one in 1978 while photographing the building for a client, and (as usual) carrying another camera to take pictures that appeal for their own sake. The camera was a rare 1954 original Hasselblad Superwide – the actual camera is illustrated on page 150 – with 38mm f/4.5 Zeiss Biogon, one of the outstanding lenses of the classic era, and one which (with optical improvements) is still available today in the latest version of the Hasselblad SWC. An orange filter was used to darken the sky and reveal the cloud effect.

Opposite: Motor racing is a subject tailor-made for the 35mm single-lens reflex, and is consequently rarely regarded as appropriate for the apparently ponderous classic camera. As if to disprove the rule, this shot was taken with a 1955 Hasselblad 1000F – hardly a camera built for speed – fitted with a 250mm f/5.6 Sonnar during trials of a new Formula 1 car at Brands Hatch in 1977. I had the benefit of operating from the pits while the driver, Tony Trimmer, drove as close as possible to achieve the most dramatic effect. Shot at 1/500th at f/8 on Tri-X.

The technique of getting under without getting out magnificently demonstrated by my son Gregory in 1973. The Leica III with which this was taken is ideally suited to the rapid snapshot in good light – just set a smallish aperture (perhaps f/11) and an appropriate shutter speed to yield correct exposure, and select a likely focus setting of, perhaps, three metres. If you have time to focus, then focus, but if not, take the picture anyway.

Chapter 3

Reflex or rangefinder? Or TLR? Or folding camera?

The classic-camera buyer has a bewildering choice before him, not only of marques but also of actual camera designs and formats. This chapter looks at each of several broadly defined camera types, discusses the advantages, disadvantages and suitability for various forms of photography of each, and summarizes in each case some of the principal brands and models of cameras that might be encountered. The table of cameras in Appendix 3 covers only wartime and post-war classics, from which you are most likely to derive a practical choice, and is not claimed to be exhaustive – a complete list of classic cameras would be almost as long as this book – but it will help as a guide to readily available types of the more important forms of camera.

The simple rigid-front viewfinder camera

A complete, detailed description of the exposure-measurement system of a modern camera can occupy as much as two pages of an A4 size brochure. It may not be easy for photographers accustomed to such complication to accept that all a camera must have to produce fine pictures is a high-quality lens, a reliable shutter and an accurately marked focusing mechanism. Exposure measurement is not actually necessary at all for many outdoor photographs with modern broad-latitude colour-negative or black-and-white films. Informed estimation is sufficient. If the shutter speed is set to the approximate reciprocal of the film speed (1/500th for a 400 ASA film, 1/250th for a 200 ASA film, 1/125th for a 100 ASA film and so on) and the diaphragm is set to f/16 in bright cloudless sun, f/11 in bright sun, f/8 in bright cloudy weather, f/5.6 in average cloudy weather and f/4 in dull conditions, ninety per cent or more of all outdoor photographs taken will produce excellent results, especially if a little common sense is employed to allow extra exposure in streets with tall buildings, or for back-lit portraits. Most of the outdoor pictures in this book were taken in this way.

There is much to be said for the many rigid-front (i.e., non-folding) post-war 35mm cameras with a fixed high-quality lens, a simple optical viewfinder and a good four-speed to nine-speed shutter, such as a Pronto, a Prontor SV or SVS, or a Synchro Compur. Such cameras do not, as a rule, suffer very much from the ailments of old age and usually retain precise focus and parallelism despite their years, thus ensuring negatives of good all-over sharpness. Obviously, the shutter will need to be checked, as described in Chapter 2, and it is important to ensure that the lens is unscratched and that the infinity focus setting does indeed focus a subject at infinity; but, if such basic

functions have been shown to be in good order, a rigid-front viewfinder camera can provide outstanding value for money.

Some of the best-known and most reliable of this class of post-war classic are the Voigtländer Vito B, the Agfa Silette, the various Zeiss **Continas** and rigid Contessas, and the higher-specification examples of the Kodak Retinette, but there are many others. Some of these (like the Vito B) are such delightfully engineered cameras that they command slightly inflated prices as a result of collectors' interest, but, even so, they remain extremely good value. All are excellent as lightweight cameras for walking, cycling or riding, or indeed for any outdoor photography in good light that does not require focusing of subjects closer than three feet (one metre) from the film plane, and which can be tackled adequately by a lens of 'standard' focal length. Thus they are usually excellent for candid photography of people outdoors, for street scenes, for general landscape photography and for recording what the photographer sees about him or her – for some sixty per cent of all outdoor photography, in fact.

Straightforward rigid-front viewfinder cameras are not really suitable for close-up work at distances closer than (approximately) three feet. Although close-up lenses can be fitted, and the distance at which the lens will achieve focus when set to a given distance calculated from tables, one still faces the problem of defining the field of view, since the parallax effect ensures that, at close range, the viewfinder does not accurately represent the subject as 'seen' by the lens.

Simple viewfinder cameras are very limited in their application to the photography of buildings or other 'wide-angle' subjects. To photograph the west front of your favourite cathedral, you will need a wide-angle lens and a camera with lens interchangeability to accommodate it, unless you can obtain one of the comparatively scarce British Ilford Advocate 35mm cameras, made in the fifties, which are equipped as standard with a 35mm Wray or Dallmeyer wide-angle lens. Viewfinder cameras are rarely suitable for effective sports photography, partly because most sports work demands lenses of rather greater than standard focal length, and also because focusing by guesswork is less than adequate for fast action. Similarly, simple viewfinder cameras are not ideal for portraiture, since, if you get close enough to your subject to fill the frame with head and shoulders using the standard fixed lens, your proximity will result in exaggerated perspective effects which tend to make noses look big and other facial and bodily features appear distorted. It is, however, worth noting that impecunious photographers can solve this problem by the simple ex-

*The Zeiss **Contina LK** is typical of the mid-sixties series of Contina (without rangefinder) and Contessa (with coupled rangefinder) cameras. This particular model has a front-cell focusing 45mm f/2.8 Color-Pantar and a built-in selenium exposure meter.*

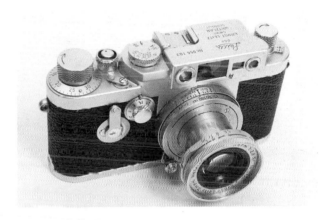

The last of the screw Leica cameras was the IIIG, the only screw Leica to have a viewfinder other than that for 50mm lenses built into the camera. The brightline viewfinder system, which provides indication for 90mm lenses, is the reason for the fourth 'window' in the front of the rangefinder housing. This IIIG is fitted with a 50mm f/2.8 Elmar lens.

pedient of using slow, fine-grain films, shooting with a tripod from a slightly greater distance – perhaps seven or eight feet from the subject – and subsequently enlarging the section of the negative required. Perspective is a function of distance from camera to subject, not of the focal length of the lens.

Despite these minor shortcomings, the straightforward high-quality rigid-front viewfinder camera, be it a Silette, a Vito or any of several others, is undoubtedly capable of providing, for a relatively low price, most of the pictorial quality and photographic enjoyment for which amateurs pay appreciably higher prices when they buy modern automatic fixed-lens compact cameras of considerably inferior engineering quality.

The coupled rangefinder

Most of the European classic-camera manufacturers of the fifties and sixties, and some in the thirties, offered their market not one camera under a given brand name but several, each sub-type offering more capability than the last from a greater range of mechanical and optical features. Thus, Agfa made available models of the Silette with an f/3.5 lens in a simple four-speed shutter, synchronized for flash; more elaborate models with Prontor eight-speed SVS shutters; and also the **Super Silette** with coupled-rangefinder focusing and either an f/2.8 or f/2 lens. The Voigtländer Vito rigid-front range extended from the simple (yet excellent) Vito B to the Vito BL with built-in exposure meter, through the Vito C with coupled rangefinder to the Vitomatic range with automatic exposure and, in the more expensive models, coupled rangefinder too. Virtually every manufacturer of high-quality fixed-lens cameras offered at least one version with coupled rangefinder.

So what, exactly, is a coupled rangefinder? It is a device, coupled to the focusing mechanism of the lens, for establishing the range, or distance, from the camera of a photographic subject. Operating the focusing mechanism both sets the focus of the lens itself and provides at the eyepiece a visual indication of what within the field of view is in focus at any given setting. The majority of coupled rangefinders follow the lead of the Leica and the Contax and operate on the coincident-image principle – providing, either in the centre of the viewfinder or in a separate eyepiece, a true double image of subjects out of focus, and merging the double image into one image only at the point of perfect focus. Some, notably American, cameras such as the Argus models and the Kodak Rangefinder 35, and the German Agfa Karat and Karamat cameras, use the split-image rangefinder,

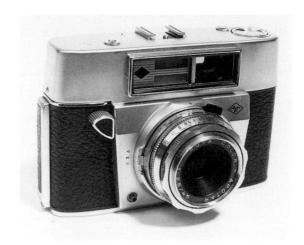

Agfa changed the design of its rigid-front viewfinder and coupled-rangefinder cameras in the sixties, and produced an ugly stark design of which this late **Super Silette**, *with coupled rangefinder, is typical. Note the shutter release on the front of the camera and the recessed pop-up rewind knob.*

which divides the viewfinder in two (usually horizontally). Only when the two halves of the subject are 'joined' without misalignment is it in focus.

The great advantage of the coupled rangefinder over the simple viewfinder is the ability that it provides to maintain accurate focus on a continuous basis while viewing the subject and composing the picture. Of all optical devices, it is one of the most useful. It makes the rigid-front fixed-lens camera reliably capable of tackling moving subjects such as children at play, or proximity sports like tennis and badminton. It ensures (with practice) that every picture is in focus and that guesswork is eliminated.

The folding camera

Of all the classic-camera forms, the folding-bellows camera has spawned the greatest number and variety of progeny. Chapters 10 and 11 will be devoted to rollfilm folding and 35mm folding cameras respectively, so we will not at this point launch ourselves into an extended discussion of different manufacturers' types and their relative advantages, but will confine ourselves to a general comparison of folding and rigid cameras. The two or three principal ranges of 35mm folding cameras offered a progressively ascending list of optional features similar to those provided on the rigid cameras – from more versatile lens and shutter combinations, to coupled rangefinder and (in a mi-

nority of examples) built-in exposure meters. It is broadly true that, from every purely photographic standpoint, there is little to choose between a rigid viewfinder camera in good condition and a folding camera of similar specification in similarly satisfactory order. Each has much the same capability and comparable disadvantages.

The major benefit of a given folding camera over its rigid counterpart is its portability. A folding Vito IIA or IIB, with a practically identical specification to a Vito B, will fit unobtrusively into a jacket pocket or handbag, even with its ever-ready case, whereas a Vito B, with its projecting lens and shutter assembly will not, especially if a case is fitted.

Against this benefit of portability must be set the comparative lack of durability and susceptibility to damage of the folding camera. Leather bellows are liable to perish and develop pin-holes, especially if they are folded when damp. The sliding and jointed struts that erect the bellows rely, for their ability to maintain rigidity of the lens panel and parallelism of the lens to the focal plane, on the perfect alignment and straightness of the struts themselves, and on their bearings not being worn. A lens panel that wobbles, or a lens that is not parallel to the film, will certainly produce pictures inferior to those of a rigid-front camera. The conclusion that must therefore be drawn is that folding cameras must be checked very carefully if they are being bought for use. It is worth noting, incidentally, that, despite Kodak's reputation for being a manufacturer of cameras for snapshotters, the higher-specification Kodak folding rollfilm cameras (e.g., the Kodak Six-20 Special) are among the most rigid and best-engineered available.

Rollfilm folding cameras, usually designed to produce eight, twelve or sixteen exposures on (usually) 120 or 620 film or (less commonly) on 127 film, are undoubtedly the most compact and portable means of producing comparatively large, medium-format negatives or transparencies. Many professional photographers habitually carry a 6cm x 6cm folding camera, such as a post-war Zeiss Super Ikonta or an Agfa Super Isolette, to produce 'stock shots' – 6cm x 6cm colour transparencies of subjects likely to be capable of generating income on a long-term basis when lodged with a picture library, or which are useful as examples of their creative photographic ability. However, cameras with front-cell lens focusing, even high-quality Zeiss cameras, were rarely set to a true infinity focus even when fresh from the factory, and having the infinity focus set accurately is likely greatly to improve image sharpness.

Folding cameras are essentially portable. A folding camera, complete with ever-ready case, will fit into a small briefcase or a raincoat pocket and will, given care, produce first-class pictures. It is, essentially, a form of camera ideal for people who move around and travel light, and the reintroduction of folding cameras in recent years by manufacturers such as Plaubel and Fuji is a recognition of the market value of this advantage.

The twin-lens reflex

A twin-lens reflex (TLR) consists of a lower lens with (usually) a between-lens shutter and iris diaphragm focusing an image on film, plus an upper matched lens without a diaphragm, which focuses an image via a mirror on to a ground-glass or fresnel screen. Both lenses are mounted (in most cases) on a common panel which is racked in and out by a focusing knob on the side of the camera or (as in the case of the Japanese Minolta Autocord) at the bottom of the front of the camera. Chapter 8 will discuss the various forms of twin-lens reflex in some detail. The purpose here is to assess its particular merits as a class of camera.

With a twin-lens reflex such as a Rolleiflex, a large negative is produced by means of a lens of superb definition mounted in such a way as to ensure

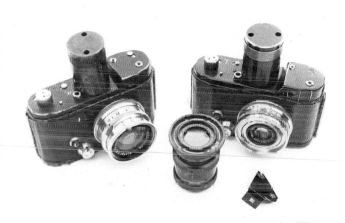

The Luftwaffe version of the Robot II clockwork motor-drive camera is an interesting camera to use, since the extra spring power of this 'long-spring' version (the motor tower on the top of the camera is twice the height of that on standard cameras) makes possible some twenty exposures before the clockwork motor has to be rewound. The camera on the left is fitted with the scarce 40mm f/2 Biotar lens, that on the right with a 40mm f/2.8 Tessar. In the centre is a 75mm f/3.8 Tessar in the same black wartime finish as the cameras, with (bottom right) a simple mask finder that plugs into the two locating sockets that can be seen on top of the viewfinder housing.

continuing accurate register and focus. The camera is heavy, box-shaped, easy to hold steady, and therefore not liable to the unsharpness that can so easily be caused by camera shake. As a result, small sections of Rolleiflex negatives, given correct exposure and development, can be successfully enlarged to give results comparable to those from a 35mm negative shot with a long-focus lens.

Because the Rolleiflex or Rolleicord, or any other

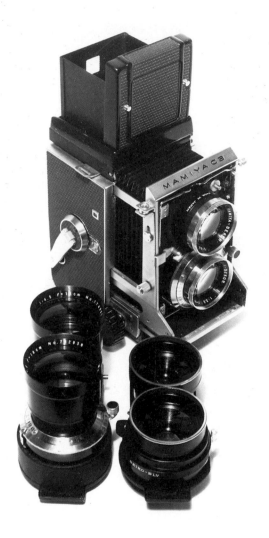

The Mamiya C3, one of the simplest and most practical of the Mamiya C series of twin-lens reflex cameras with interchangeable lenses. This particular camera was used to take the picture of the Duke of Edinburgh on page 144. The lenses fitted to the camera are early chrome bezel 105mm f/3.5 Sekors, and those in front are (left) early chrome-bezel 180mm f/4.5 Sekors and (right) a later pair of all-black 65mm f/3.5 Sekors.

twin-lens reflex, has an upper viewing lens without a shutter to provide the image on the focusing screen, the image is not lost, even for an instant, when the shutter is fired. This makes the twin-lens reflex peculiarly suitable for flash photography, for weddings, parties and professional conference photography. Like any reflex camera, the twin-lens reflex provides a realistic indication of differential focus on the screen (albeit always in this case at full, or slightly greater than full, aperture). Like a rollfilm single-lens reflex, a 120 rollfilm twin-lens reflex gives a large, approximately 6cm x 6cm, focusing image that makes photographic composition easier and, to many photographers, more enjoyable; but, unlike rollfilm single-lens reflexes, a good twin-lens reflex can be had quite cheaply. I bought the particular Rolleiflex 3.5E used for one or two pictures in this book for £75 plus the cost of a shutter overhaul – approximately £100 ($130) in all – in 1984. Decent Rolleicord and Zeiss Ikoflex twin-lens reflex cameras are, even in 1994, available for less than that. Even a late **Rolleiflex 3.5F** with an exposure meter, whose price is somewhat inflated by collector interest, should not cost more than £300 ($450) or so at 1994 prices, and is sometimes available for less.

So, for what is the twin-lens reflex a sound choice? For routine studio and portrait photography, a properly maintained twin-lens reflex with a first-class lens is ideal. Few cameras are better for photographing babies, because you can see the subject right up to and through the moment of exposure, and because, by classic-camera standards, a crank-wind twin-lens reflex can be wound and fired extremely quickly. A twin-lens reflex also minimizes the mechanical delay between the pressing of the shutter button and the exposing of the film. Few single-lens reflex cameras offer a delay shorter than 1/30th second, and some are as long-winded as 1/15th second. In candid, news or action photography, such delays can be the difference between a masterpiece and a disaster.

The twin-lens reflex is ideal for photographing groups of people under most conditions, although large groups in confined spaces can introduce a need for a wide-angle lens. For routine photography of predictable occasions, the Rolleiflex takes a lot of beating, particularly if you need to take pictures over the head of a crowd – you just turn your back to the subject and the camera upside down, hold it high above your head, and look up into it to focus. War photographers have in the past adapted this technique to enable them to take pictures of hazardous situations from the comparative safety of a trench, the principle being that it is better to risk losing even your Rollei than your head.

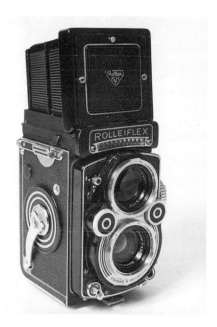

The ultimate f/3.5 **Rolleiflex** *– a* **3.5F**. *This particular camera is not quite the last version, as the final series had a switch on the side with the crank to enable the user to select counting for the twenty-four exposures of 220 film. The lens here is a five-element 75mm f/3.5 Schneider Xenotar. The 3.5F was often fitted with a 75mm f/3.5 Zeiss Planar, which is regarded by the cognoscenti as a superior lens. I have never been able to demonstrate any difference in performance between the two.*

Although quickly wound and fired once in use and focused, the twin-lens reflex is not spectacularly easy to bring to bear on a subject quickly. It is a fairly leisurely camera by comparison with a motorized modern single-lens reflex, but is likely to prove, over a long period of intensive use, a great deal more reliable.

Classic single-lens reflexes

When considering single-lens reflexes (SLRs) as classic cameras for use, one must exercise more than the usual amount of caution. By comparison with simple viewfinder or coupled-rangefinder cameras, or with twin-lens reflexes, any single-lens reflex is a complex mechanism, subject to wear, demanding of spare parts which may be unobtainable, and expensive (or sometimes impossible) to repair. To consider the single-lens reflex as a single class of camera is far from easy.

One should ideally divide classic single-lens reflexes into three groups: 35mm reflexes with focal plane shutters; 35mm reflexes with leaf shutters; and roll-film single-lens reflexes. The characteristics of each, particularly in respect of their long-term reliability and their ability to produce pictures that are acceptable by modern standards, vary greatly.

For landscape photography, a twin-lens reflex is excellent, provided you are working on negative rather than reversal emulsions, can avoid the temptation to shoot tightly composed square pictures, and are in a position subsequently to enlarge sections of the negative and eliminate unwanted areas. Rarely is the whole of a square negative required in a landscape, and this fact points to the first major disadvantage of the twin-lens reflex – with a fixed lens of approximately 'standard' focal length and square format, it is less than ideal for location colour-reversal work, unless you are in a position to be selective about your subject matter. On the credit side for landscape work, the twin-lens reflex makes the use of deeply coloured filters relatively easy, since the focusing is unhindered by the filter.

Other significant disadvantages are the sheer size, weight and obtrusiveness of the twin-lens reflex. The antithesis of the convenient folding pocket camera, the twin-lens reflex is a camera of which both photographer and subject are likely to be constantly aware.

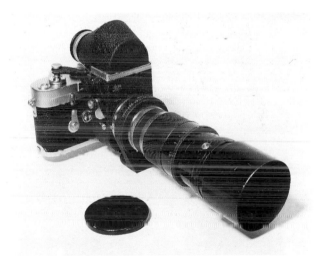

Since the thirties, Leitz has supplied reflex housings that fit the Leica rangefinder cameras and convert them to function as single-lens reflex cameras with lenses of focal length greater than 135mm, or for close-up work. This Leica M3 is fitted with a Visoflex II, into which has been inserted an adaptor 16466M, into which in turn is screwed a pre-war 200mm f/4.5 Telyt lens, which is shown fitted with its hood.

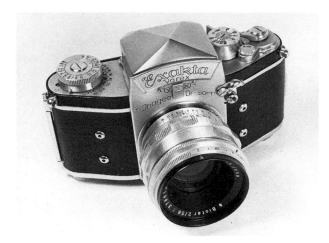

*An **Exakta Varex VX** (or Exakta VX in the USA), fitted with a 58mm f/2 pre-set Biotar and removable pentaprism. All Exakta cameras need to be checked very carefully before purchase, particularly for shutter faults.*

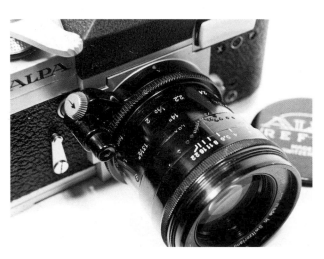

*The 50mm f/1.8 Kern Macro-Switar lens, as fitted to this **Alpa 6c** single-lens reflex, has a very long focusing travel, which enables it to focus as close as eleven inches from the film plane. The lens mount is engraved not only with exact focusing distances (both 11½" and 11¼" are actually specified) but also with the relevant increases in exposure that are required as the lens is extended from the film plane, and the reproduction ratio – ⅓ at the closest setting, shown here. The perforations visible just beyond the aperture scale are the unique Alpa depth-of-field indication, which produces a graph made up of coloured dots to show depth of field at the set aperture.*

Classic 35mm SLR cameras with focal-plane shutter

Most classic 35mm single-lens reflexes are fairly noisy, quite large, and decidedly unsuitable for covert photography in quiet places. Do not attempt to use one in church at your cousin's wedding without first obtaining permission or sizing up the opportunities for rapid retreat! This is particularly true of the focal-plane type of SLR. By the nature of their shutters, reflex cameras of this type usually have only limited flash synchronization, and will probably be incapable of synchronizing with flash at shutter speeds greater than 1/30th or 1/50th of a second. This makes it extremely difficult to use a flashgun as a means of 'filling' or lightening shadows.

With the exceptions of the **Exakta** and Leicaflex series of SLRs, and to a lesser extent the **Alpa**, you will find it difficult or well-nigh impossible to obtain wide-angle or long-focus lenses for most classic focal-plane SLRs with bayonet lens mounts. Even lenses for the Exakta and Alpa are far from easy to obtain in the eighties, but can be tracked down, given perseverance and patience. By far the easiest lenses to obtain are those with 42mm x 1mm screw-thread mount, developed before the Second World War, marketed by East German Zeiss on the Contax S in 1948 and used for all the subsequent East German Contax reflex, Pentacon F, FM and later Praktica cameras. The 42mm x 1mm mount was taken up by Asahi of Japan for all the Pentax cameras of the sixties and most of the seventies until the Pentax K series cameras with bayonet lens mount were introduced, and also by the Russians for most of their Zenith reflexes. For this reason, modern 'independent' branded lenses providing a full range from very short to extremely long focal lengths with 42mm screw mount were available in the seventies, and can readily be obtained second-hand to be used with much older classic cameras, thereby increasing their versatility dramatically.

Almost as important is the tremendous potential for close-up photography with bellows, extension tubes or microscope offered by single-lens reflexes with interchangeable lenses and focal-plane shutters. Close-up accessories with the 42mm screw or Exakta bayonet mount are easily obtainable (try the British BPM bellows or other similar bellows systems with interchangeable mounts), and provide a wealth of new photographic opportunities.

However – a word of warning. The focal-plane shutters of East German cameras dating from the fifties can, because of less than perfect engineering standards at that time, be subject to considerable wear after thirty years or more of use. Check both shutters and mirror mechanisms carefully, and, if in doubt, ask a

qualified repairer to check the camera before you use it intensively.

To sum up: the great advantage of a classic focal-plane shuttered 35mm single-lens reflex is the range of lenses that can often be obtained for it, even in the eighties, and the enormous facility for close-up photography that the use of accessory bellows provides. The disadvantages are the risk of unreliability, the noise, and the lack of vision through the viewfinder once the shutter button has been pressed. For sports and action photography, an SLR with focal-plane shutter and long-focus lenses is ideal. For wide-angle subjects, if you have or can obtain the appropriate lenses, the focal-plane SLR reigns supreme.

Classic 35mm single-lens reflex cameras with leaf shutter

Three main families of camera fall into this group. These are the single-lens Contaflex series, the Kodak **Retina Reflex** series and the Voigtländer Bessamatic/Ultramatic series. For the purposes of this chapter, all these and other similar families, such as the Paxette Reflex, have common characteristics, although there are in fact important differences between the various marques (see Chapter 7).

A single-lens reflex with a between-lens or behind-lens shutter is quieter than an SLR with a focal-plane shutter, and provides the great advantage of full flash synchronization at all shutter speeds that is characteristic of high-quality leaf shutters, and is therefore also available to users of (for example) a Rolleiflex, a Retina IIIC or a Zeiss Contessa. The full flash synchronization at all speeds of a single-lens Contaflex, a Retina Reflex or a Bessamatic makes it possible (for instance) to determine, when photographing a person with the light behind him or her, what the correct exposure for the well-lit background is, and then to fill the foreground either partially or wholly with light from a flashgun on or near the camera.

This degree of control of lighting outdoors is available only with leaf shutters and is, with their greater reliability, one of the principal reasons for many professionals preferring leaf-shuttered rollfilm SLR cameras such as the Hasselblad. You may recall that the Japanese Bronica 6cm × 6cm SLR system, which had for almost twenty years been based on a succession of cameras with focal-plane shutters, began anew with the leaf-shuttered SQ system in 1981/82. Hasselblad changed from its original 1948 focal-plane system to leaf shutters as early as 1957.

In addition to the benefits of leaf-shutter flash synchronization, each of the classic 35mm leaf-shutter systems was provided with a limited range of lenses, each marque having its own unique lens mount, none

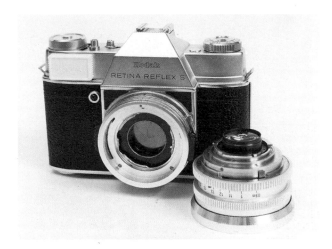

A **Retina Reflex S** shown with its standard f/1.9 Xenon lens removed to reveal the behind-lens Synchro Compur shutter. All 'S' series Retina lenses fit any Retina Reflex S, III or IV, and the Retina IIIS.

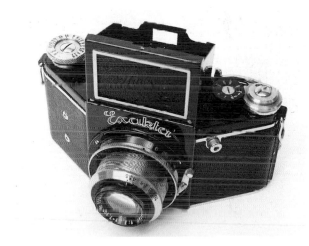

The **VP Exakta B**, a rollfilm single-lens reflex introduced in 1934, which produced eight pictures on 127 VP film. This example appears to be in good condition, but is fitted with the f/3.5 Exaktar lens, whose performance leaves much to be desired. The lever at three o'clock on the lens mount is the infinity catch. When a VP Exakta is in its case, the lens helix is wound right back into the body. Before use, the lens must be wound forward until the infinity catch clicks home. You can then wind the camera and bring the reflex mirror into the viewing position. To focus on subjects closer than infinity, the infinity catch must be pressed before the lens can be extended further forward.

of which was interchangeable with any of the others. In almost every case, the quality of the lenses is excellent, but the limitations imposed by the presence of the leaf shutter resulted in there being no ultra-wide-aperture lenses available, and in there being no lenses of wider angle than 28mm.

All the leaf-shuttered classic SLR families are mechanically complex, and consequently can be very expensive to repair. A late Contaflex or Ultramatic is a beautiful camera to use and a joy to own. However, it is, twenty-odd years after its manufacture, a pearl with a price, since any such leaf-shutter 35mm SLR will require occasional servicing, particularly if it is of the Contaflex Super B or Ultramatic generation of cameras with optional automatic or semi-automatic exposure setting.

To sum up, therefore: if you feel you want a classic 35mm SLR and your interest is in close-up work or in the acquisition, albeit with difficulty, of a substantial fleet of lenses from 20mm wide-angle to 400mm telephoto, buy a single-lens reflex with a focal-plane shutter – perhaps an Exakta, an Alpa, a Leicaflex or a Pentax from the early sixties. If you want the benefits of flash synchronization at all shutter speeds and (perhaps) automatic exposure with limited lens inter-

changeability, opt for a leaf-shutter SLR. There are, however, further alternatives.

The classic rollfilm single-lens reflex

Rollfilm single-lens reflexes are not an easy area for the aspiring purchaser. Possibly because the mass of focal-plane shutter components increases (roughly speaking) in proportion to the negative area, the reliability and longevity of service of rollfilm single-lens reflexes decrease sharply as the size of the camera and of the negatives it is designed to produce increases. It is difficult to think of any randomly chosen example of a rollfilm single-lens reflex with a focal-plane shutter made prior to 1960 upon which one could genuinely expect to rely for routine photography in the eighties. Certainly, there are exceptional pre-war **Reflex Korelles** which perform well, we may come across Agiflexes in good order forty years on, and I was working professionally with a large Hasselblad 1000F outfit as recently as 1977. My point is that, while such relatively aged yet sound rollfilm single-lens reflexes exist, they are few and far between, and finding them requires considerable perseverance.

The best buys in rollfilm single-lens reflex cameras are, in my experience, the leaf-shuttered Hasselblad 500C, which some would argue is not a classic camera anyway, or the focal-plane-shuttered East German Praktisix/Pentacon Six series of cameras, which, despite comparatively rough-and-ready engineering, seem to maintain their reliability reasonably well even with heavy use. Most other classic rollfilm single-lens reflexes are bought at the purchaser's peril. By buying a medium-format classic SLR, one gains the benefit of full close-up photographic capability with the advantage of a large negative. However, it should not be forgotten that Hasselblad lenses are extremely expensive, and that lenses of other than normal focal length are hard to find for most rollfilm single-lens reflexes. Here again, the exception is the Praktisix and its later cousin the Pentacon Six, for which lenses from the 50mm Flektagon wide-angle to the excellent 180mm f/2.8 Sonnar remain readily available on most second-hand markets, and longer lenses can be found with some perseverance.

The rangefinder system cameras

Perhaps the most important group of classic cameras are the rangefinder system cameras, notably the Leica and the Contax systems. The choice between the reflex types already discussed and one of the rangefinder systems is essentially a matter of personal preference. Rangefinder system cameras are smaller,

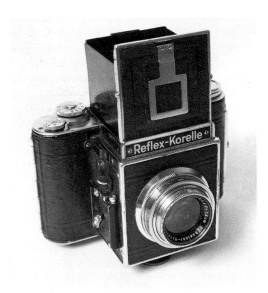

*The pre-war **Reflex Korelle** – this is a Korelle II with slow speeds – is an effective if ponderous 6cm x 6cm single-lens reflex with a cloth, horizontally running focal-plane shutter providing speeds from 2 seconds to 1/500th second. It is common for the leverwind to become disconnected from the shutter and film transport, but this is comparatively easily put right by a repairer who is prepared to take the trouble. This particular Reflex Korelle has an 80mm f/2.8 uncoated Tessar.*

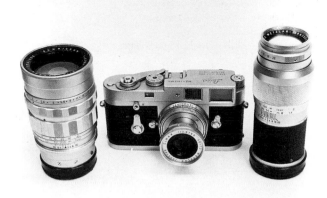

*The 'M' series **Leica** cameras brought new flexibility to the Leica system, but not always as much as users would wish. This Leica M2, fitted with a 50mm f/2.8 Elmar, is flanked by (left) a 90mm f/2 Summicron (a magnificent lens, if you are strong and have stamina), for which the M2 has a built-in finder, and by (right) a 135mm f/4 Elmar, which could be used on an M2 only with an accessory viewfinder.*

*My double-stroke **Leica M3**, with collapsible 50mm f/2 Summicron and Leicameter MC. The lever to the right of the lens as we look at it is the field selector. Moving this raises in the viewfinder the brightline frames for lenses other than the lens actually in the camera, so that the suitability of a focal length for the picture can be judged. The MC meter is coupled to the speed dial by a prong, and has two ranges for dull and outdoor light, selected by the milled wheel with the arrow, on top of the meter.*

lighter and much quieter than reflexes, but have marginally less versatile ranges of lenses, require more complex accessories for close-up work and provide a less 'realistic' viewfinder for pictorial composition, without the indication of depth of field provided by a reflex camera. Reflex cameras, although bigger and heavier, come closer within the context of classic-camera usage to modern thinking and practice, and may be preferred by photographers who find it difficult to work with anything other than a single-lens reflex, but who nonetheless want the peculiar pleasure of using a finely engineered classic.

However, rangefinder cameras offer positive advantages when focusing wide-angle lenses, particularly in poor light. The coincident images of a **Leica** or a Contax are as clearly separated when a 28mm or 21mm lens is slightly out of focus at two metres as they are when a 135mm is in need of focusing. Seeing whether a wide-angle lens on a single-lens reflex is in or out of focus under poor conditions can be very difficult, particularly with single-lens reflexes like the early ('Cyclops') Contarex and the Leicaflex I, where only a centre ring of the viewfinder screen actually indicates focus. If you plan to make extensive use of wide-angle lenses in poor light, think seriously about a rangefinder system.

So let us move on to detailed consideration of the rival rangefinder systems, starting with the Leica.

Opposite: Taking a few moments' rest close by Lincoln Cathedral, this lady was photographed in June 1984 with an Alpa 6c focal-plane single-lens reflex, fitted with a 50mm f/1.8 Macro-Switar. This print is, from a very small part of the negative, yet is of quite acceptable quality – one of the benefits of investing in the more sophisticated, though not necessarily more expensive, lenses.

A winning smile from Stephanie James in 1984 – taken with an Agfa Ambiflex single-lens reflex with its 135mm f/4 Color-Telinear telephoto lens and prism. The actual camera used for the shot is illustrated on page 124. Single-lens reflex cameras with either behind-lens or focal-plane shutters, and a good range of lenses, are best for this type of photography, since the limited lens range of (for example) the Contaflex will inhibit the ability to shoot portraits from a distance.

It is even possible to use folding medium-format cameras for quite creditable action pictures. The boy's third dart has been captured in mid-air about a foot from the dartboard, and is not too blurred to be recognizable, despite the fact that the top speed of the Velio shutter on this particular 6cm x 6cm Zeiss Nettar is only 1/200th second. This picture shows that there is much to be said for perseverance in attempts to find the advanced-specification versions of classic-camera families, with high-quality lenses and shutters. A Synchro Compur's top speed of 1/500th second would have frozen the dart much more effectively.

One of those idyllic country scenes that a classic rigid viewfinder camera handles well –
in this case the camera was a Zeiss Contessa LKE with 50mm f/2.8 Tessar and coupled
rangefinder.

Opposite above: Stonehenge, Wiltshire, as seen by a Voigtländer Vito B with 50mm
f/3.5 Color-Skopar fitted with an orange filter. It is the filter which has darkened the sky
and heightened the drama of the stone.

Opposite below: The excellent lens quality of the f/4.5 Novar of the same Zeiss Nettar
as was used for the dartboard picture is shown by this near-abstract shot of the highly
polished external accessories of a vintage Rolls-Royce. More pictures are made unsharp
by camera shake or poor processing than by poor lenses.

My father behind his Leica IIIB in about 1963. The camera is fitted with one of the scarce 73mm f/1.9 Hektor lenses of the late type in rectilinear focusing mount, with a Leitz VIOOH or IMARECT universal viewfinder. Note the orange rangefinder filter, slightly eccentrically fitted to the viewfinder window – these filters increase the visual contrast of the rangefinder and make focusing easier. The picture was taken with a Leica IIIC fitted with a 90mm f/4 Elmar.

A sparrow loose in the roof of the sports hall at Bethany School, Kent, promises to enliven speech day. A wary parent eyes the miscreant bird and assesses its aim. The picture was shot by available light with a double-stroke Leica M3 and 50mm f/2 Summicron.

Opposite: Medium-format folding cameras are ideal for taking on family walks, because they are compact, fairly light to carry, and can produce very crisp results. This picture of my daughter Emma when she was about seven years old was taken on Ashdown Forest in Sussex with a Zeiss Ikonta M with 105mm f/3.5 Novar and a built-in but uncoupled rangefinder.

Picturesque stone steps and a wary collie who probably eats photographers for lunch, taken from a safe distance in Whitby, Yorkshire, during 1984 with a Contaflex Super B single-lens reflex. The camera – illustrated on page 120 – is fitted with the 50mm f/2.8 recomputed Zeiss Tessar. Shots like this are ideal for the standard lens of a 35mm camera, and, if many of your pictures are taken with standard lenses, and a modest wide-angle or telephoto lens is needed only occasionally, a Contaflex may prove ideal.

Emulating Cartier-Bresson. Classic Leica photography

Attempting to present in a single chapter a balanced view of all the cameras, lenses and accessories that have formed part of the Leica system over sixty years is akin to trying to write a thousand-word précis of the works of Shakespeare. Leaving aside the many specialized and now rare Leica models designed for particular purposes (the Leica 250, Leica MD and others) and ignoring the large number of minor variants and sub-models beloved of collectors, there have been fifteen different models of Leica with either fixed or interchangeable lens with screw lens mount (nineteen if one differentiates between the wartime IIIC and post-war IIIC, and between the Black Dial and Red Dial versions of the IIIF, IIF and IF), and ten 'M' models plus the Leica CL with interchangeable bayonet lens mount. To fit these cameras, again excluding the very large number of variants which collectors would regard as distinct lenses, there have been some twenty-four different screw-mount lenses which couple to the Leica rangefinder. At the time of originally writing this book in 1984, there had also been twenty-three bayonet-mount lenses which couple to the Leica 'M' camera rangefinder, and seven lenses designed to be used with the various Visoflex reflex housings which, mounted between the camera body and the lens, effectively convert the Leica camera to function as a single-lens reflex. To this impressive evolutionary tree of Leica camera technology should be added the quite extraordinary range of accessories that have been marketed by Ernst Leitz of Wetzlar, West Germany, for the various Leica models since 1925, and which, with the cameras and lenses, make up a system capable of almost any type of photography possible with the 35mm format.

It can be appreciated, therefore, that to discuss the use of the Leica system thoroughly would require more than the present space allows. There are a number of substantial existing standard works on Leica photography whose thickness proves the point – but the function of this chapter is rather different from such a manual. We are looking at the Leica system comparatively from the standpoint of enjoying the use of classic cameras, and at the results that they can produce in the nineties, and not from the point of view of an instruction manual.

Every Leica a world-beater?

The Leica, more than any other classic camera, is a legend in its time, expected by the initiated always to produce unquestionably superior results by comparison with all available alternatives. Several generations have fostered in their offspring this belief in the inherent superiority of Leica cameras and their lenses, each quite genuinely expressing the view that, in their

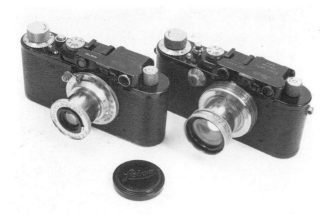

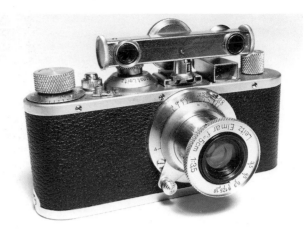

*The first two Leica models with coupled rangefinder were the **Leica II** (left), distinguishable by having no slow-speed dial on the face of the camera, and the **Leica III** (right). The Leica II is fitted with a 50mm f/3.5 Elmar of the early type whose infinity position was at eleven o'clock to the lens mount. The Leica III has a 50mm f/2 Summar. Both cameras and their lenses are finished in black enamel with nickel-plated bright parts.*

*A handsome chrome **Leica Standard** fitted with the 50mm f/3.5 Elmar and the pre-war FOKOS short-base rangefinder, mounted on a foot which enables it to swivel through 90 degrees, so that the photographer can get at the shutter-speed dial. The post-war FOKOS rangefinder has no foot, but the circular end fits the shoe of the camera and makes it possible to mount the rangefinder vertically.*

time, Leitz equipment was the best available. However, the comparative standards of the 1990s are greatly different from those that prevailed in the 1950s, and they in turn were significantly higher than the standards of the 1930s. To expect, by present-day standards, the results of a 50mm f/3.5 Elmar made in 1933 to outstrip those of a first-class Japanese lens of the mid-nineties is to invite disappointment. Not only will the contrast of the image produced by the Elmar be lower, but the extent of the aberrations shown by a modern lens test will be much greater. But therein lies part of the appeal of classic, and even of modern, Leitz lenses. For it remains Leitz policy not to design lenses purely to achieve high resolution of flat two-dimensional test charts, but deliberately to leave intact a modest degree of aberration and curvature of field to improve the rendition of three-dimensional subjects. This design policy causes photographs taken with Leitz lenses, both ancient and modern, to have quite distinct qualities of 'roundness' of image and 'plasticity' which Leica users cherish. Nonetheless, it remains true that Leitz lenses of each generation excel only by the standards of their time, and that in many instances, where the lenses were made before the Second World War, Zeiss lenses achieve higher resolution and contrast. Despite this, many classic-camera users, after trying both, find that the slightly soft and rounded image of a 50mm f/2 Summar is preferable to the bitingly uncompromising sharpness of a 50mm f/2 Sonnar.

Choosing your Leica – the 'screw' cameras

The question I have been asked most frequently by newcomers to classic Leica photography is 'Which model should I buy?' The only possible answer is to explain a little of the evolution of the system, and to apply to that an analysis of the potential user's interests and needs.

If your Leica will be your only camera, do not consider the three forms of the Model I Leica – the models A, B and C in the American nomenclature – for regular use. They will be both expensive and unreliable by comparison with later, still collectible models, such as the **Leica II** of 1932, the **Leica III** of 1933 and the **Leica Standard**, which are all based on the one design with a number of significant improvements on the first three models. The Leica II and III were the first Leica cameras with coupled rangefinder, the only major difference in practice between the two being the range of shutter speeds. The Leica II has speeds from 1/20th to 1/500th; the Leica III has additional slow speeds from 1 second to 1/8th second. The Leica Standard is essentially a Leica II without the rangefinder – it has a simple optical viewfinder on the top of the camera, similar to that of a Model C, which the Standard outwardly resembles. The simple way to differentiate between a Model C and a Standard is to try pulling up the rewind knob. That of a Leica Standard can be pulled up to facilitate rewinding. The lower-profile knob of a Model C cannot.

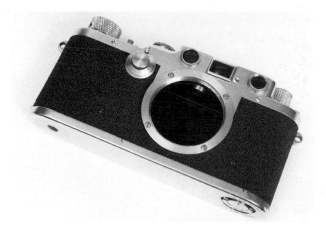

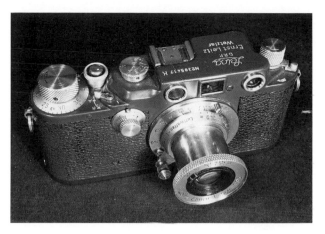

The rangefinder of a Leica is actuated by a spring-loaded cam-following wheel on an arm just within the top of the lens throat – it can be seen at the top of the throat of this Leica IIIC. The wheel runs on the rear coupling rim of the lens in the camera as it moves in and out to focus, thereby moving the arm and the rangefinder prism.

*Much sought after by collectors are the grey-painted wartime Luftwaffe **Leica IIIC** cameras, like this example, which has its original 50mm f/3.5 Elmar lens, engraved 'Luftwaffen Eigentum'. The 'K' after the number indicates that the camera was fitted with a specially ball-raced shutter, to provide more consistent reliability under extreme temperature conditions.*

The Leica IIIA, which appeared in 1935, is for practical purposes a Leica III with the addition of a new higher shutter speed of 1/1000th second. Incidentally, it is normal for the speed dial of a IIIA not to drop home at the 1/1000th second position as it does at other speeds. The IIIB, which appeared in 1938, has some important improvements to the body of the camera by comparison with the IIIA, but the only significant difference in use is the introduction of a more convenient arrangement for the viewfinder and rangefinder eyepieces. In the models prior to the IIIB, the two eyepieces are distinctly separated by some 25/32nds of an inch. In the IIIB and the subsequent models with screw lens mount, the two eyepieces are much closer together, with only ¼ inch separating them, and are contained within a black elliptical enclosure. This makes the necessary transfer of the user's eye from rangefinder to viewfinder appreciably quicker in practice.

The first major redesign of the **Leica** came with the **IIIC**, introduced initially as the 'wartime version' in 1939/40. Although superficially similar in appearance, the IIIC differs from the IIIB externally as a result of its one-piece body shell. The IIIC can be distinguished from its predecessors by the chrome panel which extends downwards from the rangefinder housing at the front of the camera around the lens mount, and from its successors by its small shutter-speed dial (9/16ths inch in diameter), similar to that of the earlier cameras, on the top-plate. The IIIF and IIIG models

that followed have much larger shutter-speed dials, with, in the case of the 'F' series cameras, a further series of numbers engraved around the shutter-speed dial which are used to set the delay of the flash synchronization.

The first IIIC cameras, made during the Second World War, have their rewind lever on a raised platform on the top-plate, and are numbered below 400,000. These are comparatively scarce, and examples (particularly those with red shutter blinds or unusual German services engravings) are sought after by collectors. The post-war Leica IIIC, numbered above 400,000, can be identified by its having a catch above the slow-speed dial to retain the dial at the 1/30th second position, but is little different in use from the earlier camera. Any IIIC of either type is likely, if in good order, to provide more accurate and repeatable shutter speeds than any of the earlier models, since its mechanical design is appreciably improved. When buying a post-war Leica IIIC, you may find that the chromium plate is peeling from the brass top- and bottom-plates. Because of a nickel shortage during the immediate post-war period, the chromium plating on early post-war IIIC cameras is often poor. After the war, Leitz produced, alongside the IIIC, a Leica IIC, without slow speeds, and a Leica IC, without rangefinder or slow speeds. Both these latter models are comparatively scarce, and therefore more expensive to buy than the IIIC, which has more features for the user. A rare version of the wartime IIIC

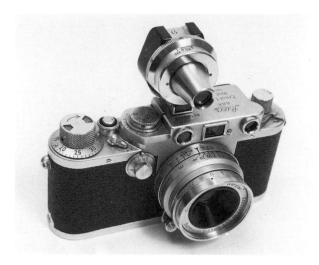

*A **Leica IIIF** Black Dial camera – note the larger-diameter main speed dial by comparison with the IIIC, and the flash-delay setting figures engraved into the camera top-plate around the circumference of the speed dial. The camera is fitted with the late version of the 35mm f/3.5 Summaron that accepts the same E39 (39mm screw-in) filters as the 50mm f/2 Summicron. A VIOOH universal viewfinder is in the accessory shoe.*

with a built-in delay-action mechanism, known as a IIID, also exists, and is much coveted by Leica collectors.

The **Leica IIIF**, introduced in its so-called Black Dial version in 1951, was the first Leica to be manufactured with built-in flash synchronization, and incorporated further mechanical improvements which again make it a more reliably precise camera for photography in the eighties. The term 'Black Dial' refers to the fact that the engraved figures of the flash-synchronization delay dial around the speed dial on top of the cameras were filled with black paint. The later Red Dial version, whose engraved flash-delay figures are filled in red, differed primarily in having speeds of 1/25th, 1/50th, 1/75th and 1/100th, instead of 1/30th, 1/40th, 1/60th and 1/100th, and in having a modified flash-synchronization system. Some IIIF cameras of both types were fitted with a delay-action mechanism. As with the 'C' series cameras, IIF and IF models were produced, each in both Black Dial and Red Dial versions.

The final screw-mount **Leica** was the **IIIG**, with a simplified range of shutter speeds conforming to the modern international standard (1/30th, 1/60th, 1/125th and 1/250th), which was manufactured concurrently with the bayonet-mount Leica M3 and M2

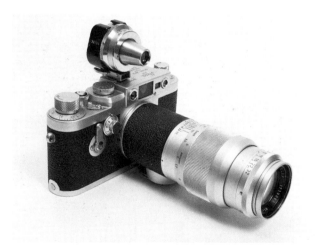

*The last of the screw Leica cameras was the **Leica IIIG**, introduced in 1957. It is recognizable by having four 'windows' in the front of the rangefinder housing and a larger viewfinder window, to provide its brightline viewfinder system, which has indications of field for the 50mm and the 90mm lenses. This IIIG is fitted with the last version of the 135mm f/4.5 Hektor, a lens which first appeared as a heavy black-enamelled, brass-mounted lens in 1933, and continued through several versions with A36 (36mm push-on) filter mount until the version shown here, with E39 filter mount, was introduced in 1954.*

*The top-plate of the **Leica IIIG** is clean and uncluttered. Under the rewind knob, on the left, is the variable dioptric adjustment for the rangefinder, and the rangefinder and viewfinder eyepieces are within the elliptical black enclosure, to the right of which is the flash-synchronization socket. The large speed dial has its speeds in geometrical progression, with settings for bulb and electronic flash. On the back of the camera is a film reminder dial.*

cameras. Much prized by collectors, despite being reasonably common, the Leica IIIG, alone among screw-mount Leica cameras, has a built-in brightline viewfinder system which provides for 90mm as well as 50mm lenses, and delay action. For some reason that is not altogether clear, the IIIG has consistently maintained a very high price by comparison with the IIIF models that preceded it and the Leica M3 with which it was concurrent, and, although a delightful camera to use, is therefore not particularly good value for money from the standpoint of the user. Although a IG was manufactured, without rangefinder, no IIG was marketed, despite a prototype having been made.

Making your choice

So, which of the Leicas with screw lens mount should you buy? If flash is important to your photography, look for a IIIF, IIF or, if you can afford it, a IIIG. Although earlier cameras that have been flash-synchronized after manufacture can often be found, the flash mechanism is rarely as reliable or as flexible as that of the cameras manufactured with synchronization. If your primary interest is in outdoor photography – landscapes, people and the world about you – and flash is not necessary, then a Leica IIIC probably represents the most cost-effective option, being substantially cheaper than a IIIF, and little older, although a sound II, III, IIIA or IIIB will do equally well. Remember that the 1/1000th second setting is present only from the IIIA onwards, and that a IIIC is an appreciably newer camera, although it is normally available at much the same price as a IIIB, and for not much more than a III or IIIA.

The bayonet-mount 'M' cameras

In 1954, Leitz caused a considerable stir by breaking with what had come to be seen by Leica enthusiasts as the holiest tradition in photography. By introducing the **Leica M3**, with its larger, squarer, heavier body and its bayonet lens mount, Leitz came, in the eyes of many a traditionalist who revered the Leica as perfection incarnate, dangerously close to heresy.

The Leica M3 represented a radical redesign of the Leica concept. Not only did the new camera have a bayonet lens mount, it also had a new viewfinder system with automatic parallax correction and automatically operated brightline viewfinder frames for lenses of 50mm, 90mm and 135mm focal lengths, which came into view when the appropriate lens was inserted into the body and obviated the need for special viewfinders for these focal lengths. The M3 had leverwind – the first production Leica with this

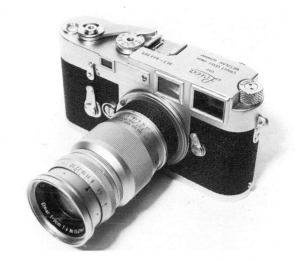

*With the first **Leica M3** cameras were introduced bayonet-mount versions of the 'fifties-generation' lenses – this double-stroke M3 is fitted with a 90mm f/4 Elmar. Note the position of the field-selector lever inclined towards the lens. As the lens is inserted, its mount selects the appropriate viewfinder within the camera, and the selector lever moves to that position as the lens clicks home.*

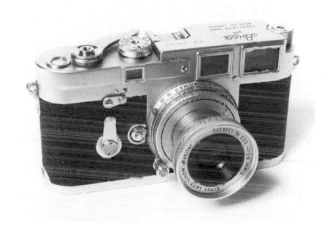

*The first **Leica M3** double-stroke cameras, introduced in 1954, were numbered from 700,000 to 710,000, and are known as 'first-series' M3 bodies. This example is numbered 704,457, and is fitted with the bayonet-mount version of the 50mm f/3.5 Elmar with E39 filter mount. Note that the camera has no field-selector lever beneath the viewfinder.*

The screw Leica is loaded by removing the base-plate. The cassette of film must first have its leader attached to the take-up spool, which has to be lifted out of the left-hand chamber. Both cassette and spool, joined by the film (trimmed to have a four-inch leader) are then eased down together into the right and left chambers respectively, the film going into the slot behind the shutter assembly. A little gentle pressure and movement of the wind knob are sometimes necessary to get the film-transport sprockets engaged properly with the perforations in the film. Always check (with any 35mm camera, but particularly with a screw Leica) that the rewind knob is turning when you wind and fire the three waste frames at the start of the film. If it is not, the film is not passing through the camera, and you must reload.

feature – which required two strokes of the lever to complete the winding of film and shutter between exposures. It had a back which opened to reveal the shutter and film-transport sprockets, although the camera was still loaded through the bottom, as is a screw Leica. The shutter speeds were all on one dial, which, for the first time in a production Leica, did not rotate when the shutter was fired – features which made it possible for an exposure meter to be coupled to the shutter-speed dial, also for the first time in a Leica. Every Leica M3 had a delay-action mechanism, a bigger, brighter viewfinder than any screw Leica, and a magnificently quiet and reliable shutter which, in early models (from serial number 700,000), retained the 1/25th, 1/50th, 1/100th, 1/200th second shutter-speed progression. Later models had the 1/30th, 1/60th, 1/125th, 1/250th progression.

Despite these apparent breaks with tradition, Leitz had not forgotten that, in almost thirty years, it had sold a great many fine lenses with screw mounts to fit

the traditional Leica camera, whose thickness from lens flange to film plane was 28.8mm. The new Leica M3 was cleverly designed to have a flange-to-film register of 27.8mm, thereby making it possible for Leitz to supply a range of **bayonet adaptors** of 1mm thickness which not only converted any standard coupled Leica screw lens to fit and couple with a Leica M3, but also actuated the viewfinder mechanism of the camera appropriately to the lens. Thus, with an appropriate 50mm, 90mm or 135mm bayonet adaptor, enthusiasts could (and can) use screw Leitz lenses on any 'M' Leica with no disadvantage. Quite soon after the introduction of the M3, a special version of the 35mm f/3.5 Summaron was produced with built-in optics looking rather like spectacles above the lens itself. These optics altered the field of view of the standard 50mm viewfinder frame of the M3 to give an image correct for the 35mm lens, and thereby introduced a 35mm lens that made full use of the advantages of the Leica M3.

More than 250,000 Leica M3 cameras were manufactured, those from serial number 919,251 having single-stroke leverwind instead of double-stroke. It is thus a relatively easily obtained camera, available at very reasonable cost if one takes account of the high standard of its engineering, its extreme reliability, quietness and effectiveness as a camera, and the long-term investment potential that it provides.

The Leica M2, M1 and M4

In 1957, Leitz recognized the developing trend towards greater use of wide-angle lenses. This increasing tendency to regard the 35mm lens as 'normal', instead of the 50mm lens, was partly the outcome of improving lens design and glass technology, which made the results of wide-angle lenses comparable with those from lenses of longer focal length. The **Leica M2** had the essential features of the M3, albeit with a number of detailed variations of specification, but with the major difference of providing viewfinder frames for 35mm, 50mm and 90mm lenses instead of the 50mm, 90mm and 135mm frames of the M3.

In 1963, the introduction by Leitz of the 135mm f/2.8 Elmarit lens, with built-in optics not unlike those of the 35mm lenses for the M3, made it possible for M2 owners to use a 135mm lens without an accessory viewfinder. The new lens utilized the 90mm viewfinder frame within the M2, and the accessory optics that formed part of the lens, and covered the viewfinder and rangefinder windows of the camera when it was fitted, adapted the field of view shown within the 90mm frame to be correct for the 135mm focal length. Similarly, users of the M3 were also able to

A range of bayonet adaptors was introduced with the Leica M3 to make it possible to use Leica screw lenses in bayonet-mount bodies. These are marked with the focal lengths for which they are suitable, as they each select an appropriate viewfinder frame within the camera.

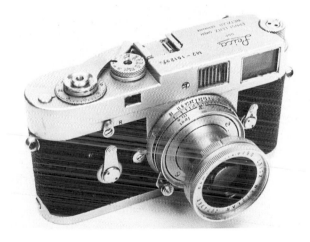

The Leica M2 appeared in 1957, and provides 35mm, 50mm and 90mm built-in viewfinders, instead of the 50mm, 90mm and 135mm of the M3. This particular Leica M2 is fitted with a bayonet-mount 50mm f/2.8 Elmar.

benefit from a larger viewfinder image than was normal with the 135mm lens on the camera, since the 135mm f/2.8 Elmarit utilized the 90mm frame and enlarged the image within it. Readers who wear spectacles may find it useful to know that an M3-type 35mm lens, with the additional viewfinder-modifying

optics above the lens, when fitted to an M2, leaves the 50mm brightline frame in place, but modifies the field of view within it to be correct for 35mm. This produces a 35mm viewfinder that is easier to see when wearing glasses.

Further to confuse the chronology of the Leica family tree, the Leica M1 appeared in 1959, and was the bayonet 'M' equivalent of the Leica Standard – an 'M' Leica without coupled rangefinder and without the brightline viewfinder mechanism of the M3 and M2, instead of which it had etched viewfinder frames permanently visible in the viewfinder. The M1 was produced principally for the laboratory and technical photographic market, commands inflated prices because of the interest of collectors, and is unlikely to be a cost-effective purchase for the classic-camera user.

The **Leica M4** of 1967 marked the beginning of the maturity of the Leica 'M' camera system. With built-in parallax-corrected automatic viewfinder frames for 35mm, 50mm, 90mm and 135mm lenses, but otherwise different from the M2 and M3 only in details, the M4 was the first of the series genuinely to rival, although not equal, the versatility of the single-lens reflex. The Leica M4, easily distinguished by the positioning of its rewind crank on a sloping end to the top-plate, has become the most sought after of the principal Leica 'M' cameras (disregarding specialized rare collectibles like the MP and MD), and consistently maintains a relatively high price in the market.

TTL exposure meters in Leicas?

In 1971, Leitz introduced the Leica M5, a further radical redesign of the Leica, not only in its shape, which was derived from a prototype of the M4 with which Leitz had not proceeded, but in its incorporating a through-the-lens (TTL) exposure-metering system. The Leica M5 was not entirely successful. By the time it was withdrawn in 1977, only 27,000 of the cameras been made, and the Leica M4 had been reintroduced some time before by popular demand. In 1975, the M4 had been succeeded by the Leica M4-2, which was manufactured by Leitz, Canada, in Midland, Ontario, and was essentially a Leica M4 without delay-action mechanism, without a built-in meter (as in the case of the M4), but with the facility to add motor drive. When the M4-P was introduced in 1980, it offered no fewer than six fields of view in the viewfinder – 28mm, 35mm, 50mm, 75mm, 90mm and 135mm, and further refinement was brought to the range in the autumn of 1984 by the launch at the Photokina Exhibition in Cologne of the Leica M6, essentially a Leica M4-P with an added through-the-lens exposure-metering facility.

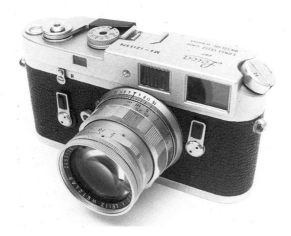

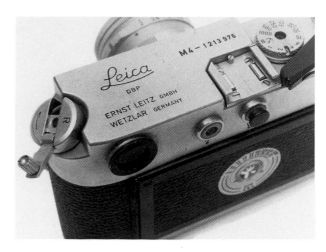

In 1967, the **Leica M4** was introduced, combining the best features of the M2 and M3, and providing built-in viewfinders for 35mm, 50mm, 90mm and 135mm lenses. An inclined crank was fitted instead of a rewind knob, and the wind lever was redesigned with a black tip. The lens fitted to this camera is a 50mm f/2 rigid chrome Summicron.

The **Leica M4** was the first 'M' Leica to have standard 3mm flash-synchronization sockets – in this picture, the socket for electronic flash is uncovered, and that for bulb flash has a black protective cover over it. Previous 'M' Leicas need an adaptor (readily available from independent suppliers even now) to convert the Leica flash socket to standard 3mm flash plug size. Note the rewind crank folded down ready for use.

Meanwhile, the Leica CL (Compact Leica), manufactured co-operatively by Leitz in Germany and Minolta in Japan, had been launched in 1973. Although not, by our definition, a classic camera, the Leica CL has through-the-lens exposure metering, retains the 'M' bayonet lens mount, and is an effective and compact camera from which the Minolta CLE, which also accepts Leica 'M' lenses (in most cases), is derived.

Which 'M' Leica is for you?

Buying a classic 'M' Leica is a significant investment for most people, and is not the cheapest route to the enjoyment of classic cameras. Nonetheless, if you can afford it, a Leica M2, M3 or M4 is the pinnacle of classic 35mm photography. The early double-stroke Leica M3 is normally the least expensive of the models, although a 'first series' Leica M3, numbered between 700,000 and 710,000, will often command a premium price among collectors. The single-stroke M3 and the M2 seem to command about twenty-five per cent more than the double-stroke M3. An M4, typically, will cost approximately twice to two and a half times the price of a double-stroke M3. Which you buy is largely determined by your photographic style and the focal lengths of the lenses you like to use. My personal choice is the double-stroke M3, not because it is cheapest, but because I like it. Any M2, M3 or M4

Leica in good condition will give reliable service and great pleasure for many years, so decide which suits your photography, and spend some time finding a good one.

The Leica lenses

Most of the many Leitz lenses manufactured since 1925 have been, by the standards of their time, fine lenses, and all the post-war lenses and many of the pre-war objectives remain capable of delivering excellent results by the standards of the eighties. Provided that you judge a lens by the subjective quality of the images it produces, and not exclusively by esoteric criteria such as MTF figures and resolution determined by test charts, the older Leitz lenses can yield great satisfaction.

It is not practical in a book such as this to discuss in detail all the Leitz lenses in turn. The range of lenses that has been and is available can quickly be established by a glance through a *Leica Manual*, or through any one of a dozen other specialist publications; and which of the several options at any given focal length you buy will be determined largely by your budget and by your own preference for lightweight modest-aperture lenses or heavier wide-aperture lenses. The role of this book is to help you avoid pitfalls, and to offer general advice to steer you towards a wise choice.

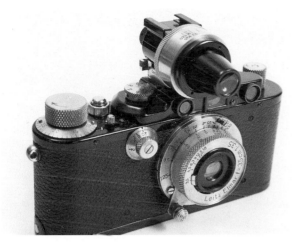

*Each lens of other than 50mm focal length requires, when used on a screw Leica, an appropriate additional viewfinder mounted in the accessory shoe. This Leica III is fitted with a **35mm f/3.5 Elmar** and a Leitz **VIDOM** universal viewfinder, in this case in black-and-nickel finish to match the camera. The VIDOM provides an image which is reversed left to right.*

Pre-war Leitz lenses

Prior to the Second World War, there was no anti-reflection coating available, either to Leitz or to any other manufacturer. The more glass-to-air surfaces there were present within a lens, the greater the degree of internal reflection that took place, and the greater, therefore, the loss of contrast and image quality. Wide-aperture lenses, by their nature, had (and have) more elements than smaller-aperture lenses, and therefore more glass-to-air surfaces. There fore the difference to be observed between the performance of wide-aperture lenses and lenses of modest aperture prior to coating is much greater than one would expect in post-war lenses.

In general terms, therefore, if you buy lenses for a pre-war Leica outfit, particularly if you plan to shoot colour pictures, you are well advised to seek out the lenses of modest aperture. The best of these is, fortunately, the commonest lens of all – the 50mm f/3.5 Elmar, of which even uncoated examples deliver excellent results if used sensibly with a lens hood. As a wide-angle lens, look for a clean and bright **35mm f/3.5 Elmar** rather than the 28mm f/6.3 Hektor, which in any event commands a premium price as a result of collectors' interest. Add a 90mm f/4 Elmar and a 135mm f/4.5 Hektor, plus a **VIDOM** or VIOOH universal viewfinder, and you have, with your Leica II, III, IIIA or IIIB, a versatile, lightweight and compact outfit

capable of a wide range of photography for quite a modest price. Even buying the items separately from dealers, it should be possible to assemble such an outfit based on a Leica III in 1994 for about £550 (UK) or around $700 in the USA. If you find an outfit for sale privately, you might well buy it for between half and two-thirds of that figure, although you would also, of course, buy with it the expectation of having to have some servicing carried out before the equipment was fully usable.

If you are determined to buy the wider-aperture lenses, the **50mm f/2 Summar** can be an excellent lens if the glass is bright and unscratched. The front surface of the Summar is of a very soft glass which quickly becomes dulled by hairline scratches if a user habitually cleans it with the end of his necktie. A scratched Summar can, in fact, produce delightful soft-focus effects at full aperture, and is worth owning for the fun of such experimentation, but it is not the adequate general-purpose lens one might expect it to be. It should also be said that the optical performance of Summars, even in perfect condition, varies considerably between individual examples of the lens, and it pays, if the chance offers, to try a Summar before buying it. Although despised by collectors for being unoriginal, Summars that have been coated can deliver results of very high quality indeed.

The later 50mm f/2 Summitar, introduced just before the war, is a decidedly better lens, although very subject to flare if uncoated. Fortunately, from the

*This **50mm f/2 Summar** in the original non-collapsible mount is a considerable rarity. This version of the lens was discontinued very soon after the introduction of the Summar, and was replaced by the collapsible lens.*

user's standpoint, most Summitars that began life as uncoated lenses have been coated since, and are capable of first-class results. The same is not true of the earliest of the Leica wide-aperture lenses, the 50mm f/2.5 Hektor, which is usually a dismal performer, best left to adorn the collectors' shelves. The 50mm f/1.5 Xenon, introduced in 1935, has seven elements and no fewer than ten air-to-glass surfaces, and is, in its original uncoated form, extremely subject to flare. One of the most expensive of pre-war Leitz lenses ($186 in USA, May 1939), the Xenon was introduced to provide Leica owners with a lens comparable to the Zeiss 50mm f/1.5 Sonnar of the Contax, but in this it fell well short of the mark.

The only pre-war wide-aperture Leica lenses of a focal length other than 50mm were the 73mm f/1.9 Hektor, which cost only slightly less than the Xenon at $180 in 1939, and the special-purpose 90mm f/2.2 Thambar soft-focus portrait lens. Examples of the 73mm Hektor lens are scarce, and therefore expensive, but can perform very well indeed, particularly if they have been coated. The Thambar is downright rare, very overpriced because of the interest of collectors, and not noted for its performance except in the limited area of soft-focus work.

There were (and are), both before and after the war, telephoto lenses for the Leica of focal lengths longer than 135mm, intended for use with reflex housings interposed between the camera body and the lens. These effectively turn the camera into a single-lens reflex. The pre-war 200mm f/4.5 Telyt, used in this way with the PLOOT reflex housing or the later Visoflex 1, is of very fine quality, although heavy and somewhat cumbersome. The 400mm f/5 Telyt, introduced in 1937, is rare, expensive and even heavier and more cumbersome than the 200mm Telyt, but is a very good lens if you can obtain one.

Post-war screw lenses

After the Second World War, most of the pre-war range of Leica lenses, which had in any case been manufactured during the war, continued to be marketed in factory-coated form for several years, although discontinued lenses such as the Summar, the 50mm Hektor, the 73mm Hektor and the Thambar did not reappear. Post-war lens numbering began at 600,000, so it can be assumed that any Leitz lens numbered above 600,000 is post-war, any between 527,000 and 600,000 is wartime (i.e. 1939–45), and any numbered below 527,000 is pre-war. The coating greatly improved the performance of Leitz lenses, particularly in the cases of the 50mm f/2 Summitar, the 35mm f/3.5 Elmar and the 135mm f/4.5 Hektor, and

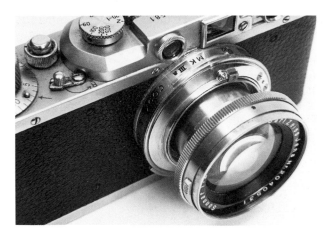

During the fifties, when import controls severely restricted camera availability in Britain, great ingenuity was employed to make the best of available equipment. The British engineering firm of Cook and Perkins made a series of adaptors to enable Contax lenses to fit and couple with the rangefinder of Leica screw cameras. This picture shows a pre-war uncoated Zeiss 50mm f/2 Sonnar, mounted in a Cook and Perkins Mk IIIA adaptor on a Leica II. This late version of the adaptor permits the mounting of all focal lengths of Contax lenses from 35mm upwards. Earlier adaptors were for 50mm lenses only.

was a first step towards the elimination of the Zeiss lead in lenses that had sustained the market position of the Contax camera before the war.

From 1949 onwards, a new generation of Leitz lenses of distinctly improved performance began to appear. The 35mm f/3.5 Summaron, a six-element lens, replaced the four-element 35mm Elmar, and the 50mm f/1.5 Summarit replaced the Xenon, which it resembles but outperforms. An 85mm f/1.5 Summarex, which had been manufactured during the war, also became available to the public in 1949, although one is lucky to find an example nowadays, and even luckier to buy one at an affordable price. Improved lightweight versions of the 90mm f/4 Elmar and 135mm f/4.5 Hektor made their appearance, and in 1953, the 50mm f/2 Summicron superseded the Summitar, again with a substantial gain in performance attributable to use of the then new rare-earth glasses. The same new glass technology made possible a 50mm f/2.8 Elmar, a much underrated lens, and a 28mm f/5.6 Summaron, which replaced the 28mm Hektor in 1956. A 35mm f/2.8 Summaron and a **35mm f/2 Summicron** followed before screw-lens production ceased in the early sixties, as did other last-generation screw lenses such as the 90mm f/2.8 Elmarit, the 90mm f/2 Summicron and the 135mm f/4 Elmar. These very late screw

lenses are all either scarce or rare, and all command premium prices.

Buyers and users of classic Leica equipment can take it that the performance of the new generation of Leitz lenses originated in the early fifties is almost universally superior to that of the lenses that were replaced, and that, since market prices for the lenses of the fifties are rarely much more, and are sometimes less, than those of earlier lenses, the 'fifties generation' must represent the best value to a user of the screw Leicas. The rarer screw lenses that followed, although undeniably of improved versatility and marginally better performance, will, because of their scarcity, prove to be unreasonably expensive for the user.

Bayonet Leica lenses

The introduction of the **Leica M3** in 1954 did not immediately bring about a revolution in Leitz lens design, and for almost ten years, both the screw and bayonet versions of identical lenses were made side by side. All the lenses of the 'fifties generation' detailed above, with the exception of the 28mm f/5.6 Summaron, were made in bayonet form, and the subsequent generation of wider-aperture rare-earth computations, scarce with screw mount, are relatively common with the bayonet mount. Thus, users of Leica M2, M3 and M4 cameras have a choice of a wide range of late-fifties and early-sixties lenses of excellent performance at relatively reasonable prices by comparison with the cost of new Leitz lenses in the eighties. By 1963, new Leitz bayonet lenses that had not been made for the screw cameras were appearing – the excellent 90mm f/2.8 Tele-Elmarit in 1963, the 28mm f/2.8 Elmarit in 1965 and the 35mm f/1.4 Summilux are examples – and further new lenses appeared in the seventies, and continue to be introduced even in the eighties.

It is almost impossible to offer advice on the choice of classic bayonet Leica lenses, for they are all of high performance, and It is broadly true with the bayonet range that you get what you pay for. If I had to specify a Leica 'M' camera outfit offering, on current market evidence, the best value and performance for money, I think it would be a double-stroke Leica M3 with 50mm f/2.8 Elmar, a 35mm f/2.8 Summaron with M3 optics, a **90mm f/4 Elmar** and a 135mm f/4 Elmar, but there are so many possible permutations that there can be no universally acceptable choice.

Using your Leica – which accessories will you need?

It is in the nature of the Leica system to impose a greater need for accessories upon the user than is

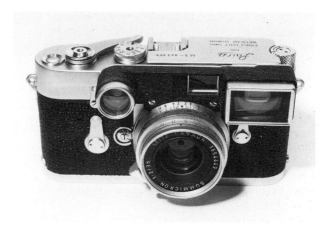

*For the **Leica M3**, which has no 35mm brightline finder built into the viewfinder system, Leitz manufactured a range of special 35mm lenses, each of which incorporates a pair of lenses, rather like spectacles, above the lens unit itself. These correct the field of view of the 50mm viewfinder to provide the correct coverage of a 35mm lens. This particular lens is a **35mm f/2 Summicron** for M3, which is fairly scarce, but the similarly mounted 35mm f/2.8 and f/3.5 Summaron lenses are more readily available. There is also a very scarce 35mm f/1.4 Summilux in this form.*

*In 1960, a collapsible version of the **90mm f/4 Elmar** was introduced, which has the great advantage that, when collapsed, it fits inside a standard Leitz ever-ready case. This example is fitted to a **Leica M3**, with an MC meter fitted in the accessory shoe.*

This is the close-up device BEEINS for 1:1 ratio photography using the 35mm Elmar lens, in use with a Leica III – the set-up that was used to photograph the stamp illustrated on page 76. A similar, and more common, piece of equipment, coded BELUN, makes possible the use of the 50mm f/3.5 Elmar for 1:1 copying. Either produces an image on the film that is the actual size of the subject. No focusing is required. The lens is simply set to infinity on the end of the extension tube, and the clamp of the copying device is tightened around the external diameter of the lens.

made necessary by single-lens reflex systems. The cost of obtaining a Leica outfit capable of all the tasks that a single-lens reflex outfit can perform may prove to be very much greater than the cost of the camera and lenses alone. The reason for this may be understood if one compares the versatility of (for example) a classic focal-plane shuttered single-lens reflex outfit with that of a Leica 'M' outfit, and then lists the accessories needed for each to carry out a range of tasks.

Assume that we are comparing, on the one hand, an Alpa 6c single-lens reflex of the early sixties, fitted with a 50mm f/1.8 Macro-Switar and supplied with 90mm f/2.5 Angénieux and 35mm f/2.8 Curtagon lenses, with, on the other hand, a Leica M2 of the same period with 50mm f/2.8 Elmar, 90mm f/2.8 Elmarit and 35mm f/2.8 Summaron. On the face of it, we are comparing like with like, aside from the fact that the

Alpa outfit should cost significantly less under normal market conditions.

For all routine photography of townscapes, landscapes, people and events, either system is equally capable of delivering results of approximately equal quality, given equal proficiency with the two systems on the part of the photographer. If, however, he were to decide to photograph a butterfly on a flower, or any other subject requiring close focusing, the position is rather different. The Alpa needs no accessories, since its macro lens focuses without accessories to as close as 8.5 inches from the subject. Even if the Alpa (or any other comparable top-quality SLR) were not fitted with a macro-focusing lens, it would need only an inexpensive 2-dioptre close-up lens (about £10 or $15) or a set of slightly more expensive extension tubes (maybe £25 or $35 secondhand) to make possible straightforward focusing and viewing of the subject, since, because one views through the lens of a single-lens reflex, no parallax problem arises. What you see through the viewfinder is what you photograph.

Photographing that same butterfly on the flower

*The **Visoflex III reflex housing** was the first that could be fitted to the camera without removing the prism, and was equipped with an instant-return mirror, a feature which makes the Leica with the Visoflex much more acceptable as a single-lens reflex camera. The mirror is actuated, and the shutter fired, by pressing the arm down on the shutter button. In this picture, a 200mm f/4 post-war Telyt lens is fitted, via a 16466M adaptor.*

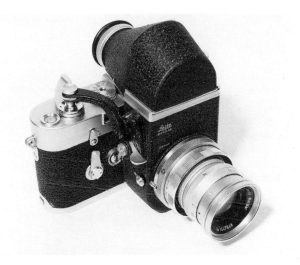

*Removable heads in some of the long-focus lenses, and special focusing mounts, make it possible to fit 90mm and 135mm lenses to the **Visoflex II** or **III** with the capability of focusing to infinity. This Leica M3 is fitted with the head of a 90mm f/4 Elmar in a Leitz focusing mount 16467N on a Visoflex II. A 65mm f/3.5 Elmar, specially made for use on the Visoflex II and III in universal focusing mount 16464, is the shortest lens that can be used on any of the reflex housings.*

*Occasionally, one comes across lenses made by other manufacturers to fit the Leitz Visoflex. This enormous objective is a 500mm f/7 Komura lens from Japan, with its hood standing beside it, mounted in a **Visoflex III** on a Leica M3.*

with a Leica M2 is rather more demanding of resources. The standard lens and rangefinder, with its automatic parallax correction, focus only to just under three feet from the subject. Adding a close-up lens would, given a tape-measure and a set of focus tables, enable one to achieve a sharp image, but would not make it possible to use the viewfinder or to frame the subject. Something else is needed. An accessory known as SOOKY-M or SOOMKY (according to period) fits between the lens and the camera, and, by placing a pair of prismatic lenses over the viewfinder and rangefinder windows, makes it possible to use the rangefinder and viewfinder in the normal manner as close as 17.5 inches from the subject. If one had the close-focusing version of the rigid 50mm f/2 Summicron, that too provides rangefinder and viewfinder facilities to within eighteen inches. The SOOKY-M accessory would, at 1994 prices, cost about £95 ($110) secondhand, and the close-focus Summicron about £195 ($260) secondhand. Neither actually gets the photographer close enough to photograph the butterfly to fill the frame.

To get closer, the Leica user must use a **Visoflex reflex housing** – a Visoflex I, II or III – which fits between the camera and a lens in a specially designed focusing mount, and effectively converts the Leica into a single-lens reflex, albeit one of rather forbidding aspect to those accustomed to the modern marvels of Nikon and Minolta. A **Visoflex II** costs about £80 secondhand in Britain in 1994. A used **Visoflex III** is usually priced at over £150. Even that is not all, since, to use the lens head of the 90mm f/2.8 Elmarit, which unscrews from its full-length focusing mount, the photographer needs a Leitz Universal Focusing Mount 16464 (about £60 or $75 secondhand), plus an extension tube 16471J (about £20 or $25 secondhand) in order to achieve the ability to fill the frame with the butterfly.

To fit a lens of longer focal length than 135mm to the Alpa, or to any other single-lens reflex, is straightforward. You just buy the lens, fit it, focus and fire away. To fit a 200mm lens to a Leica M2, you again need a Visoflex II or III (about £150 secondhand), plus an adaptor 16466 (about £50 or $70 secondhand). The point is that, although the Leica system is capable of virtually any photography possible with the 35mm format, it is at its best when used with lenses of between 35mm (28mm with the Leica M6 or M4-P) and 135mm, and when tackling non-close-up subjects. Within those limitations, the Leica is more easily focused, very much quieter, lighter, smaller and less obtrusive than any full-frame single-lens reflex.

Viewfinders for screw Leica cameras

Users of screw Leica cameras face precisely similar problems with close-up photography and the use of long-focus lenses, and solve them either with close-up devices known as NOOKY (for the 50mm f/3.5 Elmar), NOOKY-HESUM (for the 50mm Summar, Summitar or Hektor) and SOOKY (for the 50mm collapsible Summicron or 50mm f/2.8 Elmar), each of which retails secondhand at around £40 to £55 in Britain, or with Visoflex I or II reflex housings designed to fit the screw cameras. However, their problems do not end there. Devotees of the screw-mount Leicas must also use accessory viewfinders whenever they use wide-angle or long-focus lenses of focal lengths other than 50mm, since, with the sole exception of the Leica IIIG, whose viewfinder includes a brightline indication for 90mm lenses, all the screw Leicas have only a 50mm viewfinder built into the camera.

Although there have, in fact, been a great many different Leica accessory viewfinders, most classic-camera users, as distinct from collectors, settle either for a universal finder or for appropriate brightline finders. The choice in brightline viewfinders is straightforward – each fits in the accessory shoe of the camera and defines the field for one particular focal length of lens. Brightline viewfinders have been available for 21mm, 28mm, 35mm, 50mm, 73mm, 85mm, 90mm and 135mm, and, of these, the 50mm, 90mm and 135mm types are common and easy to obtain. The 35mm

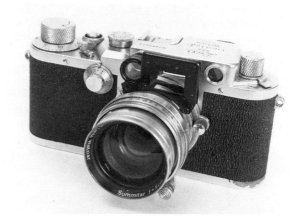

The simplest and most effective way of producing close-up pictures with a screw Leica is with the NOOKY (for the 50mm f/3.5 Elmar), NOOKY-HESUM (for the 50mm f/2 Summar or Summitar) or SOOKY (for the 50mm f/2 collapsible Summicron). This Leica IIIC is fitted with a 50mm f/2 Summitar mounted in a NOOKY-HESUM. The prism over the rangefinder window enables it to measure distances from approximately three feet down to about seventeen inches with normal coupling to the lens, which focuses on a closer plane because the device acts as an extension tube between the lens and the body. The lens (in all cases) is inserted into the close-up device in the collapsed position, and it is the erection bayonet of the lens that secures it in the device.

*The three major types of Leitz **universal viewfinder** for the screw Leica cameras. On the right is a 'torpedo' finder, VISOR, which has engraved frames on the glass within the finder, and was in production in this form in 1931/32. In the centre is a black-and-nickel VIDOM, dating from about 1934, a viewfinder which is more common in all-over chrome finish, in which form it was discontinued in about 1939. The VIDOM reverses the viewed image left to right. On the left is the post-war VIOOH or IMARECT universal finder, which gives a right-way-round image.*

finder should be common but is moderately scarce, and the 28mm and 21mm finders are always difficult to locate secondhand. The 73mm and 85mm finders are rare and very scarce, respectively. A brightline finder gives a brilliantly illuminated field of view, with a clearly defined translucent white line to show the edge of the picture area. The advantage is that the photographer can, with the non-wide-angle types, see what is going on just outside the picture area, which can be invaluable for moving subjects and sports photography.

The two commonly found Leitz **universal viewfinders** are the VIDOM, a pre-war optical universal viewfinder providing for focal lengths of 35mm, 50mm, 73mm, 90mm, 105mm and 135mm, but with its image reversed left to right, and the VIOOH, a later wartime and post-war viewfinder providing settings for 35mm, 50mm, 85mm (73mm in early examples), 90mm and 135mm, which offers an image that is both the right way up and the right way round. This latter finder is known as the IMARECT in the United States, and is suitable also for 28mm lenses if you are able to locate one of the scarce optical adapters coded TUVOO which screw into the front of the VIOOH finder.

Either VIDOM or VIOOH is equally usable with any screw Leica camera, although most people find the extra cost of the VIOOH or IMARECT money well spent. A further alternative, not made by Leitz but often used by Leica enthusiasts, is the zoom Tewe finder, which normally offers a continuous set of focal lengths from either 28mm or 35mm to 200mm, although other versions exist. All these universal finders are readily available from classic-camera dealers in Europe and the USA. Older universal viewfinders, usually known as Leitz 'torpedo' finders, may turn up, and if you buy one cheaply you are doing well, for, among collectors, they change hands for twice and three times the price of later, more common, universal viewfinders. Torpedo finders can be recognized by having (usually) three black engraved frames for different focal lengths visible when one looks through the eyepiece, and by having no built-in mechanism for indicating different focal lengths.

Hoods and filters

It is a cardinal rule of classic-camera photography, especially with pre-war uncoated lenses, that a lens hood is essential. Obviously, it makes sense to use the original type of hood supplied by the manufacturer if you can get it, but, if not, buy any hood that will fit and which is designed for approximately the right focal length. Remember that a hood that fits the lens front, but is for a shorter focal length than the lens in use, is of some assistance, and is certainly better than nothing. A hood for a longer focal length than that in use will almost certainly vignette, or cut off the corners of the picture.

Fortunately, it is relatively easy to get correct Leitz lens hoods for most reasonably common Leitz lenses of all ages, and any Leica dealer who handles second-hand equipment should know which hood fits the lens about which you ask. Virtually all Leica hoods clamp over the external circumference of the front of the lens, the hoods of pre-war design usually having a clamping screw, and most of those of post-war design a spring retaining clip. Many of the pre-war and early post-war Leitz screw-mount lenses have a common A36 (36mm external diameter) front, and for this size, if you are a screw Leica user, you are likely to need a FISON hood for a 50mm f/3.5 Elmar, a FOOKH (or the earlier prewar FLOOO) for a 35mm f/3.5 Elmar or 35mm f/3.5 Summaron, and a FIKUS extending lens hood to provide for your 90mm f/4 Elmar and your 135mm f/4.5 Hektor. You can, in fact, use the FIKUS for your 50mm f/3.5 Elmar instead of the FISON, if you wish. If you have a 50mm f/2 Summar, you need SOOMP, and if you use a 50mm f/2 Summitar, you

need a collapsible affair rather like a rat trap designed by a maniac, which goes under the code-name SOOPD. You should look for A36 clamp-on filters for all these lenses except the Summar, which, although it will accept A36 filters, will suffer from slight vignetting if used with them at full aperture. The Summar should ideally have E34 (34mm screw-in) filters, which are, however, difficult to find. The Summitar requires a curious special chamfered E38.5 filter, which is usually readily available.

Most of the post-war lenses of the 'fifties generation' manufactured after 1954 had A42 (42mm external diameter) fronts, and took E39 (39mm screw-in) filters, which are plentifully available second-hand and are still available new. All the following lenses, likely choices for a reasonably priced classic 'M' Leica outfit, take E39 filters. For the 35mm f/3.5 or f/2.8 Summaron and the 50mm f/2 Summicron, in their late screw as well as bayonet versions, you need an IROOA hood, or the later 12585 (the Leitz catalogues changed to number codes instead of letters during the sixties). For a 50mm f/2.8 or late E39 f/3.5 Elmar, you need an ITOOY hood, and for an E39 90mm f/4 or 135mm f/4 Elmar, or a 90mm f/2.8 Elmarit or Tele-Elmarit, or a 135mm f/4.5 Hektor, you need IUFOO, also called 12575N. One could list hoods and filters endlessly, but that is not the purpose of this book; so, for lenses other than those above, I recommend that you take the advice of a Leica dealer, or look up the hood and filter specification for the lens in question in one of the many reference books on Leica.

Will the Leica be right for your photography?

The Leica system is complex, fun, beautifully engineered and, for many enthusiasts, a lifetime's obsession. As a range of photographic tools, it is relatively expensive, yet unparelleled for general 35mm photography. If the Leica owner has no alternative camera system more simply suited to close-up and long-focus photography, using Leica equipment for everything can prove very pricey indeed.

The Leica, particularly the 'M' Leica, if you can afford it, is superlatively suited to fast, unobstrusive, quiet photography. It is an ideal photo-journalist's tool; a means of seizing pictures almost instinctively and without thought. The Leica, more than any other in my experience, becomes an extension of the photographer's view of the world.

There are many cheaper ways to enjoy classic cameras than owing Leica equipment, but no better ways. There is, however, at least one very close rival to the Leica, and that is the Zeiss Contax system, to which we turn next.

A moment of harmony between bird and child caught in St James's Park, London, in 1960 with a Leica IIIC fitted with a 90mm f/4 Elmar. The Leica is difficult to equal as a means of catching the moment that matters in most situations, and has the advantage that, because it is so quiet, the subject rarely notices that a photograph has been taken. As a result, you usually get a second chance for a further candid picture.

Copying of tiny objects does not need spectacularly complex equipment. This picture of a postage stamp was shot with a Leica III, fitted with a 35mm f/3.5 uncoated Elmar mounted in the Leitz BEEINS 1:1 copying device, as illustrated on page 72.

Opposite above: What red-blooded male would not join a railway preservation society if all the firemen looked like this? The train, on the Bluebell Railway, was steaming out of the station when the girl leaned out from the cab, providing no more than a second or two in which to snatch the picture. Shot with a Leica IIIC fitted with 50mm f/3.5 coated Elmar.

Opposite below: Poetry in locomotion in the sheds of the Bluebell Railway in Sussex, a private railway preservation group whose members restore railway locomotives and rolling stock to their former glory. This is the running gear of a 'West Country' locomotive, photographed in 1984 with a Leica IIIC fitted with a 50mm f/3.5 coated Elmar.

In situations like this, the Leica is superlative. This picture of the Chamber Choir at Ashford School, Kent, was taken during a performance without disturbing anyone – a tribute to the remarkable quietness of the 'M' shutter. Although this particular shot was produced with a Leica M4-P fitted with 50mm f/2 Summicron, it could just as easily have been taken with any of the earlier 'M' cameras, which are no less silent.

Rendering texture in light and shade is one of the joys of creative photography. This hank of rope hanging on a tree was shot with a Leica M3 fitted with a 200mm f/4 Telyt in a Visoflex III reflex housing.

Opposite: Lifeboat drill at sea can offer some interesting pictures. This shot of one of the boats of a cruise ship was taken in mid-Atlantic with a Leica IIIA fitted with a 50mm f/2 uncoated Summar.

Railway stations and airports have a curious quality about them which produces quite distinctive pictures of people expecting something to happen, yet resigned to the probability of its not happening yet. This picture was shot on Liverpool's Lime Street station concourse with a Leica M3 fitted with a 35mm f/2 Summicron.

Conversation is almost a subject for the camera in itself, but is not easy to photograph without disturbing the people concerned. This picture was taken in Liverpool with a Leica M3 fitted with 50mm f/2 Summicron, held and fired at waist level and focused by estimation.

Opposite: The essence of the English seaside holiday – chips with everything – captured in Scarborough, Yorkshire, with a wartime Leica IIIC complete with the famous red blinds. The camera was fitted with a 50mm f/2 Summitar of the same vintage.

SNACK BAR
SOFT DRINKS · ICES

TAKE · AWAY
FISH & CHIPS
HOT DOG , BURG RS

FISH
AND
CHIPS

FISH
AND
CHIPS
HOT DOGS

FISH
AND
CHIPS

EAT IN
FISH & CHIPS
STEAK PIE & CHIPS
PASTIE & CHIPS
SAUSAGE & CHIPS
MILK SHAKES – ICES
TEA · COFFEE · MINERALS

TEA & COFFEE
by the CUP.
HOT & COLD
SANDWICHES
and PIES.

TAKE AWAY
HOT DOGS
BEEFBURGERS
FISH & CHIPS
PIE & CHIPS
SAUSAGE & CHIPS
CHIPS
COLA – ORE

HOT DOGS

Take Away
FISH &
CHIPS

HOT
BACON ROLLS
BURGERS
HOT DOGS

TAKE AWAY
FISH &
CHIPS

Chapter 5

The other great rangefinder system – photography with a Contax

There is more to the choice between the classic Leica and Contax rangefinder camera systems in the eighties than the simple comparison of cameras and features that sufficed when the equipment was new. Contax cameras are inherently more complex mechanically than their Leica equivalents, and most pre-war Contax cameras have withstood the test of time less well than have pre-war Leicas. If you find a pre-war Contax that runs sweetly and smoothly, whose shutter speeds are reasonably accurate and repeatable, whose rangefinder is bright and not misaligned, and which looks smart, regard yourself as being in luck. The likelihood of a need for servicing, identified by informed examination of the camera, is the main reason for the much greater than normal difference between prices asked for the pre-war Contax cameras by specialist dealers and those asked privately. A good specialist classic-camera dealer should have identified the faults, have had them rectified, probably at substantial cost, and be prepared to offer a modest guarantee. Private deals are at the buyer's risk.

Post-war **Contax equipment**, from the West German Stuttgart factory, is, as well as being significantly newer, of a much improved mechanical design. The Contax IIA and IIIA models can be approached with the expectation of good condition, although cautiously in respect of the shutter's probable need for servicing. The most frequently encountered fault on post-war Contax bodies is the failure of the shutter to open at the highest speed (1/1250th), and tapering at the 1/500th and 1/250th settings – so check for these problems as described in Chapter 2.

In the beginning: the Contax I era

The **Contax I**, introduced in 1932, and recognizable by the knob on the front of the camera, had a long-base coupled rangefinder, was finished entirely in black apart from small areas of nickel-plated metal, and was offered with an impressive range of interchangeable lenses and accessories, which was added to during the period 1932 to 1934. One of the most innovative features of this and all later Contax rangefinder cameras was the fact that the 50mm lenses had no focusing mount. The focusing helix was part of the camera body, and the 50mm lenses dropped into it and located on an 'inner bayonet' mount. Lenses of all other focal lengths had their own focusing mounts and were fitted to an external bayonet mount. An internal coupling tube, attached to the moving portion of the lens-focusing mount, coupled with the camera-focusing mount, and thereby drove the rangefinder. Unlike Leica focusing with standard lenses, which was accomplished with a lever on the lens

mount, the Contax was provided with a focusing wheel on the top of the camera body for the 50mm lenses, an effectively positive rangefinder coupling and focusing system. Other lenses were focused conventionally by turning the lens head.

First examples of the Contax I, from spring 1932 to late 1933, had no slow speeds, their vertically running metal focal-plane shutters having speeds from 1/25th to 1/1000th of a second, and a rangefinder based on half-silvered or half-gilt mirrors. In 1933, slow speeds down to $\frac{1}{2}$ second were added, and in 1934 the Contax I came of age with a redesigned rotating-wedge prismatic rangefinder and important improvements to the shutter design which rendered the capping of the shutter far more reliable. This improved camera can be recognized by its having an accessory shoe with bevelled sides and bright nickel-plated strips along the top edges.

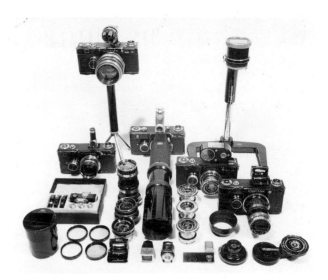

In the mid-seventies, I amassed a substantial collection of Contax equipment for research purposes. This picture shows all the black-and-nickel Contax I era equipment of that collection, which, while not a complete 'set' by any means, gives in one photograph an idea of the scope of the system. The five Contax I cameras (left to right) are:

(1) A late slow-speeds camera with 50mm f/2 rigid nickel 'slip-ring' Sonnar and 'lighthouse' viewfinder
(2) (on Zeiss table tripod) A no-slow-speeds camera fitted with black-and-nickel 85mm f/2 Sonnar
(3) A slow-speeds camera fitted with the 300mm f/8 Tele-Tessar and its viewfinder
(4) A no-slow-speeds camera with 50mm f/2.8 Tessar and Helios exposure meter
(5) A slow-speeds camera with 85mm f/4 Triotar and collapsible Albada viewfinder.

Either side of the long lens in the centre, the two rows of lenses stretching from front to back are:

(left-hand row)
(1) 50mm f/2 Sonnar with internal iris control
(2) 40mm f/2 Biotar
(3) 135mm f/4 Sonnar

(right-hand row)
(4) 50mm f/3.5 'black-face' Tessar
(5) 50mm f/2.8 'bright-face' Tessar
(6) 50mm f/2.8 'black-face' Tessar,

The open box with lenses and a rangefinder visible is a Contameter close-up outfit, and a number of other accessories can also be seen.

Left: Patriotism was not enough. The country needed your Leica or Contax too.

A full range of lenses in black enamel and nickel-plated finish was offered, from the 28mm f/8 Tessar, which was never, in any of its versions, coupled to the rangefinder, to the coupled 180mm f/6.3 Tele-Tessar, and on to the 300mm f/8 Tele-Tessar and 500mm f/8 Fern ('Far' or 'Distant') Tessar, focused, at this stage of the Contax system's development, laboriously with a removable focusing screen. The range included a 50mm f/1.5 Sonnar two years before Leitz offered the f/1.5 Xenon, a 40mm f/2 Biotar, for which Leitz had no parallel, and an 85mm f/2 Sonnar of excellent quality, which was a substantially better lens than the Leitz 73mm f/1.9 Hektor. All the black and nickel Contax lenses other than those of 50mm focal length are comparatively rare (even the 50mm lenses are scarce), but there is no reason why a classic-camera user intent upon taking pictures with his Contax I should not fit later chrome Contax lenses, since all pre-war Contax lenses are completely cross-compatible between the models I, II and III.

Despite the increased reliability of the late Contax I with slow speeds, there can be no doubt that any Contax I is best regarded as a collectible rather than a usable camera. Extensive use of even a good late

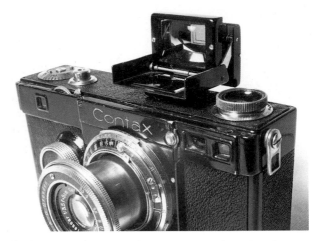

*The later no-slow-speeds **Contax I**, introduced in the autumn of 1932 and manufactured until 1934, had no 'pimple'. This camera is fitted with a 50mm f/3.5 'black-face' Tessar and the folding 50mm and 85mm Albada viewfinder, an early form of reflecting brightline finder which produced a rather dim image of the field of view.*

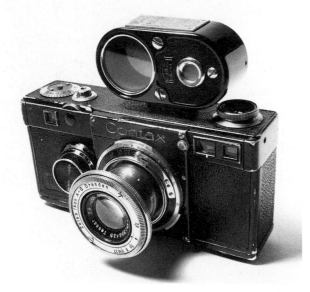

*The earliest type of **Contax I**, introduced in March 1932, had no slow speeds and a noticeable hump, known to collectors as the 'pimple', over the bearing of the focusing-wheel shaft (top left, in front of the shutter button). This example of that rare camera is fitted with a 50mm f/2.8 'bright-face' Tessar, and the Zeiss Helios exposure meter, almost certainly the world's first photo-electric exposure meter designed to fit in a camera accessory shoe.*

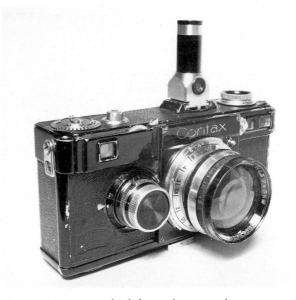

Contax I cameras which have slow speeds are recognizable by the two knurled rings of the speed-setting assembly on the front of the camera. This late Contax I has the 'slip-ring' version of the rigid 50mm f/2 black-and-nickel Sonnar, so called because the aperture settings are on the bright ring, conventionally rotating on the barrel of the lens.

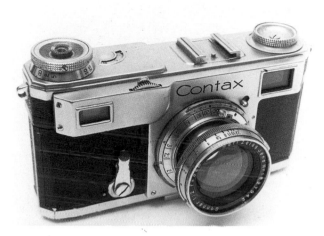

*The **Contax II**, launched in March 1936 and manufactured until 1945, is the commonest of all the Contax cameras, and is here fitted with the commonest of the standard lenses – the 50mm f/2 collapsible Sonnar. These are the camera and lens with which several of the pictures in this chapter were taken, and there is little doubt that those photographs are among the sharpest and crispest in the whole book.*

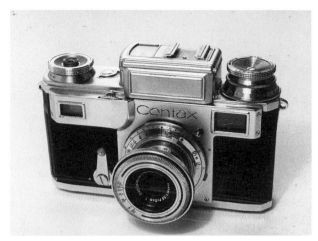

*This handsome **Contax III**, which is, of course, a pre-war camera, is fitted with the post-war East German 'T' coated **50mm f/3.5 Tessar**, which is easily distinguished from its pre-war counterpart by the engraved black line around the front element of the lens, on the faceplate. The post-war East German Tessar is much superior in definition and contrast to the pre-war lens, and appears to be of slightly different optical design.*

Contax I will almost certainly bring about mechanical trouble, from which even a skilled repairer may not be able to rescue it.

The coming of the chrome Contax

In March 1936, the completely redesigned Contax II was launched by Zeiss, closely followed later the same year by the Contax III, which was essentially the same camera, but with a different top-plate which included a built-in photo-electric selenium exposure meter. New features of the **Contax II** and **III** (other than the exposure meter of the III), included a new top shutter speed of 1/1250th of a second (for long to remain the fastest available on any production 35mm camera), the placing of all the speeds on one continuous shutter-speed dial (those on the Contax I were located in several groups), a delay-action mechanism, and a viewfinder and rangefinder combined into one eye-piece – those of the Contax I being in separate eyepieces. Both the Contax II and the III were also offered only in chrome finish.

The Contax lenses that had previously been available in black and nickel were gradually offered in chrome finish to match the new cameras, and one or two new lens designs of very high quality began to make their appearance. In 1936, the **180mm f/2.8 Sonnar** appeared, initially rushed out in rangefinder-

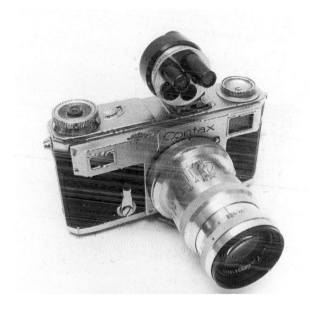

*The same **Contax II**, but fitted here with a post-war, lightweight, coated West German Triotar and a pre-war Zeiss universal viewfinder. Settling for a good pre-war body until one of the scarce IIA or IIIA bodies turns up makes good sense, since post-war lenses can be acquired gradually and used on the pre-war body.*

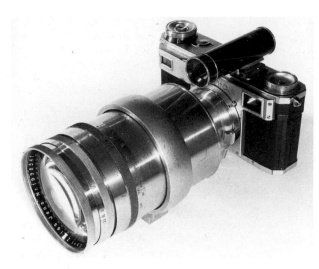

The rare and remarkable **180mm f/2.8** *rangefinder-coupled* **Sonnar**, *rushed into production to catch the 1936 Berlin Olympic Games, is here fitted to a Contax II. The lens unit itself is identical to that in the Flektoscop, shown in the chrome-collection group picture on page 90. The 180mm f/2.8 Sonnar is a very high-performance lens, but is extremely heavy.*

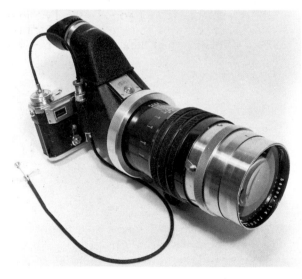

At the Leipzig Fair of 1940, Zeiss introduced the **300mm f/4 Sonnar**, *a large and quite magnificent piece of optical engineering which had what I believe to be the world's first example of a pre-set diaphragm. It was mounted into the same Flektoscop reflex housing that was supplied with the 180mm f/2.8 Sonnar.*

coupled form, apparently because Dr Goebbels wanted German photographers to be seen using the new world-beating lens at the Berlin Olympic Games. Subsequently, the lens appeared in its normal production form, with the Flektoscop mirror reflex housing, which was (and is) used on a tripod, with a twin-cable release operated by a single plunger. When this was pressed, one cable raised the mirror before the exposure, and the other tripped the camera shutter. Disconcertingly to a modern user, the image presented by the Flektoscop for focusing is inverted – which was nothing new to a generation accustomed to field cameras, but is strange to those brought up with the image-erecting pentaprism.

Next came the 35mm f/2.8 Biogon, an outstanding wide-angle lens by any standard, even that of the nineties, followed during 1938 by the budget-priced and commercially unsuccessful 35mm f/4.5 Orthometar. Although of somewhat inferior performance by comparison with the Biogon, which was a hard act to follow, an Orthometar produces entirely adequate resolution and medium contrast.

As the war began, only the 180mm f/6.3 Tele-Tessar and the 300mm f/8 Tele-Tessar of the original range of Contax lenses had been discontinued, the 180mm Tele-Tessar having been replaced by the 180mm Sonnar. In 1940, at the Leipzig Fair, Zeiss introduced, to replace the discontinued 300mm Tele-Tessar, a **300mm f/4 Sonnar**, fitted to, and focused with, the same type of Flektoscop reflex housing that was supplied with the 180mm Sonnar. The 300mm Sonnar is rare – I have owned just one over many years – and therefore unlikely to be available at a price appropriate to using it for anything so ordinary as taking photographs. The Contax II and III were manufactured during the war for the German armed services, and oddly engraved cameras marked 'MF' followed by a four-figure number, '*Luftwaffen Eigentum*' (Air Force Property) or '*Kriegsmarine Eigentum*' (Navy Property) turn up from time to time, and are pleasantly different to own as curiosities or collectibles, but are no different in use from pre-war cameras.

Because of the Russian occupation of East Germany at the end of the war, Contax production effectively ceased (although a few Contax II cameras were made under Russian control – these have 'Carl Zeiss Jena' engraved in the accessory shoe), and it was not until the new West German Zeiss Ikon in Stuttgart revealed its redesigned **Contax IIA** in 1950, followed by the Contax IIIA in 1952, that the Contax marque was able once more to challenge the much more deeply entrenched position of the Leica in the 35mm camera market.

The Contax IIA and IIIA

A challenge the Contax 'A' series cameras certainly were, for they were smaller, lighter, quieter and more reliable than the pre-war models, from which they can be readily distinguished by their having a 1-second setting on the shutter-speed dial. The Contax IIIA differed from the IIA, as did the III from the II, in having a built-in selenium exposure meter as part of the top-plate. All Contax IIA and IIIA cameras have built-in flash-synchronization mechanisms, as well as improved factory-coated f/2 or f/1.5 Sonnar, or f/3.5 Tessar, standard lenses of truly superb quality.

The first type of Contax IIA of 1950, and the first IIIA of 1952, had a rather strange form of mechanical flash-synchronization which required a separate flash-synchronization switch to be screwed into a socket on the back of the camera top-plate. From the switch emanated a cable with a standard 3mm coaxial flash socket at the other end, and it was into this socket that the flashgun was plugged. Different flash-synchronization switches were supplied by Zeiss for bulb flash (catalogue code 1361) and electronic flash (catalogue code 1366). The switch 1366 is nowadays scarce and difficult to obtain, and, if you are interested in using a Contax for electronic flash, it would be wise to ensure that you buy a Contax IIA or IIIA of the second type.

This latter version of the two cameras has a standard

3mm coaxial flash socket in the rear edge of the top-plate, and is thus directly comparable with most other flash-synchronized cameras, needing no flash-switch accessory. The second versions of the Contax IIA and IIIA both appeared in 1953, and can be further distinguished by their having a yellow-filled engraved figure for the highest shutter speed on the dial capable of flash synchronization. These revised IIA and IIIA models were never again altered, and remained in production until the demise of the Contax marque in 1962.

Post-war Contax lenses

Both the old Carl Zeiss works in Jena, in Russian-controlled East Germany, and the new West German Zeiss organization, in Stuttgart and Oberkochen, produced lenses for the Contax cameras after the war. Those from East Germany were 'T' coated versions of pre-war optical designs in rather inferior aluminium-alloy mounts, whereas those from West Germany had better-engineered chromed brass mounts and, in most cases, substantially recomputed or new optical designs.

The East German lens range included an alloy version of the **35mm f/2.8 Biogon**, which, although in a mount akin to the pre-war Biogon, is optically somewhat redesigned. It is important to note that neither this post-war East German Biogon nor the pre-war

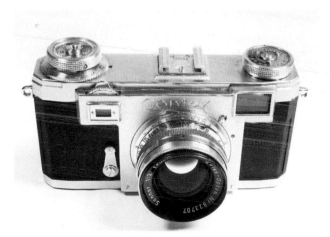 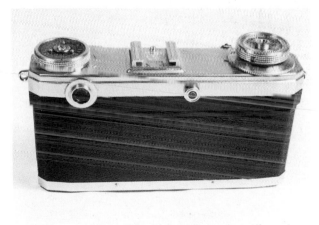

*The post-war West German **Contax IIA** was lighter, quieter and more reliable than the pre-war cameras. This particular example, although a late-type IIA, introduced in 1953, is fitted with a 50mm f/2 rigid post-war West German Sonnar marked 'Zeiss-Opton', which means that the lens was manufactured before 1952, and is thus of earlier date than the camera.*

*A back view of the same **Contax IIA** illustrated on the left, showing the 3mm standard flash-synchronization socket, as fitted to a late Contax IIA or IIIA. Earlier IIA and IIIA cameras had a threaded hole where the 3mm coaxial socket is in this picture, into which a separate accessory flash switch had to be screwed before the flashgun could be plugged in.*

Biogon will fit any 'A' series Contax camera. Other frequently encountered East German alloy lenses of the post-war period were 50mm f/1.5 and f/2 (non-collapsible) Sonnars, a **50mm f/3.5 Tessar**, an 85mm f/2 Sonnar and a 135mm f/4 Sonnar, all based on the pre-war Contax lens range. All the East German alloy lenses are optically excellent, but the mounts wear badly, and it may be found that results are not up to standard because of the focusing and alignment problems caused by the wear.

The West German Zeiss company, which at first marked its lenses 'Zeiss-Opton' and later reverted to 'Carl Zeiss', manufactured a redesigned range of coated lenses akin to the pre-war range, but without the 28mm Tessar, the 35mm Orthometar or the 40mm (sometimes 42.5mm) f/2 Biotar. A completely new version of the 35mm f/2.8 Biogon was made available, identifiable by its not having an extensively protruding rear element, and this is in fact the only form of the f/2.8 Biogon which will fit a Contax IIA or IIIA. A second, lower-priced 35mm lens to fit the IIA and IIIA, the 35mm f/3.5 Planar, was manufactured alongside the Biogon from 1954 onwards, and is an excellent performer.

The West German 50mm f/2 Sonnar was, unlike the pre-war collapsible lens, of rigid construction, and the 50mm f/1.5 was substantially redesigned to provide quite astonishingly good performance. The 85mm f/4 Triotar, in its pre-war form a rather unsatisfactory lens, was recomputed with a much larger front element to

become an excellent lightweight medium-long-focus objective, and lightweight coated versions of the 85mm f/2 and 135mm f/4 Sonnars made acclaimed appearances. In 1955, the 21mm f/4.5 Biogon lens equalled, if it did not outclass in contrast and illumination, the first 21mm Leitz Super Angulon, which was not to appear until 1958; and there were other, rarely seen, lenses manufactured during the mid-fifties with which this book will not concern itself, simply because you are very unlikely ever to encounter them.

Buying a Contax in the eighties

You will have gathered that buying a **pre-war Contax** for regular use is not without its pitfalls. If you are keen to embark upon photography with a pre-war Contax outfit, and it can be very rewarding, I would strongly recommend that you accept the cost of buying from a specialist dealer in classic cameras and thereby gain the benefit of his experience in checking them and getting them serviced.

For reliability, quietness, better handling and the very best optical quality, it certainly pays to buy post-war West German Contax equipment if you can locate it, which is not always easy. If possible, buy a late-type Contax IIA or IIIA with a standard 3mm coaxial flash socket, and a West German standard lens – it is quite common to find East German 50mm Sonnars in West German cameras and you should not pay the very top price for such a combination. If you cannot immediately find a post-war IIA or IIIA, you might consider starting with a good example of the more common pre-war Contax II or III models, and acquiring post-war lenses against the day when you are able to find and buy a post-war camera. All the post-war lenses fit and operate with the pre-war cameras.

You will need either individual viewfinders or a universal viewfinder if you plan to use lenses other than the 50mm standard lens, and it is best, if possible, to use post-war universal viewfinders on post-war cameras, and the pre-war universal viewfinders on pre-war cameras, as the height of the cameras is substantially different, and the parallax correction on the viewfinders allows for this. The post-war universal viewfinder is cylindrical, with an optically adjustable eyepiece. The pre-war version was asymmetrical, with one flat side and the other side rounded, and a simple non-adjustable eyepiece. The post-war universal viewfinder usually also has the word 'Stuttgart' in white on the top. If you will need only a viewfinder for the 85mm and 135mm lenses, you might consider the simpler optical multiple 'torpedo' viewfinder, or the even simpler mask finder that fits over the built-in viewfinder of the camera. Both are quite often avail-

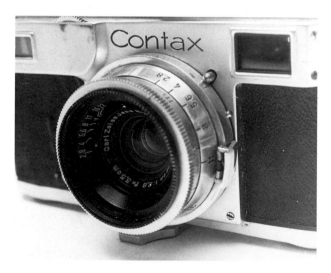

An East German post-war **35mm f/2.8** *alloy-mount* **Biogon** *fitted to a Contax II. This particular example is not badly worn and is in quite acceptable condition, but many of the alloy-mount lenses should be treated with some caution.*

*The principal members of the **pre-war Contax** 'family' as one group. In front: (left) Contax I, (right) Super Nettel. Centre: Nettax. Behind: (left) Tenax II, (right) Contax II. At the rear is the twin-lens Contaflex.*

able secondhand at prices well below those for universal viewfinders. Many other accessory viewfinders were made at various times for the Contax system, most of which, especially the optical viewfinders for individual focal lengths, are quite common, reasonably priced and very effective.

Accessories for the Contax

As was the case with the Leica system, a very large range of accessories for close-up and specialized photography was available for the Contax models both before and after the war. The following guidelines may prove useful to classic-camera enthusiasts bent on employing Contax equipment for photography of other than routine subjects.

The standard close-up equipment for most routine purposes both pre- and post-war was known as the Contameter. A pre-war Contameter (seek one with code 1343 engraved on the rangefinder for use with a Contax I or II; code 1340 for Contax III) consists of a coincident-image accessory rangefinder designed to fit in the accessory shoe of the camera, three close-up lenses intended to fit over or to screw into the standard lens, and three matching lenses that fit on to the exit pupil of the rangefinder. With the camera focusing mount set to infinity, each pair of accessory lenses provides accurate focusing and parallax correction at one fixed close-up range. A post-war Contameter is more sophisticated and incorporates an adjustable rangefinder which provides data for

setting of the camera focusing. Contameters provide simple close-up capability for distances down to about twelve inches from film to subject.

More demanding close-up applications requiring greater magnification were served before the war by the Contaprox, an auxiliary focusing mount with a very long helix and its own 50mm f/3.5 Tessar lens, which, mounted on a tripod, was first focused on the ground-glass screen supplied with the unit. The screen was then removed, the camera substituted for it, and the exposure made. After the war, a Contaprox II unit, redesigned in West Germany, appeared, which did not have its own lens and was designed to be used with a standard 50mm f/3.5 Tessar, or one of the other 50mm lenses.

Perhaps the most sophisticated of the Contax close-up devices was the Contatest, a device rather like the Leitz SOOKY-M, which fitted between the body of a

Both Leitz and Zeiss supplied stereo devices after the war for the production of stereo ('3D') pairs of transparencies. Leitz manufactured the Stemar twin-lens unit for the screw Leica, and Zeiss produced a series of Stereotar units, the Stereotar B being for interchangeable-lens Contaflex cameras, and the Stereotar C, illustrated here, being a twin-lens stereo device for the Contax. It was supplied with a special viewfinder to fit in the accessory shoe, and a 'distance prism' to provide enhanced stereo effect in pictures taken at ranges greater than ten feet. The 'OO' (separated 'O's) symbol on the distance prism, also to be found on the cream plastic-bodied stereo slide viewers made by Zeiss, indicates that the distance prism or viewer is intended for stereo pairs created by a twin-lens unit. Two interlocking 'O's, like Chinese rings, indicate that the accessory is for a beam-splitter device, like the Stereotar B.

The pre-war chrome-finished equipment in my collection of the seventies provides an overview of most of what the **Contax II** *or* **III** *user might acquire. The two cameras are (left) a Contax II fitted with the 180mm f/2.8 Olympic Sonnar in Flektoscop reflex housing and (right) a Contax III with 50mm f/1.5 Sonnar and pre-war universal viewfinder – the actual camera with which the wedding picture on page 77 was taken. The lenses in the four rows, taking the rows from front to back and left to right, are:*

> *(leftmost row)*
> (1) *35mm f/4.5 Orthometar*
> (2) *35mm f/2.8 pre-war Biogon*
> (3) *85mm f/4 Triotar*
> (4) *180mm f/6.3 Tele-Tessar*
>
> *(second row)*
> (5) *28mm f/8 Tessar*
> (6) *42.5mm f/2 Biotar*
> (7) *85mm f/2 Sonnar*
> (8) *135mm f/4 Sonnar*
>
> *(third row)*
> (9) *50mm f/2.8 Tessar*
> (10) *50mm f/2 collapsible chrome Sonnar*
>
> *(fourth row)*
> (11) *50mm f/3.5 Tessar.*

In the background on the right is a Zeiss small-reproduction stand, and several viewfinders and other accessories, including the Zeiss extending lens hood (bottom left-hand corner), are shown.

post-war Contax IIA or IIIA camera and the standard lens, and made possible normal focusing and view-finding with the camera rangefinder/viewfinder at ranges as close as approximately eighteen inches. Unfortunately, this unit is quite rare, and is difficult to locate at a sensible price.

For scientific applications, West German Zeiss introduced in 1954 a 115mm f/3.5 Tessar designed for use on the Zeiss equivalent of the Leitz Visoflex, the Panflex reflex housing. In its standard mount, this lens focuses to infinity on the Panflex, and a set of extension bellows was marketed to make possible close-up reflex focusing with the lens. Only limited numbers of this exceptionally useful and high-quality lens were made, and both it and the Panflex itself are quite rare.

Is a Contax outfit right for your photography?

The principal advantages that the Contax system has over the Leica, and, indeed, over other coupled-rangefinder systems, are the fast, accurate focusing made possible by the unusually long-base rangefinder and the focusing wheel on top of the body, the marginally higher top shutter speed than any other classic 35mm rangefinder camera (although it is questionable whether the 1/1250th-second setting on most Contax shutters actually delivers that short an exposure), and the very high-quality yet relatively modest market price of the lenses.

The fact that the lenses, particularly the 35mm Biogon and the 50mm, 85mm and 135mm Sonnars, yield such excellent results at full aperture makes a Contax an excellent camera for candid photography in poor light, and its speed of focusing makes it a camera suitable for applications requiring constant refocusing, such as proximity sports and theatre work. It is worth noting that many experienced Contax users have given it as their opinion that the pre-war 35mm f/2.8 Biogon should be treated as an f/4 lens for full shadow exposure to be achieved – in other words, it pays to set the Biogon one stop wider open than your exposure meter indicates when shooting negative film.

Disadvantages of the Contax system are its substantial weight, which is much less noticeable with the post-war equipment, the aforementioned requirement for servicing once in a while, and the noticeable 'wheezing' noise made by the shutter when fired at speeds of 1/50th second or slower, which can be disconcerting both to photographer and to unwitting subject when shooting candid pictures.

Few systems at the price of pre-war Contax equipment can match the optical quality and sharpness of

results that pre-war Contax lenses can deliver when mounted in a camera in good condition. Post-war Contax cameras are relatively expensive, and currently (1994) sell at prices approaching those of Leica M3 equipment, so the optical-value-for-money argument is less significant, or perhaps can be discounted, when one compares mid-fifties equipment. Most people who buy and use Contax equipment do so for the simple reason that they enjoy the unrivalled feeling of solidity and engineering that a Contax offers when it sits in the hand or pulls the jacket out of shape from the right-hand pocket. As always, you pay your money and you make your choice.

Pre-war cousins of the Contax

The remarkable 35mm **twin-lens Contaflex**, mentioned in Chapter 1, appeared in 1935, and was the world's first camera with a built-in exposure meter, the first

chromium-finished camera from Zeiss Ikon, and, at 44 ounces without lens, one of the heaviest of classic cameras. As well as the 50mm f/1.5 Sonnar, the 50mm f/2 Sonnar and the 50mm f/3.5 Tessar lenses that were available as standard-lens options, Zeiss marketed special versions of the 85mm f/2 Sonnar and 135mm f/4 Sonnar to fit the Contaflex, and later introduced a version of the 35mm f/2.8 Biogon. Other lenses listed in the Zeiss catalogue included an 85mm f/4 Triotar and a 35mm f/4.5 Orthometar, but I have yet to encounter anybody who claims to have seen these lenses. Certainly, the 85mm Sonnar seems to be the commonest lens of non-standard focal length for the Contaflex, and even that is extremely scarce.

The standard reflex viewfinder of the camera included fields of view for the 85mm and 135mm lenses engraved on the ground-glass screen, but the 35mm Biogon needed a special accessory viewfinder which fitted slightly quaintly to the exterior of the lens

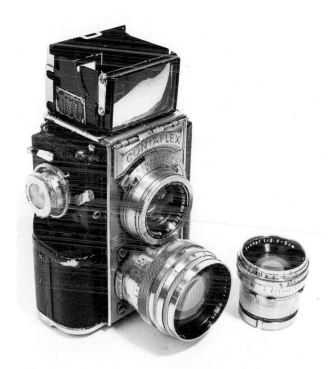

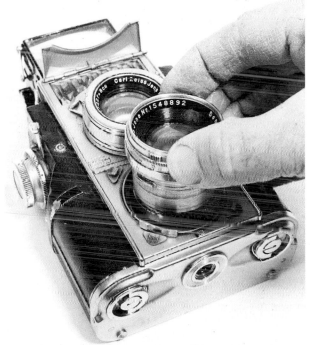

*A **twin-lens Contaflex** fitted with the 85mm f/2 Sonnar looks a little ungainly to the modern eye. Beside the camera is the standard 50mm f/2 Sonnar. The shutter speeds are set with the two rings of the knob on the right-hand side of the camera, which also winds the shutter and film. The shutter release is the lever just in front of the knob. The lever above and behind the knob is the delay action.*

*Changing the lenses of a **twin-lens Contaflex** requires that the grips either side of the lens at nine o'clock and three o'clock be twisted to seven o'clock and one o'clock (the grip at seven o'clock can be seen directly beneath the thumb in the picture), so that the lens can be lifted out. A groove in the base of the lens (visible in the picture on the left) locates with a key when the new lens is inserted, and the grips are then twisted back to their original position.*

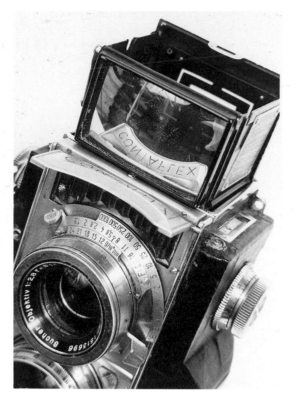

*A view of the **built-in exposure-meter** assembly of the twin-lens Contaflex, showing the receiver cell beneath its raised cover, and the movable aperture scale above the viewing lens which zeroes the needle in the window to the right of the hood on to an index point. When the needle is zeroed, the exposure is read from the movable scale and transferred to lens and shutter.*

mount. The shutter of the twin-lens Contaflex was derived from that of the Contax I, and its speeds are set in a series of ranges by a complex system of knob and rotating ring. Like the shutter of the Contax I, most Contaflex shutters have become unreliable with the passage of time, and, like the Contax I, the Contaflex is best regarded as a collectible that should be used as little as possible. In any event, the camera itself is scarce, and the accessory lenses are downright rare, with the result that buying a twin-lens Contaflex outfit is a major investment unlikely to be justified by the pleasures of classic-camera photography.

The Super Nettel

In 1934, Zeiss adapted the Contax I body and mechanism, fitted a bellows, drop-door front and a non-interchangeable 50mm lens, and produced the **Super Nettel**, a coupled-rangefinder folding camera of high

quality that bore obvious resemblances both to the Contax I and to the rollfilm Super Ikonta folding cameras. Above the 50mm f/3.5 Triotar lens (this version of the camera was priced at £18 12s. in Britain) or the 50mm f/3.5 Tessar (£20) was a pair of contra-rotating wedge prisms for the rangefinder, just as in the Super Ikontas of the time. The shutter had slow speeds extending only to 1/5th second, rather than the ½ second of the Contax, and the Super Nettel's wind knob was on top of the camera with the shutter button in the centre of the knob – the system that was to appear two years later on the Contax II and III.

In 1936, a chrome-finished version of the Super Nettel was introduced, and the low-cost (and inferior) Triotar lens was dropped. This Super Nettel II, which is very scarce indeed, was priced at £28 in Britain, only £3 less than a Contax I with an f/3.5 Tessar.

Once again, it has to be said that any Super Nettel is unlikely to be reliable as a classic camera for intensive use, and that the camera is best regarded as a charming collectible.

The Nettax

Also in 1936, in every way a remarkable year for Zeiss Ikon, a further Contax derivative called the **Nettax** appeared on the market. The Nettax had the same body and mechanism as the Super Nettel, but, instead of the bellows and the fixed lens, sported an interchangeable retractable 50mm Tessar, usually f/2.8, which had the rotating wedge prism assembly for the rangefinder built into an extended area of the lens mount. When the lens was fitted, the prism was positioned over the rangefinder window of the body, so completing the rangefinder optics.

Although a 105mm f/5.6 Triotar and a 28mm f/8 Tessar were catalogued for the Nettax, none of the many Zeiss collectors and enthusiasts around the world with whom I have been in touch during the past twenty years has ever seen the 28mm lens, and, as far as I know, no photographic museum has an example. The British Photographic Museum, until recently in Totnes, South Devon, England, had the only 105mm f/5.6 Triotar for Nettax that I have seen.

The two Tenax models

The vogue in the late thirties for rapid-action and motorized cameras, fuelled by the appearance of the Robot clockwork cameras with 24mm x 24mm square format on 35mm film, and by the Leitz clockwork motor drive MOOLY for the screw Leica cameras, apparently inspired Zeiss to produce two rapid-action trigger-wind cameras known as the Tenax and the

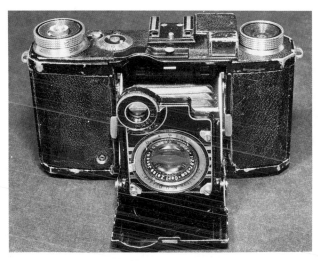

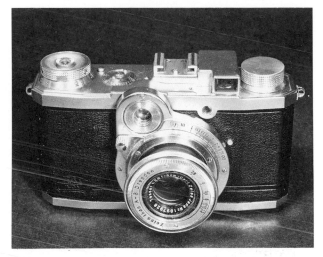

This **Super Nettel I** with 50mm f/2.8 Tessar had, unfortunately from the standpoint of collectibility and value, been synchronized for flash through the lower front panel. Such non-original features greatly reduce the value of a camera as an investment.

The **Nettax** is an agreeable camera which handles well, and one tends to feel that it is a pity that the war interrupted its production. Had it been produced in considerable numbers, and if its wide-angle and long-focus lenses were available, it would be an enjoyable choice as a classic camera. Unfortunately, it is scarce, and its non-standard lenses are almost non-existent.

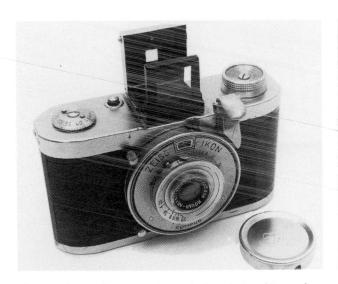

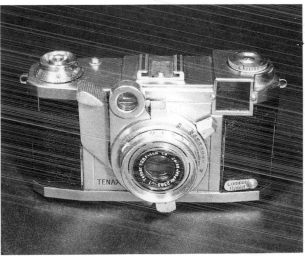

The much simpler **Tenax I** bears little relationship to the Tenax II, except insofar as it also employs a single-thrust lever to wind the film and the shutter, this time on the other side of the lens. Note the special slotted lens cap.

The **Tenax II** had a strong lever (left of the lens as we look at it here) which, when depressed, wound the film and shutter in one fast action. This example has the 40mm f/2.8 Tessar lens in Compur Rapid shutter.

Tenax I. The Tenax, introduced in 1938, and usually known since as the **Tenax II** because it was the more sophisticated and complex of the two cameras, was equipped with a behind-the-lens Compur shutter and a choice of interchangeable 40mm standard lenses, either an f/2 Sonnar or an f/2.8 Tessar. A limited range of interchangeable lenses was supplied, those catalogued being a 75mm f/4 Sonnar and a 27mm f/4.5 Orthometar. The camera was fitted with a coupled rangefinder not unlike that of the Nettax, with a rotating wedge prism unit within the mount of each lens.

The rapid-wind facility was achieved by means of a large trigger – one stroke wound the film and cocked the shutter for the next picture. A Tenax II, while correctly regarded as a member of the Contax family, was of course fundamentally different in not having a focal-plane shutter. It thereby avoided the principal cause of the unreliability in old age of the various cameras equipped with the Contax I shutter mechanism, and can be an excellent high-speed camera for the classic-camera enthusiast if in sound condition. Unfortunately, the Tenax II is scarce and sometimes rather expensive, but examples can sometimes be picked up cheaply in out-of-the-way camera shops.

The Tenax I, introduced in 1939 after the Tenax II, is a much simpler and smaller camera without interchangeable lenses. Like the Tenax II, it had a rapid-action trigger, and produced fifty pictures 24mm square on a standard thirty-six-exposure length of 35mm film, but there the resemblance ended. The Tenax I was smaller, lighter, made from entirely different body components and was fitted with a non-interchangeable 35mm f/3.5 Novar in a Compur shutter. The Tenax I had no rangefinder and only a flip-up viewfinder instead of the sophisticated single-eyepiece rangefinder and viewfinder of the Tenax II. Yet it was and is (if in sound condition) an effective small fast-action camera, although one which looks and feels a little odd and dated today.

Is the Contax worth it?

This chapter may have seemed somewhat scathing about the potential reliability of early Contax models, but such criticisms will serve only as a challenge to the truly committed classic-camera enthusiast, who rarely allows his desires to be frustrated by mere logic. As a great admirer of the Contax system, I hope more classic-camera users will persevere with the marque, and thereby help to maintain a worldwide stock of sound cameras and lenses in use, for there is no doubt that they are capable, even now, of the very finest photography.

The moment in the autumn breeze on the front at Brighton, Sussex, illustrated here lasted only a second or two, and it was the speed of reaction that the Contax design makes possible that enabled me to get the picture before the woman's arm dropped and the child moved. Shot with a Contax II with 50mm f/2 Sonnar and orange filter.

Opposite: *There are times when almost abstract images present themselves to the passing photographer, just begging to be photographed. These deck chairs, the railings, the sun and the shadows were such an image. Fortunately, I was the photographer. Shot with a Contax II with 50mm f/2 uncoated Sonnar.*

I took cover from one of the wettest days of the year in a flower show at the Horticultural Halls in London. There I rapidly discovered opportunities for the excellent qualities of the 50mm f/2 Sonnar, and found people to be so absorbed in their interest that the occasional wheeze of the Contax II at 1/25th second passed unnoticed.

Old-fashioned industrial settings offer outstanding photographic potential if you look at the dirt and grime with fresh eyes. This picture was taken in a very traditional foundry in the North of England during the seventies. Shot with a Contax III with 35mm f/2.8 Biogon at 1/25th second at f/2.8.

If you want to take lively, unposed pictures of young children, play hide and seek with them in the woods. Shoot quickly and plentifully, and, with luck, some of your pictures will be creatively effective and technically of good quality. This picture of David Logan, a friend's son, was captured in exactly this way with a Contax III and a 135mm f/4 Sonnar on a winter excursion on Ashdown Forest, Sussex. The important point is that there were several shots on the film which failed dismally, but the few that succeeded made the effort worthwhile. Rangefinder cameras are undoubtedly easier for most people to focus quickly in bad light conditions, and the long base of the Contax rangefinder makes for a higher proportion of successful grabbed pictures.

The famous 'bite' of the image yielded by the 50mm f/2 Sonnar, which made the lens so sought after in the thirties, is well illustrated by this picture taken in a sunlit Brighton square. So crisp is the image that it is hard to believe that this picture was taken with a camera and uncoated lens almost fifty years old when the shot was taken during 1984.

Opposite: To capture the fleeting spirit of romance in wedding photographs is one of the most difficult photographic tasks, rarely tackled successfully by formal, posed pictures. This shot was taken while the official photographer was changing his Hasselblad magazine back, and as the bride and groom relaxed for a moment. The flare of the uncoated f/1.5 Sonnar fitted to the Contax III shooting against the light has softened the image and added to the intimacy of the picture.

Chapter 6

Despite what the Germans say, not all classic cameras are European

It is a popular misconception that the Japanese camera industry resulted from a blaze of enlightenment shortly after General MacArthur set foot in Tokyo in 1945. The truth is that the Japanese camera-manufacturing industry is almost as old as that of Germany, and, unlike the German industry, has consistently learned from, and profited by, both its own mistakes and those of others. Nippon Kogaku, which manufactures Nikon equipment, dates from 1917 and was itself the product of a merger of three optical firms dating back to 1881. Canon was manufacturing fine 35mm cameras in the thirties; Minolta made hand-and-stand plate cameras and rollfilm cameras when the Leica was new; Konishoroku, which manufactures Konica equipment, is one of Japan's oldest manufacturers. The emergence of Japanese cameras on the US and European markets after the war was, however, certainly a product of US occupation and investment, both intentionally, in the sense that the American administration of post-war Japan recognized the potential of the industry, and indirectly, in that American photo-journalists and soldiers discovered the quality of post-war Japanese cameras and lenses, and noised it abroad.

Not all immediately post-war Japanese cameras were of lasting quality, but two great classic lines developed and matured alongside many other lesser breeds. These were the Nikon and Canon rangefinder camera systems, and their immediately subsequent single-lens reflex systems. Together, they overshadow all other Japanese classics, although folding rollfilm cameras like the Mamiya Six (a 1956 camera similar to a 6cm x 6cm Super Ikonta) and the Semi-Minolta (a 1950 sixteen-exposure on 120 folding camera rather like a Zeiss Nettar) and 35mm rangefinder cameras like the Konica II and IIA should perhaps be permitted some sort of niche in the hall of fame.

The Canon rangefinder series of cameras was essentially derived from the Leica design, and used the Leica 39mm screw lens mount and rangefinder coupling. Thus, Leica screw lenses fit and couple to Canon rangefinder bodies, and vice versa. The early models of the Nikon rangefinder cameras were, externally, very similar to the pre-war Zeiss Contax II, and used a (virtually) identical lens mount with similar characteristics. Internally, the Nikon rangefinder cameras bore little resemblance to the Contax, and, in fact, owed more to the Leica for their excellent mechanical and optical design. The Nikon rangefinder was based directly on the optical design of the Leitz rangefinder, but with the benefit of the longer base of the Contax; and Nikon shutters, like those of the Leica range, were of cloth, and travelled horizontally, instead of being metal and travelling vertically, as in the Contax.

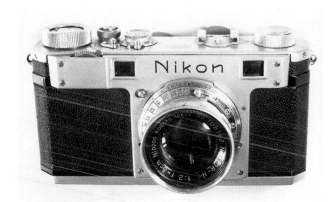

*The **Nikon S**, introduced in 1951, is the earliest Nikon rangefinder camera that is available in any quantity either in Europe or the USA. The Nikon S is easily distinguishable from later models by the similar size of the rangefinder and viewfinder windows. This example is fitted with a 50mm f/2 Nikkor. Note the similarity of the lens mount and locating clip to that of the Contax cameras illustrated in Chapter 5. Picture by courtesy of Ricky Hood.*

Both Nikon and Canon rangefinder cameras were soundly designed and extremely well made, with the result that most that are available now continue to work well with only occasional servicing. Unfortunately, from the standpoint of the enthusiast who buys his cameras to take pictures, the interest of collectors world-wide (not least in Japan) has pushed prices for good classic Japanese rangefinder cameras sky-high, and they can be difficult to obtain at prices that make economic sense. The same applies to the excellent ranges of lenses that were offered with each system. Given a clear choice between Nikon rangefinder and the Canon system, I would choose Nikon, partly because the Nikon rangefinder lenses were of superior performance, and partly because the Nikon brought together the best of Leica and Contax in one excellent camera. However, much of the rest of the world agrees with me, with the result that Canon rangefinder cameras and lenses, although expensive, tend to be less so than their Nikon equivalents, and Canon equipment is definitely easier to find, both in the USA and in Europe.

The Nikon system

Early Nikon rangefinder models, which began in 1948 with the Nikon I of 24mm x 32mm format on 35mm film, and continued in 1949 with the Nikon M of 24mm x 34mm format, bore a considerable resemblance to the Contax II. They were normally supplied with a collapsible 50mm f/2 Nikkor, and, although reasonably successful, were not manufactured in large numbers, were not exported to any degree, and are very scarce. The first Nikon model that was actively marketed in the USA was the **Nikon S**, introduced in January 1951, and usually fitted with a redesigned rigid 50mm f/2 Nikkor lens, although by the following year the 50mm f/1.4 Nikkor was available as an option. The first Nikon S cameras retained the non-standard 24mm x 34mm format of the Nikon M. Thenceforward, all Nikon rangefinder cameras were supplied with the standard 24mm x 36mm format. The much-publicized love affair between photo-journalists of *Life* magazine, who were covering the Korean War, and the Nikon S gave the Nikon cameras a head start in the US market, and the stage was set for the big US marketing launch in December 1954 of the Nikon S2.

The **Nikon S2** had leverwind, a 1:1 life-size viewfinder image, a new maximum speed of 1/1000th of a second, single-socket flash synchronization and many other improvements, including a reduction in weight. It was a mature Nikon, and it earned instant success. Over 56,000 Nikon S2 cameras were sold before the model was discontinued in March 1958, more than any other Nikon rangefinder model. The S2 was succeeded by the **Nikon SP**, an advanced camera with built-in suspended brightline viewfinder frames for 50mm, 85mm, 105mm and 135mm lenses, selected by an external dial and not, as in the Leica M3, by the insertion of the lens. For the first time in a Nikon rangefinder camera, it had delay action and the facility

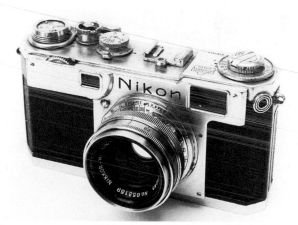

*The commonest of Nikon rangefinder models is the **Nikon S2**, introduced at the end of 1954, and illustrated here with 50mm f/2 Nikkor. This is the actual camera with which the two pictures on pages 109 and 110 (bottom) were taken.*

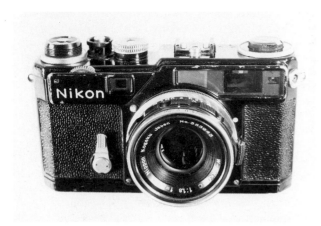

*The **Nikon SP** brought, in 1958, the sophistication of suspended brightline viewfinder frames covering focal lengths from 50mm to 135mm to the Nikon viewfinder/rangefinder system. This is a black Nikon SP, fitted with the 35mm f/1.8 wide-angle lens in black mount, for which the camera would require the universal viewfinder in use. Picture by courtesy of Ricky Hood.*

*Looking down on to the top-plate of the same **Nikon SP** with 35mm f/1.8 lens, one can see the single dial for speeds from 1 second to 1/1000th, the wind lever, frame counter and advance/rewind system which is almost identical to that of a Nikon F single-lens reflex and, on the milled ring around the rewind crank at the left-hand end, the viewfinder frame selector, which is set to 85mm (8.5cm). Picture by courtesy of Ricky Hood.*

for adding motor drive. It was a very sophisticated camera. Alongside the SP, Nikon marketed the S3, actually an SP with the expensive brightline finder mechanism replaced by simpler etched finders, and $60 trimmed off the price.

Aside from the rare Nikon S4 and the even rarer half-frame format Nikon S3M, the **Nikon S3** was the last of the line – certainly it is the latest of the cameras the latter-day user is likely to be able to afford. To fit the Nikon rangefinder cameras, Nippon Kogaku supplied a formidable range of top-quality lenses – 21mm, 25mm, 28mm, a wide selection of 35mm and 50mm lenses, 85mm, 105mm, a variety of 135mm lenses and 180mm, 250mm, 350mm and 500mm telephotos and a 1000mm f/6.3 Reflex-Nikkor that looked like a second cousin of the Mount Palomar telescope. There were a motor-drive unit, reflex housings that had a remarkable resemblance to the original Leitz PLOOT and its successor the Visoflex I, and a wide range of viewfinders and close-up accessories.

Any Nikon rangefinder camera is a delight to use, combining the beautifully precise and rapid focusing of a Contax with the silky feel and quietness of a good Leica. As a camera for photo-journalism, a Nikon is in the first league. Obtaining the additional lenses is not at all easy, and getting the universal viewfinder that you will need if you do not have a Nikon SP will prove even more difficult, although you can always use a Leitz, Zeiss or Tewe viewfinder as a substitute until you locate the genuine Nikon article. Thus, it would be wise not to expect to treat a Nikon rangefinder camera as a system camera until you have been lucky enough to find the items you need. Because so many more Nikon rangefinder cameras were sold in the USA than in Europe, American readers will find it a great deal easier to track down what they want than will those in Europe.

When buying Nikon rangefinder equipment, take particular care to check the condition of the camera-body focusing mount, which is inclined to wear, and, in the case of the S2, S3 and SP, whether the leverwind returns properly after winding.

Nikon rangefinder equipment has the same limitations as any other rangefinder system where close-up work is concerned, plus the additional hazard, by comparison with the Leica system, of it being well-nigh impossible to find the more unusual accessories, even if you are willing to foot an inflated bill once they have been located. It is therefore wise to steer clear of the Nikon rangefinder system if you want to build up a large or comprehensive outfit for a wide range of photography. It would be far better to regard the fortunate acquisition of a Nikon, and maybe a lens or two, as a delightful outfit for occasional use.

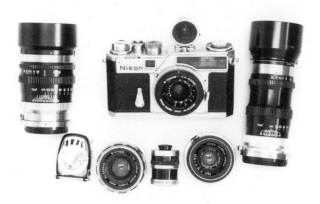

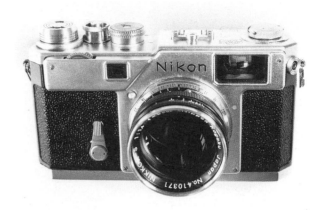

A **Nikon SP** outfit, with the scarce 25mm f/4 Nikkor fitted to the chrome Nikon SP, and the 25mm viewfinder in the camera accessory shoe. To the left of the camera is the late black version of the 105mm f/2.5 Nikkor with its lens hood fitted, and to its right is the 135mm f/3.5 lens in similar finish, also with its hood. In the lower row are (left to right) the Nikon accessory exposure meter, the 35mm f/1.8 Nikkor, the universal viewfinder and the 35mm f/2.5 Nikkor. Picture by courtesy of Ricky Hood.

The **Nikon S3**, also introduced in 1958, is essentially a simplified Nikon SP without the benefit of the brightline viewfinder system. This example is fitted with the late black 50mm f/1.4 Nikkor. Picture by courtesy of Ricky Hood.

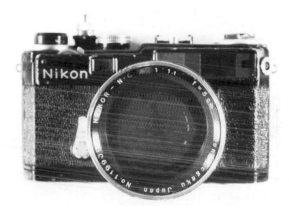

During the early period of Nikon rangefinder camera production, a range of chrome-on-brass lenses was manufactured. In this picture (left to right) are the 135mm f/3.5 Nikkor, the 135mm optical viewfinder, the usual type of 85mm f/2 Nikkor, the Nikon universal viewfinder and a special version of the 85mm f/2 Nikkor that was apparently issued to the US forces photographers. Picture by courtesy of Ricky Hood.

At the time of the availability of the Nikon SP, Nippon Kogaku also offered the market this formidable 50mm f/1.1 standard lens, which reputedly performed well. Picture by courtesy of Ricky Hood.

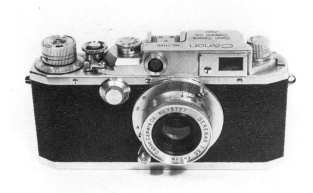

The **Canon II** series cameras appeared in 1952, and are usually found either with this 50mm f/3.5 Serenar, or with a collapsible 50mm f/1.9 Serenar. Leica screw lenses fit, and usually couple to the rangefinder correctly. Picture by Colin Glanfield.

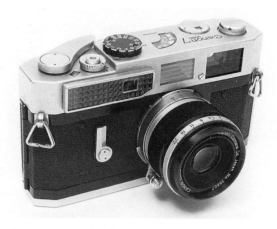

The last two models of the Canon rangefinder series were the Canon 7 and the Canon 7S. This is a **Canon 7**, which had built-in brightline viewfinders for 35mm, 50mm, 85mm, 100mm and 135mm lenses, and a built-in selenium exposure meter.

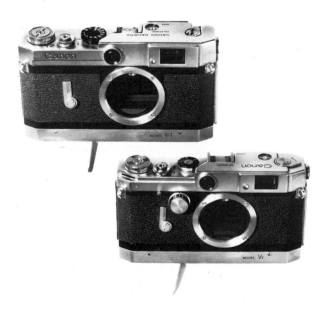

The **Canon VT** and **VIT** models were equipped with a built-in trigger-wind base which made them extremely effective as cameras for rapid action. The Canon VIT (upper camera) has all its shutter speeds on a single non-revolving speed dial, whereas the earlier VT (lower picture) has a revolving shutter-speed dial and the slow speeds on a separate dial on the front of the camera, in the manner of a screw Leica. The Leica-thread lens mount and rangefinder coupling arm of the Canons can be seen clearly in this shot. Picture by Tony Hurst.

Canon rangefinder equipment

The Canon rangefinder system owed its origins to the Canon 35mm cameras of the thirties, and, by the time the post-war period of reconstruction in Japan had begun, there was a well-established background of 35mm camera design and technology at Canon. The Canon rangefinder cameras of the early fifties have an appearance not unlike that of a Leica, with the shutter-speed dial on the top-plate and a slow-speed dial on the front in the same positions as those in which they would be found on a Leica IIIC. Unlike the screw Leicas, however, the **Canon II**, III and IV series have only a single eyepiece for an integral rangefinder and viewfinder, and therefore only two 'windows' in the front of the rangefinder housing – a considerable advantage over the twin eyepieces of the screw Leica. All the Canon II, III and IV models have a horizontally running cloth focal-plane shutter akin to that of a Leica, and the standard Leica screw lens mount and rangefinder coupling. The Canon II, IIB and IIC were all available at the one time, and were essentially the same camera (the II) with additional features. The Canon II (price $168.50 with f/3.5 lens in the USA in 1951) had a top speed of 1/500th second, as did the IIB (price $249.50 with f/1.9 lens), which was endowed with a rangefinder magnifier for focusing in poor light. The IIC (price $285.45 with f/1.9 lens, also in 1951) had a higher top shutter speed of 1/1000th second and full flash synchronization.

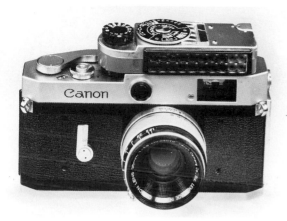

The **Canon P** had 35mm and 50mm brightline viewfinders built into the camera, and could be equipped with a separate exposure meter which coupled with the shutter-speed dial in the manner of the Leicameters on Leica 'M' cameras. This chrome Canon P is fitted with the excellent 35mm f/1.8 Canon lens. Picture by Tony Hurst.

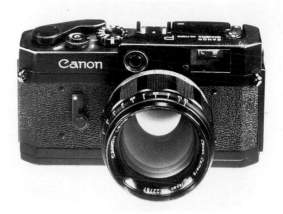

The Canon P was also available in black finish, although this is a decidedly scarce collectible camera. This very handsome example is fitted with the **Canon 50mm f/1.2 lens**, which is generally not up to the standard of the smaller-aperture lenses. Picture by Tony Hurst.

The Canon IV, which appeared in several sub-versions, introduced, for the first time in Canon cameras, a multiple viewfinder within the camera. This was not a brightline finder, but a magnification system with three settings to give correct fields of view for 50mm, 100mm and 135mm lenses. Like the Canon IIC, the Canon IV also had a top shutter speed of 1/1000th second and full flash synchronization, and, in its Canon IV-S2 version, was priced at $295 in the USA in 1954.

The Canon V and VI series which followed were substantially redesigned, and looked very little like the screw Leicas, although the V series still featured a rotating shutter-speed dial, and slow speeds on a separate dial on the front of the camera. Both retained the standard Leica screw lens mount and rangefinder coupling. Brightline finder systems made their appearance in the Canon cameras, and the Canon VI featured a switchable 35mm and 50mm viewfinder, controlled by a knob on the back of the camera. In the Canon VI, all the shutter speeds were, for the first time, grouped on a single dial on top which, unlike the dials of earlier models and screw Leicas, did not rotate when the shutter was fired. The **Canon VT** and **VIT**, both much sought after by collectors, featured a trigger-wind base built into the camera, by which the left hand of the user wound the film and shutter by pulling a trigger handle along parallel with the base of the camera while keeping the camera to his eye and his right hand poised to fire the shutter.

The final Canon rangefinder models were the Canon 7 and 7S, which represented the logical conclusion of Canon rangefinder design. The **Canon 7** featured a built-in selenium exposure meter with low and high light ranges, and a large, bright viewfinder not unlike that of the Leica M3, with built-in suspended viewfinder frames for 35mm, 50mm, 85mm, 105mm and 135mm focal lengths. Unlike the Leica M3, these frames were not actuated by the insertion of the lenses, but instead were selected by a knob on the top of the camera. The Canon 7 had delay action, speeds from 1 second to 1/1000th second and titanium-foil shutter curtains instead of the earlier rubberized fabric or steel foil. These foil curtains are inclined to rumple, and it pays, when buying a Canon 7 or 7S, to look for a shutter that is as unrumpled as possible. The Canon 7S was essentially similar to the Canon 7, but was equipped with a CdS meter (cadmium sulphide battery-powered cell) instead of the selenium exposure meter of the 7.

Canon rangefinder lenses

Lens development of the Canon rangefinder series followed that of other manufacturers of the day, the standard lenses of the II series of 1951 being the collapsible 50mm f/3.5 Serenar, an excellent coated four-element lens, or the collapsible 50mm f/1.9 Serenar, again capable of excellent performance, even at full aperture. By the time the Canon IV of 1954

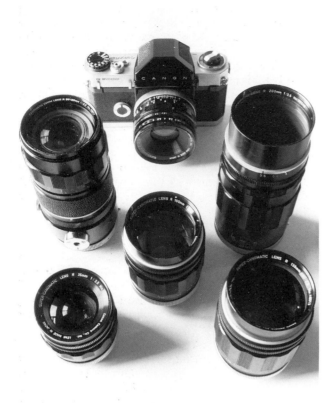

A Canonflex R2000 outfit. The camera, introduced in 1960, was one of the first to offer a highest shutter speed of 1/2000th second, and had a removable pentaprism and optional waist-level finder. This example is fitted with a 50mm f/1.8 Super Canomatic R lens with automatic diaphragm. An accessory clip-on exposure meter was available to fit the lugs visible on the front of the camera below the shutter release. The lenses, left to right and working down the picture are: (top row) 55mm-135mm f/3.5 Canomatic Zoom R; 200mm f/3.5 Canomatic R; (centre) 100mm f/2 Super Canomatic R (the actual lens with which the two pictures on pages 110 (top) and 111 were taken); (bottom row) 35mm f/2.5 Super Canomatic R; 135mm f/2.5 Super Canomatic R. The first Canonflex camera was the Canonflex of 1959, which looked almost identical to the camera illustrated here, but had a top shutter speed of 1/1000th. A Canonflex RP (1960) was essentially a Canonflex with fixed pentaprism. The Canonflex RM of 1962 had an exposure meter built into the top-plate.

was made available, the standard lens was usually either a rigid version of the chrome-finish 50mm f/1.9 Serenar, which is the characteristic standard lens with which one usually finds early post-war Canon rangefinder cameras, or the early chrome version of the recomputed 50mm f/1.8 Canon lens which, in black-and-chrome mount, was standard to the V, VI and 7 models (the mixture of roman and arabic numerals is, it should be said, the way Canon itself described its models). The range of standard lens options broadened in the late fifties to include an excellent 50mm f/1.4 Canon lens (the name Serenar had by this time been abandoned in favour of the simple title 'Canon'), and a **50mm f/1.2 Canon lens** which I have always found less than satisfactory. The ultimate Canon standard lens was the enormous 50mm f/0.95 objective, which was too large to use the screw lens mount and which fitted over an external bayonet on the body of the Canon 7 and 7S that was normally used for the mounting of the Canon 'Mirror Box', the uncompromisingly named Canon equivalent of the Leitz Visoflex II reflex housing. The combination of Canon 7 and f/0.95 lens was, and is, sometimes known as the 'Canon Dream'.

As with the Nikon rangefinder system, a full range of lenses was manufactured. The lenses made until the mid-fifties under the 'Serenar' name were of chrome on brass, with optical designs owing more to Zeiss than to Leitz, and are characteristically of quite surprising heaviness – a feature they share with pre-war Contax lenses of similar construction. When the Canon IV series of cameras was launched, the chrome finish was retained, but new lens computations began to appear under the 'Canon' name. Focal lengths available at this time were 28mm, 35mm, 50mm, 85mm, 100mm and 135mm, all of which turn up secondhand from time to time. At the same time as the redesign of the cameras themselves that produced the Canon V and VI models, the lens range was revamped, and from the late fifties onwards, all the lenses were predominantly black, with chrome aperture rings, and were much lighter. The optical performance of these later lenses is extremely good, and there were some very advanced specifications, including 35mm f/2 and 35mm f/1.4 wide-angles.

Choosing your Canon rangefinder equipment

Although it is becoming progressively more difficult to find good Canon rangefinder equipment on the market, either at a sensible price or at all, it is still possible with perseverance to build up an outfit to use. Although it is true that virtually all Canon rangefinder cameras are likely still to be capable of

functioning reliably, and that all the lenses are of at least good quality, there is no doubt that the later lenses are both much lighter in weight and give significantly better performance. The Canon 7 and 7S have extremely attractive specifications, but are prone to exposure-meter faults, so check the meter function carefully before buying a camera – in particular, try pressing gently on the surface of the exposure-meter window on the front right of a Canon 7, and you may find that the exposure meter stops working until the pressure is released. In other instances, the reverse is true, and the meter works only when the window is pressed. In either case, the meter has faulty connections and needs servicing. Check the battery terminals of any Canon 7S very carefully and, with either the Canon 7 or 7S, look closely at the titanium shutter blinds for a rumpled surface. If they are not smooth, check repeatedly for even running of the shutter before committing yourself.

Other Japanese rangefinder cameras

Other Japanese manufacturers also launched coupled-rangefinder cameras looking to a greater or lesser extent like the screw Leica, and it is these that are genuinely Leica copies, with little evidence of originality in their design. Typical of these are the Leotax series, of which the Leotax D-III and D-IV, almost identical in appearance to a Leica IIIB, appeared in 1951. The principal difference between these two

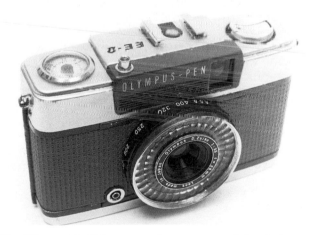

The Olympus half-frame pocket cameras of the sixties and seventies are capable of remarkably high-quality results, although their being defined as classics must be somewhat marginal. This is a Pen EE-2, which differs from the Pen EE in having a 400 ASA film-speed setting on the exposure meter.

models was the provision of flash synchronization on the D-IV. Some Leotax cameras were fitted with a 50mm f/2 Nikkor in Leica screw mount, others with a 50mm f/3.5 lens that looked exactly like a Leitz Elmar. The later Leotax D-VI of 1955 was often fitted with a 50mm f/1.5 lens that looked very similar to the Leitz Summarit, and this combination was priced at $287.50 in the USA.

In 1950, there had also appeared a Leica copy known as the Nicca, equipped with a 50mm f/2 Nikkor lens in Leica screw mount. This again looked remarkably similar to a Leica IIIB, and was priced at $215 in the USA. Spiratone imported the Tanack into the USA from Japan, again as a Leica copy, and there were a number of others.

American contenders for the Leica market

Taking an overall view of the American camera scene, there seems to be general agreement that the US camera industry was as unsuccessful at manufacturing and marketing top-quality miniature-camera systems as it was successful in marketing cameras for the low-price snapshot market.

The first full-scale attempt on the market that Leitz and Zeiss had created and shared was launched by Kodak with the introduction of the Kodak Ektra in 1941. Outstandingly innovative, with interchangeable magazine backs as well as interchangeable lenses, the Ektra was expensive to produce, and only two thousand were made before production was finally interrupted by the war. When, in 1946, the question of recommencing production of the Ektra was discussed by Kodak, it was found that increased costs would necessitate a retail price of $700, and the design was quietly dropped. I personally confess to never having seen an Ektra, and it is likely that the same will be true of most of my European readers, since the camera is very rare outside the USA, and decidedly scarce even in America.

Towards the end of the Second World War, Premier Instrument Corporation of America became a subcontractor to E. Leitz of New York, which had accepted a US Army Signal Corps contract to design and manufacture a mass-produced duplicate of the Leica IIIA. Remarkably, and with great virtuosity, Premier succeeded in producing a working prototype by September 1945, by which time the war was over, and neither E. Leitz nor the Signal Corps wanted the camera. Somewhat modified, the Kardon was offered to the civilian market in 1947 in competition with the Leica IIIC, newly arrived from Germany. Sadly for Premier, the Kardon flopped dismally, although it was reputed to be an effective camera.

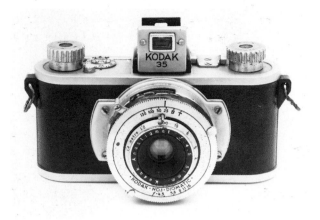 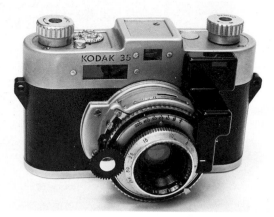

*Manufactured from 1938 to 1948, the **Kodak 35**, here in the version with f/4.5 lens, was heavy, ugly and less than spectacularly successful in the battle for the popular American market with the Argus C, C2 and flash-synchronized C3. Yet the Kodak 35 was manufactured to closer tolerances and offered much more consistent lens quality than did the rectangular Argus cameras. Picture by Colin Glanfield.*

*A reliable workhorse of a camera, whose appearance could hardly be described as beautiful, the **Kodak 35** f/3.5 Rangefinder was made from 1940 to 1942, and again from 1946 to 1951. This is a pre-war example. Most Kodak 35 cameras work well if the shutter is serviced, and the lenses are capable of excellent results.*

In 1949, Bell and Howell launched its attempt upon the precision 35mm market in the form of a futuristic, bulky, horrendously expensive and, to European eyes, ugly camera named the Foton 155A. Made of die-cast aluminium with polished-chrome trim, the Foton sported a British-designed Taylor-Hobson-Cooke Amotal f/2 lens, a Contax-like focusing wheel and the t/stop (as distinct from f/stop) diaphragm graduation principle. The t/stop system, the 't' standing for 'transmitted light', was favoured at that time by the motion-picture industry in preference to the f/stops we all know and love, and Bell and Howell, long-established in motion-picture equipment, decided to launch a camera using that system because it was theoretically preferable, ignoring the fact that the market was most unlikely to want to buy it. The market made its choice, and many of the 16,900 Foton cameras that were manufactured were never sold at anything approaching their $700 premium retail price.

Other American classics

There are no easy criteria for deciding which of the many 35mm and rollfilm cameras produced in the USA, other than those already discussed, qualify for the term 'classic'. The 620 rollfilm Kodak Medalist (pre-war) and Kodak Medalist II (post-war) certainly should; perhaps the rangefinder **Kodak 35** should be allowed into the fold, with, possibly, the Perfex models, or one or two of the better Bolseys. However, from a classic user's standpoint, there can be little doubt that the great European classic cameras represent a better investment and will prove to be a more reliable buy in the 1980s, and that the Japanese classics come a close second. Few American cameras that are likely to be available to the would-be purchaser at a realistic price qualify for anything better than third place. Interesting they are, better than the competition they are not.

Old wood and rusty iron have a textural appeal all their own, and the Nikon S2 and 50mm f/2 Nikkor with which this shot was taken during 1984 have rendered the texture beautifully. There is no doubt that the Nikon rangefinder lenses are of very high quality.

Opposite: *The happy, gappy grin of a little girl enjoying herself in a garden tree-house – a shot which did not remain available for very long. The picture was taken with a Canonflex R2000 fitted with a 100mm f/2 Super Canomatic lens. This is a very enjoyable, if rather heavy, single-lens reflex of the early sixties, whose lenses have the same Canon breech-lock mount as current Canon reflex cameras, but an entirely different diaphragm mechanism, which makes the two systems quite incompatible.*

Her Royal Highness Princess Alexandra, photographed when she was opening a school in Sussex in 1979 – the sort of portrait of an important member of the Royal Family that any photographer can obtain, given a degree of patience and a little intelligence (in both senses of the word) in deciding upon a viewpoint. This shot is on Sakuracolor colour-negative film, which is the reason for the apparent grain – it is, in fact, a lesser enlargement than many entirely grain-free pictures elsewhere in the book. The picture was taken with a Canonflex RM – a version of the Canonflex with built-in selenium exposure meter – and a 100mm f/2 Super Canomatic lens.

Lime Street, Liverpool, shot from a hotel window at a dizzy height with a Nikon S2 and 50mm f/2 Nikkor. The overall quality delivered by the Nikkor lens is extremely pleasing.

Chapter 7

Who sold you that then? Out and about with a classic 35mm SLR

The essential differences in principle between focal-plane-shuttered single-lens reflexes, leaf-shuttered single-lens reflexes and rollfilm single-lens reflexes have been discussed in Chapter 2. In this chapter, we look at a selection of actual 35mm single-lens reflex types, and at their advantages and disadvantages in day-to-day use. A discussion of rollfilm single-lens reflexes comes later in Chapter 9.

Focal-plane-shuttered 35mm SLR cameras

Kine-Exakta and Exakta Varex

The world's first generally marketed single-lens reflex, the **Kine-Exakta** was introduced in 1936, modified in 1937, and developed as a series of distinctively different Exakta single-lens reflexes until the demise of the marque at the end of the sixties. All Exakta 35mm SLRs have the unique shutter with speeds from 12 seconds to 1/1000th second, and all save the Exakta RTL1000 (which has both top-plate and left-hand shutter releases) have the shutter button on the left-hand side instead of the right, film loading from right to left instead of left to right, a simple bayonet mount with external automatic diaphragm actuation on the auto lenses, and a sort of rudimentary functional quality that is attractive to those who prefer not to seem slick.

An enormous variety of lenses from Zeiss, Meyer, Schacht, Schneider, Rodenstock, Steinheil and Kilfitt, among others, were produced for the successive generations of 35mm Exaktas over approximately thirty years, and all will fit any of the Exakta cameras prior to the RTL1000, which, although it has the inner bayonet mount for traditional Exakta lenses, sometimes requires adjustment to accept them. Consequently, there remains a substantial pool of secondhand lenses of high quality readily available at moderate prices that have not been inflated by collectors' interest.

The pre-war Exaktas are attractive, but are now old and usually less than reliable – a fact that is hardly surprising, in view of their complexity. The post-war models began with the Exakta II of 1949, essentially an updated pre-war camera with the facility for accepting an accessory eye-level viewing attachment. This was replaced in April 1950 by the Exakta Varex V (the term Varex could not be used in the USA for patent reasons, and was simply omitted in each case from the model designation). This Exakta Varex V (or Exakta V) was the first of its make capable of accepting an interchangeable pentaprism. By 1951, the model had been improved to become the Exakta Varex VX (Exakta VX in the USA), which was launched with the first range of auto-diaphragm lenses to become avail-

*The **Kine-Exakta** was the first 35mm single-lens reflex that looked, to the modern eye, like a single-lens reflex. The initial 1936 model, with a circular sports-finder lens, is on the right. This was superseded in 1937 by the second version, on the left, with a rectangular sports-finder lens. In this picture, the early camera (right) has a 50mm f/2.8 Zeiss Tessar, and the other a 50mm f/2.8 Schneider Xenar, but both lenses were available simultaneously. Note the difference of spelling of 'Exakta' as 'Exacta' on the left. This shows that the camera on the left is, in fact, one of those made to the pre-war design immediately after the war. The additional (topmost) hole above the flash-synchronization sockets, for fitting a Vakublitz flashgun, is only present on Kine-Exaktas made after 1940. The standard 3mm flash socket (second from bottom of the four) is a later addition.*

able. This model was upgraded in 1956 to have standard coaxial flash sockets. The Exakta Varex IIA (1957), and the **Varex IIB** (1963) followed, the IIA having a simplified shutter and an optional through-the-lens metering pentaprism. The final 'genuine' Exakta was the VX1000 of 1967, which was the first Exakta with an instant-return mirror, and was also marketed as the VX1000TL (i.e., with the through-the-lens metering pentaprism) in 1969. Its simplified near-relative, the VX500, was also launched in 1969, and the Praktica-derived Exakta RTL1000 appeared in 1970.

While these models were successively on the market, a separate line of budget-priced cameras from the same factory, and accepting the same lenses, was marketed under the name Exa. Four versions of the Exa I appeared, in 1953, 1961, 1962 and 1964, most of which had shutter speeds of 1/25th to 1/150th second, although the top speed on the final version was 1/175th. Strictly, these cameras do not have a focal-plane shutter, since the mirror mechanism itself functions as the shutter as it flips up, and, obviously, is well forward of the focal plane. The later Exa II, IIA, IIB and 500 models had true focal-plane shutters of cloth, running vertically. Early Exas are not reliable and it is best to steer well clear of them as cameras for regular use. The Exa IIB and 500 models are usually reasonably reliable, but hardly to be recommended, if only because greater facilities can be bought for very little more money if one purchases something different.

The slow-speeds and variable delay-action mechanism of ageing Exaktas can be extremely trouble-

*The main speed dial and the leverwind and exposure-counter assembly of the first-type **Kine-Exakta**. The milled quadrant adjacent to the lever is the rewind switch.*

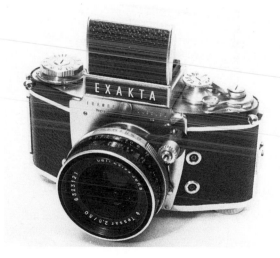

*The Exakta **Varex IIB** (VXIIB in the USA) of 1964 is one of the most usable of Exaktas. This particular camera is fitted with a 50mm f/2.8 Tessar with automatic diaphragm.*

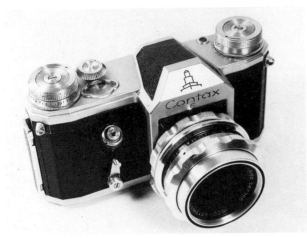

*The **Contax F** of 1957 was the last of the reflex cameras marketed under the Contax name by VEB Pentacon, formerly Zeiss Ikon, Dresden (until 1948), and Zeiss Ikon VEB (until 1957). The principal difference between this camera and a Contax D is the addition of an internal diaphragm actuator to operate the semi-automatic spring diaphragm of the lenses. The Contax F was renamed Pentacon F, and was succeeded by the Pentacon FM and the Praktica series of cameras.*

The Praktina FX was, like the earlier Praktiflex, a product of Kamera Werkstätten AG (KW) of Dresden, which became part of VEB Pentacon. It has an optical viewfinder for 50mm lenses as well as the reflex viewfinder, and is usually fitted, as it is here, with the 58mm f/2 Biotar with semi-automatic spring-loaded diaphragm, in a breech-lock mount rather like that of the Praktisix. The Praktina FX has the distinction of having been the first single-lens reflex to be available with what is now called autowind – a clockwork device advancing the film one frame at a time. The additional lens is a 100mm f/2.8 Trioplan by Meyer-Optik of Goerlitz. The mechanical reliability of the Praktina is sometimes questionable, but it is a very agreeable camera.

some, and it pays to check them very carefully. Check also that the auto-diaphragm mechanisms of any lenses you buy stop down snappily, and before the shutter fires, when the button is pressed. If this function is sluggish, exposures will be wrong. The best models, in my experience, are the Varex IIA, IIB and VX1000, with the VX1000 marginally the favourite for reliability, if only because it is newer. Buying Exakta ensures access to a lot of lenses and a great deal of fun, but buy two bodies, so that you will always have one if the other needs servicing.

The Contax and Pentacon reflexes

The Contax series of single-lens reflexes was manufactured in the Dresden factory of Zeiss Ikon after the war, when the Russians had taken East Germany. Although named Contax, the cameras bore little relationship to the Contax rangefinder cameras previously manufactured in the same plant, although it seems probable that their design owed much to pre-war research and development. The whole series of cameras had the 42mm screw lens mount that was introduced to the world by the Contax S in 1948 and became the standard mount for dozens of other cameras, including the screw-mount Prakticas, screw Pentax cameras, Zenith E series reflexes and many others. All had cloth focal-plane shutters that travelled horizontally and provided speeds from 1 second to 1/1000th, and all were fitted with high-quality lenses from Carl Zeiss, Jena. The US price of a Contax S in 1950 was $475 with f/2 lens.

Most of the standard lenses of the Contax S, as marketed in Europe, were in black, although cameras found in the USA and Canada usually have bright alloy mounts. All had simple diaphragms (i.e., not pre-set or automatic diaphragm). Those of the Contax D, a flash-synchronized development of the Contax S, which followed in 1952, had pre-set diaphragms and were in bright alloy. Both cameras were fitted either with a 50mm f/2.8 Tessar or a 58mm f/2 Biotar. In 1955, the Contax E appeared, essentially a Contax D with a built-in exposure meter, and this was followed in 1956 (at the Leipzig Fair) by the **Contax F**, which was fitted with the mechanism for automatic-diaphragm actuation. The lenses fitted to Contax F cameras were in bright alloy mounts, and had pre-set semi-automatic spring diaphragms, in which the lens is manually cocked against spring pressure to stay at full aperture for focusing, and closes instantly to the pre-set aperture when the shutter is fired. Alongside the Contax F at Leipzig was launched the Contax FB, which was a Contax F with a selenium exposure meter built into the pentaprism.

When East German Zeiss lost in the courts the right to use the name 'Zeiss', the Contax F was renamed Pentacon F, and a subsequent further development was the Pentacon FM. This gave way in the early sixties to the Praktica line of cameras from the same factory. Lenses in 35mm, 100mm and 135mm focal lengths were available for the Contax/Pentacon cameras, but are very rare in Britain and relatively uncommon elsewhere. However, all later 42mm screw lenses with pre-set diaphragms will fit and operate with any of these reflexes, and later automatic-diaphragm lenses are usually compatible with the Contax F, subject to some possible adjustment of automatic-diaphragm actuation.

All the Contax S, D, F and Pentacon F and FM cameras are subject to mechanical problems, and most are nearing the end of their useful lives. It would probably be wise to steer clear of them as cameras for regular use, although they are interesting items for any collection.

The Alpa reflexes

The Alpa cameras manufactured by Pignons SA in Switzerland form part of a scientifically orientated system in which, until the introduction at the end of the seventies of the Alpa Si2000, of Japanese origin, all camera bodies and all lenses manufactured over a period of some twenty-five years were entirely cross-compatible. The early Alpa Alpax, Prismax and Alitax reflexes of 1951 were not entirely successful, are not to be relied upon, and had a lens mount different from that which became standard with the introduction of the Alpa Models 4, 5, and 7 in 1951, followed by the Alpa 6 in 1956 and the Alpa 8 in 1957. These models were completely redesigned and much improved, and were all essentially the same camera but with different additional features. All have ten marked shutter speeds from 1 second to 1/1000th second, a further fifty unmarked speeds available as inter-mediate settings, knob-wind, and interchangeable lenses using the Alpa three-tongue bayonet mount. The Alpa 4 has a vertical magnifier finder, the Alpa 5 a 45-degree prism viewfinder. The Alpa 6 is a 5 with delay action added, the 7 is a 6 with an additional coupled rangefinder as well as reflex focusing, and the 8 is a 7 with a rangefinder in the reflex screen as well as in the separate viewfinder. As if to make life easy for the classic enthusiast, all Alpa models are clearly marked with their model number.

The Alpa 'b' series (4b, 5b, 6b and 8b), introduced in 1959, were essentially the earlier cameras with lever-wind, working front to back, and with minor changes to the shutter. These were initially added to, and were

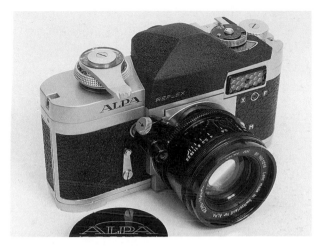

*The **Alpa 6c** – used for the two pictures on pages 128 and 129 – with its 50mm f/1.8 Macro-Switar. The unusual wind lever works from front to back, and the shutter-speed dial revolves when the shutter fires, so the fingers have to be kept out of the way. However, the Alpa 6c, and the through-the-lens-metering Alpa 9d, which is essentially the same camera, are quite magnificently engineered.*

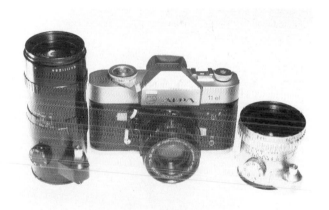

*The Alpa 10 and 11 series cameras were all manufactured using this redesigned body, although the lens mount and front-to-back wind lever are similar to those of the 6c and 9d. This example of the **Alpa 11el**, which appeared in 1973, is fitted with the later 50mm f/1.9 Macro-Switar, and has with it, on the left, a 180mm f/4.5 Alitar and, on the right, a 28mm f/3.5 Angénieux Retrofocus, later available in black finish. Both have the unique Angénieux diaphragm setting knob on the top of the lens.*

later succeeded, in 1960, by the **Alpa 6c**, a redesigned camera with pentaprism viewing parallel to the axis of the lens (as in modern SLRs) and a built-in selenium exposure meter, and, in 1963 by the 9d, which I believe to have been the world's first camera with through-the-lens metering, although this is disputed by US enthusiasts who award the distinction to Topcon. This particular argument appears to hinge on quite different European and US marketing-launch dates for the two cameras. A 9f model was also available from 1965 to 1968, and was a 9d with no meter. After these, in the late sixties and early seventies, came the 10 and 11 series, another redesign. The 10d, introduced in 1968, and its simplified cousin the 10s, launched shortly afterwards, had conventional match-needle through-the-lens metering. A 10f, without a meter, was also on sale. The 11e (1971) and the **11el** (1973) offered metering by coloured diodes. Any of the 10 and 11 series cameras was available to special order as a half-frame camera, and I have owned a half-frame 10s.

Most Alpa cameras will be found with either a 50mm f/1.8 Kern Switar (usually on the early models), or a 50mm f/1.8 Kern Macro Switar. The 10 and 11 series cameras will usually have the later 50mm f/1.9 Kern Macro-Switar. A tremendous range of additional fine lenses by Angénieux, Schneider and Kilfitt was available, and this was augmented, particularly during the seventies, by a system of lens adaptors that made possible the fitting of top-quality lenses by other manufacturers. Most of these, including those for Leicaflex lenses, Exakta lenses and the first adaptors for Pentax screw and Nikon reflex bayonet, did not permit the use of the automatic diaphragm of the lens when it was fitted to an Alpa, but two adaptors were designed for auto-diaphragm actuation. These were for Pentax/Praktica screw (42mm screw thread) and Nikon bayonet. I have used both, and own one of the Nikon adaptors, which works well with my Nikon lenses, or with modern 'independent' zoom and ultra-wide-angle lenses, a point illustrated with an Alpa 6c in Chapter 13. These adaptors can be found on the secondhand market – you may even still find one new somewhere – and the added versatility makes Alpa an attractive proposition.

Alpa cameras are relatively slow and exacting to use, but are fine precision instruments, quiet in operation and capable of magnificent results. Their major disadvantage is a tendency to shutter tapering (see Chapter 2) which implies a need for a service every so often. Plenty of Alpa equipment is available and prices are fair, since there is relatively little collector interest in the marque. Alpa can be an excellent choice for the classic-camera user who enjoys a somewhat individual camera with its wind lever working in the wrong direction, and is particularly suitable for close-up applications.

The Contarex system

Probably the ultimate example of Zeiss Ikon 35mm camera design was the Contarex, a large, heavy (44 oz with standard lens), beautifully engineered and decidedly complex camera, which, in 1958, was the world's first SLR camera with built-in coupled exposure meter, and which developed into a range of cameras as Zeiss attempted, in the late sixties, to maintain its place in the top-quality camera market. Initially launched in 1960 (UK price £289 2s. 10d.), the first and longest-lived model of the **Contarex** rapidly became known as the **'Cyclops'**, because of the single circular selenium exposure-meter cell set high in the front of the camera above the lens. This meter coupled directly with the shutter and with a unique diaphragm-actuation system, by which the set aperture was shown in a window above the meter cell, on the camera body. A version of the camera without a meter (and therefore without the 'Cyclops' eye) was known as the Contarex Special. There was no diaphragm slip ring or stop indication on any of the lenses (other than the 21mm Biogon, which requires

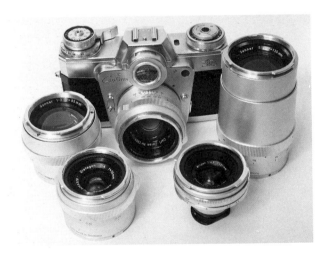

*The original **Contarex** of 1958, known as the **'Cyclops'**, is large and heavy, but is equipped with some of the best lenses available for any classic camera. In this picture, the camera is fitted with a 50mm f/2 Planar, and, around it (left to right) are the 85mm f/2 Sonnar, the 35mm f/4 Distagon, the 21mm f/4.5 Biogon and the 135mm f/4 Sonnar. The Contarex was a notable landmark in camera design, for it was the world's first single-lens reflex with built-in coupled exposure meter.*

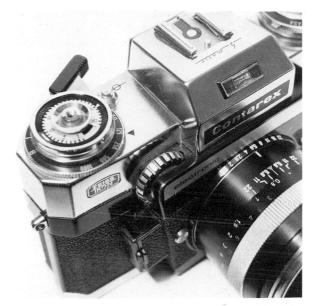

For the Contarex cameras, Zeiss Ikon marketed **interchangeable magazine backs**, which made it possible for the film to be loaded into a removable magazine, rather than into the camera itself. The dark slide, partly withdrawn from the base of the magazine back in this picture, protects the film from light when the back is removed from the camera, and it is therefore possible to carry several backs loaded with different types of film, and to choose the film appropriate to the picture or circumstances. For the magazine back to be fitted, the take-up spool and the thin metal 'shells' within which the cassette normally fits have to be slid out of the body.

A close-up of the right-hand side of the top plate of a **Contarex Electronic**. The shutter-speed dial can be clearly seen – here set to 1/125th second – as can the serrated fingerwheel (to the right of the Zeiss Ikon logo) with which the diaphragm and the meter are set by observation of the meter needle in the viewfinder. The lens on this camera is the 50mm f/2.8 Tessar.

the mirror to be lifted and is not coupled to the meter). A fabric focal-plane shutter provided speeds from 1 second to 1/1000th second, and delay action was standard. A system of optional **interchangeable film magazines** with dark slides permitted the changing of emulsions in mid-film, and the standard 50mm f/2 Planar focused as close as 11.75" without accessories (17.75" with the 55mm f/1.4 Planar). A full range of superlative West German Zeiss lenses was available, initially from 21mm to 500mm, and later from 16mm to 1000mm focal lengths. Early lenses are satin-chrome finished. The later, much-collected, lenses are black.

Late in the sixties, Zeiss Ikon launched a modified and substantially improved Contarex with through-the-lens CdS spot-metering, which was known as the Contarex Super, and followed this up with the **Contarex Electronic** and Super Electronic. This latter camera has many unusual facilities, including remote electrical control, if you can obtain the accessories that make it happen.

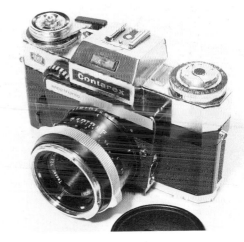

The **Contarex Electronic** of 1967 was the first single-lens reflex to have an electronically controlled focal-plane shutter. Like the Contarex Super, introduced in the same year, it had through-the-lens metering, and, for both, the new black-finished lens range extended from 18mm to 1000mm. In 1969, the Contarex Super Electronic, which was again of similar appearance, became the first single-lens reflex to have aperture-preferred automatic exposure control, although this was only possible with an additional accessory.

Contarex lenses are among the best of all lenses for classic cameras. However, Contarex 'Cyclops' cameras are something of an acquired taste, and many photographers find them clumsy and difficult to use efficiently. If you can get to like the feel of the 'Cyclops', a Contarex outfit is magnificent value, particularly if you can overcome the mind-bending complexity of the interchangeable-backs system, and thereby remove the need for two camera bodies if you wish to shoot both black-and-white and colour. Bear in mind that the 21mm f/4.5 Biogon ultra-wide-angle lens requires the mirror of the camera to be raised before it is inserted, and that no mirror lift is available on Contarex Super, Electronic and Super Electronic cameras. Therefore, the excellent 21mm Biogon, which is often available at quite a low price, can be used only on the Contarex 'Cyclops' or Special. This lens requires a separate 21mm viewfinder, which should usually be sold with the lens. Although a 21mm Zeiss viewfinder occasionally becomes available, it can take many months to locate, and it is best to be cautious of buying a 21mm Biogon that does not have a viewfinder with it.

Leicaflex

Since it did not appear for the first time until 1965, the **Leicaflex**, or 'diesel Leica' as it has been disparagingly termed by some enthusiasts, is only marginally within our classic period. Yet it was the first reflex camera made by Ernst Leitz, and the last great German single-lens reflex marque to be introduced, so is, in its own way, undeniably a milestone. The first Leicaflex, since (but not at the time) termed the Leicaflex I, had a built-in CdS exposure meter with a window in the front of the prism, and a shutter with a (true) 1/2000th-second setting. Usually supplied with a 50mm f/2 Summicron R lens, it was a beautiful, heavy and already outdated camera when it came on the scene to vie with the Japanese competition. A full range of magnificent and very expensive lenses from 21mm to 400mm focal lengths was available. A slightly modified version, incorporating an exposure-meter switch, became known as the Leicaflex II.

In 1968, the Leicaflex SL appeared, a modified Leicaflex with through-the-lens metering, to be followed in 1969 by the Leicaflex SL-MOT, which could accept motor drive, and in 1974 by the Leicaflex SL-2. These had the same lens mount as the original Leicaflex, but needed versions of the lenses with two meter-coupling cams rather than the single cam of the earlier lenses. The advent of the Leica R3 with auto-exposure facilities, during the late seventies, in turn introduced a triple-cam range of lenses. Hence, if you

*The **Leicaflex**, introduced in 1965, was the first single-lens reflex manufactured by Ernst Leitz, and was of uncompromisingly high quality, with a price to match. The shutter provides speeds from 1 second to 1/2000th second, and the camera was normally equipped with a 50mm f/2 Summicron R, or the greatly more expensive 50mm f/1.4 Summilux R. The original Leicaflex is an underrated camera, and is an excellent buy for the classic-camera user if he can afford whatever additional lenses he is likely to require, since, as with all Leica equipment, these can cost significantly more than approximately equivalent lenses of other systems. Picture by Colin Glanfield.*

have a non-TTL Leicaflex, single-cam, twin-cam or triple-cam lenses will fit and couple to the meter. If you have a Leicaflex SL or SL-2, you must use twin-cam or triple-cam lenses if the meter is to give the full-aperture metering it is designed to provide.

Which of these focal-plane systems is it best to buy?

The best value for money among classic focal-plane-shuttered SLR systems is probably Exakta, since the cameras are relatively cheap and fairly reliable, and lenses are comparatively easy to find in a vast range of focal lengths. However, Exakta cameras are not always easy to sell, and should be bought only as a long-term acquisition. The greatest creative and qualitative satisfaction will probably come from Contarex or from Leicaflex, if you can afford them and if the cameras appeal to you. Alpa is a specialized taste. I like it, but I know more people who dislike it than I do photographers who share my taste for this rather individual camera system.

Leaf-shuttered 35mm SLR cameras

The Zeiss Contaflex system

The post-war Zeiss **Contaflex** single-lens reflex is in no way related to the pre-war twin-lens reflex of the same name. The extensive series of 35mm Contaflex SLR cameras began in 1953 with the Contaflex I, fitted with a non-interchangeable 45mm f/2.8 Tessar lens in Synchro Compur, and ended with the Contaflex S of 1971, which was blessed with the late-type recomputed 50mm f/2.8 Tessar of outstanding performance. Since, in this particular range of cameras, lens options are limited, the series of cameras is best set out as a table. Note that here, as earlier, the abbreviation 50/2.8 is used to mean 50mm f/2.8.

A limited range of interchangeable lenses was available for those models able to accept them, but

Type	Year	Lens	Wind	Meter	Auto-exposure
Contaflex I	1953	45/2.8 Tessar (non-interchangeable)	Knob	None	None
Contaflex I (X-M shutter)	1954	45/2.8 Tessar (non-interchangeable)	Knob	None	None
Contaflex II	1954	45/2.8 Tessar (non-interchangeable)	Knob	Selenium (non-TTL)	None
Contaflex III	1956	50/2.8 Tessar (interchangeable)	Knob	None	None
Contaflex IV	1956	50/2.8 Tessar (interchangeable)	Knob	Selenium (non-TTL)	None
Contaflex Alpha	1957	45/2.8 Pantar (interchangeable)	Knob	None	None
Contaflex Beta	1957	45/2.8 Pantar (interchangeable)	Knob	Selenium (non-TTL)	None
Contaflex Super – (First type)	1959	50/2.8 Tessar (interchangeable)	Lever	Selenium (coupled – non-TTL)	None
Contaflex Rapid	1959	50/2.8 Tessar (interchangeable)	Lever	None	None
Contaflex Prima	1959	45/2.8 Pantar (interchangeable)	Lever	Selenium (coupled – non-TTL)	None
Contaflex Super B	1963	50/2.8 Tessar (interchangeable – recomputed)	Lever	Selenium (TTL)	Auto or manual
Contaflex Super – (Second type)	1963	50/2.8 Tessar (interchangeable – recomputed)	Lever	Selenium (coupled – non-TTL)	None
Contaflex Super BC	1965	50/2.8 Tessar (interchangeable – recomputed)	Lever	CdS (TTL)	Auto or manual
Contaflex S	1971	50/2.8 Tessar (interchangeable – recomputed)	Lever	CdS (TTL)	Auto or manual (improved)

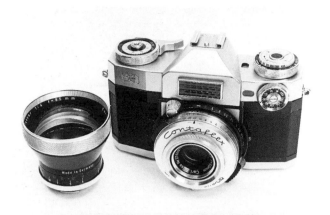

*The single-lens **Contaflex**, as will be seen from the table on page 119, went through many changes of specification and design. This is a 'first-type' Contaflex Super of 1959, with interchangeable 50mm f/2.8 Tessar and, beside it, an 85mm f/4 Pro-Tessar long-focus lens. The fingerwheel (top right), operated by the left forefinger, both sets the lens diaphragm and moves the meter needle in the viewfinder.*

*The top view of a **Contaflex Super B** – the actual camera used for several pictures in this book. The repeater needle for the exposure meter is visible in the window to the left of the pentaprism housing. The shutter release is in the centre of the exposure counter at the extreme bottom right.*

in all cases only the front components of the lens were interchanged, those elements behind the shutter being common to all focal lengths. Cameras with interchangeable 45mm f/2.8 Pantar lenses could be fitted with either a 30mm f/4 Pantar wide-angle, or a 75mm f/4 Pantar long-focus lens unit. These Pantar lenses also fitted the Contina III rangefinder camera with interchangeable Pantar lens. Contaflex cameras with 50mm f/2.8 interchangeable Tessars were provided with Pro-Tessar lens units, initially of 35mm f/4, 85mm f/4 and 115mm f/4 specifications, although later versions of the 35mm and 85mm lenses were marketed with a wider f/3.2 maximum aperture. There was also an M 1:1 close-up lens for same-size reproduction on the negative or transparency.

Most books on Contaflex equipment state or imply that all Pro-Tessars fit all Tessar-equipped Contaflex cameras. Care is needed, however, for the M 1:1 Tessar for a camera with recomputed standard Tessar does not fit an earlier Tessar-equipped Contaflex, and there may be other examples of non-compatibility that I have yet to discover. Certainly, the front 50mm elements of late recomputed Tessars and those of the earlier 50mm Tessars are not interchangeable. Zeiss made available for the 'Super' series of Contaflex models interchangeable magazine backs similar in principle to those made for the Contarex system, and supplied a full range of 'Proxar' close-up lenses, filters and hoods.

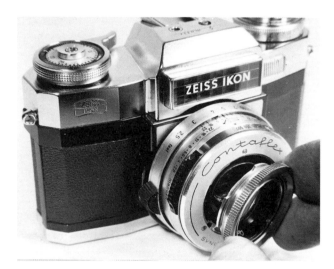

*The front element of the lens of a single-lens Contaflex is removed by pressing in the tab at six o'clock on the lens mount and simultaneously twisting the front element in an anticlockwise direction. The camera in this picture is a **Contaflex Super B**. The 'second-type' Contaflex Super is superficially identical, but lacks the settings for 'auto' and 'manuell' on the aperture-setting ring and, of course, the mechanism for automatic exposure setting.*

The late recomputed Tessar provides distinctly and observably superior results to those from the earlier Contaflex Tessar, although this should not be under-rated. The auto-exposure diaphragm-control mechanism of the **Contaflex Super B** and Super BC is often found to be sluggish in cameras that have not been recently serviced, resulting in incomplete stopping down and incorrect exposure. This can be corrected, but the work to do the job is both extensive and expensive – at least £50 sterling in Britain in 1984. Watch for problems with the slow speeds on Conta-flex shutters, and always check the accuracy of an exposure meter against a known meter. A really sound Contaflex is a joy to own. A Contaflex in poor condition can be very frustrating indeed.

Perhaps the major consideration in deciding whether or not to invest in Contaflex SLR equipment is the limitation imposed by the small available range of lenses. If you have real reason to believe that you will need for your photography lenses of wider angle than 35mm (or 30mm with the Pantar-equipped models), or of greater telephoto effect than 115mm, then Contaflex equipment is not for you. The Contaflex is ideal for a photographer who takes most of his best pictures with a standard lens, and uses a wide-angle or a moderate long-focus lens only once in a while.

The Retina Reflex system

The single-lens Contaflex with between-lens shutter spawned several competitive systems, most of which opted for the greater potential for lens interchange-ability afforded by placing the shutter behind the rear element of the lens, rather than between the elements. The Kodak Retina Reflex series began in the same mould as the Contaflex, and was then rede-signed as a behind-lens-shuttered system.

The first Retina Reflex, launched in 1957 (Kodak Stuttgart Type No. 025), was equipped with the Kodak 'C' series interchangeable-front-element lenses al-ready well proven in the Retina 'C' series folding cameras (see below, Chapter 11). The standard lens was either the 50mm f/2 Schneider Retina-Xenon C or the 50mm f/2 Rodenstock Retina-Heligon C, and each was provided with its own limited series of inter-changeable front elements. Thus, the user of a Retina Reflex camera with a Xenon lens had available a 35mm f/4 Curtar-Xenon C, a very compact 35mm f/5.6 Curtar-Xenon, and an 80mm f/4 Longar-Xenon. If his camera was fitted with a 50mm f/2 Heligon, he could obtain an identical series of Rodenstock Heligon accessory lenses. It is important to know when buying that it is impossible to fit Heligon accessory lenses to a Xenon-equipped camera, or vice versa. This first

A **Retina Reflex S**, fitted with the scarce and desirable 50mm f/1.9 Xenon standard lens, is flanked by (on the left) a 135mm f/4 Schneider Tele-Xenar and (on the right) a 35mm f/2.8 Schneider Retina-Curtagon. This camera has the plastic incident-light diffuser fitted over its meter window. This small accessory is frequently lost, but repays being cared for, since it makes the exposure meter very much more versatile.

Retina Reflex had a built-in uncoupled selenium exposure meter.

By 1959, Kodak had rethought both its Retina rangefinder cameras and the Retina Reflex series, and launched a redesigned Retina Reflex at approximately the same time as the rangefinder Retina IIIS. This was the **Retina Reflex S** (Kodak Stuttgart Type 034), which differed from the original Retina Reflex in having its shutter behind the whole lens, and in thereby having totally interchangeable four-element 50mm Schnei-der Xenar or Rodenstock Ysarex f/2.8 lenses, or six-element 50mm Schneider Xenon or Rodenstock Heligon f/1.9 lenses. The match-needle selenium exposure meter was now coupled to the lens dia-phragm, and the range of available interchangeable lenses was expanded to two wide-angle options (28mm and 35mm) and three telephoto options (85mm, 135mm and 200mm) with complete inter-changeability – i.e., any Retina Reflex S-type lens now fitted any Retina Reflex S, regardless of the manu-facture of its standard lens.

In 1961, Kodak launched the Retina Reflex III (Kodak Stuttgart Type 041), with identical lens options to the Reflex S, but with an exposure-meter needle visible in the viewfinder, which now had a split-image rangefinder in the centre of the screen. The shutter release was moved from the top-plate to the front of the camera – a thoroughly retrograde step – and various minor changes were made. Finally, in 1964,

came the Retina Reflex IV (Kodak Stuttgart Type 051), supplied only with Schneider lenses, and with a new close-focusing facility to two feet. The Reflex IV had a small prismatic window on the front of the pentaprism housing to reflect an image of the shutter and diaphragm settings into the viewfinder, and a red warning signal for inadequate light conditions, plus other minor changes to specification by comparison with the Reflex III.

When Retina Reflex cameras are working well, they are very pleasant to use, and capable of excellent results, although, in my experience, the Contaflex recomputed Tessar standard lens is noticeably superior to anything fitted to a Retina Reflex. The range of lenses is of moderate contrast and performs well, although not, in my opinion, as well as the entirely comparable Voigtländer lenses of the Bessamatic and Ultramatic (see below). Retina Reflex equipment is relatively inexpensive, since the cameras and lenses are quite easy to obtain and collector interest in them is minimal, and provides a means of acquiring a substantial and versatile outfit of classic SLR equipment at modest cost. The catch is that, when repairs become necessary (a fairly likely eventuality if a Retina Reflex is worked hard), spares are either difficult for your repairer to obtain or are simply unobtainable (which, in fairness, applies equally to several other camera systems mentioned in this book), and the cost of disassembling and repairing a Retina Reflex can be high – in fact, some repairers simply refuse to handle them. However, there are repairers who are very happy to work on a Retina Reflex at a reasonable price, and it pays to shop around and find an enthusiast for the marque.

The Voigtländer SLR cameras – the Bessamatic and the Ultramatic

In 1959, Voigtländer entered the burgeoning market for leaf-shuttered 35mm single-lens reflex cameras with a handsome, solid and beautifully engineered reflex named the **Bessamatic**. Like the later models of the Retina Reflex series, the Bessamatic had a behind-lens rather than a between-lens X-M Synchro Compur shutter, and a built-in selenium exposure meter coupled, by means of the large-diameter knob below the rewind knob, to the aperture ring. From the start, the Bessamatic had a neat match-needle exposure-setting device visible in the reflex viewfinder (a facility that was ahead of its time), an unusually wide range of film-speed settings for the meter (12 ASA to 3200 ASA) and a split-image rangefinder in the reflex screen. To me, and to most other photographers of my acquaintance, the Bessamatic is the classic leaf-shuttered

*This is the **Bessamatic** used to shoot a number of the photographs that appear in this book. Fitted here with its standard lens, a 50mm f/2.8 Color-Skopar X, the Bessamatic is neat, compact and easy to handle. The Voigtländer ultraviolet filter is to one side.*

single-lens reflex that handles best and which has an immediately usable feel about it.

The Bessamatic was offered with a choice of either a high-quality 50mm f/2.8 Color-Skopar, in my experience capable of better performance than the Retina Reflex lenses, but not quite up to the standard of the late recomputed 50mm Zeiss Tessar, and a remarkably good 50mm f/2 Septon which, unfortunately, is scarce and difficult to obtain due to collectors' interest. A version of the Bessamatic without a built-in meter, the Bessamatic M, as well as being available with these two lenses, could also be supplied with a 50mm f/2.8 Color Lanthar, a lower-priced lens.

In 1962, the Bessamatic was improved by the addition of a reflective system to make the set aperture and shutter speed visible in the reflex viewfinder. Known as the Bessamatic II or Bessamatic de Luxe (although not marked as such), this model is somewhat scarce.

To fit the Bessamatic cameras, a range of first-class and well-engineered lenses was available in focal lengths from 35mm to 350mm, to which was added the world's first production multi-focus lens for a 35mm still camera, the Voigtländer 36-82mm f/2.8 Zoomar.

In 1963, an entirely redesigned camera with a choice of automatic or manual exposure control was introduced as the Ultramatic. This had a selenium exposure meter coupled to the iris, in the manner of the Contaflex Super B, and accepted the same range of lenses as the Bessamatic, although only lenses with a yellow dot on the rear face of the lens mount coupled to the exposure-measurement system of the Ultra-

matic. This was followed in 1965 by the Ultramatic CS, which was provided with an auto-exposure system controlled by a CdS exposure meter measuring exposure through the lens. Both Ultramatic models, unlike the Bessamatics, have a deserved reputation for being somewhat unreliable, and for being very difficult to repair, and should be bought for regular use only if one is prepared for possible problems.

British prices for the available models in 1966 were as follows:

Lens	Bessamatic II	Bessamatic M	Ultramatic CS
50/2.8 Color Lanthar		£ 80 15s. 11d.	
50/2.8 Color Skopar	£122 12s. 11d.	£ 88 18s. 8d.	£154 0s. 8d.
50/2 Septon	£155 3s. 11d.	£121 9s. 8d.	£186 11s. 8d.

The lens range available in 1966 in Britain, together with its prices, was as follows:

Lens	Price
35mm f/3.4 Skoparex wide-angle	£ 50 11s. 5d.
40mm f/2 Skopagon (9-element) semi-wide-angle	£ 97 13s. 0d.
90mm f/3.4 Dynarex medium-long-focus	£ 61 0s. 8d.
135mm f/4 Super Dynarex long-focus	£ 55 10s. 3d.
200mm f/4 Super Dynarex telephoto	£115 13s. 5d.
350mm f/5.6 Super Dynarex telephoto	£169 14s. 6d.
36-82mm Zoomar multi-focus	£165 13s. 2d.

The Bessamatic is, to my mind, one of the most suitable classic cameras for an enthusiast who is already accustomed to modern single-lens reflex cameras, and who wants the peculiar pleasures of classic-camera photography without too great a change of technique. The Bessamatic, almost alone among classic SLR cameras, handles and feels much like a modern reflex camera, yet conveys, like others of its period, a stimulating sense of fine engineering that is missing from almost any camera other than Leica made in the eighties. The lenses, while not easy to obtain, are to be found with a degree of perseverance, and well repay the effort.

Other leaf-shuttered SLR cameras

There were, in addition to the principal families of leaf-shuttered single-lens reflexes listed above, a considerable number of other cameras of broadly

The large milled ring around the rewind knob, when turned, moves both the aperture-setting ring on the lens assembly and the exposure-meter index in the viewfinder. Centre the meter index over the meter needle, and correct exposure is set. In the picture, the Bessamatic is fitted with a 135mm f/4 Super Dynarex.

Unlike the Contaflex, Contarex and Retina Reflex series of cameras, a Bessamatic has no built-in accessory shoe. Voigtländer therefore marketed this shoe, which clips neatly over the rim of the viewfinder eyepiece and sits on top of the pentaprism.

*The Agfa **Ambiflex**, introduced in 1959 and used for several of the pictures in this book, sported an interchangeable finder system. It is seen here with the waist-level viewfinder fitted. The prism is in front, at the bottom of the picture. The camera is fitted with a 50mm f/2.8 Color-Solinar, and the lens to the left of the picture is the 90mm f/3.4 Color-Telinear. That to the right is the 135mm f/4 Color-Telinear.*

the same type. Space does not allow detailed coverage of all these, but there are several which bear consideration as classic cameras for latter-day use.

The Agfa **Ambiflex** was a behind-lens-shuttered SLR with a coupled selenium meter and a Prontor Reflex X-M shutter, which was available with either a 50mm f/2 Solagon or 50mm f/2.8 Solinar standard lens interchangeable with a range of other high-quality lenses. Unusually among leaf-shuttered SLRs, the Ambiflex had a true focusing screen, providing focusing across the whole image, instead of the usual 'brilliant' finder in which only a central ring actually provided focusing. The Ambiflex II also sported an interchangeable finder system, and either waist-level or pentaprism finders could be fitted. An Ambiflex is a very usable camera, but one that should be bought only with great care, since, like most others of the type and period, it is expensive to repair. The Agfaflex series of cameras were simplified versions of the Ambiflex, the Selecta-flex was a simpler camera of the same group with an automatic exposure system, and the Colorflex I and II were again simple versions of the same design.

The Paxette Reflex series of cameras are relatively scarce, since they appeared late in the series of Braun cameras and were made only for a limited time. The Paxette Reflex of 1959 had a fixed Enna Reflex Ultralit 50mm f/2.8 auto-lens. The later Paxette Reflex Automatic of 1963 featured a version of the same lens with front-element interchangeability in the manner of the Contaflex. These lenses were of sound but not outstanding quality, and the Paxette Reflexes have a, perhaps undeserved, reputation for mechanical unreliability. They are not a particularly wise choice for the modern classic-camera enthusiast, since the range of lenses to fit the camera is very difficult to obtain.

So which leaf-shuttered SLR is the best buy?

Assuming that, in any given case, you can locate an example in good order (see Chapter 2), the safest and potentially most versatile and useful purchase among 35mm leaf-shuttered single-lens reflexes is either a Contaflex Super (ideally the late type with recomputed Tessar lens) or a Bessamatic. Either is of good potential reliability. Lenses are easier to obtain for the Contaflex than for the Bessamatic, but the range of Bessamatic lenses that you should eventually be able to locate with perseverance is wider.

Although there are, in fact, plenty of Contaflex Super B, Super BC and S cameras with automatic exposure systems that work well, there are probably just as many that do not, and distinguishing the good from the bad is not always easy at first sight. The same applies to the Voigtländer Ultramatic models. I would therefore suggest that you buy these models as additional cameras, if you can afford such a luxury, to an outfit based on the simpler model with the same lens mount.

This conversation piece, photographed in Whitby, Yorkshire, in 1984, was a snapshot in the most literal sense, captured within a moment of spotting the picture, before anybody moved. The camera was a Contaflex Super B with 50mm f/2.8 Tessar, which I find to be an effective piece of equipment for snatched pictures.

This lady was intent upon her painting in the gardens of Wilton House, near Salisbury, Wiltshire. The camera was a Contarex Super Electronic fitted with a 135mm f/4 Sonnar, which delivers a beautifully crisp and yet rounded image.

The object of the painter's absorption was the Palladian Bridge at Wilton House, photographed here with the 35mm f/4 Distagon on the same Contarex Super Electronic as the above picture.

Another of those pictures which just happened, while walking in this case in Brighton, Sussex, with a Bessamatic around my neck. The camera had an orange filter fitted, which was beneficial to the textural rendering of the wall, tending to lighten the yellowish sunlit areas, and darken the shadows. Shot with a Bessamatic I with 50mm f/2.8 Color-Skopar.

The 50mm f/2.8 Color-Skopar of the Bessamatic is capable of rendering fine detail extremely well, as this picture, also taken in Brighton, reveals. Shot with a Bessamatic I with 50mm f/2.8 Color-Skopar.

A walk in the vicinity of Lincoln Cathedral with an Alpa 6c was rewarded with this pleasing composition. I was looking at the possible shot through the camera when the couple brushed past me, walked through the arch and completed the picture. Shot with 50mm f/1.8 Macro-Switar.

Another Alpa picture, also obtained in Lincoln, which is a very satisfactory location for pictorial photography. The 50mm f/1.8 Macro-Switar lends a certain 'old-fashioned' quality to the image, which is sharp without being hard.

This shot of Stephanie James was produced with an Agfa Ambiflex fitted with a 90mm f/3.4 Color-Telinear, set almost wide open at f/5.6. The lack of depth of field helps to focus attention on the smiling eyes.

Children absorbed in music-making are wonderful subjects. These two percussionists of the band of St Nicholas School, Uckfield, Sussex, are a study in total concentration. The camera was an Agfa Ambiflex, fitted with a 135mm f/3.4 Color-Telinear.

So far, we have made little reference to rollfilm classic cameras, and have concentrated on the great 35mm classic systems. This is not unreasonable, since most of the classic cameras that are generally available, and which are suitable for use in the eighties, are of the 35mm format. One of the great exceptions to this rule is the twin-lens reflex, and, of all twin-lens reflex cameras, the Rolleiflex and the Rolleicord stand supreme. It was the Rolleiflex and the Rolleicord that made fixed-lens twin-lens reflexes standard professional photographic workhorses for some four decades, and earned the twin-lens reflex the reputation as a serious amateur's camera that it still enjoys.

A little history

The original Rolleiflex, the only 6cm x 6cm Rolleiflex to have knob-wind, rather than leverwind, appeared in December 1928 with an f/4.5 Tessar lens and a Compur shutter. In 1933, the original model of a long line of lower-priced knob-wind Rolleicords (the metal-plated Rolleicord) was launched, fitted with the three-element Zeiss Triotar in a rim-set Compur shutter. As in virtually every other camera of its day, the shutter of the Rolleicord had to be cocked as a separate operation after the film was wound, and this endearing feature continued right to the end of the Rolleicord line. By 1936, the Rolleicord was being offered in two versions – metal-plated with f/4.5 Triotar 'for rollfilms only', and leather-covered with f/3.8 Triotar 'to take the plateback and many Rolleiflex accessories', and the first leverwind Rolleiflex – the 'Standard Leverwind' model, with f/3.8 Tessar had appeared.

In 1937, the **Rolleiflex Automat** was introduced, with a revolutionary development in camera loading. The paper leader of the film was loaded under a feeler roller, and there was, for the first time, no need to stare through little red windows at numbers on the backing paper in order to wind the film to the first exposure. The Automat also introduced the well-known and much-copied Rollei bayonet internal and external filter and hood mounts, although initially only on the taking lens (collectors refer to this first design as a 'single-bayonet Automat'). In 1938, the single-bayonet Automat was priced at £31 5s. in Britain. The 'double-bayonet' camera followed in 1939, and the Rolleiflex Automat, with its superb f/3.5 Tessar and Compur Rapid shutter, became as dominant a medium-format camera among commercial photographers as the Hasselblad is today.

Meanwhile, the Rolleicord had also been deprived of its little red window and had been endowed with the semi-automatic loading system, to become the Rolleicord II, which, with f/3.5 Triotar, cost £16 10s. in

Chapter 8

Not every twin-lens reflex is a Rolleiflex

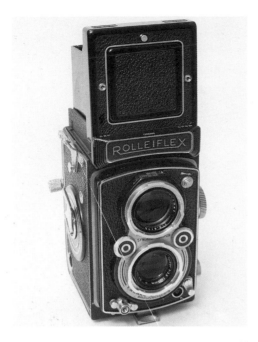

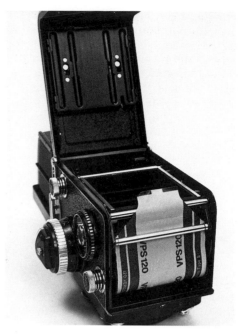

Rolleiflex Automats, either the 1951 model illustrated here, or the 1955 light-value model, are sound buys for the classic-camera user, because they feature both a factory-coated 75mm f/3.5 Tessar and the Synchro Compur shutter, rather than the Compur Rapid. They are likely to be reliable, if in good condition. This is the actual camera used for the picture of the domed roof at the Liverpool Garden Festival (page 141).

The extremely convenient loading system of the *Rolleiflex Automat,* introduced first in 1937, has been fitted to every twin-lens Rolleiflex except the Rolleiflex T. The film leader is fed under the sensor roller, as shown here, and attached to the take-up spool. The back is then closed. As the crank is wound, the roller senses the extra thickness of the start of the film, and trips the counter mechanism.

Britain in 1938. To load the Rolleicord, you simply thread the film, line up the arrow on the backing paper with a red dot inside the back of the camera alongside the film aperture, then close the camera and wind until a stop is reached. The film is then ready for the first exposure. All Rolleicords from the IA through to the VB feature this system, and it was so successful that most other TLR manufacturers used it in their post-war designs.

Other pre-war twin-lens reflexes

Franke and Heidecke, manufacturer of the Rollei cameras, had not had the TLR market to itself in the thirties, dominant as the firm was. Zeiss Ikon had developed a range of Ikoflex cameras which, typically of Zeiss, were innovative, complex, not easily understood and unreliable in middle age. Voigtländer launched as early as 1933 its **Voigtländer Superb**, a twin-lens reflex that incorporated several original ideas. Foremost among these was the first, and possibly the most sophisticated, TLR parallax-correction mechanism ever devised. The whole viewing lens

assembly was progressively tipped further down out of parallel with the taking lens as the focus was set closer. The Superb also had the shutter speeds on its rim-set Compur engraved back-to-front (mirror fashion) so that a neat prism device could present them to the photographer as he looked down at his focusing screen.

Other pre-war twin-lens reflexes included the Foth-Flex and the Reflecta, neither of which is likely to be particularly sound for use today, and Voigtländer's simpler series of focusing Brilliant cameras, upon which the modern Russian Lubitel is modelled. The Dresden-manufactured Zecaflex offered a novel design, in which the camera part of the twin-lens reflex folded, and one could also buy the tiny 127-size Pilot Reflex, in which the whole lens panel collapsed on lazy tongs into the body.

After the war

The coming of peace brought the first of the f/2.8 line of 6cm x 6cm Rolleiflexes, fitted with a disastrous f/2.8 Tessar, which was quickly withdrawn and replaced

with a similar camera fitted with an East German f/2.8 Biometar. Later models (commencing with the 2.8C) had the much superior 80mm f/2.8 Zeiss Planar or Schneider Xenotar lenses. Rolleis were now supplied with coated lenses, initially with flash-synchronized Compur Rapid shutters, then, after 1951, with the new Synchro Compur with electronic flash synchronization. In 1954, this was replaced by the VXM Synchro Compur with switchable electronic and bulb synchronization and delay action. In 1955, the 'light-value' Rolleiflex Automat appeared, introducing the dubious benefits of cross-coupled aperture and shutter scales linked to a light-value index.

In the late fifties and early sixties, the 3.5E, 2.8E and Rolleiflex T models ushered in the optional integral meter, at first in uncoupled form, providing a light-value reading for transfer to the light-value scale of the coupled shutter and aperture mechanisms, then, in the F series cameras, coupled directly to the shutter and aperture to provide direct exposure setting. The Rolleicord VA introduced a range of accessories to

*This close-up shows the reverse-engraved shutter speeds of the **Voigtländer Superb**, and the prism which enables the photographer to read them the right way round from above. The lever at eleven o'clock to the shutter assembly is the shutter release; that at two o'clock is the cocking lever.*

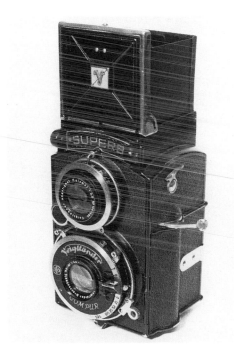

*The **Voigtländer Superb** was one of the more remarkable pre-war twin-lens reflexes and, fitted with either the five-element Heliar lens or the four-element Skopar, remains capable of delivering high-quality results. The lever positioned slightly away from the side of the body is the film-advance lever, and the focusing knob is the milled circular projection at four o'clock to the shutter assembly around the lower lens. Apertures are set with the knob on the front panel, between the two lenses.*

provide quickly interchangeable picture format, making possible sixteen or twenty-four exposures on 120 film by changing the film counter and inserting a mask in the film aperture. Care is needed in buying these particular accessories, since, with the Rolleicord VB came the introduction of an interchangeable focusing hood – also a feature of the Rolleiflex T and of E and F models – which necessitated a version of the 16-on and 24-on adaptor kits with a different focusing-screen mask. These kits for the VB can be recognized by a reference to the VB, both on the box and on the pouch in which the kit is kept, and by small cut-out notches in the sides of the focusing-screen mask, which allow space for the hood catches. By the mid-sixties, the final Rollei twin-lens reflex models – the 2.8F, the 3.5F, the Rolleiflex T and the Rolleicord VB – were established, not to be discontinued until the mid-seventies.

Other post-war contenders

Rollei, although still pre-eminent, was not alone in the TLR marketplace. In Britain, the **MPP Microcord** had

*Britain's best-known contribution to the world of the twin-lens reflex is the **MPP Microcord**, manufactured in the fifties by Micro Precision Products, then of Kingston, Surrey. Its coated f/3.5 Ross Xpres lens, of the unusual focal length of 77.5mm, is a very high-quality objective, fully the equal of a Tessar. A slightly more expensive model named the Microflex was also marketed by MPP, fitted with a Taylor Taylor-Hobson Micronar lens.*

*Zeiss Ikon produced a whole range of **Ikoflex** twin-lens reflex cameras, both before and after the Second World War. This is a comparatively scarce model, the Ikoflex Ic of 1955, fitted with a coated 75mm f/3.5 Novar in a Prontor SVS shutter, and equipped with a selenium exposure meter. Although experience suggests that Ikoflex cameras cannot be said to be as reliable as Rolleiflex equipment, they are sound and well engineered. Picture by Tim Hawkins.*

appeared early in the fifties with an excellent f/3.5 Ross Xpres lens, first in an Epsilon shutter and later in the much more reliable Prontor SVS. A later development was the Microflex, with Rolleiflex-like features and the Taylor-Hobson Micronar lens. In France, SEM produced a range of Semflex cameras, for one of which there was even an adaptor to use 828 Kodak Bantam film. Notable to collectors was the Semflex Studio, which had 135mm lenses and emulated the Tele-Rolleiflex. In West Germany, the new Zeiss Ikon in Stuttgart produced a post-war series of **Ikoflexes**, and from Munich there came the Rollop, with high-quality Enna lenses.

In Japan, the Yashicamat had appeared, equipped with a Tessar-like Yashinon lens of outstanding mid-aperture (i.e., f/8 or thereabouts) performance – I used two Yashicamats for photographing weddings and children in the sixties. The Yashicamat, fore-runner of the still-current (1984) Yashica 124G, had Rolleicord-type loading, but single-action combined crank transport and shutter cocking, so was fast and effective. A version known as the Yashicamat LM had a built-in meter. Yashica also marketed the **Yashica 635**, with a 35mm adaptor kit like Rollei's Rolleikin supplied with the camera, but with the lesser Yashikor three-element lens, knob-wind and separate shutter cocking.

Another arrival from Japan was the Minolta Auto-cord, in some ways sounder mechanically than the early Yashica TLRs, and with excellent Rokkor lenses. Versions with and without meters were produced. Other Japanese manufacturers, notably Mamiya and Ricoh, also produced fixed-lens twin-lens reflexes, but Japan's greatest innovation was, and is, the Mamiya C series interchangeable-lens TLRs, of which more anon.

The Rolleiflex 2.8F and 3.5F

A **Rolleiflex** 2.8F or **3.5F** is a magnificent instrument. A 3.5F weighs in at almost 46 oz. in its case, and operates with a silky smoothness that few others can emulate.

*The **Yashica 635** was one of several Yashica twin-lens reflex cameras available in the sixties, of which the Yashicamat was the most expensive and best equipped. The 635 was sold complete with a 35mm adaptor outfit, rather like the Rollei 'Rolleikin' accessory, to enable the user to convert the camera at will to use 35mm film. Although the 635 and the Yashica D were fitted with the three-element Yashikor lens, rather than the four-element Yashinon, they perform well, and should not be underrated.*

*The last of the Rolleiflex models with f/3.5 lens was the **Rolleiflex 3.5F**, equipped either with a 75mm f/3.5 Zeiss Planar, or a Schneider Xenotar of similar specification. This particular camera has the Xenotar, plus the built-in coupled selenium exposure meter that greatly increases the effective speed of the camera in use.*

Sadly, the sheer quality of its engineering priced the Rolleiflex out of its market, since, in 1978, when the Rolleiflex 2.8F was last available new, it was priced at over £630 in Britain.

When you hold a Rolleiflex 3.5F or 2.8F, open its focusing hood, remove the hinged lens cap and focus with the large knob on the left-hand side of the camera, the substantial lens panel moves forward to provide a minimum focusing distance of rather less than three feet, indicated on a scale around the knob. Two pointers under the transparent exposure-meter cover within the focusing knob provide the coupled exposure measurement. The slim pointer is the meter needle, moving in response to the light level measured by the selenium cell behind the front scutcheon bearing the camera name. The thicker pointer with the ring is the index, coupled to both the aperture and the shutter settings. Two finger wheels, either side of the centre of the lens panel, rotate to adjust shutter speeds and apertures, which are reported in the window at the top of the lens housing. When the meter index, which moves as shutter and aperture are adjusted, is over the needle, you have a correct exposure setting – provided, that is, that you have set the ASA speed of the film on the ASA dial, low on the left-hand side of the camera. It is a positive, effective and reliable system to use.

The Rolleiflex T

The Rolleiflex T cameras, initially produced as a grey-covered model, which could not accept the Rolleikin 35mm adaptor, and subsequently as a black model, which could, have a 75mm f/3.5 four-element Tessar instead of the five-element Planar or Xenotar of the F. Although the shutter of a T is a Synchro Compur, the synchronization in cameras made after 1970 was X (electronic flash) only, and the shutter has cross-coupled aperture and shutter-speed settings. Instead of wheels to set the aperture and shutter speeds, the T has setting knobs protruding from the circumference of the shutter housing. Perhaps most important, the T

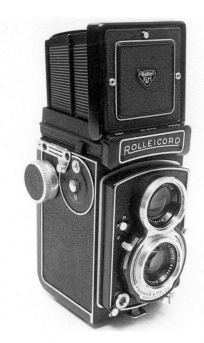

*The last of the Rolleicord models was the **Rolleicord VB**, introduced in 1966, and differing from the Rolleicord VA only in having a removable focusing hood, which makes it possible to fit a Rollei prism and to use the accessory slide projector made by Rollei, which utilizes the upper lens and focusing mirror of the camera as the projector lens. This is a typical VB.*

does not have the Automat film-loading system – when loading the film, one must line up the arrows on the backing paper with the red dots on the side of the camera before closing the back, just as one would with a Rolleicord.

The Rolleicord VB

The **Rolleicord VB** differs from the Rolleiflex T in having a 75mm f/3.5 Schneider Xenar instead of the Tessar, in having knob-wind instead of leverwind, and in having the focusing knob on the right of the camera instead of the left – an apparently minor point that can be of great significance to some users. The shutter cocking is separate from the film transport, and the shutter is fired with the same lever that cocks it – this protrudes downwards below the shutter housing, is pulled to the right to cock the shutter, and is pushed to the left to fire it.

It is worth noting that the earlier Rolleicord V was, in effect, a VB without removable hood or exchangeable film-counter assembly (for different formats),

and a VA was a V with the interchangeable film counter, but without the interchangeable hood. In other respects, all three models are identical. Pre-1970 VB cameras have a VXM Synchro Compur. Post-1970 cameras have the Synchro Compur X without bulb-flash synchronization.

The Tele-Rolleiflex

This model appeared in 1959 and was made in comparatively limited numbers for photographers needing a TLR with a lens of longer than normal focal length. Essentially, a Tele-Rolleiflex is a camera of E or F specification, with or without optional meter, and fitted with a 135mm f/4 Sonnar instead of the 75mm or 80mm lens. It performs very well indeed, taking size 3 filters and its own special book-form close-up lens sets of 0.35 and 0.7 dioptre, necessary if you need to focus more closely than the normal minimum distance of 8.5 feet. The 0.35 Rolleinar produces focusing from 9' 2''

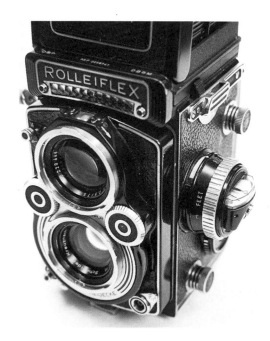

The meter needle of a Rolleiflex 3.5F or 2.8F can be seen here beneath the transparent cover within the focusing knob on the side of the camera. The thicker arm with the ring on the end is the meter index, which is moved by changing either the shutter speed or the set aperture, displayed in the window above the viewing (top) lens. The thinner arm is the actual meter needle, over which the index must be positioned.

to 4' 5", and the 0.7 Rolleinar focusing from 4' 6½" to 3' 6". Closer focusing distances are achieved by fitting size 4 Rolleinars (if you can get them) to the bayonet on the book-form Rolleinar. The Tele-Rolleiflex is a magnificent camera for studio portraiture, although interest among collectors has made it expensive – 1994 prices in Britain and the USA are of the order of £700 ($1000).

The Wide-angle Rolleiflex

This special wide-angle model with a unique 55mm Zeiss Distagon lens was produced to meet professional demand at the end of the fifties. The camera is of specification similar to a 3.5E, with an exposure-value Synchro Compur featuring cross-coupled aperture and shutter-speed scales, and no eye-level mirror-focusing device in the hood. Filter and close-up accessory size is Rollei bayonet 4. Relatively few of these cameras were made, and prices of the Wide-

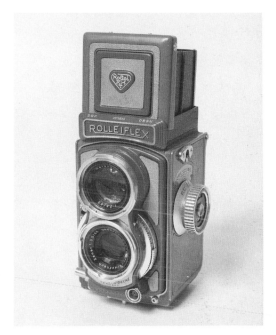

*The beautiful little grey **Rollei 4x4** takes twelve exposures on 127 film, and produces first-class results. Its principal limitation is the restricted availability of 127 film.*

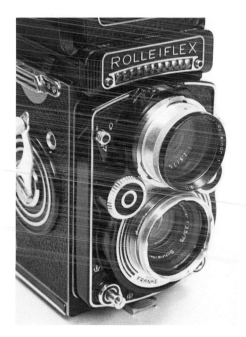

Close-up photography with a twin-lens Rollei is accomplished with Rolleinar close-up sets. Each set consists of a thick upper lens, which is also a prism to compensate for parallax error, and a matched thinner lower lens. Sets were generally available in powers of 1, 2 and 3 dioptres, and for special purposes in 4-dioptre form, and in Rollei sizes 1, 2, 3 and 4. This is a Rolleinar 1, 2, which indicates the power of 1 dioptre, in size 2. Size 1 fits all Rolleis with f/3.5 Tessar or Xenar lenses. Size 2 is right for all Rolleis with f/3.5 Planar or Xenotar lenses. Size 3 is for all Rolleis with f/2.8 lenses except the pre-war Rollei Sport. Size 4 fits the Wide-angle Rollei.

angle Rollei can be very high indeed, although they vary tremendously – I have recently heard of prices as low as £800 in Great Britain and as high as $2,500 in the United States.

The Rolleiflex 4x4

The grey **Rolleiflex 4x4** introduced in 1957 was, after a break since 1939, the last of a series of 'Baby' Rolleiflexes taking twelve exposures nominally 4cm x 4cm on 127 VP film, the first of which had appeared, soon after the birth of the Rolleiflex, in 1931. The 4x4 has knob-wind like a Rolleicord, although winding on also cocks the shutter, as with a Rolleiflex. The lens is a 60mm f/3.5 Xenar of very high quality in a VXM Synchro Compur shutter. It is worth noting that the 4x4 has limited clearance between the taking and viewing lenses, and for this reason, although its filter mount is standard Rollei No. 1 bayonet, it needs special filters and the grey hood marked '4x4'. Note also that the shutter will not operate unless the viewing hood is raised. Many a 4x4 has been rejected

over the secondhand counter because the shutter seemed not to fire!

The Rolleimagic

This interesting but commercially disastrous camera appeared in two successive versions in the sixties, when interest in cameras with automatic exposure was growing fast. Essentially a Rolleicord with a large selenium meter providing automatic aperture setting and thereby auto-exposure, the Rolleimagic I was automatic without the option of manual exposure setting, and the Rolleimagic II provided that option, but was otherwise similar. The Rolleimagic appealed to few and sold even fewer, with the consequence that it is now a scarce collectible camera.

Rollei TLR accessories

It would be impracticable to include here a full catalogue of the vast range and variety of Rollei twin-lens reflex accessories, but the following table sets out the major items and groups of items that were available, and provides a guide to their compatibility with major post-war models.

It must be emphasized that the table is not intended to be in any sense a complete list of accessories – so please do not write telling me that I have left out the panorama head!

Included under 'Filters' are colour-correction, polarizing and soft-focus filters, and there have, for example, been several types of Rolleikin and at least two types of Rolleimeter.

Accessory	2.8 Rolleis	3.5 Planar Xenotar	3.5 Tessar Xenar	Tele	W/A	4x4
Size 1 hoods, Rolleinars and filters	No	No	Yes	No	No	Some
Size 2 hoods, Rolleinars and filters	No	Yes	No	No	No	No
Size 3 hoods, Rolleinars and filters	Yes	No	No	Filters	No	No
Size 4 filters and Rolleinars	No	No	No	Yes (in Rolleinars 0.35 & 0.7)	Yes	No
Book-form Rolleinar	No	No	No	Yes	No	No
Mutar tele and w/angle lenses	(Yes in appropriate sizes 1, 2, 3)			No	No	No
Prism	(Yes in late models with removable hoods)					No
Pistol grip	Yes	Yes	Yes	Yes	Yes	No
Rolleikin 35mm kit	Yes (check type)	Yes	Yes (but not grey T)	Yes	Yes	No
16-on 'flex kit	No	No	Yes (T)	No	No	No
16-on 'cord kit	No	No	Yes (VA and VB only)	No	No	No
24-on 'cord kit	No	No	Yes (VA and VB only)	No	No	No
Rolleifix	Yes	Yes	Yes	Yes	Yes	No
Cut film back	Yes	Yes	Yes	Yes	Yes	No
Rolleimeter rangefinder	Yes (Subject to camera no. being above 1,100,000)	Yes	Yes	Yes	Yes	No

The Mamiyaflex C series camera system

The end of the fifties saw the introduction of the original, very basic, **Mamiyaflex**, which later blossomed first into the C2, then the **C3**, then into the C33, the C330, the C220 and the C330F, with a steadily expanded and improved range of lenses and features. Even today, the early Mamiyaflex C2, C3 and C33 cameras remain quite remarkable value, and are capable of delivering extremely high-quality results with great versatility. Each lens unit consists of a pair of identical lenses, the lower with straightforward aperture and shutter-speed settings around it, the upper with a 3mm flash-synchronization socket. Lenses made prior to the introduction of the C330 have chrome bezels around the front glass, with the aperture and shutter-speed settings engraved black into the chrome. Lenses of the C330 era and after are entirely black, more modern in appearance, and have the aperture and shutter settings as filled white figures against the black finish.

Mamiya C series lenses

There has been, since the very early days of the **Mamiya** C2 and **C3** a range of Mamiya Sekor lenses covering the focal lengths 65mm, 80mm, 105mm, 135mm and 180mm, all of which focal lengths can be found secondhand in chrome-bezel mounts. Subsequently, the 55mm and 250mm lenses were added to the range, and these occur in black mounts only. Early chrome lenses of the C2 and C3 period are for the most part compatible with later cameras, the only anomaly being that the shape of the 180mm f/4.5 lens mount was altered to accommodate the auto-cocking lever of the C33 and later cameras. You should therefore be very careful to check any chrome-bezel 180mm lens that you intend using with a self-cocking camera to

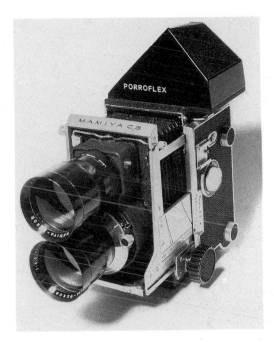

*This is the actual equipment used both for the picture of the lion (page 143) and for the shot of the Duke of Edinburgh (page 144). The **Mamiyaflex C3** is fitted with the 180mm f/4.5 Sekors, and has a Porroflex eye-level viewing system installed in place of the waist-level finder. Note the rudimentary but effective spring clip across the top of the lens panel, which is all that secures Mamiyaflex lenses in place.*

see if it will fit and operate – a 180mm lens of the C2/C3 period does not fit later cameras. It is also worth noting that no 250mm Mamiya Sekor provides auto-cocking.

The following table sets out the lenses that are available, with some basic details.

Lens type	Chrome	Black	Elements	Min. apert.	Closest focus
55mm f/4.5	No	Yes	9 in 7 groups	f/22	9 ½″
65mm f/3.5	Yes	Yes	6 in 5 groups	f/32	10 ¹¹⁄₁₆″
80mm f/2.8	Yes	Yes	5 in 3 groups	f/32	12 ¹⁵⁄₁₆″
105mm f/3.5	Yes	Yes	5 in 3 groups	f/32	23″
105mm f/3.5D	No	Yes	5 in 3 groups	f/32	23″
135mm f/4.5	Yes	Yes	4 in 3 groups	f/45	35 ½″
180mm f/4.5	Yes	Yes	5 in 4 groups	f/45	50 ¾″
180mm f/4.5 Super	No	Yes	5 in 4 groups	f/45	50 ¾″
250mm f/6.3	No	Yes	6 in 4 groups	f/64	80 ¾″

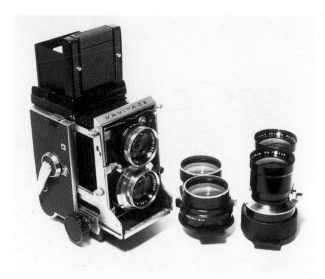

*This picture of the **Mamiya C3** and three of its lenses shows clearly the way in which the whole lens-panel assembly is racked forward on a bed for focusing, with bellows between the lens panel and the camera body. The black knob at the bottom of the right-hand side provides the focusing movement. An internal baffle is lowered with a knob on the side of the camera to protect the film when changing lenses.*

Note that 'Closest focus' in the above table refers to distance from film to subject – the lens surface will, in the case of the wide-angle lenses, focus so close as almost to touch the subject. For photographers who try the occasional close-up subject, the most important accessory is a gadget called a Paramender which, as the name suggests, corrects for the inherent parallax problem of twin-lens reflexes in close-up work, caused by the fact that the viewing lens 'sees' the subject from a higher position than does the taking lens. In its original form, and in the cosmetically improved version known as Paramender 2, the Paramender is simply a camera platform which attaches to the tripod bush of the camera and fits between the camera and the tripod head. The platform attached to the camera is at the top of a short column which goes up and down through a collar formed by the end of the unit at the tripod end. In close-up work, you set the camera at the low position, i.e., with the Paramender column as far down as gravity will take it. Having composed your shot, you extend the Paramender column to its uppermost position before you press the shutter release. This automatically places the taking lens in the exact position formerly occupied by the viewing lens, and thereby eliminates the parallax effect.

Which twin-lens reflex should you choose?

If you set extreme quality above versatility, buy the latest Rolleiflex you can find and afford – a 2.8F or 3.5F, or a 2.8E or 3.5E. Judged by optical quality and mechanical durability alone, there is nothing better among twin-lens reflexes. For similar Rollei quality, but less versatility compensated for by lower price, choose a Rolleicord VA or VB, or a Rolleiflex T, and you will achieve excellent results and virtually ever-lasting service.

If versatility and lens interchangeability matter to you more than ultimate mechanical and optical quality, and you seek a medium-format camera capable of tackling almost any subject, I would suggest the Mamiyaflex series, but would recommend that you accept the simplicity of the C3 or C2, since the rudimentary shutter-cocking mechanism of the C33 is inclined to be troublesome – a problem overcome in more recent models (which are excellent, but hardly qualify as classic cameras).

The various models of the Minolta Autocord offer high optical quality and ruggedness approaching that of the late Rolleis, and should be relatively inexpensive. Voigtländer Brilliant and Zeiss Ikoflex twin-lens reflexes never achieved Rollei standards of long-term reliability, and are best regarded as collectibles, but a sound Voigtländer Superb is thoroughly usable.

Buying a twin-lens reflex

Everything in a TLR depends on the lens panel being parallel to the film plane. Be very cautious about buying a twin-lens reflex whose focusing is stiff, as this often indicates that it has been dropped on its front, and look for other evidence of such mistreatment. Avoid twin-lens reflex cameras with dents in the back, as the blow may have pushed the pressure-plate, and therefore the film, out of parallel with the lens panel.

When buying Rolleiflexes, check that the wheel that sets the aperture is not stiff, and that the shutter button pops smartly out after being pressed. Stiffness or sluggishness indicates a need for servicing. If you are buying a middle-aged Yashica twin-lens reflex, wind the film crank slowly with the camera close to your ear and listen carefully for any sounds of mechanical roughness which might indicate approaching trouble with the film-transport gearing. If you hear anything, let somebody else buy the camera.

There is, in the final analysis, much to be said for trusting in the high engineering and optical standards of the Rolleiflex, and I find it difficult, in truth, to recommend any other twin-lens reflex, when sound classic Rolleis can be bought so cheaply.

At the Liverpool International Garden Festival in September 1984, storm clouds gathered beyond this rather fine metal-clad structure. Suddenly the sun caught the curve of the dome. The picture was taken with a 1951 Rolleiflex Automat with a 75mm f/3.5 Tessar fitted with an orange filter.

The Rolleiflex is ideal for portraiture and studio photography. This picture of Emma Matanle was shot using three Courtenay studio flash units, with brown Colorama paper as the background. The direct light from front left of the picture was reflected from a silver brolly, a second unit illuminated the hair from behind and to the left, and the third unit was pointed at a reflector to the right to provide some fill-in light. Shot with a Rolleiflex 3.5E with 75mm f/3.5 Xenotar.

Direct flash on a twin-lens reflex is a reliable way of producing pictures of children that parents love. One is often told that direct flash is bad technique, but, if an electronic flashgun is on a bracket so that it is a little to one side of the camera, and if a slight diffuser – a piece of tracing paper or a handkerchief will do – is placed over the flash-head to soften the effect somewhat, the results can be beautifully natural. Make sure, however, that the diffuser does not obscure the 'eye', or light-receiver cell, if your flashgun is of the 'computer' type. This particular picture, of a young lady named Gay Humphrey, was taken late in the sixties with a Yashicamat with which I earned much of my living at the time. The 80mm f/3.5 Yashinon lens was, and remains, first-class.

Another of those direct-flash shots, this time with a Rolleicord VA with a 75mm f/3.5 Xenar. This was a genuine, unposed snapshot of a small boy out of bed and aware that trouble, in the form of a mother who thought he should be in bed, was approaching.

It could be said that a full-grown male lion with toothache is not the ideal subject for a twin-lens reflex. In this case, however, the twin-lens reflex was a Mamiyaflex C3 fitted with a pair of 180mm f/4.5 Sekors, and the photographer was on the right side of the cage.

I was photographing a visit by His Royal Highness The Duke of Edinburgh to an oyster hatchery, and had scaled a wall to gain a vantage point. The boys found the precariousness of my position temporarily more interesting than the royal visitor, and the Duke found it entertaining that one of them was even photographing me rather than him. For this type of journalistic photography, if you need or want to work with a medium format, the Mamiyaflex with interchangeable lenses is difficult to beat. Shot with a Mamiyaflex C3 with 180mm f/4.5 Sekors.

On location with a BBC Horizon film unit, I had the opportunity to take some interesting shots of the filming in progress. This picture of producer Christopher La Fontaine discussing the shot with his cameraman was taken by the lights that were set up for the filming. Shot with a Mamiyaflex C3 with 65mm f/3.5 Sekors.

Single-lens reflexes were as much a part of the photographer's armament in the early years of the twentieth century as the wood-and-brass field camera, although modern devotees of the electronic SLR would find those archetypal single-lens reflex cameras strange to the eye. It was therefore a natural development that, as rollfilm and 35mm cameras gradually took the place of plate cameras in all but professional studios and press work, there should be a place for rollfilm single-lens reflexes. At first, these were essentially modified plate SLRs with rollfilm backs – in the mid-thirties, one could still buy adapted Soho Reflex, Graflex and Thornton-Pickard reflexes whose design dated from the period immediately after the First World War – but, by the second half of the decade, new designs were appearing. In the catalogues of 1938 one finds the American Graflex II, which produced ten pictures on 120 film, the box-shaped Pilot 6, and the similarly rectangular Primarflex, which, although a rollfilm camera, 'can be used also for plates'. The Primarflex was marketed with a range of high-quality lenses, and was the inspiration behind Victor Hasselblad's work which led to today's leading rollfilm SLR.

Perhaps the best known of this generation of rectangular rollfilm single-lens reflexes was the focal-plane-shuttered Reflex Korelle, which was initially introduced in about 1936 without slow speeds (the Reflex Korelle I), and was by 1938 available with speeds from 2 seconds to 1/500th second (the **Reflex Korelle II**). The Reflex Korelles came with a choice of interchangeable screw-thread standard lenses, and are usually found with a high-quality 80mm f/2.8 Tessar or Xenar, but may sometimes be fitted with the absolutely appalling f/2.9 Victar. Longer-focus lenses also come on the market from time to time, but very few wide-angle lenses were ever made, because of the limitations imposed by the design of the camera. A later 'Meister' or 'Master' Korelle had a bayonet lens mount and wider throat to overcome this problem, and it is sometimes possible to obtain a Meister Korelle with a set of lenses. This makes a very usable camera outfit, and a good example of one of the earlier Korelles, if used very carefully, may also be satisfying. However, the rest of this thirties generation of rollfilm SLRs should not, in my view, be bought for serious classic photography. They are, quite simply, past it.

The rollfilm Exaktas

Possibly the first truly original design in rollfilm single-lens reflexes was the **VP Exakta** series, mentioned briefly in Chapter 2, which was initially introduced in

And not every SLR takes 35mm film

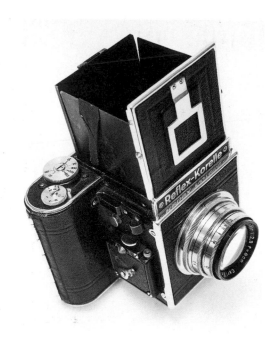

*The pre-war **Reflex Korelle II**, which has a cloth, horizontally running focal-plane shutter with speeds from 2 seconds to 1/500th second. This particular camera is fitted with an 80mm f/2.8 Tessar.*

1933, first seriously marketed in 1934, and improved with what may qualify as the world's first leverwind mechanism in 1935. Four models (albeit with many sub-versions that are the subject of endless discussion among collectors) were made, these being the Models A, B, C and Junior. More **Exakta B** models were produced than the total production of the other models put together. All produced eight exposures on 127 film, which, contrary to usual practice, was loaded and transported right to left. The Exakta Junior had a non-interchangeable lens of only average quality, but the other models were fitted with 75mm or 80mm standard interchangeable lenses, usually of high quality (but beware the awful **Exaktar**!), in a screw mount within a focusing helix. This had a very narrow throat which limited the potential for wide-aperture and wide-angle lenses. A special version of the VP Exakta B was produced with a wider throat and a choice of 80mm f/1.9 Meyer Primoplan or Dallmeyer Super-Six, or 80mm f/2 Zeiss Biotar lenses, under the name 'Night Exakta'. The Model C had a built-in plate back as well as normal rollfilm loading.

As was suggested earlier, the VP Exakta was a well-conceived and practical camera, but its mechanism was not built to last indefinitely. However, examples that have seen little use do still turn up, and may function well, although for how long must be open to question. Since Kodak has ceased production of some types of 127 film, and may be expected to discontinue more, buying a VP Exakta for regular use would be an act of folly.

Similar doubts must also apply to the Exakta 66, the pre-war version of which is of trapezoidal shape like a VP Exakta, and is, in any case, very rare. A post-war camera of the same name is quite different, being box-shaped, but is almost as rare and just as unreliable. Although 120 film is, of course, still a mainstay of photography, relying on an Exakta 66 is more likely to produce heartache than photographs.

The coming of the Hasselblad

Hasselblad equipment has been pre-eminent among medium-format systems for so long that it is almost hard to realize that it was not always so. Although far from the first rollfilm 6cm x 6cm single-lens reflex, the Hasselblad 1600F of 1948 was the originator of the modular single-lens reflex principle and gave the medium-format photographer much of the flexibility of large-format camera systems, allied to speed comparable with 35mm cameras and the less versatile but much beloved Rolleiflex twin-lens reflexes.

Since the beginning, **Hasselblad** model designations have been both logical and informative. The number represents the highest shutter speed, the letter the type of shutter. Thus the 1600F had a top speed of 1/1600th on a vertically running and immensely complex focal-plane shutter. The next model, the **1000F** of 1952, redesigned in some important mechanical respects, also had a focal-plane shutter, this time providing a highest speed of 1/1000th second. The **500C** of 1957 was fitted with a Synchro Compur shutter in each lens, giving a fastest speed of 1/500th. Although the 1000F and 1600F looked remarkably similar to the Hasselblad of today, they had a different (almost a screw) lens mount, no auto-diaphragm mechanism, a standard 80mm f/2.8 Tessar (earlier models had an Ektar) of sometimes indifferent quality, only a limited range of additional lenses (60mm f/5.6 Distagon, 135mm f/3.5 Sonnar and 250mm f/5.6 Sonnar plus various lenses from other manufacturers) and no electronic flash synchronization above 1/25th second. On the credit side, the F cameras had full magazine interchangeability with 12-on and 16-on 120 backs, and full finder interchangeability. Classic-camera enthusiasts should note that, although any twelve- or sixteen-exposure Hasselblad film magazine (*not* Polaroid backs) will fit an F camera, the original F rollfilm magazines do not fit C and later cameras.

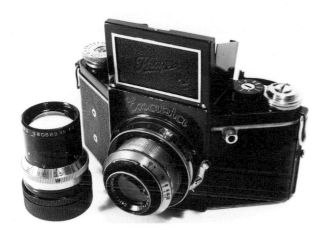

The **VP Exakta B** comes in many sub-versions, and it is quite probable that, if you buy or own one of these cameras, yours will differ in detail from this camera, which is fitted with a 75mm f/3.5 Tessar and has a 150mm f/5.5 Tele-Megor standing beside it. Some VP Exaktas have the infinity catch at nine o'clock to the lens mount instead of three o'clock; some early examples have knob-wind rather than leverwind; some have plated speed dials instead of black, as on this camera; and some late cameras are in chrome, instead of black, finish.

A close-up of the focusing mount of another VP Exakta, this time fitted with the budget-priced and low-performance 75mm f/3.5 **Exaktar**. The infinity catch can clearly be seen. When the camera is put away in its case, the shutter must first be fired to get the mirror into the raised position, and the large milled ring can then be rotated until the lens is fully retracted into the body of the camera.

The coming of the 500C with flash synchronization at all speeds, a shutter in every lens, comparative quietness, great reliability, and the until recently unmatched and ever-widening range of West German Zeiss lenses took the Hasselblad system into a position of professional market domination. All told, Hasselblad made 3,627 1600F cameras, 10,400 1000F cameras and rather fewer than two thousand original Super-wides with the first version of the 38mm f/4.5 fixed Biogon. By 1974 (according to the British Journal of Photography) production of 500C/M cameras had reached eighteen thousand per year.

With the 500C was introduced the still-current (although several times updated) 80mm f/2.8 Planar. The lens mount was redesigned as a four-prong bayonet needing one-eighth of a turn anti-clockwise to release it, and automatic diaphragm was provided on all lenses. By the time the 500C/M was introduced in 1971 – the primary difference being the interchangeability of the focusing screen – the system had eight Zeiss lenses, prism finders with and without built-in meters, the magnifying hood (dating from the F period), 12-on, 16-on, Superslide 16-on, 24-on and 70mm backs, a Polaroid back made by Arca-Swiss (known as the Polaroid magazine 80), and an armoury

The rear view of a **VP Exakta** with the back open shows clearly the negative aperture filled with the curtains of the cloth focal-plane shutter. The dial on the right-hand side of the camera sets slow speeds from 1/10th second to 12 seconds (with the main shutter-speed dial on the left set to 'B'), and also enables the user to set delay action of from 1/10th second to 6 seconds, in marked increments.

147

*The **Hasselblad 1000F** family, shown as a group. The camera on the left is a Hasselblad 1000F with standard 80mm f/2.8 pre-set Tessar. The camera on the right is a Hasselblad Superwide of the original type, with fixed 38mm f/4.5 Biogon. Between them and slightly behind is the 250mm f/5.6 Sonnar, and in front of it is the 60mm f/5.6 Distagon wide-angle, the scarcest of the lenses. In front of the Superwide, at lower right, is a 135mm f/3.5 Sonnar, and opposite, at lower left, is a set of Hasselblad extension tubes. Between them are two Hasselblad Series 7 filters, and completing the picture at the foot is a Hasselblad cable release, important because the Hasselblad 1600F and 1000F had a unique cable-release thread which only the Hasselblad release will fit. Equipment loaned by Douglas Cole.*

of other accessories. Much-modified Hasselblads had been to (and had been left on) the moon, and there were also the motorized 500EL and Superwide C models for special applications.

The Hasselblad 1000F in use

It is a source of great sadness to me that the focal-plane-shuttered **Hasselblad 1000F**, a camera which I greatly enjoyed using professionally, is, in its old age, too unreliable for regular use, unless one is prepared to invest in and carry at least two as a provision against breakdowns. The 1000F is a fine camera to use, with lenses of the highest quality, but the film transport and shutter are usually frail, and are virtually impossible to get repaired.

Nonetheless, using a 1000F is an experience, especially if you can obtain the superb 60mm f/5.6 Distagon wide-angle lens, and the 135mm f/3.5 and 250mm f/5.6 long-focus Sonnars with pre-set diaphragms. As with later Hasselblads, the camera shutter will not fire if you accidentally leave the dark slide in place, or if you have just used the final exposure on the film (although this last is not true if your camera is fitted with the earliest type of F film magazine). You have to check, when changing film magazines, that both the body and the magazine show signals of the same colour – either red or white – in the little windows low down on the right-hand side of both camera and magazine, or you will either double-expose or waste a frame of your film. You should always cock the shutter before changing the shutter speed and, unlike most other cameras, the Hasselblad 1000F should be stored with its shutter cocked.

Using the Hasselblad 500C

Pressing the shutter button on a **Hasselblad 500C** may or may not make anything happen. As with the 1000F, the shutter will not fire with a magazine on the camera if the magazine is empty, if the film is finished or if the dark slide is in place. There is also a shutter-button lock that must be 'off'. Having loaded the camera and removed the dark slide, try again, and press the button.

Firing a Hasselblad 500C/M produces a sound reminiscent of an aristocrat with asthma. The apparently protracted nature of this subtle wheeze – it is actually extremely fast – is due to a remarkably complex series of events that occurs when the shutter is fired. The between-lens shutter closes, the diaphragm shuts down to its pre-set aperture, the mirror snaps up out of the light path, the rear curtain shutter opens and – finally – the shutter fires.

The standard focusing hood supplied with the camera is remarkably effective and has a full-screen magnifier that excludes extraneous light very well. The magnifying hood is a useful alternative for spectacle wearers because it provides a variable dioptric eyepiece.

It is worth noting that the fastest and safest way to wind a Hasselblad 500C when it is hand-held is to use the double-twist technique. With the standard knob fitted, grasp the wind knob in the right hand and the camera body in the left. Simultaneously twist the camera towards you and the knob away. You will find that this achieves a complete wind in one quick action. Using the special knob with a crank over-enthusiastically off the tripod can easily result in the camera flying out of your hand.

In this picture of a **Hasselblad 1000F** fitted with the 250mm f/5.6 Sonnar, the shutter-speed dial around the winding knob can be seen. Speeds available on the titanium-foil focal-plane shutter are 1 second to 1/1000th second. The large-diameter cable-release socket can be seen at the lower front corner of the side of the camera. Equipment loaned by Douglas Cole.

On the left-hand side of a **Hasselblad 1000F** is a long shoe into which either the rare sports finder with flash-synchronization sockets or this simple flash-socket unit fits. 'Strobe' is electronic flash, 'Flash' is bulb flash. If you are rash enough to use bulb flash with a 1000F, you set the delay after ignition before the shutter opens with the small dial marked in milliseconds above the flash shoe. The button below the lens is the lens-release catch. The polished-steel handle protruding from the side of the camera is the dark slide, which has to be withdrawn before the shutter will fire. Equipment loaned by Douglas Cole.

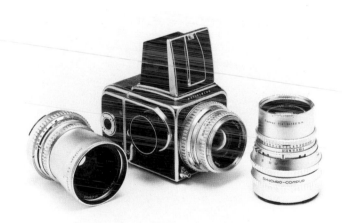

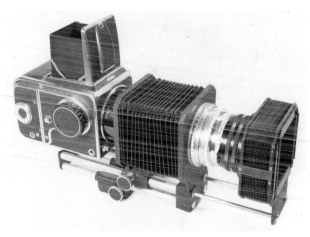

In 1957, the **Hasselblad 500C** with Synchro Compur shutters in each lens replaced the 1000F. This is a typical 500C, fitted with the standard 80mm f/2.8 Zeiss Planar, with (right) a 150mm f/4 Sonnar and (left) a 50mm f/4 Distagon wide-angle lens. As can be seen, the appearance of a 500C is remarkably little changed from the exterior design of the 1000F, despite the total mechanical redesign of the camera. Picture by Tim Hawkins.

This formidable assembly is the Hasselblad 1000F bellows unit with bellows lens hood, which also functions as a transparency copier. The black tube from the lens hood screws into the Series 7 filter-retaining thread of the 80mm f/2.8 Tessar. Equipment loaned by Douglas Cole.

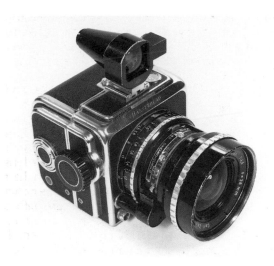

The original 1954 Hasselblad **Superwide** *did not have the characteristic shutter button on top of the camera that is a feature of the later Superwide C. Instead, it is on the front of the camera. Focusing is by estimation or by measurement on the lens-focusing scale, and a spirit level, visible on top of the camera, makes it possible to avoid distortion in the picture by keeping the camera level. The projection on the side of the viewfinder is a prism which reflects the image of the spirit level into the photographer's eye when he hand-holds the camera. Equipment loaned by Douglas Cole.*

The Hasselblad Superwide and SWC

In 1954, shortly after the 1000F had replaced the 1600F as the standard camera in the Hasselblad range, the professional need for an extreme-wide-angle flat-field lens was met by the introduction of the Hasselblad **Superwide**. This was a non-reflex camera with a non-interchangeable 38mm f/4.5 Biogon lens covering 6cm x 6cm, a Synchro Compur shutter, a viewfinder fitting into an accessory shoe on top of the body and the standard magazine fitting at the rear. Although relatively few were made, this camera was very successful, largely because of the outstanding performance of the Biogon lens.

In 1959, the Superwide was brought into line with the 500C with modifications that produced the Superwide C. This model added leverwind and automatic cocking of the shutter to the earlier specification, and, like the 500C, had a chrome-finished lens unit instead of the black enamel of the original Superwide. The shutter button was also repositioned to be on the top of the camera. The remarkable performance of the 38mm f/4.5 Biogon, which provides a distortion-free 90-degree image that is bitingly sharp even in the

corners, makes the Superwide or SWC an extremely effective tool for industrial, architectural and press photographers needing to produce top-quality images that do not look like 'wide-angle' pictures. The viewfinder has a built-in viewing prism that carries to the eye an image of the circular spirit level on top of the camera. This makes it relatively easy to hand-hold the camera so that it is level in both planes, and therefore helps the photographer to maintain parallels as they should be in the picture.

Hasselblad lenses

The lenses for the original F series Hasselblads (1600F and 1000F) had only pre-set or simple diaphragms, and were limited in scope by comparison with the modern system. With the advent of the 500C in 1957, a range of new chrome-mount lenses, each with fully automatic diaphragm and its own built-in Synchro Compur, was made available, and the range of C lenses was gradually increased over the years. Black finish was introduced during the seventies. The following table

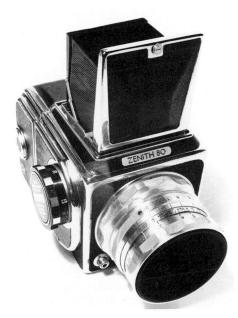

During the seventies, two Soviet state-owned factories in Russia and the Ukraine successively produced two versions of the same camera, the Zenith 80 and the Kiev 80. Both are near-copies of the Hasselblad 1000F, but the lens mounts are not compatible, despite looking similar, unless some modest machining is carried out. The film backs are also not cross-compatible. This is a Zenith 80 which, like the Kiev 80, is prone to similar shutter and film transport problems to those of the Hasselblad 1000F.

summarizes the Hasselblad lens range, and indicates which lenses were available for each camera and in each finish.

	1600F/1000F	'C' chrome	'C' black
Wide-angle lenses			
30/3.5 F-Distagon	–	–	Yes
40/4 Distagon	–	Yes	Yes
50/2.8 Distagon	–	–	–
50/4 Distagon	–	Yes	Yes
55/6.3 Wide Ektar	Yes	–	–
60/5.6 Distagon	Yes	Yes	–
60/4 Distagon	–	Yes	–
60/3.5 Distagon	–	–	Yes
Standard lenses			
80/2.8 Ektar	Yes	–	–
80/2.8 Tessar	Yes	–	–
80/2.8 Planar	–	Yes	Yes
100/3.5 Planar	–	Yes	Yes
105/4.3 UV Sonnar	–	Yes	Yes
110/2 Planar F	–	–	–
Long-focus and telephoto lenses			
120/5.6 S-Planar	–	Yes	Yes
135/3.5 Sonnar	Yes	–	–
135/3.5 Ektar	Yes	–	–
135/3.5 Dallac	Yes	–	–
135/5.6 S-Planar	–	Yes	Yes
150/4 Sonnar	–	Yes	Yes
250/4 Sonnar	Yes	–	–
250/5.6 Sonnar	Yes	Yes	Yes
254/5.6 Ektar	Yes	–	–
350/5.6 Tele-Tessar	–	–	Yes
432/5.6 Dallon	Yes	–	–
500/8 Tele-Tessar	–	Yes	Yes
500/8 Tele-Apotessar	–	–	–
508/5.6 Dallon	Yes	–	–

Buying a Hasselblad

The first obstacle to be overcome for most people contemplating the purchase of a Hasselblad is that of finance. Even comparatively elderly Hasselblad 500C cameras and their lenses are very expensive on the secondhand market, and the cost of embarking on the use of 1000F equipment, while apparently less, is inflated by collectors' interest in some of the lenses and by the regrettable necessity to buy more than one camera in order to provide for the possibility of mechanical disaster. Having established that you can afford the exercise, what should you look for?

First, recognize that Hasselblad equipment is more often used by professionals than by amateurs, and that a professionally used Hasselblad will have transported more film in a week than most amateur cameras use in six months. After ten years of use of that kind, even a Hasselblad will be showing signs of age. Check for slackness in the lens mount, for sluggishness of the slow speeds of the shutter, and for a smooth wind when you twist the knob. Take off the magazine and look for worn gears at the back of the camera where the magazine couples to the body. While the magazine is off, wind and fire the shutter and make sure that the rear shutter curtain snaps open and shut convincingly. Do the same while watching the lens diaphragm, with the aperture ring set to the smallest aperture. Make sure that the diaphragm stops down immediately and totally to the pre-set aperture before the shutter fires. If you see the diaphragm 'creeping' to a closed position, an expensive service is needed. Best of all, try to locate an amateur-used camera and lenses, and most of the problems will probably not arise.

Other post-war rollfilm SLRs

The Praktisix and Pentacon Six

The most significant post-war classic SLR system to emerge from the camera factories of Europe was the Praktisix series, and its successor, the Pentacon Six. A large and relatively heavy 6cm x 6cm camera of a shape and appearance more akin to a 35mm camera than to the rectangular Hasselblad design, the Praktisix was manufactured in East Germany and was fitted via a reliable and sound breech-lock mount with automatic-diaphragm lenses from East German Zeiss in Jena. The normal standard lens was an excellent 80mm f/2.8 Biometar, and there was a full range of other lenses. Available new alongside the Hasselblad 500C, which (for example) was priced at £298 0s. 6d. in Britain in 1966, the **Praktisix II** cost little more than half the price of the Swedish camera – £157 18s. 6d. in the same 1966 catalogue.

The following table – the information is from the 1966/67 Wallace Heaton Blue Book – summarizes the Praktisix lens range:

Lens	Price
50mm f/4 Flektogon wide-angle	£ 98 17s. 6d.
65mm f/2.8 Flektogon wide-angle	£107 11s.10d.
120mm f/2.8 Biometar medium-long-focus	£ 74 12s. 8d.
180mm f/2.8 Sonnar long-focus	£119 17s. 2d.
300mm f/4.5 Telemegor telephoto	£ 47 7s. 9d.
300mm f/4 Sonnar	'Price on application'
500mm f/5.6 Meyer	'Price on application'

The breech-lock lens mount of the Praktisix can be seen to be very similar to that of the Praktina 35mm single-lens reflex in the top picture. Breech-lock lens mounts, in which the rotating of the milled ring tightens the lens to the body without the machined surfaces of lens and body rubbing against each other, are inherently less prone to wear than conventional bayonet mounts. Praktisix II camera loaned by Colin Glanfield.

The Praktisix and the later Pentacon Six, although, like most East German cameras of the fifties and sixties, somewhat poorly finished and rather rudimentary in design, was, and can still be, a reliable workhorse capable of very high-quality results. Its fabric focal-plane shutter, with speeds from 1 second to 1/1000th second and delay action, performs well if serviced occasionally, and the only major flaw in the design is the inadequacy of the gearing of the film-transport mechanism, which can result in gears becoming stripped if the film-transport lever is jerked,

forced or wound over-energetically. In short, the Praktisix should be treated tenderly, and, if respected, will prove an excellent acquisition.

The Agiflex range from Britain

During the period in the fifties when Britain was afflicted with swingeing import controls, the Aeronautical and General Instrument Company (AGI) of Croydon, England, manufactured a series of near-copies of the pre-war Reflex Korelle cameras, known as the **Agiflex** I, **II** and III, to meet serious amateur and semi-professional demand for a roll-film single-lens reflex in the British market. The first two Agiflex models looked almost exactly like the Korelle I and II, but had a three-tongue bayonet lens mount instead of the screw mount of the Korelles. These cameras were fitted with 80mm f/3.5 Agilux Anastigmat lenses of excellent performance, and 160mm and 240mm telephoto lenses, with a set of extension tubes, were marketed to go with them. Subsequently, as though to emulate the Meister Korelle, AGI launched the Agiflex III, which had a wider throat, and a bayonet lens mount of greater diameter, into which was fitted an improved 80mm f/2.8 Agilux lens of first-class performance. Once again, a range of lenses was provided to fit the new mount, although no wide-angle lenses were supplied for any of the Agiflex cameras.

The Agiflex models are not particularly easy to locate, even in Britain, but if you are able to find a good example, particularly of the Agiflex III, it will prove a very worthwhile, if slightly ponderous, camera. Like the Korelles, all Agiflex cameras must be wound with care, since the wind mechanism and the shutter are joined with a cord which can be broken by rough handling. One must also allow for the fact that the faster speeds on an Agiflex shutter are likely to give appreciably longer exposures than the indicated speeds suggest.

The Bronica SLRs from Japan

Although it is difficult to justify including the early Bronica rollfilm SLR cameras within the classic definition, it seems sensible to mention them, if only to utter a small warning. During the late fifties and the sixties, a series of Bronica 6cm x 6cm single-lens reflexes, very similar in appearance to the later, and highly successful, Bronica S2A, was marketed in Britain and the USA. These were the Bronica S, the S1, the S2 and the C. Many users of the early S and S1 models (whose lens is focused by turning a knob on the side of the camera) experienced severe problems with the film-transport mechanism, and, as the availability of spares

The **Praktisix II**, second version of the 6cm x 6cm post-war single-lens reflex manufactured by the state-owned East German company, Kamera Werkstätten AG (KW) of Dresden – others of their cameras with the 'Prakti' prefix were the Praktiflex 35mm SLR and the Praktina, illustrated in Chapter 7. In this picture, the camera is fitted with the waist-level viewfinder. After KW became part of VEB Pentacon in 1957, the same camera became known as the Pentacon 6. Camera loaned by Colin Glanfield.

The same **Praktisix II**, here fitted with the optional detachable pentaprism, with the waist-level finder folded beside it. The lens is the standard 80mm f/2.8 Biometar, a medium-contrast lens providing very crisp performance. Camera loaned by Colin Glanfield.

A close-up of the top-plate of the **Praktisix II** shows the clearly marked shutter-speed dial on the left-hand side of the top-plate, the simple one-pull erecting focusing hood and the neat magnifier with prong apparently designed to blind photographers who do not wear spectacles. Camera loaned by Colin Glanfield.

The post-war **Agiflex II** from Britain, introduced in the early fifties, is very similar in specification and design to the pre-war Reflex Korelle II. Only one standard lens was available, an 80mm f/3.5 coated four-element Agilux Anastigmat of very worthwhile performance. Beside the camera (right) is the 160mm f/5.5 Agilux telephoto lens, and on the left is a set of AGI extension tubes. A 250mm f/5.5 Agilux telephoto was also available. Picture by Colin Glanfield.

for these models is as limited as the problems that are likely to make them necessary are abundant, early Bronica models are best avoided. The S2, which was the first model to have conventional focusing by twisting the lens mount, was a great deal more reliable, but was still decidedly sensitive to over-enthusiastic use, and must be treated with great care. If you particularly fancy using a Bronica with a mechanical focal-plane shutter, I would suggest you buy an S2A.

So which rollfilm SLR should you choose?

The choice in this class of cameras is made relatively simple by the limited number of types that are available and which can be expected to work properly. In short, if you can afford it, buy a Hasselblad 500C. If you cannot, buy a Pentacon Six or a Praktisix II. But be aware that buying rollfilm single-lens reflexes is a more hazardous pursuit than any other area of classic-camera purchasing.

Available-light, unposed pictures of the family at home can have an appeal quite different from that of posed pictures. The faces are hardly visible in this picture, but the scene, and the concentration of the participants on the problem in hand, express something which is instantly recognizable to the family. Shot with an Agiflex II with 80mm f/3.5 Agilux Anastigmat.

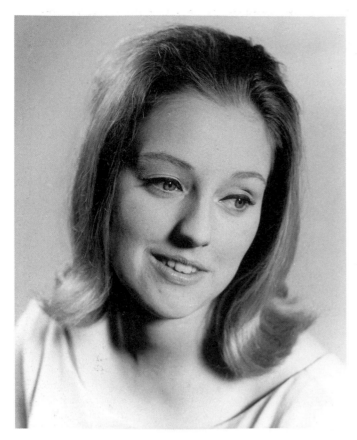

This portrait was shot with a Reflex Korelle fitted with a 150mm f/4.5 Triotar, which had been pillaged from an ancient press camera. The lens, which had no focusing mount, was screwed into a threaded hole in the top of a spare piston from an Austin 7 car engine, which had been machined appropriately by a relative with engineering facilities. The piston and lens were then attached to a BPM bellows unit, intended for 35mm close-up work, but adequate for 6cm x 6cm if one allowed for a small amount of cut-off of the corners of the negative. Finally, the interchangeable-mount system of the BPM bellows made it possible for the whole assembly to be screwed into the Korelle. The results from this strange piece of equipment were excellent, and I used it successfully for several impecunious years.

This portrait of my wife Anne in the late sixties was another product of the 150mm f/4.5 Triotar mounted in the Austin 7 piston, although this time the lens was mounted on an Agiflex II. The softness of the image in the out-of-focus areas is quite different in character from that achieved by modern Japanese lenses.

Opposite: Pictures of children doing things always appeal, particularly if the activity seems unusual. Daughter Emma was using this Leitz microscope when quite young, and this candid picture was shot with a VP Exakta fitted with a 75mm f/2.8 Tessar, with the lens wide open, by the available light.

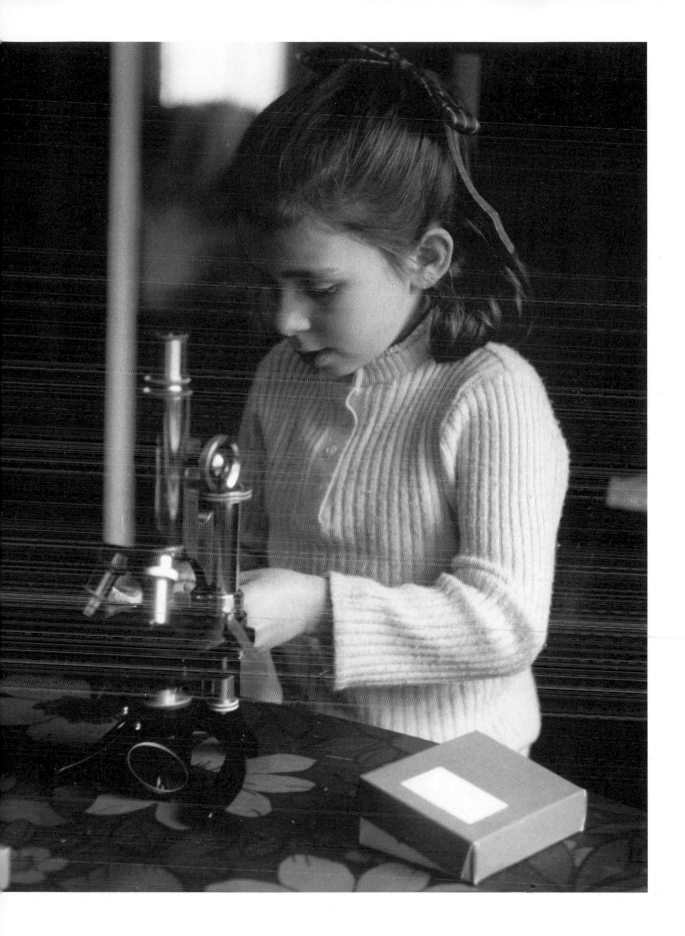

Portraits of men with lined, interesting faces benefit from strong lighting. This picture of Ted Gooch, a primary-school headmaster, was taken with a Praktisix II fitted with the 80mm f/2.8 Biometar lens.

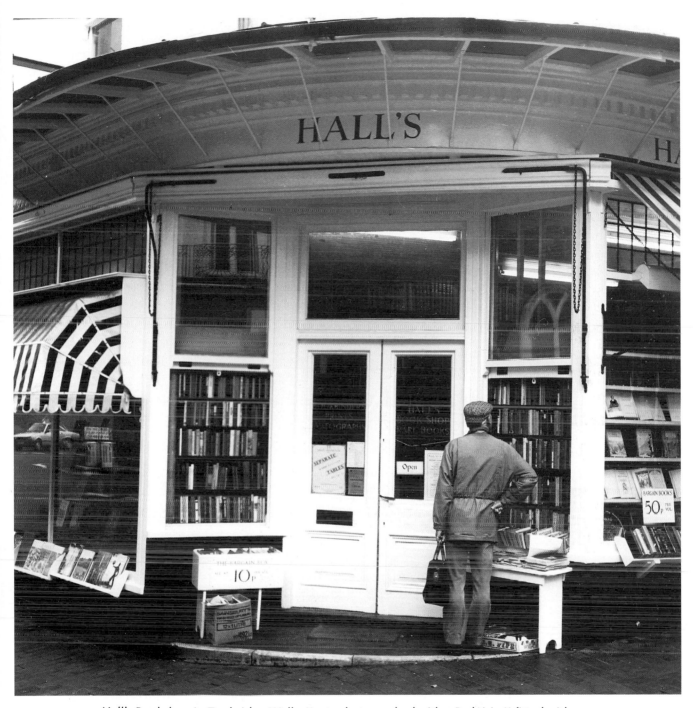

Hall's Bookshop in Tunbridge Wells, Kent, photographed with a Praktisix II fitted with its standard 80mm f/2.8 Biometar and waist-level finder. Using a waist-level finder is very helpful when the photographer needs to be unobtrusive.

Opposite: This hand-held portrait of racing driver Tony Trimmer was shot from some ten feet away with a Hasselblad 1000F fitted with a 250mm f/5.6 Sonnar. The sharpness is a tribute to the steadiness with which it is possible to hold a Hasselblad that is equipped with a long lens.

Chapter 10

The delights of unfolding a medium-format camera

It is as characteristic of rollfilm single-lens and twin-lens reflex cameras to be large and heavy as it is of rollfilm folding cameras to be compact, although not always very light in weight. There were, during the classic-camera period, literally hundreds of types of folding rollfilm camera manufactured, with an immense variety of lenses and shutters, ranging from the first-class to the truly dreadful. This chapter will attempt to advise on the question of which manufacturers' folding rollfilm cameras might safely be considered for use and which should not, and will also look more closely at some aspects of using those which are likely to be functional thirty or more years after their manufacture.

Before about 1925, virtually every major manufacturer of cameras relied for the bulk of its sales on folding plate cameras – 'hand and stand' and field cameras. As amateur photography espoused the rollfilm instead of the plate, each manufacturer first adapted existing designs to take rollfilm backs, then (in most cases) launched a compromise design, constructed for rollfilm but still capable of accepting plates. Progress was rapid, and by 1932, the Zeiss catalogue (for example) contained almost as many rollfilm cameras as it did plate cameras. By 1936, plate cameras had been relegated to the back of the catalogue, and by 1938 there was relatively little evidence of them at all. The ranges of other manufacturers, such as Voigtländer, went through a similar metamorphosis, and the folding rollfilm camera, in several formats, or picture sizes, became, by the end of the thirties, the principal tool of the advanced amateur photographer who was not actually wealthy – for, it must not be forgotten, the Leica, the Contax, the Rolleiflex and the other great classic cameras, ownership of which we rather take for granted in the eighties, were financially out of reach of all but the comparatively rich before the Second World War.

Formats

As always in a fast-developing market, a considerable range of rival formats and film sizes had made their appearance since packaged rollfilm first appeared, and cameras for a profusion of picture sizes had been manufactured to suit them. Most of these film sizes are no longer available. It is therefore important, when buying early rollfilm cameras with the intention of using them, to be quite clear whether the camera takes one of the sizes of film that remains available, or one that is now defunct. Obviously, to do this, you will need up-to-date information of film availability from the major film manufacturers, but, in 1984, it is still possible to buy film in 127, 620 and 120 sizes,

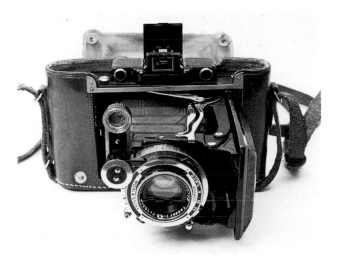

Probably the best range of folding cameras from the thirties to offer prospects of reliable use fifty years after they were made are the Zeiss Super Ikontas. This is a 1934 **Super Ikonta** *6cm x 9cm of the first type, which has no body shutter-release button. Fitted with an uncoated 105mm f/4.5 Tessar in a Compur shutter with speeds from 1 second to 1/250th second, this earliest Super Ikonta can still deliver crisp, medium-contrast pictures that are very satisfying. The brass-bound ever-ready case is rather attractive. Similar, but more compact, sixteen-exposure 6cm x 4.5cm Super Ikontas are often available, and are just as usable if in sound condition.*

although both 127 and 620 are in limited supply and may have to be specially ordered. The 120 and 620 sizes are of identical length and width, and differ only in the spool upon which they are wound – the 620 spool has a very slim core and different ends to fit into the camera. Even if you are unable to get 620 film, it is nonetheless possible, provided you have two 620 spools (one for each end of the camera film path), to rewind a 120 film in total darkness on to a 620 spool and use it successfully. Once-popular sizes such as 116, 616, 117, 119 and 129 are all totally unobtainable.

If, by measuring the picture aperture inside the back, you establish that the camera is designed to produce pictures 6cm x 9cm, or 2¼" x 3¼", the probability is that it is designed for eight exposures on 120 or 620 film, but carry a 120 film with you (and ideally a 620 too) so that you can check this. Many 8-on-120 rollfilm folding cameras have a flip-over or drop-in mask that converts them to twelve exposures 6cm x 6cm, or 2¼" square, and there are of course a great many models designed for the twelve-exposure 6cm x 6cm or the sixteen-exposure 6cm x 4.5cm

formats, and various Linhof cameras of the 'Ideal Format' which provide ten exposures each 6cm x 7cm. Folding cameras for 127 film are far less common, but have been available for 8-on-127 (6cm x 4.5cm) and 16-on-127 (3cm x 4cm). I have yet to encounter a 12-on-127 folding camera (4cm x 4cm), with the same format as the Rolleiflex 4x4, but it probably exists somewhere.

Any rollfilm format other than these, or larger than 6cm x 9cm, will be designed for a film that is no longer available – you will quite often encounter folding postcard cameras (8cm x 14cm), quarter-plate rollfilm cameras (8cm x 10.5cm) and cameras for pictures 6.5cm x 11cm or 5cm x 7.5cm. All these are obsolete.

Best buys in pre-war folding rollfilm cameras

Some suggestions for checking folding cameras before you buy them were given in Chapter 2. Be

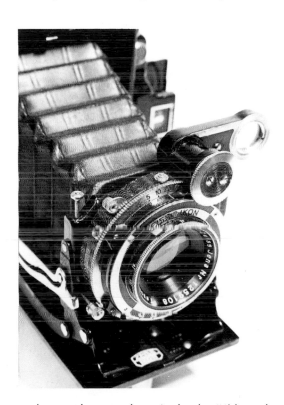

The neat plunger shutter-release is clearly visible at the top left of the lens standard in this close-up of the 1934 **Super Ikonta**. *The rangefinder arm containing the revolving circular prism (top right of the lens standard) should be folded out to the position shown here when the camera is unfolded for use. Focusing of both lens and coupled rangefinder is achieved by turning the milled wheel at top right.*

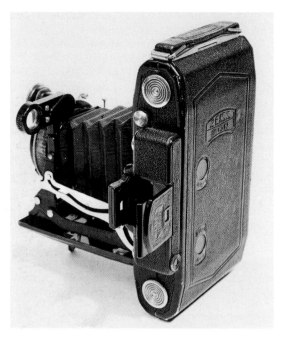

The back view of the **Super Ikonta** *6cm x 9cm shows the eyepiece for the rangefinder at the lower end of the projecting rectangular housing, on top of which is the folding viewfinder. The bright button at the top of the body is the release for unfolding the camera. Note that there are two windows in the rear door. The lower is for normal 6cm x 9cm eight-exposure use, the upper is for use when a detachable mask supplied with the camera is inserted into the negative aperture, thus converting the camera to provide sixteen pictures 6cm x 4.5cm. This mask is often missing after some fifty years, and its absence should not necessarily be held against the last owner.*

particularly vigilant when checking pre-war examples, since there is a strong possibility that the bellows will have perished and will leak light, or that the struts or front lens standard will have been damaged, with consequent disturbance to the parallelism of the lens with the film plane, or of the setting of the focus. This applies to some extent to all folding cameras, but more to those that were not originally expensive and well engineered than to those that were. For this reason, you are more likely to be successful buying pre-war folding cameras from Zeiss or Nagel than from any other manufacturers, and should be wary of buying pre-war Balda, Certo or Voigtländer folding cameras if you intend to use them frequently. An even better rule, however, is to refrain from buying pre-war folding cameras for use at all, and to stick to the post-war variety, which, as well as being of more

recent manufacture, usually have coated lenses and flash-synchronized shutters.

The rollfilm folding camera after the war

Although there were fewer brands of folding rollfilm camera available after the war and during the fifties, there were a number of excellent designs capable even now of first-class results. Principal among these are the Super Ikontas, Ikontas and Nettars from Zeiss Ikon in West Germany, the Isolette range and Super Isolette from Agfa, the Bessa and Perkeo models from Voigtländer, the **Ensign Selfix** and **Ranger** cameras from Britain, and the Mamiya folding cameras from Japan. In most cases, the manufacturer made available a range of lens options, usually offering one or more budget-priced three-element lenses, and a substantially higher priced four-element alternative, usually in a more expensive and fully featured shutter. It pays in almost every case to seek out examples of these better lenses and shutters, although this axiom is a little unkind to the Zeiss Novar, which, despite being a

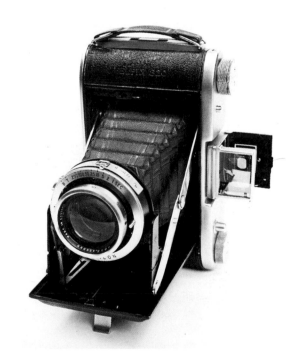

The **Ensign Selfix 820** *was manufactured in Britain and is equipped with a very satisfactory 105mm f/3.8 Ross Xpres in an Epsilon shutter with speeds from 1 second to 1/250th second. This is the camera with which the picture of the traction engine on page 169 was taken.*

three-element lens, can produce first-class results if the focus is correctly set, and yields results indistinguishable from those of the more expensive Tessar in photographs taken in the middle aperture range, between f/8 and f/16.

Thus, when buying a **Super Ikonta III**, it is worth looking for the version with the four-element Tessar lens rather than the three-element Novar, although, in fact, the f/3.5 Novar is not to be denigrated. When buying an Isolette, try to find one with f/3.5 Solinar four-element lens, which is decidedly better than the more common f/4.5 Apotar or f/6.3 Agnar (or Igestar). With Voigtländer, it is usually best to seek out a camera fitted with a Color-Skopar, rather than one with a Voigtar or Vaskar lens, although it is true to say that I have a Perkeo II with a Vaskar of excellent quality. It also pays, in most cases, to buy the larger-aperture version of a given lens – the f/4.5 Novar is a sounder buy in a Zeiss Nettar than the f/6.3 Novar, for example. It is worth noting that the 105mm f/3.8 Ross Xpres fitted to many of the better Ensign 6cm x 9cm folding cameras is capable of superb performance.

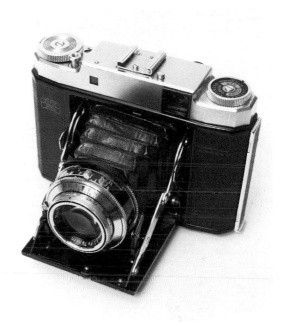

*The lightweight Super Ikonta III and IV of the mid-fifties are constructed using the same body as that of the Nettar in the picture on page 164, and are far more compact and easy to handle than earlier Super Ikonta cameras. This is a **Super Ikonta III**, and is the camera that produced the picture of the boys examining the Meccano models (page 172). A Super Ikonta IV is similar, but features an exposure meter mounted in the top-plate of the camera. Many Super Ikonta III and all Super Ikonta IV cameras are fitted with the top-quality four-element 75mm f/3.5 Tessar lens. This one has the budget-priced 75mm f/3.5 Novar, which is, however, no mean performer.*

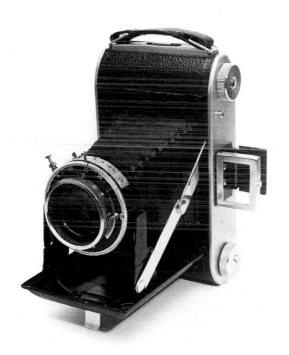

*A slightly less sophisticated but no less effective camera from the Ensign stable was the **Ensign Ranger**, again for eight exposures on 120 film, and equipped with the same 105mm f/3.8 Ross Xpres lens, this time in a simple three-speed shutter.*

Film transport

Before the war, virtually no folding camera (other than the **Super Ikontas**) had automatic exposure counting and double-exposure prevention. By the beginning of the fifties, most of the manufacturers were fitting these features, but not always to all of their models. Since it can be somewhat frustrating to have to watch numbers on the film backing paper through a little red window in order to wind on after an exposure, I must once again recommend your carrying in your pocket an expendable film or two, so that you can actually load and check a camera before you buy it.

This will rapidly reveal whether the camera has true automatic counting and double-exposure prevention, as is fitted to the later post-war Super Ikonta

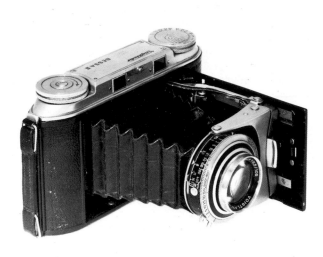

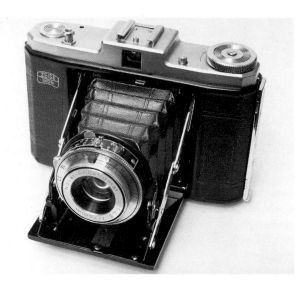

The Voigtländer **Bessa II** ought to be among the leaders in top-quality rollfilm cameras for use by classic-camera enthusiasts, but the truth is that, for all its impressive specification, the Bessa II is inadequately engineered, and rarely proves to have a satisfactorily rigid lens standard for successful photography. This is a great shame, for this camera is fitted with a 105mm f/3.5 four-element Color-Skopar and a flash-synchronized Compur Rapid shutter, and might be expected to yield top-quality results. Picture by Colin Glanfield.

This Zeiss **Nettar** was purchased for £8 sterling (about $10) in 1984, and is the camera with which the picture of the Rolls-Royce radiator on page 170 was taken. Zeiss folding cameras seem to have greater rigidity and resistance to long-term wear than other brands, and a good example like this will provide excellent value for money.

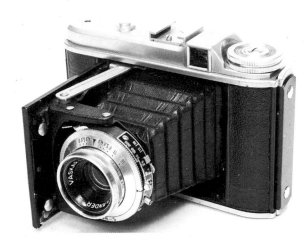

The post-war Voigtländer **Perkeo** models are soundly constructed and usually in good order. This is the camera with which the picture of the 'Duke of York' pub in Tunbridge Wells (page 168) was photographed. It has a Prontor S flash-synchronized shutter and a 75mm f/4.5 Vaskar three-element lens which, while not an expensive objective, is one which demonstrably performs well.

models. These are loaded in the manner of a Rollei-cord. The arrow on the film backing paper is lined up with a red dot, the camera back is closed, the exposure counter is tripped, and from then on you just wind until the mechanism stops you with the film ready for the first exposure. Many cameras have a simpler version, in which you use a red window to wind the film through to the first exposure, and then set the exposure counter to 1. After that, winding on can be accomplished without use of the red window until the end of the film is reached, when the backing paper must be watched through the window until the end is seen. With an expendable film, you can quickly make sure whether any given camera will suit you and your photography in practice.

Where do you start when choosing a folding camera?

The fundamental question you must settle before you buy a folding camera is what you plan to use it for most. If your primary objective is to produce the largest possible colour transparencies for reproduction in magazines or brochures from a comparatively lightweight and compact camera, then you need the highest-quality 6cm x 9cm camera you can buy –

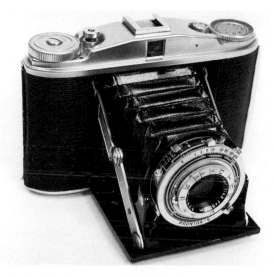

This is the **Agfa Isolette II** *with which the picture of the 'Viking Boat' fairground ride on page 171 was taken. It was one of a series of Isolette cameras, the Isolette I having a simple shutter and f/6.3 lens, the Isolette III having a built-in but uncoupled rangefinder, and the Super Isolette having coupled rangefinder and a first-class four-element f/3.5 Solinar lens in Synchro Compur shutter. This camera has an 85mm f/4.5 three-element Apotar lens in a Prontor S shutter with speeds from 1 second to 1/300th second, although a version with 4-element f/3.5 Solinar and Prontor SVS also exists.*

which does not necessarily mean the most complex. Engineering and optical quality are more important than elaborate features, and some of the best 6cm x 9cm folding cameras for colour work, in my experience, are the post-war Voigtländer **Bessa II** (if you can find one), the Agfa Super Isolette, the Zeiss Ikonta M, which has an f/3.5 Novar and an uncoupled rangefinder, and the Ensign cameras with f/3.8 Xpres. Although a Bessa II would prove expensive, because of the interest of collectors, and a Super Isolette is likely to cost around £130 ($160+) at 1994 prices, the others sell for a fraction of the price of a late 6cm x 9cm Super Ikonta, which, while undoubtedly the best camera of its class, is also a very expensive piece of equipment, fetching as much as £350 ($500) on the collectors' market.

If, on the other hand, you want to project rollfilm transparencies taken with your folding camera, then you should opt for equipment producing 6cm x 6cm transparencies (or negatives) of the most-used professional rollfilm format, which can therefore be projected by any of the commercially available 6cm x 6cm slide projectors. My personal favourites among 6cm x 6cm folding cameras are a Zeiss **Nettar** with f/4.5 Novar, which cost me £8 in 1984, and my Voigtländer

Perkeo with f/4.5 Vaskar, which was bought for £15. However, you may be just as well served by an **Agfa Isolette II** or III, or, if you can find a good example, by a Super Baldax, although these last should be treated with a modicum of caution.

Should you simply want to produce largish black-and-white or colour negatives with the smallest and most compact camera you can find, then buy one of the 16-on-120 cameras, of which the Super Ikonta of that format is by far the best known and easiest to obtain, although Japanese cameras such as the Semi-Minolta are sometimes available in the USA. Unfortunately, the late version of the 16-on-120 Super Ikonta is a rarity, and usually unobtainable, but the immediately post-war Super Ikonta of pre-war type and design, with coated lens and synchronized shutter, is quite frequently available on the secondhand market.

How about movements?

Two further alternatives in the area of medium-format rollfilm cameras are the technical and press cameras, designed for use either as a coupled-rangefinder press camera in the hand, or as a field camera on a tripod, making use of a substantial range of camera movements. Which of these movements is available depends on the make and type of the camera. A 'press' camera normally offers swing and tilt back, either with no movement of the lens panel at all or with very little movement, whereas a technical camera usually provides (in addition to swing and tilt back) rising and falling front, by which the lens axis is raised above or dropped below the centre of the film; cross front, by which the camera lens can be moved sideways from the centre of the film; and swing front, by which the lens is twisted out of parallel with the film.

The best-known classic technical medium-format camera is the **Linhof** Super Technika 6x9, which has been manufactured in several versions, each of which provides a coupled rangefinder connected to each of up to three lenses (which have to be individually matched to the rangefinder cam of the camera by the manufacturer). The numbers of the lenses that have been matched to a given camera are engraved by Linhof on the rangefinder cam, which is beneath the camera 'bed', and can be seen between the rails on which the lens standard moves. Always check, when buying a Linhof, that the engraved numbers on the rangefinder cam match the numbers of the actual lenses that you have been offered. The business of getting unmatched lenses matched to a Linhof can be expensive, although Linhof in Germany, and their

various overseas agencies, have the reputation of being among the most helpful of camera suppliers.

A slightly more lavish, but less versatile, cousin is the Linhof Technika 70, which has fewer movements at the front of the camera, but sports built-in brightline viewfinders and an excellent exposure meter within the top-plate of the camera. The Technika 70 is an easier camera to use in the hand, but is less effective as a technical camera than the Super Technika. Either of these Linhof cameras can be used with cut film in double dark slides, or with 120 or 220 rollfilm in the appropriate Linhof Super-Rollex backs, which are available either to provide ten exposures 6cm x 7cm,

or eight exposures 6cm x 9cm. Readers with a liking for complication may also care to try the Cine-Rollex back, which provides fifty-four exposures 6cm x 7cm on 70mm perforated film in a special cassette, but please don't bring your troubles to me should you try it!

Less expensive are the Mamiya and Bertram press cameras, which have no front movements, but do provide a limited degree of swing and tilt back. The Mamiya is the better practical proposition, since lenses and film backs are still available to fit it, both new and secondhand. The **Mamiya Press** has never been a particularly popular camera, and examples of

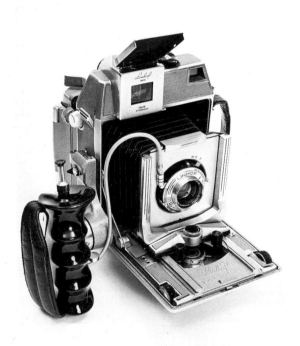

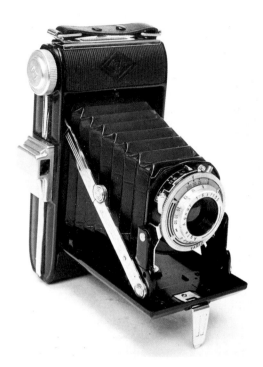

A **Linhof** *'Baby' Technika IV 6cm x 9cm technical camera is a beguiling instrument capable of first-class results in expert hands, but also of equally outstanding disasters if the photographer has not learned how to use the camera properly. This example is fitted with the 105mm f/5.6 Schneider Symmar, a lens designed to provide maximum coverage, and thereby to allow the photographer to make maximum use of the technical-camera movements, which cause the recorded image to be taken from other than the centre of the field of the lens. For general photography, a 100mm f/2.8 Planar or Xenotar, which does not permit such great technical-camera movement, might be more appropriate. In this picture, the camera is fitted with the anatomical grip, for hand-held use, and a Super-Rollex 6cm x 7 cm 'ideal-format' back, giving ten exposures on 120 film.*

Agfa manufactured a range of 6cm x 9cm folding cameras in the fifties, of which this Agfa Billy Record is one of the simplest. It has a 105mm f/6.3 Agnar three-element lens in a Vario three-speed shutter, but is, within the limitations imposed by the modest maximum aperture of its lens, capable of first-class results.

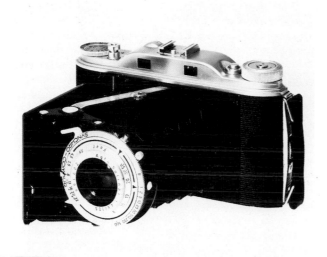

Top of the Agfa range of 6cm x 9cm cameras was this Agfa Record III, which has, in addition to an uncoupled rangefinder, a first-class four-element 105mm f/4.5 Solinar lens and a Synchro Compur shutter. This camera has been used by Colin Glanfield for quite sophisticated professional colour work, and yet is probably worth only £70 sterling ($100) In 1984. Picture by Colin Glanfield.

*Not a folding camera, but appropriate to be mentioned at this point, is the **Mamiya Press**, an underrated and unfashionable camera that provides back movements and a coupled rangefinder, and has a range of high-contrast lenses available for it from 50mm to 250mm. This is one of the original grey Mamiya Press cameras of the mid-sixties, which can be bought quite cheaply. A range of interchangeable 6 x 7cm and 6 x 9cm rollfilm backs was available.*

the original grey camera of the sixties are often available at extremely reasonable prices.

Is a folding rollfilm camera for you?

However accustomed one may be to gadgets and complexity, even in classic cameras, there is a certain appealing charm and simplicity about using a medium-format folding camera. Since folding rollfilm cameras are available very cheaply, I would suggest that you find a good example with which you feel comfortable, and simply keep it for occasional use. A Nettar, Isolette, Perkeo or Ikonta in the pocket is an excellent insurance against being caught without your camera

when something interesting happens, and is a very pleasant camera to use when time is not pressing. I would not, however, recommend a medium-format folding camera as an adequate alternative to one of the more versatile classic cameras, such as a Leica, a Contaflex single-lens reflex or a Rolleiflex, unless lightness and compactness are the principal requirements – as they might be, for instance, when mountaineering – or unless the size of the rollfilm-format transparency is important for reproduction reasons. If it is not, and compactness is the principal criterion, you may well be better served by one of the even more compact folding 35mm cameras, which form the subject of the next chapter.

The studied production of pleasing pictures with a simple yet fine-quality folding camera can be extremely satisfying. This typically English pub in Tunbridge Wells, Kent, is a location that I returned to several times over a period of two or three days before I found the combination of light and people that made the picture work. Taken with a post-war Voigtländer Perkeo 6cm x 6cm folding camera fitted with a coated 75mm f/4.5 Vaskar.

Opposite above: A candid picture shot from the waist with estimated focusing so as not to alarm the subject, whose ability to stand up might conceivably have been limited by the wet paint anyway – I did not wait to find out. Taken with a Super Ikonta III, with 75mm f/3.5 Novar.

Opposite below: The beautifully massive steam traction engines that once pulled loads on roads all over Britain are collectors' pieces in their own right. This picture was taken at a traction-engine rally in Sussex with an Ensign Selfix 820 (6cm x 9cm), fitted with 105mm f/3.8 coated Ross Xpres – a camera which benefits from subjects that are not given to rapid movement, since it is fairly ponderous to handle.

Opposite: *Fairground rides are always good for a picture or two. This one was photographed in Scarborough, Yorkshire, in 1984, with an Agfa Isolette II (6cm x 6cm), fitted with 85mm f/4.5 Apotar. To get subjects of this sort sharp with cameras providing only modest maximum shutter speeds, wait until the peak of the swing causes the subject to be momentarily stationary, and shoot at that moment.*

The beauty of fine automotive engineering photographed at a Rolls-Royce rally at Bethany School, Kent, with a 6cm x 6cm Zeiss Nettar with 75mm f/4.5 Novar. While taking photographs at this rally, I gradually acquired a team of schoolboy helpers, one or two of whom were very interested in classic cameras for their own sake. Using folding cameras well for home-processed black-and-white pictures is a form of comparatively low-cost creative endeavour that is ideally suited to schoolchildren, since an enlarger is not totally necessary, at least until the hobby is established. Contact prints of 6cm x 6cm negatives can be very acceptable.

Action of a different kind, captured by a Super Ikonta III at 1/300th second during a summer garden badminton lesson. The shuttle has almost reached the racket, and the little girl – my daughter Holly – is moving rapidly as she stretches to achieve the shot. Some subject movement is inevitable in a shot of this sort, in which the model is moving across the field of view. Taken with 75mm f/3.5 Novar.

One curious advantage of the folding camera in this era of electronic single-lens reflexes is that nobody takes you seriously, or concerns himself with what you do, if you produce an ancient-looking camera with bellows. These boys at first thought I was part of the exhibition, and then disregarded me completely as I took several pictures of their interest in the model-builder's work. Shot with a Super Ikonta III (6cm x 6cm) with 75mm f/3.5 Novar and Prontor SVS.

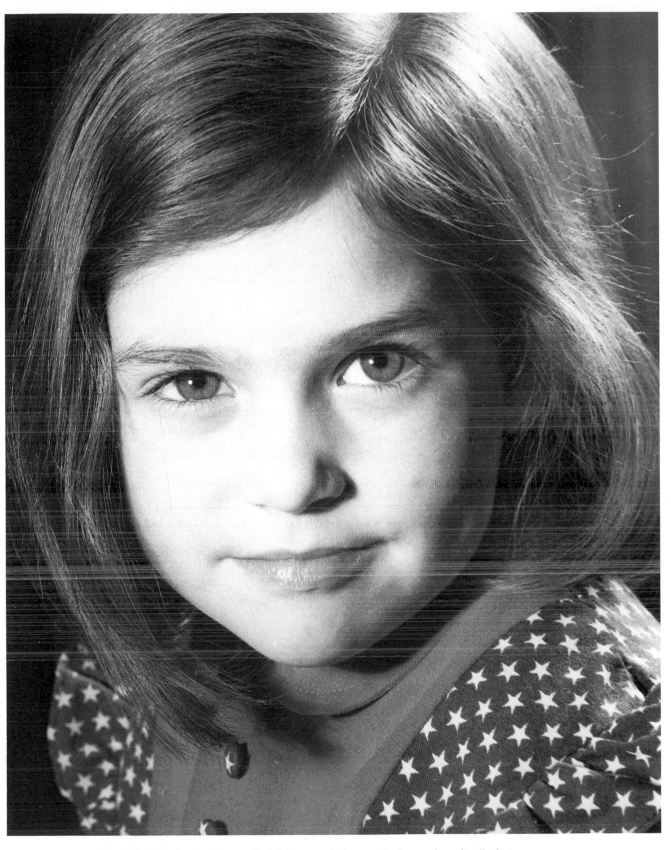

The Linhof Technika 70, used with its coupled rangefinder and studio flash, is an excellent, if expensive, piece of equipment for formal portraiture. This picture of a five-year-old Holly Matanle was taken using the 100mm f/2.8 Zeiss Planar and two flash-heads with brollies.

Chapter 11

Classic photography in your pocket – the 35mm folding camera

I described at the beginning of the book the birth of the Retina 35mm folding camera in the mid-thirties as one of the major contenders for the 35mm market of that time. The success of the Retina established beyond doubt that the proven principle of the folding camera, hitherto reserved for the 6cm x 9cm format and larger, could be even more successful as the basis for the design of 35mm cameras than it had been for larger formats, and other manufacturers were not slow to attempt to emulate the Kodak/Nagel success story. None of their folding cameras achieved fame or commercial sales comparable to those of the Kodak Retina before the Second World War, although, after the war, Voigtländer, Agfa, Zeiss and, to a lesser extent, Balda made substantial inroads upon the 35mm folding-camera market dominated by the Retina.

Despite this loss of market share in the fifties, there can be little doubt that the story of the 35mm folding camera is, essentially, the saga of the Retina and its quite remarkable number of models and sub-models. The invaluable *Collector's Guide to Kodak Retina Cameras*, published by the Petersen Publishing Co. of Los Angeles in 1973, lists thirty separate types of Retina camera, excluding the Retina Reflexes and Retinettes. To be fair, no fewer than nine of these are sub-versions of what any normal camera user would term a **Retina I**, but the point is nonetheless valid. One can trace the development of the 35mm folding camera by following the Retina story, which began with that sequence of Retina I cameras, initially black and without a shutter release on the body, then chrome, then with a body release, and finally (in 1950) with a flash-synchronized shutter.

The Retina lineage

In 1936, the **Retina II**, essentially a Retina I with the addition of a coupled rangefinder and an f/2.8 lens instead of the f/3.5 lenses of the Retina I, had been launched, and this too went through a succession of versions until, just after the war, it was available with a choice of f/2 lenses and a flash-synchronized shutter.

The year 1951 saw the first major redesign of the Retina cameras, and the launch of the **Retina Ia** and IIa. These provided two major advances by comparison with the earlier models, in addition to a great many minor improvements. The new cameras had lever-wind, instead of the knob-wind of all previous Retinas, and no longer required the shutter to be cocked separately. Most Ia and IIa models have an X-M synchronized Synchro Compur shutter, but it is worth checking this, as some early models had the X-synchronized Compur Rapid – a perfectly adequate

*This Kodak **Retina I** (Stuttgart Type 148) is typical of the immediately pre-war Retina I cameras that are still comparatively common in both Europe and the USA, although this particular type was manufactured only from March 1939 to December 1940. It is fitted with 50mm f/3.5 uncoated Ektar in a Compur shutter, and is in full working order.*

shutter, but generally accepted as making the camera worth slightly less than the commoner Synchro Compur type. A Retina Ia or IIa in really good condition remains one of the most effective and compact 35mm cameras available on the classic market, and they can be obtained at quite reasonable prices if you shop around.

That remarkable photographic year 1954, which saw the coming of the Leica M3 and the launch of many other significant cameras, brought three new Retinas. The **Retina IIIc** (correctly written with a small, lower-case 'c') was launched as the first Retina with interchangeable lenses, and was the first with a built-in exposure meter. It was also the first to have its film-transport lever moved from the top to the base of the camera. Supplied with a 50mm f/2 Retina-Xenon C or Retina-Heligon C as the standard lens, the Retina IIIc could be fitted with either the 35mm or 80mm f/4

accessory lenses, or the minuscule 35mm f/5.6 wide-angle lens, all of which were described earlier in the section referring to the original Retina Reflex, whose lenses were cross-compatible with those of the Retina 'c' series. A separate shoe-fitting multi-focus viewfinder was supplied to indicate the field of view of the 35mm and 85mm lenses when they were fitted to the Retina IIIc. Despite this versatility, the new coupled-rangefinder Retina was little larger than a Retina IIa, and was almost as compact when folded.

With the IIIc was launched a Retina IIc, with an almost identical specification, differing only in that it did not have a built-in exposure meter and was supplied with an f/2.8 Schneider Retina-Xenon standard lens, rather than the f/2 lens of the IIIc. The standard lens of the IIc was, nonetheless, also interchangeable with the 35mm and 80mm accessory lenses. The new non-rangefinder model, launched at the same time, was not known as the Retina Ic, which might have been seen as logical, but as the Retina Ib. This distinction was probably drawn because the standard lens of the Ib was a 50mm f/2.8 Retina-Xenar (as distinct from Xenon) which, although the front element could be removed, was not able to accept the 35mm and 80mm accessory lenses.

In 1957, the Ib was confusingly replaced by the **IB**,

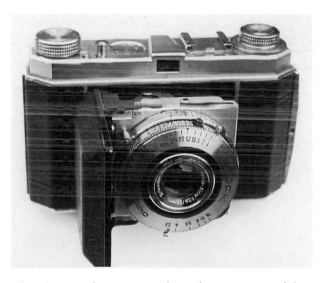

*After the war, the transition from the Retina I model to the much-improved Retina Ia happened gradually. This is a **Retina I** (Stuttgart Type 013), probably manufactured in 1950, which has a top-plate and shutter-housing fascia shaped exactly like those of the subsequent Retina Ia, but retains the knob-wind of the Retina I. The lens is a 50mm f/3.5 Xenar, mounted in a synchronized Compur Rapid shutter.*

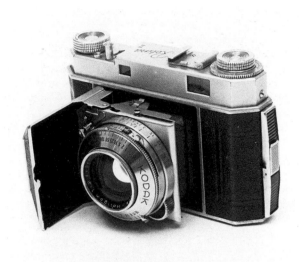

*The **Retina II**, effectively a Retina I with the addition of coupled rangefinder and a larger-aperture lens, also went through a series of changes before the Retina IIa appeared. This is the last of the Retina II models (Stuttgart Type 014), a post-war camera which was made between mid-1949 and January 1951. It is fitted with a coated 50mm f/2 Heligon, although similar cameras can be found with the 50mm f/2 Xenon, and has a Compur Rapid shutter.*

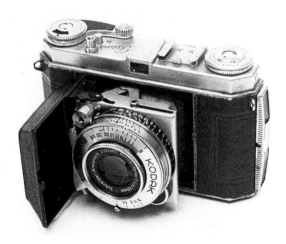

*The **Retina Ia** was introduced in January 1951 with leverwind and flash-synchronized Compur Rapid shutter (Stuttgart Type 015), but in July 1951 that initial model was succeeded by this far more common type, which is similar but is fitted with the Synchro Compur shutter. The Retina Ia is to be found with several different f/3.5 lenses, or with the 50mm f/2.8 Retina-Xenar which is fitted to this particular camera. The Retina Ia is a sound and reliable camera, as is the Retina IIa, which is similar to this, but with the addition of a coupled rangefinder and 50mm f/2 lens.*

which had a built-in exposure meter, and in 1958, a further version, still termed IB, replaced the 1957 model and added a brightline viewfinder system to the specification. The IB now looked remarkably like the new (and even more confusingly named) Retina IIIC (i.e., a capital 'C'), which was a developed version of the previous IIIc, improved by the addition of a multiple brightline viewfinder system within the camera to provide brightline frames for the 35mm, 50mm and 80mm lenses, and thereby obviating the need for the separate multiple viewfinder. At the same time in 1958, a IIC replaced the IIc, providing the same integral viewfinder system as that in the IIIC, but lacking the built-in exposure meter.

The Retina IIIC represented the pinnacle of Retina folding-camera design, but, with the infernal logic for which the purveyors of the little yellow box are renowned, a mere pinnacle was not enough. Kodak launched, also in 1958, an entirely new Retina system, the non-folding, rigid Retina IIIS, with interchangeable lenses cross-compatible with the Retina Reflex S. The IIIS, offering as it did fully interchangeable lenses (the entire lens, not just the front element, being replaced) from 28mm focal length to 200mm, should have been a great success. The fact that it was not was in fact a tribute to the devoted following of the folding cameras, which are today, in the case of the IIIC, worth appreciably more than the apparently technically superior Retina IIIS.

Other contenders for the Retina's crown

Although there were available before the Second World War the Zeiss Ikon Super Nettel, several Certo Dollina folding models, the first Voigtländer Vito, the Welta **Weltini** with coupled rangefinder, and the Balda Baldina and Super Baldina cameras, among others, there had been no serious commercial challenge to the dominance of the Retina in the hearts of the folding-camera cognoscenti. After the war, Voigtländer, Agfa and the new West German Zeiss Ikon in Stuttgart set about the problem with renewed vigour and began, by the early fifties, to produce fine folding cameras which even today represent a clear alternative to the Retina models, and which are, in some ways, preferable to them.

Voigtländer

The original folding Voigtländer Vito appeared in 1940, so was pre-war in US terms, but wartime as far as Britain was concerned. Fitted with an uncoated f/3.5 Skopar lens, its mechanical quality was not good, and examples of the original Vito rarely performed well,

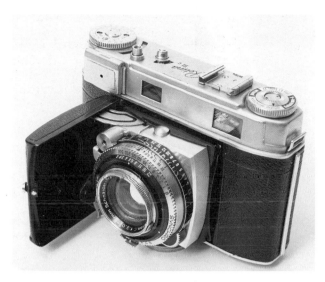

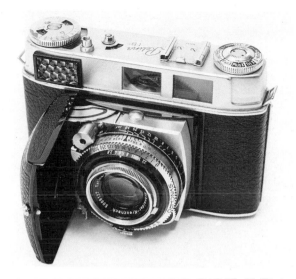

In 1954, the Retina IIa gave way to the Retina IIc (Stuttgart Type 020) and IIIc (Stuttgart Type 021). Shown here is the **Retina IIIc** used to take several pictures for this chapter. It has a selenium exposure meter built into the top-plate, coupled rangefinder and an interchangeable (front element) 50mm f/2 Retina-Xenon C lens in Synchro Compur shutter. The wind lever is on the base-plate of the camera. A Retina IIc is identical except that it does not have an exposure meter, and that it is fitted with a 50mm f/2.8 lens instead of the f/2 lens. The later Retina IIIC (big C) of 1958 can be identified by its having two much larger 'windows' in the front of the top-plate.

Looking very much like a Retina IIIC is this **Retina IB** (Stuttgart Type 019), introduced in 1957. This has a five-element 50mm f/2.8 Retina-Xenar lens of very high quality in a Synchro Compur shutter, but no rangefinder. The exposure meter is similar to that in a Retina IIIC.

even when quite new. In 1949, Voigtländer tried again with the Vito II, which looked very similar to the original Vito, but had a far superior 50mm f/3.5 Color-Skopar and significant mechanical improvements which made it a reasonably reliable camera.

In 1950, the **Vito III** appeared, a coupled-rangefinder camera fitted with the excellent 50mm f/2 Ultron lens in a body quite different from that of the Vito II, and which seemed to be related in production terms more to the Voigtländer Prominent than to the rest of the Vito series. The Vito III is quite scarce, but is an excellent and reliable camera.

Finally, in 1955, came the Vito IIA, the best of the folding Vito cameras, with the smooth all-enclosed top profile similar to a Vito B. Equipped with lever-wind, and at last a thoroughly reliable camera, the Vito IIA was fitted with the 50mm f/3.5 Color-Skopar in a Prontor SVS shutter, and is a camera to be recommended.

Quite different, and yet still (in most cases) a Voigtländer folding 35mm camera, was the **Vitessa**.

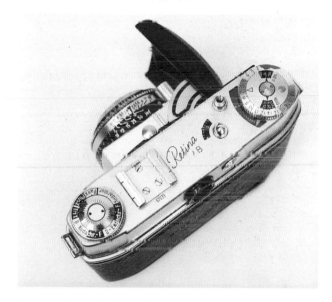

The top view of a **Retina IB** shows clearly the neat layout and easily read exposure meter and exposure counter (which counts back from 36 rather than upwards from 1). Presumably to increase sales of film, Kodak made the Retina B (b) and C (c) models cease to function when the counter reaches 1, and thirty-six exposures have been used. With most other 35mm cameras, it is straightforward, if the camera is loaded frugally, to obtain thirty-seven, or even thirty-eight exposures from a thirty-six-exposure cassette of film. The Retinas make this difficult to achieve.

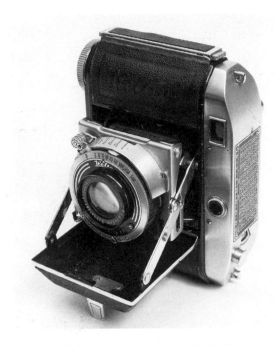 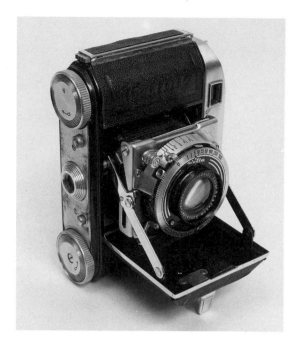

*An interesting feature of the pre-war **Weltini II** illustrated here is that the focusing mount automatically returns to infinity when the camera is closed. Most folding cameras, including the Retina models, must be manually reset to infinity focus before the door is closed. This particular Weltini II, a model which was available in 1938, has a 50mm f/2.8 uncoated Schneider Xenar in a Compur Rapid shutter, but there was also a highly desirable version with 50mm f/2 Xenon. Either type has coupled rangefinder.*

*The wind and rewind knobs of the **Weltini II** are both on the base of the camera, as seen here. The upper knob protruding from the base-plate in this picture opens the camera, the lower one has to be pressed after each exposure to manually release the double-exposure interlock, so that the film can be wound on. The shutter is cocked manually by the lever just above the shutter-speed engraving.*

One of the most original and innovative designs of the fifties, the Vitessa had two 'barn doors' instead of the usual single door, and was designed, as the name suggests, for speed. If the user is sufficiently practised, it remains one of the fastest of all non-motorized cameras. The speed is derived from the fact that the focusing of the coupled rangefinder is carried out using a knurled knob at the back of the camera top-plate, actuated by the user's right thumb, all film transport and shutter cocking is effected by a single thrust of a tall plunger placed under the left fore-finger, and the shutter is fired with the right fore-finger. Once the photographer has grasped the sequence, and mastered the necessary co-ordination, it is a straightforward operation to take pictures at a rate of two per second.

The original Vitessa, launched in 1950, was supplied either with an f/2.8 Color-Skopar lens (US price in 1956 $140) or the top-quality f/2 Ultron (US price in 1956 $160). It was followed by the Vitessa L, which was a similar camera but was fitted with a built-in selenium exposure meter. Extraordinarily, in the magic year of 1958, when the world seemed to turn against folding cameras, Voigtländer launched the non-folding Vit-essa T, superficially a Vitessa L with a rigid 'nose' for the lens and shutter, but in fact a much-modified camera with a limited range of interchangeable lenses – the 100mm f/4.8 Dynaret and the 35mm f/3.5 Skoparet.

Any Vitessa should be reliable if it is in sound condition, although the ratchet by which the film-advance plunger is supposed to be held down if pressed gently before the case is closed will frequently be found to be defective. This is no more than a nuisance, but it is obviously better if one can locate a camera in which the plunger will stay put. The f/2 Ultron is a superb lens, and the effort of finding a Vitessa fitted with it will be well repaid – although that should not be taken to mean that the alternative Color-Skopar is anything less than excellent.

Agfa

Before the Second World War, Agfa had manufactured a successful range of moderately priced folding lazy-tongs cameras under the name Karat. Although taking standard 35mm film, most of the Karat models required it to be loaded in special twelve-exposure 'Karat cassettes' – essentially the same cassette that was relaunched in the sixties and seventies, and is still available, as the 'Rapid' cassette. Of the four pre-war twelve-exposure models, three were of similar appearance – with f/6.3 Igestar, f/4.5 Oppar and f/3.5 Solinar – and the fourth had coupled rangefinder and an f/2.8 lens, usually a Schneider Xenar, in a much superior body. In passing, it is worth noting that the three apparently similar cameras are anything but similar in terms of reliability. The f/6.3 version rarely works at all, the f/4.5 camera is usually serviceable, and the f/3.5 Karat, fitted with either a Compur or a Compur Rapid shutter, can be very reliable. The f/2.8 version is usually sound, if you can find an example reasonably free from wear.

This series was not continued after the war, but the coupled-rangefinder camera was redesigned to accept standard thirty-six-exposure cassettes of 35mm film, and was launched in 1951 as the Karomat 36 (in the USA) or Karat 36 (in Europe). This much-improved model had an f/2 Xenon or Heligon lens, is faster to use than most other folding cameras because the front springs forward instantly into the taking position when a button is pressed, and is usually reliable. It can be an excellent piece of equipment for a classic-camera enthusiast to use.

The remainder of the Agfa contribution to the folding-camera market was less dramatic, consisting essentially of two very pleasant cameras, the **Solinette** and the Super Solinette, which, unlike most other 35mm folding cameras, opened from the top downwards rather than to one side. The Solinette had no rangefinder or exposure meter, and was fitted with a 50mm f/3.5 Solinar four-element lens in a Prontor SVS shutter. It was unremarkable as a camera, but reliable, well made and capable of excellent results. Its chief quality is that of being a pleasant camera to hold and use. The Super Solinette was a coupled-rangefinder version of the same design, fitted with the same lens in a Synchro Compur shutter.

Zeiss

As usual, the principal Zeiss Ikon contribution to the battle, the folding **Contessa**, was significant, complicated, appealing and not particularly successful commercially. It was not the first post-war Zeiss folding

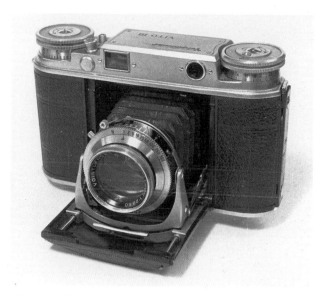

The Voigtländer **Vito III** of 1950 is not easy to find, but is a fine camera if you can locate an example. The body is akin to that of the Voigtländer Prominent (see Chapter 12) and, with coupled rangefinder, 50mm f/2 Ultron lens and Synchro Compur shutter, the Vito III is capable of top-quality results. Make sure that the front lens standard is rigid when the camera is in the taking position, as it is here. Picture by Colin Glanfield.

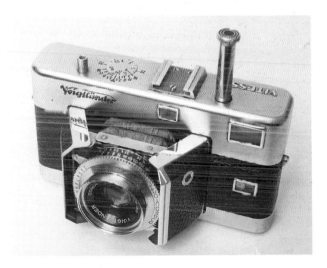

The Voigtländer **Vitessa** was introduced in 1951 and was manufactured in a number of versions – this is the folding type without an exposure meter. A Vitessa is a strange-looking camera, but it is effective and comfortable to use. The short button on the left is the shutter release; the tall plunger on the right both winds the film and cocks the shutter. This particular example has a 50mm f/3.5 Color-Skopar in a Synchro Compur shutter. The same type of camera can be obtained with a 50mm f/2 Ultron, and is a very desirable piece of equipment.

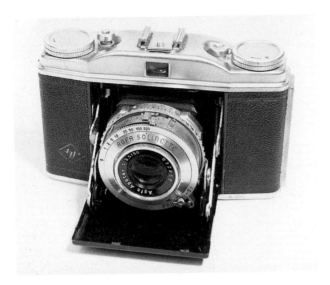

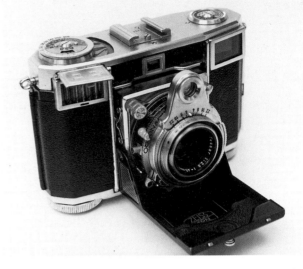

The Agfa Solinette and Super Solinette were current in the mid-fifties and, although the external finish is sometimes in poor condition, the mechanism and optics have usually stood the test of time very well. This is the standard Solinette, with a good-quality 50mm f/3.5 Apotar lens and Prontor SV shutter. The Super Solinette looked similar, apart from its having two 'windows' in the top-plate for its coupled rangefinder, but was equipped with the four-element 50mm f/3.5 Solinar lens in a Synchro Compur shutter.

The folding Contessa was introduced in 1950 with flash-synchronized Compur Rapid shutter, and was fitted with the Synchro Compur with XM synchronization from 1952 until production ceased in about 1955. The wind and rewind knobs are on the base-plate of the camera.

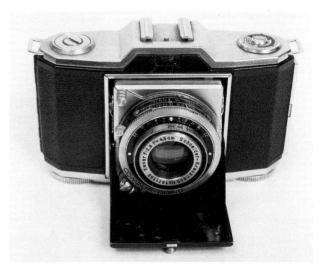

35mm camera, as there had been a folding **Ikonta 35**, subsequently renamed the Contina before that name was reapplied to a series of rigid-front viewfinder cameras. But the Ikonta 35, pleasant camera as it undoubtedly was, had not made any impression upon the Retina fraternity, and when Zeiss Ikon launched the folding Contessa, great hopes were pinned upon the design.

The Contessa owed much to the Super Ikonta for its mechanical and optical features. With a 'door' which opened from the top downwards, it had a first-class 45mm f/2.8 Tessar lens, a Synchro Compur shutter, and a selenium exposure meter built into the top-plate of the camera. The coupled rangefinder followed the Super Ikonta practice of having a circular rotating wedge prism in a 'spyglass' above the lens standard, and was very accurate and quick to use. A disadvantage from the user's point of view is the curious location of the shutter release on the shutter housing, rather than on the body of the camera.

The interest of collectors has kept the price of the folding Contessa fairly high, but it is an excellent, usable and reliable camera that is likely to appreciate in value.

*The post-war Zeiss **Ikonta 35**, manufactured from 1948 to 1954, was usually fitted with either a 45mm f/3.5 Novar or a 45mm f/2.8 Tessar lens, but, in a few of the very early examples, a 45mm f/2.8 uncoated Schneider Xenar was fitted. Some of the cameras made towards the end of the production of the model were marketed as the Contina I, and a scarce version with built-in uncoupled rangefinder was marketed as the Contina II. That aside, the Ikonta 35 is a pleasant camera, although using the shutter release at the top left-hand corner of the lens standard (as one looks at it in this photograph) takes a great deal of practice.*

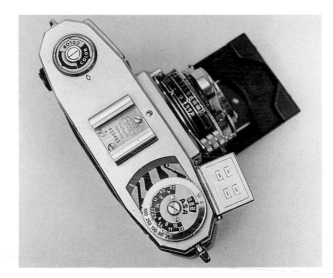

The exposure meter of the Contessa provides direct readings of shutter speeds against apertures, rather than the annoyingly obscure light-value readings of the Retina meters. The shutter release of the Contessa is, like that of the Ikonta 35, at the top corner of the lens standard, and can be seen here next to the flap of the exposure meter, which is opened to permit low-light readings to be taken. In sunlight, readings are taken with the flap closed.

Balda

This West German manufacturer, always at the budget end of the market, produced a number of attractive-looking folding cameras in the fifties, notably the Baldinette and the Super Baldinette, a version with coupled rangefinder. The lenses fitted to these cam-

eras, usually the Schneider three-element Radionar or an equivalent, were not of high quality, and the mechanical production standards to which they were built were relatively poor. If you happen to locate a Baldinette or Super Baldinette that has been little used, it is pleasant to own, but I would not recommend Balda cameras of the fifties as sound cameras for long-term use.

So which folding 35mm camera is the best buy?

It has to be said that a Retina IIIC or IIC (big or small 'c') is hard to beat as a reliable, top-quality 35mm folding camera with interchangeable lenses, all the more so as there is no other type of folding camera available with interchangeable lenses. The Retina IIC is in some ways a better buy than the IIIC, because the exposure meter of the IIIC is connected to the aperture mechanism by a cord which occasionally has been known to break, and which is difficult and expensive to repair. The f/2.8 six-element Xenon of the Retina IIC is also of marginally better contrast and performance than the wider-aperture f/2 Xenon of the IIIC. Nonetheless, it remains true to say that either of the two models produces superb results, consistently and well, from a camera of minimal size. You will find that the 'small c' versions are available for far less money than the later 'large C' types, since collectors scramble for the last versions.

If the presence of the interchangeable lenses is unimportant, then it becomes difficult to make a firm recommendation, although I would favour the Voigtländer Vitessa. Many would prefer a Retina IIa or a Vito IIA, others more individual choices, like a Contessa or a Karat 36. All are capable of excellent results, and the choice is essentially a personal one. You simply have to decide which camera suits you best.

This candid picture was taken on London's Embankment with a Retina IIIc fitted with a 50mm f/2 Xenon, and would have been lost if the subject had become aware that he was being photographed. The camera was focused by estimation and fired from waist level. The result is an effective picture. Miniature folding cameras make it possible never to miss opportunities like this.

The Voigtländer Vitessa is an ideal camera for moving subjects, since the rapid plunger-wind makes it possible to secure several shots in sequence as the subject passes by. This handsome vintage delivery van was photographed with a folding Vitessa fitted with the 50mm f/3.5 Color-Skopar.

The intense concentration of a small boy driving a tractor is caught by the Voigtländer Vitessa, fitted with 50mm f/3.5 Color-Skopar.

Believe it or not, this yawning hippopotamus was photographed with a 45mm standard lens, an exercise which demands close proximity. The print is, as far as the proportions of 10'' x 8'' paper allow, from the whole negative. The camera was an Agfa Karat with f/4.5 Oppar lens.

Opposite: The folding camera is an ideal family camera, because it is unobtrusive and easy to carry, yet can produce high-quality results – which is more than can be said for most 110, disc or low-priced compact cameras available in the eighties. This picture was taken with a Retina IIIc fitted with a 50mm f/2 Xenon during a pause in a family bicycle ride.

As the sun set on the Battle of Hastings, re-run in 1984, this strikingly back-lit picture of knights intent on finding a pint of best bitter was shot with a Retina II, equipped with a 50mm f/2 Heligon. Picture by Gregory Matanle.

On location for the making of an industrial film, for which I was the scriptwriter, I filled idle moments by shooting pictures with a Retina IIIC. This study of cameraman Phil Mottram behind an Eclair 16mm camera shows the excellent sharpness of the 50mm f/2 Xenon lens.

My script caused a certain amount of discussion between television news presenter Peter Snow (left) and the director of the film. I kept quiet and took pictures. Shot with a Retina IIIC with 50mm f/2 Xenon.

The non-folding viewfinder classic – among the most reliable of all

The most underrated classic camera of them all is, as a class of camera, the simplest. It is certainly the most numerous, and, in the case of those that were well designed and engineered when first manufactured, is often the best preserved. Because, as a class, it is little regarded by collectors, most examples are available very cheaply. It is the simple non-folding viewfinder classic, a description that covers a great number of models, many fitted with sophisticated high-quality lenses and the best leaf shutters. As has already been observed, before the Second World War, the folding camera was the staple equipment of the amateur photographer whose resources were limited. After the war, that mantle fell upon the high-quality non-folding cameras – the Silette, the Vito B, the Contina, the Retinette, the Akarelle and the Akarex – and upon others of lesser quality but apparently similar specification, such as the Paxette, the Edixa, the Lordomat, the Futura and the Finetta. Some, like the Diax, the Akarelle and Akarex, the Lordomat and the Finetta, had an interchangeable lens, and were, in a sense, the basis of a system, although few of the additional lenses were sold, and they can now be decidedly difficult to obtain. Others, like the Zeiss Contina and the Paxette, sported interchangeable-lens versions at the top of the range.

I have already discussed, in Chapter 3, the fundamental advantages of the non-folding camera with non-interchangeable lens – accurately maintained parallellism and focus, no bellows to perish, resistance to knocks and the rest. So let us take a look at some of the alternative types, and compare what they have to offer to the classic-camera enthusiast now, after their first thirty years or so of use.

Zeiss Ikon

There can be little doubt that the Zeiss Contina series of rigid-front cameras was the best engineered of its class in the fifties, although their standards appeared to slip somewhat in the sixties and early seventies as the Zeiss Ikon company struggled to maintain its camera production against marketing pressure from Japan. The pivot of the range from 1951 onwards was the Contina, of which a series of models was manufactured concurrently. The simplest Contina I was normally fitted with an f/3.5 Novar, either in a Prontor eight-speed synchronized shutter or the Pronto four-speed synchronized shutter. The same camera was available with a built-in selenium exposure meter and Prontor SVS X-M synchronized shutter as the **Contina II**, and a further version was fitted with coupled rangefinder and an interchangeable 45mm f/2.8 Pantar lens, and marketed as the Contina III. The inter-

The Zeiss **Contina II**, sometimes (unofficially) called the IIa to distinguish it from the folding Contina II previously marketed by Zeiss Ikon, is a solidly built, heavy and reliable camera capable of fine pictures. Photographs taken with this actual camera feature in this chapter. It has a sensitive selenium exposure meter within the top-plate, and a 45mm f/3.5 Novar lens mounted in a Prontor SVS shutter, which provides speeds from 1 second to 1/300th second with XM flash synchronization and delay action.

The rigid Contina and Contessa series of the early sixties lacked the feel of fine engineering of the earlier Contessa and Continas, but were, and are, reliable cameras capable of first-class results. This **Contessa LKE** has coupled rangefinder and a built-in exposure meter with a needle-centring read-out in the viewfinder.

The top-plate of the **Contessa LKE** features a repeater window so that the exposure meter can be used without the eye being put to the viewfinder, and a flash-synchronization socket covered by a rotating cover, here swung to one side to reveal the socket beneath. Note the recessed leverwind.

The base of the **Contessa LKE** as it is when a film is being rewound. When the recessed rewind button is pressed, the rewind crank pops out of its recess ready for use. The figures visible around the underside of the lens mount are the ASA film-speed settings for the meter within the camera.

*The Agfa **Super Silette** of the first, mid-fifties type, used for the two pictures on page 198. A solidly made reliable camera, it has a 50mm f/2 Solagon in a Synchro Compur shutter, and an accurate coupled rangefinder. More common is a version with a 50mm f/2.8 Solinar lens. A later, redesigned Super Silette (illustrated in Chapter 3) lacks the good looks of this camera, although it does offer the benefit of a brightline viewfinder.*

changeable 30mm and 75mm f/4 Pantar lenses for the Contina III are identical with those for the Contaflex single-lens reflex of the early types fitted with an interchangeable Pantar lens, although sets of lenses for the Contina III were marketed in a neat case with an accessory viewfinder to fit in the accessory shoe of the camera.

At the end of the fifties, a new range of cameras appeared, all built using the same rigid body design, and with increasingly sophisticated features as one progressed up the range. The simpler cameras without a coupled rangefinder, but with a built-in meter, were named Contina and had the three-element Pantar f/2.8 lens; the more feature-laden models with coupled rangefinder, Tessar lens, automatic exposure and other devices, were named Contessa, although the engineering quality of the rigid-front Contessas is rather lower than that of the folding Contessa of only a few years before. Nonetheless, the rigid-front Contessa is a fine camera which performs extremely well. Its 50mm f/2.8 non-interchangeable Tessar seems by its performance (although I have found no way of verifying this) to be of the recomputed type that performs so well in the late models of the Contaflex and on the Contarex. Certainly, although the body of a **Contessa** LK or **LKE** feels more mass-produced than one was accustomed to expect of a Zeiss Ikon camera,

the pictures these models produce can be sharp and not lacking for contrast.

Agfa

The rigid-front cameras manufactured by Agfa in the fifties performed well, and were of a high standard of reliability, but their external finish was poor, and usually now appears rubbed and marked. The 35mm rigid-front cameras were the Silette and **Super Silette**, the former being produced in a succession of versions, all with the same name. Early Silettes were normally fitted with a coated f/3.5 Apotar in a Prontor SV or SVS synchronized shutter, and had a simple non-brightline viewfinder. No exposure meter was fitted. By the late fifties, the Silette had acquired a brightline viewfinder, there were versions with an exposure meter, and some were fitted with the less-than-exciting Agnar lens. Early Silettes seemed, like the Continas, to be aimed at serious amateur photographers who were not very well off, but who wanted to take good photographs. The later Silettes were aimed to a progressively greater degree at the snapshotter, and thereby, in my biased view, fall out of consideration as classic cameras.

The Super Silette was a much superior piece of equipment, although the external finish has suffered in exactly the same way as the lesser models. Usually fitted with an f/2.8 Solinar lens, there were a limited number supplied with an outstandingly good 50mm f/2 Solagon six-element lens in a Synchro Compur shutter, and one of these is a considerable 'find'. Though not worth a great deal (about £50 in Britain in 1984), the Super Silette with the f/2 lens has tremendous potential for quiet and unobtrusive available-light photography.

Various other rigid-front Agfa cameras, such as the Optima, were produced during the late fifties and early sixties, but do not really merit attention as classic cameras.

Voigtländer

It was, perhaps, in the field of the rigid-front camera that Voigtländer shone most, although one or two of their many designs are best avoided. The Voigtländer designers of the fifties were both innovative and demanding of high production standards, and thereby achieved a range of cameras of considerable reliability and performance that also 'felt' right – solid, well-engineered and sensibly balanced in the hand. I am aware that this is a subjective judgment with which some will disagree, but it is a view based on experience.

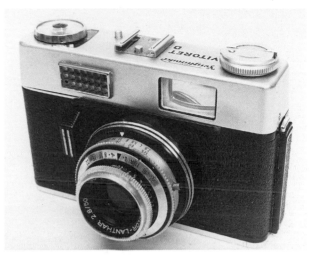

The neat and compact **Vito B** with which the two pictures on pages 196 (left) and 197 were taken. The external finish of the Vito B is much more durable than that of many cameras of its time, and they are often to be found in the near-mint condition of this very handsome example. It has a 50mm f/3.5 Color-Skopar lens in a Prontor SVS shutter.

Among the last of all true Voigtländer cameras manufactured were the Vitoret series of budget-priced rigid viewfinder cameras. Available from 1963 until 1971, there were six different types. This is a Vitoret D, with built-in exposure meter and a 50mm f/2.8 Color-Lanthar three-element lens, and is not really to be recommended.

The **Vito B** has a hinged base-plate which can be opened once the back has been unlatched. This makes the insertion and removal of cassettes of film considerably easier than it is with many other compact 35mm cameras.

The first, and most memorable, of the rigid-front Voigtländer cameras was the **Vito B**. Extremely compact and fitted with the 50mm f/3.5 Color-Skopar in a Prontor SVS shutter, the Vito B of 1954 is a true classic. One rarely finds an example that has anything wrong with it, other, possibly, than a need to have its shutter cleaned and lubricated. Its performance stands comparison with current cameras. In 1956, a modified version with a brightline viewfinder was introduced, and at the same time the Vito BL, a model with a built-in selenium exposure meter was launched. In 1957, a coupled-rangefinder model, the Vito BR, was introduced, but this, sadly, is quite rare.

In 1960, the Vito B was replaced by the Vito C, which had its shutter release on the front of the body instead of on the top-plate. This model is usually found fitted with the three-element Color-Lanthar lens, which is not of the standard of the Color-Skopar (although there are examples with the Color-Skopar), and lacks the feeling of quality imparted by the Vito B. A version with built-in meter was marketed in 1960 as the Vito CL, and the further addition of a coupled rangefinder produced the Vito CLR, the most desirable of the C series, often to be found with a Color-Skopar.

Automatic exposure setting, very much in vogue in the early sixties, was introduced in a series of Vitomatic cameras, based on the Vito B. The Vitomatic IA

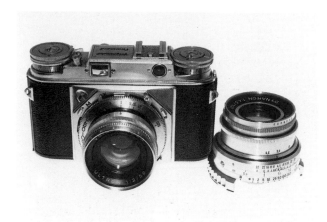

*The Voigtländer **Prominent**, although offered with only a limited range of interchangeable lenses, was a system camera of professional standard, introduced in 1950 and remaining in production, in several versions, until about 1960. Because it offered flash synchronization at all speeds, at a time when focal-plane shutter flash synchronization was not always totally reliable, the Prominent was used successfully by a number of well-known news photographers in the fifties. This particular camera is fitted with the 50mm f/2 Ultron, which exhibits very little flare for its period and produces extremely sharp negatives. Beside the camera is the 100mm f/4.5 Dynaron. Picture by Colin Glanfield.*

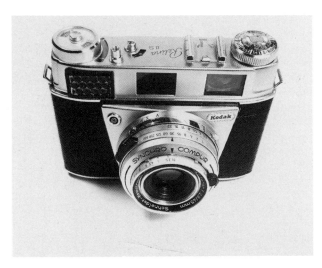

The Retina IIS, although masquerading as a sister of the interchangeable-lens Retina IIIS, is, in fact, little more than a Retinette fitted with a top-quality lens and shutter. Equipped with an interchangeable 45mm f/2.8 Xenar in a Synchro Compur shutter, the Retina IIS is capable of first-class results. Lesser, similar-looking cameras with Reomar lenses are not so exciting to own.

and Vitomatic II had no rangefinder, but offered automatic exposure controlled by a built-in selenium exposure meter – the difference between the two cameras was the more sophisticated shutter of the II. The IIA was a II fitted with a coupled rangefinder, and this model was later further improved to produce the Vitomatic IIB in 1967. All these were fitted with the 50mm f/2.8 Color-Skopar, and a Vitomatic III was therefore introduced in 1967 to provide a top-of-the-range model with an f/2 lens. Unfortunately, this camera is very scarce.

The Voigtländer Prominent

Although the post-war Voigtländer **Prominent** (there was a pre-war folding camera of the same name) was introduced in 1951 as an up-market 35mm rangefinder system camera to compete with the Leica and Contax, and could hardly be described as simple, it seems sensible to devote a few lines to this excellent camera at this point. The Prominent featured full lens interchangeability, and a limited range of lenses, with a behind-lens Synchro Compur shutter (although the first models had a synchronized Compur-Rapid) and an accurate long-base coupled rangefinder. The last of several versions featured a brightline viewfinder. A choice of standard lenses was available, the most expensive being the 50mm f/1.5 Nokton, a wide-aperture lens that provides unusually good contrast at f/1.5. The alternative lenses were the 50mm f/2 Ultron, and the 50mm f/3.5 Color-Skopar. In the other focal lengths, Voigtländer produced a 35mm f/3.5 Skoparon wide-angle, and a 100mm f/4.5 Dynaron long-focus lens, but did not go ahead with prototypes of a 24mm f/5.8 Ultragon (1950) or a 150mm f/5.5 Telomar (1955). Various other accessories were available, including the neat Turnit reversing viewfinder to provide for the 35mm and 100mm lenses (also supplied for the Vitessa T), and a reflex housing, for which a special 100mm f/5.5 Telomar lens was available.

A sound Prominent is an excellent camera, whose value is rising steadily. Check carefully the shutter-cocking mechanism of any Prominent before you buy, as this is prone to cause problems.

Kodak

During the late fifties, throughout the sixties and into the seventies, Kodak marketed a variety of ever-changing Retinette rigid-front viewfinder cameras, most of which were of high production quality, but few of which had lenses of a standard likely to be required by a serious user of classic cameras. The great majority of these Retinettes have a three-element

Schneider Reomar lens in either a Vario three-speed or Pronto four-speed shutter, and while comparatively reliable, have never been capable, because of the limitations of their lens performance, of producing work of particularly high quality.

There were, however, one or two models fitted with top-quality four-element Schneider Xenar lenses and Compur shutters which bear comparison with the Agfa Silettes and Zeiss Continas, and which, because they are little regarded by collectors, or (usually) even users, can be bought for a song. They are, therefore, a means of buying good performance for very little money. Finding a Retinette with a four-element lens and Compur shutter may not be easy, however, and, while you are looking, you may find something better. If so, I recommend you to buy it, and forget about the Retinette.

Aka

The West German-made Aka cameras, principally the **Akarelles** and the unique Akarex, are interesting, reasonably reliable, and were supplied with top-quality lenses from Schneider – the 50mm f/2.8 coated Xenar (Akarelle) or 50mm f/2 Xenon (Akarex) as a standard lens, and the 90mm f/3.5 Tele-Xenar as a long-focus lens. A wide-angle was also available,

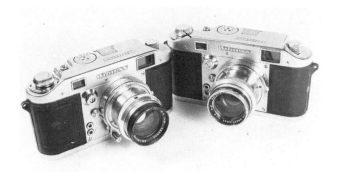

One rarely gets the opportunity of seeing one Ilford Witness, let alone two together. This British-made Leica-type camera of the fifties was not manufactured in great numbers, and is now very scarce, but was an eminently serviceable piece of engineering. The lens was a six-element 50mm f/1.9 Dallmeyer Super-Six, also of British manufacture, which, although of Leica thread, register and coupling, had a unique broken thread which enabled the standard lens to be inserted quickly in the manner of a bayonet-fitting objective.

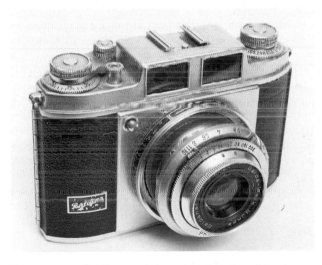

The post-war Baldina and the related series of Balda cameras of the fifties are not particularly well built, and often give trouble when some thirty years old. This Baldina is of the type whose lens is mounted on a spring-loaded tube, which springs forward when the button on the front panel is pressed.

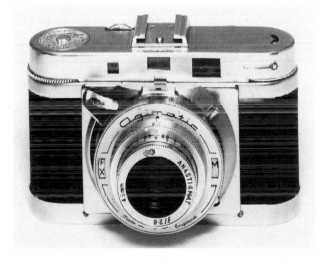

Also from Britain was the Agimatic, another of the post-war creations of the prolific designers of Aeronautical and General Instrument Co. in Croydon, which also produced three Agifold folding cameras and the Agiflex series of 6cm x 6cm single-lens reflexes, as well as a range of specialist cameras for the armed services. The Agimatic was fitted with a 45mm f/2.8 lens and a built-in extinction exposure-meter system. Picture by Colin Glanfield.

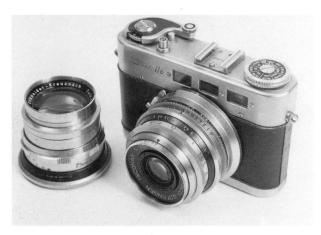

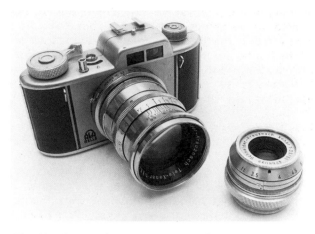

The **Diax IIB** has 50mm and 90mm viewfinders built into the camera, although they are separate optical systems and are not brightline viewfinders. This example is fitted with its standard 50mm f/3.5 Isconar, which is not to be recommended, and has beside it the 90mm f/3.5 Schneider Tele-Xenar, which is a very satisfactory objective. It was this Tele-Xenar that produced the portrait of Gregory Matanle on page 199.

The **Akarelle** is a pleasant camera with built-in 50mm and 90mm brightline viewfinders, and a limited range of top-quality interchangeable lenses. This example is fitted with the 90mm f/3.5 Schneider Tele-Xenar, and has the standard 50mm f/3.5 coated Xenar standing beside it. The shutter is a behind-lens Prontor SVS.

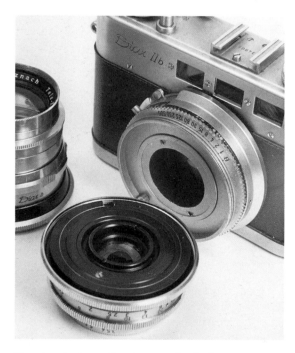

The simple, but effective, method of mounting **Diax** lenses can be seen in this photograph. The camera shutter housing has a short thread around its external circumference. The lens is located on to the shutter housing by a pin on the body engaging a slot in the lens mount, and the rearmost knurled ring of the lens is screwed on to the external thread.

although I personally have never encountered one. The Akarelle has full lens interchangeability, with a behind-lens Prontor SVS X-M synchronized shutter, and has both 50mm and 90mm brightline viewfinders built into the camera. The lens mount is interesting – a locating pin on the body mates with a slot on the rear face of the lens, and a freely rotating collar on the rear of the lens barrel simply screws home on to a male thread around the shutter housing.

The Akarex is a more sophisticated camera with coupled rangefinder, which, in a manner unique to the camera, has the viewfinder and rangefinder assembly for each lens as an integral part of the lens itself. Thus, when one changes the lens, one also changes the entire viewfinder assembly that would normally form part of the top of the camera body.

Diax

The **Diax** IIA, and the later **IIB**, first introduced in 1955, were 35mm coupled-rangefinder cameras with full lens interchangeability, and, unlike the Aka cameras, a full range of lenses to interchange. Offered with either the high-quality 50mm f/2 Xenon, or the resoundingly low-quality 50mm f/3.5 Isconar standard lens, the Diax could be fitted with a 35mm f/3.5 Schneider Xenagon, an 85mm f/4.5 Isco Isconar, a 90mm f/3.5 Schneider Tele-Xenar or a 135mm f/4

Schneider Tele-Xenar. The lens mount was on the same principle as that of the Akarelle, but the mounts are different, and the lenses are not interchangeable. Diax cameras are not spectacularly well engineered, and can give trouble, but they are quite fun to use if you are prepared to accept that they are cameras to own in addition to something better.

Paxette

The Braun Paxette series of 35mm cameras from West Germany, although they have devoted followers, can be decidedly troublesome. The first models, launched in the early fifties, had non-interchangeable Pointar, Kata and Steinheil Cassar lenses of indifferent quality, and, although this improved with the introduction of the Super Paxette with interchangeable lenses, they remained below standard of many cameras of the period. The Production and engineering standards of the early models was not as high as that of later types in the range. I would suggest that the early Paxettes be avoided as cameras for regular use, and that the later models be treated with some caution and checked carefully before purchase.

So which rigid-front viewfinder classic is for you?

The cameras reviewed here are, of course, only a small proportion of the total range that was available between the Second World War and the seventies. Nonetheless, I have tried to single out those which I feel qualify for serious consideration as usable classic cameras, and have balanced that by mentioning one or two well-known types which really do not, in my view, measure up to acceptable standards, either because they have not worn well, or because they were simply not very good cameras in the first place.

The hard truth is that you will enjoy classic cameras at their best only by buying top-quality miniature cameras that have stood the test of time. To me, in the field of rigid-front viewfinder cameras, that spells Zeiss, Voigtländer or Agfa, and I would be hard pressed, at the simpler end of the market, to choose between a Vito B and a good Contina. Further up the price range, the performance of the Super Silette with f/2 lens, and of the late rigid Contessa LK series cameras is not easy to beat, and the Voigtländer Prominent is superb, if you can both find a good one and afford it when you have found it.

Opposite: Crisp detail is essential in photographs of architectural subjects. One could not wish for greater sharpness than is shown in this picture of the spire of Salisbury Cathedral, Wiltshire, taken with a Voigtländer Vito B fitted with 50mm f/3.5 Color-Skopar.

Who says the Zeiss Novar cannot turn in a sharp picture? This shot was taken in Scarborough, Yorkshire, with a Contina II with 45mm f/3.5 Novar, and is a typical example of the type of outdoor photography at which the rigid viewfinder camera excels.

There is something romantic and secretive about a closed door in a garden wall. This particular door was also rather beautiful. I spotted it in the gardens of Wilton House while carrying a Voigtländer Vito B with 50mm f/3.5 Color-Skopar.

Rural fêtes and gatherings have a way of generating pictures, most of which are quite easily photographed with a camera with a fixed lens. This shot was taken with the same Agfa Super Silette with 50mm f/2 Solagon as the picture below.

This autogiro was moving quite briskly when I photographed it landing with the Agfa Super Silette illustrated on page 190, fitted with 50mm f/2 Solagon. By panning with the aircraft as it passed by, I was able to secure a sharp image, the blurring of the background helping to establish the impression of speed. It is very satisfying to shoot pictures like this with a camera with only a fixed lens.

Rangefinder cameras without the automatic parallax compensation of an 'M' Leica are not ideal for portraiture when used with a 90mm lens. However, with perseverance and practice, they perform well. This picture of my son Gregory was shot with the Diax IIB illustrated on page 194, fitted with the 90mm f/3.5 Tele-Xenar telephoto lens.

The skill of men at work is always a worthy subject for the camera. This shot was obtained by available light in the workshop with a Contessa LKE fitted with a 50mm f/2.8 Tessar – a sound, reliable and unglamorous camera.

The rush to escape the rain in the picturesque Shambles in York leaves the quaint, narrow street unusually clear. Shot with a Zeiss (rigid) Contina II with 45mm f/3.5 Novar in Prontor SVS shutter.

Most people who embark on using a classic camera will do so with some experience of photography. In fact, most classic-camera enthusiasts get interested in the pleasures of cameras of times past after becoming thoroughly competent in routine photography with modern cameras. It is tempting, when using a classic camera for the first time, to assume that there is really little difference between taking photographs with your folding Vito or your Contax II, and shooting the same pictures with a Canon A1 or an Olympus Trip.

In some ways, that is true. The principles are identical, and the fundamental rules of exposure, of focus and depth of field, and of composition and picture creation have not changed. Nonetheless, there are important differences of technique, of approach, of processing and of assessment of results, which should be recognized and put into effect if you are to avoid unnecessary frustration and disappointment. Using a classic camera has many parallels with owning and using a classic car.

Tolerance

You may imagine that, by tolerance, I refer to the human quality of making allowance for difficulties and inadequacy. In a way, I suppose I do, but the actual reference is to engineering tolerances.

We have come to expect, in this age of electronic timing devices and precision as an end in itself, that a watch should keep perfect time, and that a camera shutter speed marked '1000' will deliver, if not 1/1000th of a second, at least something of the order of 1/998th. In the days of mechanical timing devices, to which the shutters of classic cameras belong, it was normal to assume that the 1/1000th of a second on even expensive cameras would not yield better than, perhaps 1/800th of a second, or maybe only 1/750th. I was taught, as a boy in the fifties, to assume that any speed greater than 1/100th would be twenty per cent slow, unless the camera had been recently serviced. A mechanical shutter of advancing years should never be regarded as 'wrong' if it delivers a reasonably appropriate speed repeatably, so that you can allow for its aberrations. The trick is to know what you will be getting when you set 1/500th or 1/250th, and calculate your exposure accordingly.

There is no such thing as correct exposure for any photograph, whatever the brochures for today's immensely complex cameras tell you. For a start, it is correct, when using black-and-white or colour-negative emulsions, to give the exposure that will just deliver an image of the dimmest part of the shadow area in which you wish to see detail. If, on the other hand, you are using reversal (transparency) film, it is

Chapter 13

Getting the best from your classic camera

A good hand-held exposure meter is very important once your photography strays from the realms of average conditions in daylight, and is particularly useful for indoor pictures, where estimation of exposure becomes very difficult. While there is no reason why you should not use a modern exposure meter, you may prefer to use a meter of the same generation as your camera. This is a Zeiss Ikophot of the mid-fifties. Examples of this particular exposure meter usually work well if they have been cared for, and they can be bought quite cheaply.

correct to expose for the brightest highlight in which you wish to reveal detail. Despite the negative and the reversal films being of the same speed, perhaps 200 ASA, the 'correct' exposure will be different, often by a whole stop or more. If, as an example, you were photographing on black-and-white negative film an unshaven man by the light from a window on the right of the picture, and the side of his face on the left was in shadow, you have a choice of interpretative effect almost entirely created by exposure. Expose for the mid-tones of the light side of his face, and you will produce a low-key photograph in which the whole of his dark side is in shadow, and his hirsute chin will be revealed in striking detail against a sombre background. Expose for the shadow side, and you will produce a picture which reveals the shady side of his face, has a lighter and more realistic background, and which is altogether more realistic, although probably less interesting. The difference between the two exposures is probably at least one stop – with the same subject, on the same film.

From this, you will realize that any through-the-lens

exposure-metering system must always deliver a compromise between highlight and shadow exposure, unless it includes a spot-metering option, and the operator knows how to use it. This is why virtually all professionals who are able to take time about their work (which, obviously, does not usually include news photographers) prefer to use hand-held meters most of the time. If there has to be a compromise, they would rather work it out for themselves.

All this leads inevitably to the conclusion that the inaccuracies of shutter speeds that are likely to prevail in classic cameras really do not matter, provided you have some idea of what you will get when you set a given speed. The enormous exposure latitude of modern films is, in any case, quite sufficient to make small exposure errors insignificant in all but the most exacting work. Photography with classic cameras is more a craft than a science. A famous portrait photographer of the fifties, asked her exposure for a picture

Perhaps the ultimate classic exposure meter is the Weston Master. This is a Weston Master III, dating from about 1955, but sound working examples of the Master I and II will be found from time to time. Early Westons prior to the Master III are calibrated in Weston Rating for the film speed. Although not directly comparable to current ASA and ISO ratings, Weston units are arithmetic, like ASA, and a basis for using an early Weston meter can be found by experiment. Start by looking up in the conversion table in Appendix 2 the Weston rating equivalent to the ASA speed for the film that is the subject of the test, expose a test film in varying circumstances, and assess the results. Or compare readings from the Weston with readings from a modern exposure system of known reliability.

of a well-known personality, replied 'A long second at about three-quarters open'. It is the result that matters, not the way in which you arrive at it.

Lens performance

A further aspect of tolerance arises when assessing lens performance. The endless lens tests that appear every month in photographic magazines assume that the best lens is one in which high contrast and fine resolution of detail across the whole picture area are most pronounced. As a measure of the technological achievement of the lens manufacturer, this is fair enough, but it is not the only standard by which a lens can be judged. In the chapter on Leica equipment, I pointed out that Leitz lenses differ, even today, from their Japanese contemporaries because some of the aberrations are deliberately left intact. Most classic-camera lenses will exhibit aberrations, lower contrast than modern lenses and, in some cases, a degree of softness of the image when photographs are taken at full aperture. Classic lenses are designed for taking pictures, and it is by their results that they should be judged. There is little point in embarking on a crusade to find a pre-war lens that equals the laboratory performance of your 50mm f/1.8 Nikkor. Enjoy the images that your classic produces and exploit creatively the qualities of your lens, just as you might exploit the resolution of a modern lens.

Choosing your film – and your processing

The very fact that classic lenses are, in most cases, of marginally lower (or sometimes dramatically lower) contrast than modern optics is a reason for choosing your film carefully. In general terms, you will compensate for the lower contrast of an older, particularly an uncoated, lens if you load slow black-and-white or colour-transparency films, and fast colour-negative films, but this should not be taken as an infallible rule. The high contrast and rich colour saturation of Koda-chrome 25, for example, make it a perfect film for use with the lenses of a screw Leica or a pre-war Retina. Ilford Pan F or FP4 are ideal black-and-white films if you are having them trade processed, but are of relatively slow emulsion speed, which can impose limitations when using cameras with lenses of small maximum aperture.

If you handle your own black-and-white processing, you are able to manipulate the contrast of your negatives by balancing exposure and development time. Virtually all my recent photographs in this book, including those of the cameras themselves that I was able to provide, were taken on Ilford HP5, a 400 ASA film, normally thought of as having only moderate contrast. By rating the film at 650 ASA, and increasing development time by about one third (again a fairly unscientific approach), one lifts the contrast significantly, without increasing the apparent granularity of the image enough to matter for 10" x 8" enlargements – or 20" x 16" for that matter. I then print on Ilford Multigrade paper, which provides, when used with an enlarger with a colour head and dichroic filtration, virtually infinite control of print contrast between the equivalent of Ilford Paper Grade 1 and Ilford Paper Grade 5. Other photographers will certainly tell me I should handle the whole thing differently, for, in photography, there are no absolutely correct ways of doing anything.

It is possible, within limits, similarly to increase the contrast of colour-negative emulsions, at the expense of perfect colour balance, by judiciously increasing the time that the film spends in the first developer. If

The major classic-camera systems have all included a number of specialized accessories which can be very helpful in particular photographic tasks. The right-angle magnifier and finder overcomes the problem of wishing to use an eye-level reflex camera at ground level, and can also prevent strain to the neck if the camera is mounted on a vertical-copying stand. This particular right-angle magnifier is the Zeiss accessory for the Contarex, but most manufacturers have made similar units for their single-lens reflexes.

you try this, remember to experiment with a film that is not important, since, until you have devised exact guidelines, it is relatively easy to fail.

Bear in mind that diffuser light sources in enlargers tend to reduce contrast (and obscure somewhat the effects of scratches on negatives), whereas condenser light sources maximize contrast and highlight damage to negatives. Some old cameras have a way of putting 'tramline' scratches on the film, and using a modern colour enlarger with a diffused light source can minimize the effect of this.

Allowing for the limitations of your equipment

Most classic cameras impose, by their design, obvious limitations on the range of photography for which they can effectively be used. In a world accustomed to so-called macro and ultra-wide-angle lenses, being unable easily to photograph something five inches from the lens, or to get the whole of a cathedral nave into the picture from the west door, may seem to doom creative endeavour, but this is not so. The simple fact is that a genuinely creative and 'seeing' photographer with a simple camera and a high-quality fixed 50mm lens will achieve more than an unseeing technocrat with two Nikons and six lenses. There are some photographs that standard and moderate wide-angle lenses cannot take. That is undoubtedly true. But more pictures are lost by the inability to see than by the lack of a wide-angle lens. So, enjoy and make the most of the simplicity of the classic camera and the creative opportunities it presents.

Use a lens hood, and try some filters

Remember that old lenses, particularly uncoated lenses, need a lens hood if they are to perform well. Avoid shooting into the unshielded sun with any old lens, other than as an experiment or for a shot that will benefit from the resulting flare. This is not to say, of course, that you should not take *contre-jour* portraits, in which the subject effectively shields your lens from the light. It is with direct light impinging upon the lens that the problems arise. Try using a yellow or orange filter to increase the contrast of your outdoor black-and-white shots, always bearing in mind the effect that this will have on the tonal rendering of colours in the picture. Coloured filters darken their complementary colours and lighten similar colours. Thus, a yellow filter will make yellow subjects appear white but the blue of the sky darker, thereby showing up the white clouds. An orange or red filter further increases sky contrast, but lightens orange and red tones and darkens greens and blues. A

Bellows and close-up accessories greatly extend the range and versatility of focal-plane single-lens reflex cameras, in which category one could include rangefinder system cameras like the Leica and Contax when used with their reflex housings. In fact, if close-up work is a major interest, this is a strong argument for buying a single-lens reflex as your classic camera. Illustrated here is a Contarex Electronic attached to a Zeiss Contarex bellows unit, with a 50mm f/2.8 Tessar fitted.

green filter will lighten the colour of grass but increase the contrast of a sunlit brick wall by darkening the shaded red. The combinations are endless.

Try using a polarizing filter to increase the interest and change the tonal balance of your colour-reversal pictures. At certain angles to the sun, a polarizing filter will darken a blue sky almost to black, and can greatly enrich (for example) the green of shiny leaves or the colour of a beech tree by eliminating unwanted reflection. Remember that, unlike modern lenses which act as their own ultra-violet filter, classic lenses may not absorb much ultra-violet light, and will produce bluish and flat results on transparency emulsions where excess ultra-violet light is present – typically by the sea or at high altitudes. An ultra-violet filter, shielded by an efficient lens hood, is therefore highly desirable.

Knowing your equipment

All modern single-lens reflex cameras, aside from the unnecessary complications of their exposure-measurement systems, are remarkably similar to each

other in use. A Minolta user with reasonable photographic experience can pick up an Olympus or a Canon and, given a few minutes' experiment, use it competently and well. The same is not necessarily true of classic cameras, and you will not get the best results from a Leica, a Rolleiflex or an Ensign Selfix, however simple it looks, unless you practise with it. Hold it, wind it and fire it without film. Practise rapid focusing and setting the aperture by feel. Get to know the camera, how to hold it steady, and where to find the controls. More pictures are ruined by camera shake than were ever spoiled by the poor quality of a lens, and it is wise never to forget the value of a tripod to the quality of photographs of relatively static or controllable subjects.

Look after your camera

It may seem obvious that a camera should be cared for, but some people seem not to know how to do it. Many classic-camera enthusiasts, as a result of their acquisitive nature and of the relatively low price of many classic cameras, have a number of cameras in the cupboard. Some will be used relatively rarely. In these circumstances, it is important to spend a short time at least once a month winding and firing each camera several times, and operating the focusing mechanisms. Dust is remarkably pervasive, and will gradually clog focusing helices, exposure meter movements and the slow-speed escapement of shutters left totally idle, even in conditions that seem dust-free. For this reason, it is sensible to keep each camera in a perforated and unsealed plastic bag, just wrapped around the camera. Sealing the bag would introduce risks of condensation and mould, but an unsealed bag offers substantial protection against dust while permitting air to circulate. If the cupboard in which you keep your cameras is large and not effectively heated by the normal house heating system, open the door for a while each day to maintain normal humidity and temperature.

If a shutter escapement becomes sluggish, or other faults develop, do not attempt to service cameras yourself, unless you have been trained as a camera repairer. Even thoroughly competent instrument mechanics have been known to get into difficulties when faced with a disassembled Contax I, Retina Reflex or Contarex, and ordinary mortals do not stand a chance of success. Telephone a few camera repairers and ask if they have people who are good with the particular camera and problem you are trying to deal with, and, if they have, how much they would charge to rectify the fault. Some classic cameras are very unpopular with repairers, and some simply cannot be repaired,

Filters play a very important role in classic-camera photography, especially if you are working with black-and-white film. It is good sense to have at least uv, orange and green filters for any classic camera you are likely to use at all seriously. This shot shows how the bayonet-mount filters of the Contarex system fit on to the external lugs of the lens.

Polarizing filters are very useful, not only to suppress reflections from shiny non-metallic surfaces, such as water, glass or plastic, but also to darken the sky, particularly in reversal colour photography. The polarizing filter on the left is on the same white background as the uv filter on the right, but the polarizer has been rotated so as to reduce the transmission of reflected light. Both filters are Contarex B56 bayonet mount.

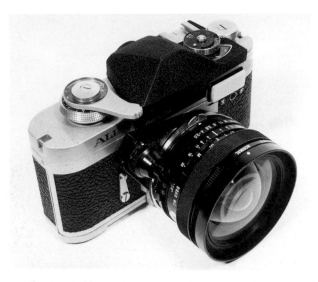

It is advisable not to be a purist about the enjoyment of classic cameras. This picture shows an Alpa 6c fitted, via an Alpa Nikon lens adaptor, with a modern 17mm Tamron SP Adaptall ultra-wide-angle lens. Given the appropriate adaptor, the whole range of Nikon lenses can be used on an Alpa, and there are other similar examples of cross-compatibility that make the whole business of buying and using classic cameras much more fun.

but in most cases perseverance will reveal somebody prepared to take the job on, albeit at a price. You may find it a more sensible course, unless the camera concerned is a rarity, simply to write off the faulty camera and buy another, treating the original camera as a useful source of spares the next time something goes amiss.

Taking classic cameras on sandy beaches, or near salt spray, is asking for trouble. Nonetheless, I have done it, and will doubtless do it again, without having caused any damage. If you must take a classic camera (or any camera, for that matter) on a beach, keep it in its case and keep the lens capped all the time, except when actually making an exposure. If the weather is windy and the spray is flying, put a plastic bag with a hole cut in it over the whole camera and secure the hole around the circumference of the lens with an elastic band, so that only the lens is exposed. Keep the glass capped except when taking pictures. When you get away from the spray, use a little ether or alcohol on a cotton bud to wipe the lens surface clean of any salt deposit, then polish it as lightly as possible with a soft

lens-cleaning tissue. This is regrettable and bad practice, but not as bad as leaving salt on the lens. If you do not want to clean your lens, you will have to do without photographing the boiling sea – or keep a uv filter on the lens at all times, and clean that instead.

If you do have the misfortune to drop your camera in the briny, your only hope of rescuing it for the future is to drop it at once (literally within minutes) into a bucket of clean fresh water, and swish it about. Throw that water away, and put it in another lot. Then keep it there until you get the camera to a repairer. Inevitably, the repair will be a total strip-down, which will be expensive and possibly not worthwhile. The repair may prove impossible, either because of non-availability of spares to replace parts damaged by immersion, or because the camera was not immersed soon enough and has begun to corrode. Remember, if you have irreplaceable shots on the film in the camera, that all films have to go into water to be processed, and all is not lost if the film has been wet for an hour or two. Rewind it with the camera in the water, and remove the cassette. If you do your own processing, the film can then be processed as normal. If you do not, look in your telephone book for a trade processing laboratory of the sort used by professional photographers, and take the problem to them. They will almost certainly sort it out for a small surcharge.

However, the best answer is to use a neckstrap and stay clear of the sea.

Above all, enjoy it

I hope this book will have increased both your knowledge of classic cameras and your interest in the immense creative possibilities that they offer. Photography, even if you earn your living at it, should be fun. Happy photographers take better pictures. So find a classic camera that you like, and stick to it.

Try to make use of your pictures – line a wall of one room of your house with your best shots, or stage an exhibition locally. Offer to present a talk on photography, or on using interesting old cameras, to your local school or camera club. Pictures are not pictures unless they are talking to somebody.

Finally, try not to become discouraged when things go wrong. Just as early Rolls-Royce cars, while the finest in the world, occasionally break down, the path of classic photography is strewn with minor misfortunes.

It is the disasters which make the good days so much more fun.

One of those natural compositions that are always just around the corner if you look out for them, this picture was shot in Brighton, Sussex, on an autumn day. The dog seems to be interested in classic cameras – in this case it was a Bessamatic with 50mm f/2.8 Color-Skopar.

Who has not, at some time, bought one drink and two straws? Photographed in Whitby, Yorkshire, on a hot summer's day with a Contaflex Super B fitted with 50mm f/2.8 Tessar. The wary eye suggests that the right-hand boy had spotted the camera but was not prepared to stop sucking, for fear of missing out on his share.

Fairground organs are fascinating things, and these boys were completely oblivious to my photographing them from quite nearby with the Agfa Super Silette with 50mm f/2 Solagon, illustrated on page 190.

This picture was spotted by my daughter Emma as she walked in Mons, Belgium, with a Zeiss Contina II (illustrated on page 189). The visual echoes of archways and staircases make an effective picture. Fitted with 45mm f/3.5 Novar. Picture by Emma Matanle.

During a photographic shoot for a catalogue, a teenage model was allowed to fondle a lion cub. The moment did not last long, the sun was in the wrong place, and I did not have time to move elsewhere, so I took the picture anyway. The resulting flare is actually quite attractive. The moral is, don't worry about details – if you see a picture, shoot first and worry afterwards. Taken with a Mamiyaflex C3 with 105mm f/3.5 Sekors.

Bright, fresh, blustery autumn weather by the sea can produce pictorial opportunities like this, with the wind rippling the puddles and the sun casting long, hard shadows. Shot with a Voigtländer Bessamatic with 50mm f/2.8 Color-Skopar and orange filter.

High-speed action can be tackled successfully with medium-format cameras, as this picture of a water-jet-powered speedboat shows. It was shot with a Mamiyaflex C3 fitted with the 180mm f/4.5 Sekors and the Porroflex eye-level mirror viewing system.

This interesting composition came into view below a bridge in Whitby, Yorkshire, and was captured with a Contaflex Super B with 50mm f/2.8 Tessar.

Appendix 1: Some useful addresses

Users of classic cameras cannot, as a rule, just walk into their local camera store and buy appropriate accessories, or just leave their camera for repair knowing that the job will be done by a specialist. Camera retailers, understandably enough, deal in modern equipment, and usually supply only the accessories for modern cameras, for which there is a mass market. Few camera retailers are particularly knowledgeable about cameras marketed before they first took an interest in photography, and information about classic cameras has frequently to be sought from specialist sources.

There are, fortunately, in both Europe and the USA, specialized dealers, repairers and accessory manufacturers who take an interest in the needs of the classic-camera user; and who are prepared to try and find ways around the problems that classic cameras can present. There are also a number of classic-camera and photographic historical societies, formed on a national or international basis, which provide a basis for research into, and knowledge of, particular areas of photographic interest. Such societies form a valuable means of communication and trade between collectors and users, and are often a useful starting point when seeking information within the limits of their speciality.

A further useful source of both information and equipment is provided by the major national auction houses which, from time to time, hold specialized photographic auction sales, at which it is often possible to pick up at relatively insignificant prices good-quality classic cameras that happen to be of little interest to major collectors. It is, however, best not to buy equipment at auction without having first inspected it, since many collectors and some dealers use auctions as a means of finally disposing of stock in poor condition which is otherwise unsaleable. Auction houses do not usually describe condition in the detailed manner of dealers, and a camera correctly described as (for example) 'Leica III, 50mm f/3.5 Elmar' may turn out not only to be unusable, but also unrestorable and fit only to be a source of parts.

The following is in no sense a complete or exhaustive list, and some readers will doubtless wonder why their particular society, favourite supplier or repairer has been left out – the answer, simply, is that the author did not know about them. Nonetheless, the following list will provide a useful start to classic-camera enthusiasts needing help or information.

(a) Classic-camera and photographic historical societies

USA
American Photographic Historical Society
520 West 44th Street, New York, NY 10036
All areas of photographic history.

American Society of Camera Collectors
4918 Alcove Avenue, North Hollywood, CA 91670

The Chicago Photographic Collectors Society
PO Box 375, Winnetka, IL 60093
Classic and vintage cameras in general.

International Kodak Historical Society
PO Box 21, Flourtown, PA 19031
Specializing in the history of Kodak equipment and technology.

Leica Historical Society of America
7611 Dornoch Lane, Dallas, TX 75248
All forms of Leica equipment.

The National Stereoscopic Association
PO Box 14801, Columbus, OH 43214
All aspects of stereo 3D photography.

The Photographic Historical Society of New England
PO Box 189, West Newton Branch, Boston MA 02165
Photographic history.

The Photographic Historical Society of New York
PO Box 1839, Radio City Station, New York, NY 10101
Photographic history.

Zeiss Historica
c/o Maurice Zubatkin, PO Box 631, Clifton, NJ 07012
Contax and related cameras. All forms of classic Zeiss equipment.

West Germany
Club Daguerre
Mohlenstrasse 5, 5090 Leverkusen, Hitdorf
Photographic history and images.

Ihagee Historiker Gesellschaft (Ihagee Historical Association)
IHG (Herr P.E. Lanczak), Charlottenburgerstrasse 22A,
5090 Leverkusen 1
Principally Exakta equipment of all forms, but essentially concerned with the developing of knowledge and information about Ihagee equipment.

Leica Historika
Klaus Grothe, Bahnhofstrasse 53,
3252 Bad Münder 1
All forms of Leica equipment.

United Kingdom
The Historical Group of the Royal Photographic Society
The Octagon, Milsom Street, Bath, Avon BA1 1DN
Photographic history.

Leica Historical Society
Mrs June Ainslie (Secretary), Leica Historical Society, Armitage Court, St Mary's Hill, Sunninghill, Berkshire SL5 9AU
All forms of Leica equipment.

The Pen F Register
c/o 1 Sylvan Close, Hemel Hempstead, Hertfordshire HP3 8DN
Maintains a register of Pen F, Pen FT and Pen FV users and their equipment and fosters communication between enthusiasts.

Photographic Collectors Club of Great Britain
c/o PCCGB Membership, BEED Printing, 5 Station Industrial Estate, Low Prudhoe, Northumberland, England
Classic and vintage camera equipment from the standpoints of both collectors and users.

Club Rollei
Hôtel de France, St Saviour's Road, Jersey, Channel Islands

Netherlands
Camera Oldtimer Club
PO Box 324, 3800 AH Amersfoort

Dutch Society of Photographica Collectors (Harry van Kohl)
PO Box 4262, 2003EG Haarlem

Ihagee Historiker Gesellschaft (Ihagee Historical Association)
IHG (H.D. Ruys), Tesselschadelaan 20, NL 1217 LH Hilversum
As IHG, West Germany.

Belgium
Photographica
Chausée de la Hulpe 382, 1170 Bruxelles

France
Club Niépce Lumière
35 rue de la Mare à L'Ane, 93100 Montreuil

(b) Major auction houses which hold photographic sales
(catalogues are usually available by mail on an annual subscription basis)

USA
Christie's East
219 East 67th Street, New York, NY 10021
Phillips
867 Madison Avenue, New York, NY 10021
Sotheby's
980 Madison Avenue, New York, NY 10021
Sotheby's
7660 Beverly Boulevard, Los Angeles, CA 90036
Swann Galleries Inc.
104 East 25th Street, New York, NY 10010

West Germany
Petzold K.G.
36 Maximilianstrasse and 3 Apothekergässchen, Augsburg 8900
Regina Cornwall
Handelstrasse 17A, D 5000 Köln 1

United Kingdom
Biddle and Webb
Ladywood, Middleway, Birmingham B16 0PP
Bonhams
Montpelier Street, London SW7 1HH
Christie's South Kensington Ltd
85 Old Brompton Road, London SW7 3LD
GMB Auctions
Box 5534, 30 Lower Brook Street, Ipswich, Suffolk 1P4 1AL
James Norwich Auctions Ltd
33 Timberhill, Norwich NR1 3LA
Phillips
7 Blenheim Street, New Bond Street, London W1Y 0AS
Sotheby's
34-35 New Bond Street, London W1A 2AA

(c) Specialist periodicals
(note that general photographic magazines normally available on a news-stand have not been included)

USA
Shutterbug Ads – Photographic News
PO Box F, Titusville, FL 32781
Invaluable monthly newspaper packed with articles by and for classic-camera enthusiasts, plus ads by major suppliers and repairers. A must! Available worldwide by annual subscription.

Viewfinder (members' publication)
Leica Historical Society of America,
7611 Dornoch Lane, Dallas, TX 75248
Magazine featuring matters concerning Leica equipment and Leica photography.

United Kingdom
LHS Newsletter (members' publication)
Mrs June Ainslie (Secretary), Leica Historical Society, Armitage Court, St Mary's Hill, Sunninghill, Berkshire SL5 9AU
Quarterly magazine featuring Society news and articles of specific Leica interest.

Rollei Collector
David Smart, 43 Keithleigh Gardens, Pitmedden, Ellon, Aberdeenshire AB4 0GF, Scotland
Quarterly duplicated magazine full of information for Rollei twin-lens reflex enthusiasts. Also functions as a marketplace for sales and wants. Available by annual subscription.

(d) Repairers and custom accessory manufacturers
Most camera repairers would assert that they repaired and serviced screw Leica equipment. Most reputable camera-repair companies will be quite capable of providing routine leaf and focal-plane shutter servicing. However, not all will be prepared to undertake labour-intensive work such as the servicing of between- and behind-lens-shuttered reflex cameras. Only a few will undertake the making of parts for obsolete mechanisms.

The following addresses are of companies in the USA which advertise a speciality in classic-camera repair, and firms in the United Kingdom which the author knows to provide an expert service, either in camera repair or in the manufacture of accessories for obsolete camera fittings. It must be emphasized that there are many more equally competent repairers, and that the best approach to getting any particular camera serviced is either to ask advice of members of a classic-camera or collectors' society, or to phone a number of repairers and discuss the job with each. However, the following names and addresses are provided to give the reader somewhere to start. The author and publisher can accept no responsibility for the quality of any work commissioned from the firms listed in this appendix.

USA
Boeders Camera Repair
Rt. 38, 19120 Miami Boulevard, Fort Myers, FL 33912
Leica rangefinder, Retina, Minox, Hasselblad repair.

Continental Camera
2753 W. Pratt Boulevard, Chicago, IL 60645
Leica and Zeiss equipment restoration.

Ercona Corporation
125 Wilbur Place, PO Box 161, Bohemia LI, NY 11716
Optical repairs, regrinding and recoating lenses.

Don Goldberg
2451 Thatcher Lane, McFarland, WI 53558
Leica and Minox repair.

Marflex Service Corporation
201 E. Main Street, Little Falls, New Jersey, NJ 07424
Rollei and Voigtländer servicing and repair.

Metro Camera Service Inc.
1470 S. Federal Boulevard, Denver, CO 80219
Leica and Hasselblad repair.

Purchase Camera Repair
1115 So. University Avenue, Ann Arbor, MI 48104
Rollei twin-lens reflex restoration and repair.

Ken Ruth and Terry Terhaar
PO Box 113, Davenport, CA 95017
Leica, Ektra, Foton, Zeiss, Rollei TLR repair, plus nickel plating and leather bellows supply.

Swiss Camera and Optical Service Corporation
38 West 32nd Street, New York, NY 10001
Bolex, Leica, Hasselblad, Rollei and view camera repair.

Michael Taglieri
9 Birchwood Terrace, Groveland, MA 01834.
Leica restoration and repair.

Tect Camera Repair
Ted McDonald, PO Box 31234, Corpus Christi, TX 78404
Exakta, Graflex, Pentacon 6 repairs. 'We love challenges!'

Universal Bellows Co. Inc.
25 Hause Avenue, Freeport, NY 11520
Custom-made bellows for folding cameras.

W.D. Service Inc.
701 So. First Avenue, Ste. 470 Arcadia, CA 91006
Graflex repairs and servicing.

United Kingdom

T.A. Cubitt and Son
240 Torbay Road, Harrow, Middlesex HA2 9QE
Repair and servicing of most classic equipment, plus specialized custom manufacture of extension tubes and adaptors.

Les Frankham, FRPS, FRSA, FBIM
166 Westcotes Drive, Leicester LE3 0SP
Specialized Zeiss and Voigtländer repairer and restorer appointed by Zeiss Foundation.

H.A. Garrett & Co. Ltd
300 High Street, Sutton, Surrey SM1 1PL
Repair and servicing of most classic equipment.

Optical Instruments (Balham) Ltd
6 Weir Road, Balham, London SW12 0NA
Optical repairs, repolishing, recoating and restoring of lenses.

R. Smith
44 Reddington Road, Plymouth, Devon PL3 6PT
NOT a camera repairer, but a specialist repairer of leatherwork and camera cases. Restores classic-camera cases to much of their former glory.

SRB Film Services
286 Leagrave Road, Luton, Bedfordshire LU3 1RB
NOT a camera repairer, but an extremely versatile manufacturer of lens-mount adaptors, filters for oddly sized mounts and similar engineering products.

Ed. G. Trzoska
150 Harrowgate Drive, Birstall, Leicester LE4 3GP
Repair and servicing of most classic cameras.

(e) Specialist classic-camera dealers

There are very few camera stores which deal only in classic equipment, but quite a few which regard classic cameras as a major part of their business, and have sufficient background knowledge of classic equipment to give advice on value. There are also a number of well-respected dealers who handle only classic equipment, but deal principally by mail and do not have conventional shop premises. Most of these see customers in peron only by appointment, and it is advisable not to call on them unannounced.

The following is simply a selection of addresses of companies of which the author has experience or some knowledge. It is intended as a means of enabling the reader who is interested in classic cameras to make contact with one or two sources. Many more will quickly be discovered if the reader looks at a copy of *Shutterbug Ads – Photographic News* or *Amateur Photographer*, the world's largest-selling weekly photographic magazine. The author and publisher accept no responsibility for the success or otherwise of readers' dealings with companies listed here.

USA

Burton Tilley's World Cameras
1625 Larimer, Suite 3003 (30th Floor), Denver, CO 80202
Specialist in a wide range of classic cameras, notably Canon and Nikon rangefinder, Leica, Contax, Contarex, Voigtländer and Rollei TLR.

Classic Camera
20219 Mack Avenue, Grosse Pointe Woods, MI 48236
Deals in a wide range of classic cameras and lenses.

Collector Cameras
1806 E. 15th Street, Tulsa, OK 74104
Leica, Leicaflex, Linhof, Hasselblad, Rollei TLR, and Pen F and FT are among this firm's wide range of classics.

Olden Camera
1265 Broadway at 32nd Street, New York, NY 10001
All the major classic marques are sold here.

A Photographer's Place
133 Mercer Street, New York, NY 10012
Photographic books and price guides.

Reinke International Fotodealer
51 Banjo Branch Road, Mars Hill, NC 28754
Leica, Nikon, Canon etc.

Stan Tamarkin
PO Box 2997, New Haven, CT 06515
Long-established Leica specialist.

Village Camera Shop
13300 Kercheval, Detroit, MI 48215
Specializes in classic Zeiss, Leica and Alpa equipment.

United Kingdom

Andrews Cameras
16 Broad Street, Teddington, Middlesex TW11 8RF
Leica, Zeiss, Rollei and other collectibles.

Brookside Photographic
160 Derby Road, Canning Circus, Nottingham NG7 1LR.

Classic Camera Company Ltd
45 Ainger Road, London NW3
Specialists in Nikon.

Classic Collection
2 Pied Bull Yard, Bury Place, London WC1A 2JR
Also a widely varied large stock of fine classics. A Leica specialist.

Collectors' Cameras
PO Box 16, Pinner, Middlesex
Wide range of collectibles, including cameras of vintage era.

Fieldgrass and Gale Ltd
203 Welsbach House, The Business Village, Broomhill Road, London SW18 4JQ
Rollei and various collectibles in addition to modern equipment.

Grays of Westminster
40 Churton Street, London SW1V 2LP
Strong on early Nikon F and FZ.

Hove Camera Co.
34 Church Road, Hove, E. Sussex BN3 2GJ
Long-established specialist Leica dealer.

Jessop Classic Photographica
67 Great Russell St, London WC1.
A formidable stock of classic equipment.

Stephens of Salford
484 Cheetham Hill Rd., Manchester M8 7JW
Leica specialists.

P.H. Van Hasbroeck
34 Bury Walk, London SW3 6QP
Specialist dealer in high-grade collectibles. Not a conventional shop – phone or write to discuss your needs.

Vintage Cameras
254-256 Kirkdale Corner, London SE26 4NL
Wide range of classic and vintage cameras. Very knowledgeable across a broad spectrum of equipment.

Appendix 2: Film-speed conversion

There have, during the classic-camera period, been a number of quite different systems in use for the expression of film sensitivity, or speed. In the mid-eighties, the two most frequently encountered systems are the ASA and DIN standards, but classic cameras incorporating exposure meters, and classic hand-held exposure meters, are frequently calibrated to obsolete standards such as Scheiner, Weston, General Electric or H. & D.

In order to make effective use of the exposure meter in (say) a Contax III or a twin-lens Contaflex, one must know a conversion factor for setting the speed of a film rated at (perhaps) 64 ASA on a meter marked only in Scheiner or DIN. Unfortunately, the problem is greater than is at first apparent for several reasons:

(a) Because the sensitometric bases for calculating film speeds vary greatly from standard to standard, there is no absolute or totally reliable way of converting speeds expressed in one system to accurate ratings in another.

(b) The basis for DIN speed calculations was changed in 1958. Before then, DIN speeds were expressed as fractions – 27/10 for example – but since then the '/10' has been dropped, and the actual speed rating is nearly, but not quite, comparable.

(c) The basis for ASA speed ratings was changed in the mid-sixties.

(d) Few elderly exposure meters are, in any case, still accurately calibrated according to the standards that they were manufactured to serve.

(e) The Scheiner scale as used in Britain was substantially different from the Scheiner scale as used in the USA. A German camera with a meter marked in degrees Scheiner and originally exported to Britain will be calibrated in UK Scheiner, but another, identically marked, camera originally manufactured for the US market will be calibrated in US Scheiner. Both types are in circulation in both Britain and the USA, and there is no way of telling them apart other than by experiment.

The following table of approximate film-speed equivalents is, therefore, at best a guide only. Comparison of this table with those given in other books will reveal differences between virtually any two tables selected. This does not mean that any of the tables is wrong; it merely indicates the approximate nature of the calculations involved.

To work out the film speed at which to set the meter on a classic camera for any given modern film, first determine the apparently correct speed from the table below, then expose a test film, shooting each subject five times, once at the correct exposure, and once each at one stop and two stops greater and less exposure. From this test, the correct setting will emerge for that film.

ASA/BS (arith.)	ASA/BS (log, new) degrees	ASA/BS (log, old) degrees	DIN degrees	General Electric	Weston	Scheiner (UK) degrees	Scheiner (USA) degrees	H. & D. (UK)	H. & D. (Europe)	Ilford Speed Group
1	0.2	12	1	1	1	13	8	33	100	–
3	0.5	16	6	4	2.5	17	12	100	300	A
6	1	19	9	8	5	20	15	200	600	B
10	1.5	22	11	12	8	22	17	290	800	C
25	3	25	15	32	20	26	21	800	2400	D
50	4	28	18	64	40	29	24	1600	4800	E
64	4.2	29	19	80	50	30	25	2000	6000	E
100	5	31	21	125	80	32	27	3200	10000	F
125	5.3	32	22	160	100	33	28	4000	12000	F
160	5.5	33	23	200	125	34	29	5100	15000	F
250	6.3	35	25	320	200	36	31	8000	24000	G
400	6.5	37	27	500	320	38	33	13000	40000	–
800	8	40	30	1000	650	41	36	26000	80000	–

Appendix 3: Some frequently encountered classic- camera

Manufacturer	Simple v/finder	Fixed-lens coupled r/f	Folding v/finder	Folding coupled r/f
Agfa (W. Germany)	Silette (various)	Super Silette (various)	Solinette	Super Solinette Karamat 36
AGI (G. Britain)	Agima	Agimatic	Agifold (6x6)	Agifold III
Alpa (Pignons SA, Switzerland)	—	—	—	—
Ansco (USA)	—	—	—	—
Argus (USA)	Argus A Argus A2 Argus A2F Argus A3 Argus CC	Argus C4 Argus 21	—	—
Balda (W. Germany)	Baldina (various)	Super Baldina	Baldinette (35) Baldax (6x6) Baldini (35) Balda (6x9)	Super Baldinette (35) Super Baldax (6x6)
Braun (W. Germany)	Paxette (various)	Super Paxette (various)	—	—
Canon (Japan)	Canon Demi series (½ frame)	Canonet (various)	—	—
Certo (W. Germany)	—	—	Dolly (VP)	Super Dollina II Super Six (6x6) Dolly Supersport (6x6)
Corfield (G. Britain)	—	—	—	—
Diax (W: Germany)	—	—	—	—
Edixa (Wirgin, W.Germany	Edixa (various)	—	—	—
Exakta (Ihagee, W. Germany)	—	—	—	—
Graphic (USA)	—	Graphic 35	—	Pacemaker Crown Graphic (5"x4 Pacemaker Speed Graphic (5"x4" Anniversary Speed Graphic (¼ plate or 5"x4") Miniature Speed Graphic (2¼"x3
Hasselblad (Sweden)	Hasselblad Superwide Hasselblad Superwide C	—	—	—
Ilford (G. Britain)	Advocate Sportsman (various)	—	—	—
Kalart (USA)	—	—	—	Kalart (2¼"x3¼")
Kamera Werkstätten AG (E. Germany)	—	—	—	—
Kodak (USA)	—	Medalist Medalist II (both 2¼"x3¼" on 620) Kodak 35 rangefinder	—	Super Kodak Six-20
Kodak Retina (W. Germany)	Retinette (various)	Retinette 2B Retina IIS	Folding Retinette Retina Ia Retina IB Retina Ib Retina If	Retina IIa Retina IIc Retina IIC Retina IIIc Retina IIIC

Twin-lens reflex	35mm SLR	Rollfilm SLR	35mm r/f system camera
Flexilette (35mm)	Ambiflex Agfaflex Selectaflex Colorflex	—	Ambi Silette
—	—	Agiflex I, II, III	—
—	Alpa (models 4-11 with various suffixes)	—	—
Ansco Automatic Reflex	—	—	—
—	—	—	Argus C2 Argus C3 Argus C33
—	—	—	—
—	Paxette Reflex Paxette Reflex Automatic	—	—
—	Canonflex (various)	—	Canon II Canon IIB Canon IIC Canon IV Canon V Canon VT Canon VI Canon VIT Canon P Canon 7 Canon 7S
—	—	—	—
—	Periflex 1 Periflex 2 Periflex 3 Periflex Gold Star Interplan (various)	Corfield 66	—
—	—	—	Diax IIA Diax IIB
—	Edixa Reflex (various models)	—	—
—	Exakta Exakta Varex (VX) Exakta IIA Exakta IIB Exakta VX 500 Exakta VX 1000 Exa I, IA, II, IIA, IIB	Exakta 66	—
—	—	Super D Graflex (5"x4" or rollfilm)	—
—	—	Hasselblad 1600F Hasselblad 1000F Hasselblad 500C	—
—	—	—	Witness
—	—	—	—
—	Praktiflex II Praktiflex Synchro Praktina II Praktina FX	Praktisix Praktisix II Pentacon 6	—
Kodak Reflex Kodak Reflex II (both 6x6 on 620)	—	—	—
—	Retina Reflex Retina Reflex S Retina Reflex III Retina IV	—	Retina IIIS

Manufacturer	Simple v/finder	Fixed-lens coupled r/f	Folding v/finder	Folding coupled r/f
Konica (Japan)	—	Konica II Konica IIA	—	Pearl II (6x4.5)
Leica (E. Leitz, W. Germany)	—	—	—	—
Leotax (Japan)	—	—	Semi-Leotax (6x4.5)	—
Mamiya (Japan)	—	—	—	Mamiya (6x6) Mamiya 6 (6x6)
Minolta (Japan)	—	Minolta Unomat	Semi-Minolta (6x4.5)	—
MPP (Micro Precision Products, G. Britain)	—	—	—	Micropress (5″x4″) Micro-Technical (various – all 5″x4″)
Nicca (Japan)	—	—	—	—
Nikon (Japan)	—	—	—	—
Olympus (Japan)	Olympus I Pen D series Pen S Pen E series (all ½ frame)	—	—	Olympus 66
Pentacon (E. Germany) **E. German Zeiss** (E. Germany)	—	—	—	—
Premier Instr. Corp. (USA)	—	—	—	—
Reid & Sigrist (G. Britain)	—	—	—	—
Robot (W. Germany)	Robot II Robot Star (both interchangeable lens)	—	—	—
Rollei (W. Germany)	Rollei 35 Rollei B35 Rollei C35 Rollei 35S	—	—	—
Tower (Japan/USA)	—	—	—	—
Voigtländer (W. Germany)	Vito B Vito C Vitoret Vitomatic	Vitomatic II Vitomatic IIA Vitomatic IIB	Vito II Vito IIA Perkeo (6x6) Bessa (6x6) (6x9)	Vito III Vitessa Vitessa L Bessa II (6x9)
Welta (W. Germany)	—	—	Perle (6x4.5) Welti (35mm)	Welti II (35mm)
Werra (E. Germany)	Werra I	Werra III Werramatic	—	—
Zeiss Ikon (W. Germany)	Contina (various)	Contessa (various) Contessamat Contina III	Ikonta35 Contina Nettar (various) (rollfilm) Ikonta M (6x9) Ikonta IIC (6x9)	Contessa (folding) Super Ikonta 532/16 Super Ikonta 533/16 Super Ikonta 3 Super Ikonta 4 Super Ikonta 531/2

Twin-lens reflex	35mm SLR	Rollfilm SLR	35mm r/f system camera
Koniflex Tele-Koniflex	—	—	—
—	Leicaflex Leicaflex SL Leicaflex SL2	—	Leica IC Leica IIC Leica IIIC Leica IF Leica IIF Leica IIIF Leica M3 Leica M2 Leica IIIG Leica IG Leica M1 Leica M4 Leica M5 Leica MP Leica MD Leica MDa
—	—	—	Leotax D III Leotax D IV Leotax D VI (Leica copies)
Mamiyaflex Automatic Mamiyaflex II (6x6) Mamiyaflex C series	—	—	—
Minolta Autocord	Minolta SR1 & SR7	—	Minolta 35
Microcord Microflex (both 6x6)	—	—	—
—	—	—	Nicca III (Leica copy)
—	Nikkorex Nikon F	—	Nikon M Nikon S Nikon S2 Nikon S3 Nikon S4 Nikon SP
—	Pen F Pen FT Pen FV (½ frame)	—	—
—	Contax S Contax D Pentacon F Pentacon FM Pentacon FB	—	—
—	—	—	Kardon 1 (Leica copy)
—	—	—	Reid I Reid II Reid III (Leica copies)
—	—	—	Robot Royal Robot Royal II Robot Royal III Robot Royal 36
Rolleiflex Automat (various) Rolleiflex 3.5E (various) Rolleiflex 3.5F Rolleiflex 2.8C Rolleiflex 2.8D Rolleiflex 2.8E (various) Rolleiflex 2.8F Wide-angle Rolleiflex Tele-Rolleiflex Rolleimagic I Rolleimagic II Rolleicord V Rolleicord VA Rolleicord VB Rolleiflex 4x4	—	Rollei SL66	—
—	Tower 23	—	Tower 35
Brilliant	Bessamatic Ultramatic Icarex (various of each)	—	Vitessa T Prominent (various)
—	—	—	—
—	—	—	—
Ikoflex I Ikoflex IB Ikoflex IIA Ikoflex Favorit	Contaflex I, II, III, IV Contaflex Alpha, Beta, Prima Contaflex Super, Super B, Super BC Contaflex S Contarex Contarex Super Contarex Super Electronic Contarex Professional Contarex Special	—	Contax IIA Contax IIIA

Modern Miniature Cameras

THE following pages present a review, believed to be exhaustive, of cameras making negatives of size 6 × 6 cm. (2¼-in. square) or under. Descriptions and illustrations of the cameras are followed by a price-list showing the different lenses and shutters with which each camera can be obtained, with prices of the different combinations.

Classification is by size, the smaller cameras coming first. Instruments taking unusual sizes have been placed at the beginning or end of the nearest group taking a standard size of picture.

In all size-groups the reflex cameras have been separated out and placed at the end of the appropriate section. Range-finder cameras have also been placed together, except in the 24 × 36 mm. size, where the existence of groups of related cameras (e.g., the Dollina series) would render this arrangement confusing.

The name of the maker or British agent appears at the foot of each review; for addresses readers are referred to the advertisement pages of this issue. An index to advertisers appears on page 46.

Picture Size less than 24 × 36 mm.
Negative material 16-mm. or 35-mm. Ciné Film unless otherwise stated.

Picture Size 13 × 18 mm.

CORONET MIDGET.
Miniature box-form camera making 6 exposures each 13 × 18 mm. on special 6-exposure film costing 6d. Fitted f/10 meniscus lens of focal length 29 mm. in instantaneous shutter working at 1/30th sec. Direct-vision optical finder. Claimed to be the world's smallest camera. Dimensions 2½ × 1 × 13/16ths in. Weight 1½ oz. Price 5s. 6d.
Coronet Camera Co.

SOLA.
Ultra-miniature quick-fire camera making 24 exposures, each 13 × 18 mm. on a specially-spooled length of unperforated 16-mm. ciné film. Reloadable

cassettes provided with camera. Fitted 2.5-cm. f/3 Kinoplan, focussing to 2 ft., in interchangeable mounting. Behind-lens shutter speeded 1 to 1/300th sec.

Body contains clockwork motor which automatically winds film on and resets shutter after each exposure, allowing exposures to follow one another in very rapid succession. Automatic exposure-counter. Reversible brilliant and folding frame finders. Dimensions 3½ × 2½ × 1½ in., including lens. Weight 13½ oz. Price £21.
Wallace Heaton, Ltd.

Picture Size 18 × 24 mm.

KORELLE-K.
Non-folding camera with moulded body, taking up to 100 pictures each 18 × 24 mm. on a length of 35-mm. ciné film. Takes standard 36-exposure cassette (gives 70 exposures) or Contax spool, but Korelle-K cassettes (reloadable) can also be used. Film winds

from one light-proof cassette to another across the back of the camera so that the camera can be opened and the film cut at any time. Fitted with interchangeable lenses, normal focal length 3.5 cm., in Compur shutter. Shutter interconnected with film wind to prevent double exposure. Dimensions 3½ × 2½ × 1½ in. Weight 10½ oz. complete. Price from £11 11s.
Photo-Optics, Ltd.

Picture Size 24 × 24 mm.

PHOTAVIT MODEL I.
Rigid body, lens and shutter carried on telescopic tube. Makes 8 exposures on size 10 films, or 12 exposures on special film. Fitted non-interchangeable 40-mm. lens in 3-speed shutter, with safety catch. Direct-vision optical tubular finder. Automatic film-wind by counter-scale on winding-knob. Dimensions 3½ × 2½ × 1½ in. Weight 6½ oz. Price from £1 18s.
Dr. Hepner (Seeing Camera).

PHOTAVIT STANDARD II.
Rigid body, lens and shutter carried on telescopic tube. Uses 35-mm. ciné film in own cassettes, or specially spooled. Fitted non-interchangeable 40 mm. lens in diaphragm shutter with release on body of camera. Automatic film-wind by turning knob to stop; exposure-counter numbered up to 20 provided. Shutter-release and film-wind interlocked. Partly-exposed strip can be unloaded in daylight for developing. Dimensions, 3½ × 2-7/16ths × 1½ overall. Weight 11½ oz. Price from £9 10s.
Dr. Hepner (Seeing Camera).

ROBOT.
Takes up to 50 pictures 24 × 24 mm. on ciné film. Special cassettes can either be filled in dark-room or by means of daylight-loading spools. After each exposure a clockwork mechanism resets shutter and winds film on, so that series photographs can be taken as fast as release can be pressed. Fitted interchangeable lenses in screw-in mount, standard focal length being 30-mm. Built-in behind-lens shutter, speeded 1 to 1/500th sec. and Time. Built-in

filter, which, when brought into place automatically halves shutter-speed. Focussing by helical mount; depth shown by coloured dots (" zone focussing "). Take-up cassette used; hence film can be taken out in daylight when part only has been exposed. Combined tubular and right-angle finder. Dimensions 4½ × 2½ × 2 in. Weight 20 oz. Price from £23 10s.
"Robot" (H. E. J. Spearman).

TENAX.
Quick-fire camera with rigid body. Takes standard 36-exposure Contax spool, giving on it 50 exposures, or gives 18 exposures on short-length spool, or will take Contax cassettes. Fitted for interchangeable lenses in bayonet mount, normal focus being 4 cm. Uses Compur-Rapid shutter, with release on body of camera. Coupled range-finder

combined with view-finder. Film advance and shutter-wind carried out simultaneously by depressing a lever beside the shutter, allowing exposures to follow one another in very rapid succession when desired. Lenses of 27-mm. and 75-mm. focal lengths will be available shortly. Dimensions, 5 × 2½ × 1½ in. Weight 16 oz. Price from £31 10s.
Zeiss Ikon, Ltd.

Picture Size 24 × 36 mm.
Negative material 35-mm. Ciné Film unless otherwise stated.

BALDINA.
Uses standard 36-exposure daylight-loading cassette. Standard roll-film camera type of construction, with non-interchangeable Vidanar f/4.5 lens of focal length 5 cm., in Prontor delayed-action shutter. Parallax-correcting view-finder. Dimensions 5 × 3½ × 1-1/16th in. Weight 16 oz. Price £6 10s.
Norse Trading Co. (London), Ltd.

COMPASS.
Takes separate plates 35 × 43 mm. in paper envelopes, making on them negatives 24 × 36 mm., but can be fitted with roll-film back at an extra charge of £5. Non-interchangeable 3.5-cm. lens, aperture f/3.5, fitted in two-draw telescopic tube. Between-lens shutter giving exposures from 4½ secs. to 1/500th sec.

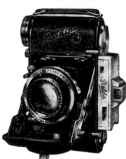

The Super-Baldina camera. Baldina is identical, but has no range-finder.

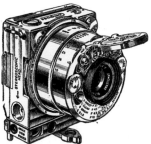

Focusses from 1½ ft., focussing being coupled with range-finder of 3-cm.

base. View-finder, which can be used also as an angular view-finder, contains an exposure meter of extinction type. Focussing can also be carried out on the focussing screen with the aid of the magnifier incorporated. A lens hood, a set of three filters, and a combined panoramic and stereoscopic head are also built into the camera. The camera is made entirely of metal. Dimensions 2½ × 2½ × 1½ in. overall. Weight 8 oz. Price £30.
Compass Cameras, Ltd.

CONTAX MODEL II.
Takes up to 36 exposures on 35-mm. ciné film, using standard cassettes. Contax spools, or special cassettes which can be loaded with any desired length of film. Fitted for wide range of lenses of focal lengths from 1½ to

Some of the miniature cameras that were on the market in 1938.

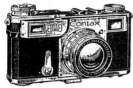

20 in., and apertures up to f/1.5, interchangeable by bayonet mount.

Practically all are coupled with built-in range-finder, which is combined in one eyepiece with view-finder. All-metal focal-plane shutter, speeded ⅟₈ to 1/1,250th sec., winding which transports film. Delayed-action fitted. Shutter release in centre of winding knob on top of camera. Detachable back allows plates to be used. Dimensions 5½ × 2¾ × 1⅜ in. Weight 20½ oz. without lens. Price from £40 10s.
Zeiss Ikon, Ltd.

CONTAX MODEL III.

Identical in all respects with Contax Model II, except for the addition of a photo-electric exposure meter on the

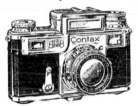

top of the camera. Dimensions 5½ × 2¾ × 1⅜ in. Weight without lens 25 oz. Price from £53.
Zeiss Ikon, Ltd.

DOLLINA O.

Self-erecting folding camera taking standard 36-exposure cassettes. Fitted f/4.5 Certar lens in between-lens shutter. Focussing to 3 ft. by front cell. Has

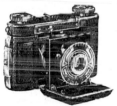

cast metal body. Film-wind locks automatically as each frame is brought into position. Automatic counter. Optical direct-vision finder. Dimensions 5 × 3½ × 1⅞ in. Weight 16 oz. Price from £5 5s.
Actina, Ltd.

DOLLINA MODEL I.

Self-erecting folding camera using standard 36-exposure daylight-loading cassette. Baseboard-type construction, lens-front supported on lazy-tongs. Focussing by knob on camera-body operating through the lazy-tongs, and

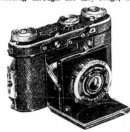

camera can be focussed either open or closed. Non-interchangeable lenses,

fitted in Compur or Compur-Rapid shutter, with release on body of camera. Dimensions 5 × 3½ × 1⅞ in. Weight 18 oz. Price from £9 17s. 6d.
Actina, Ltd.

DOLLINA MODEL II.

The specification of this camera is exactly the same as that of the Dollina Model I, except that there is added a

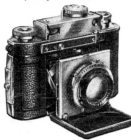

coupled range-finder of the coincidence type. Dimensions 5 × 3½ × 1⅞ in. Weight 19½ oz. Price from £12 19s. 6d.
Actina, Ltd.

DOLLINA MODEL III.

Self-erecting camera with baseboard, taking standard 36-exposure cassettes. Fitted non-interchangeable 5-cm. lens in Compur shutter with release on body of camera. Focussing by coupled

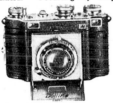

range-finder controlled by knob on top of camera; automatic compensation for parallax. Film-wind and shutter-release interconnected. Dimensions 5 × 3½ × 1-13/16ths in. overall. Weight 19½ oz. Price from £14 19s. 6d.
Actina, Ltd.

KARAT.

Self-erecting collapsible camera, taking 12-exposure lengths of 35-mm. ciné film in special chargers. Fitted non-interchangeable 5-cm. lens in diaphragm shutter with release on body of camera.

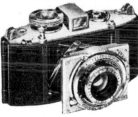

Focussing to 3 ft. Film-wind and shutter release interlocked to prevent double exposures. Tubular direct-vision finder. Dimensions 4⅛ × 2¾ × 1-13/16ths in. Weight 15 oz. Price from £4 4s.
Agfa Photo, Ltd.

LEICA STANDARD.

Makes up to 36 exposures on standard 35-mm. ciné film, which may be used either in a standard daylight-loading cassette or in the Leitz all-metal charger into which any desired length of film up to 5¼ ft. (36 exp.) is loaded in the dark-room. Focal-plane shutter, the setting of which automatically advances the film. Shutter speeds from 1/20th to 1/500th sec. Interchangeable lenses of focal lengths from 2.8 to 40 cm., that normally fitted having a focal length of 5 cm. Depth-of-focus scale fitted to all

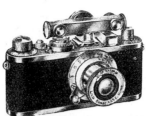

lenses. Fitted with shoe for detachable short-base range-finder (price £2 7s. 6d.). Dimensions 5½ × 2½ × 1½ in. Weight 17 oz. with f/3.5 Elmar lens. Chromium finish. Price from £18 5s.
E. Leitz (London), Ltd.

LEICA MODEL II.

Specification as Standard Leica, but

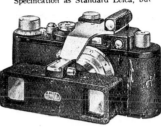

with the addition of built-in range-finder coupled with the focussing mounts of the interchangeable lenses. The view-finder for use with the 5-cm. lens is built into the range-finder casing. Weight and dimensions as Standard Leica. The illustration shows Model II with stereo attachment "Stereoly" (price £7 6s. 6d.) in position. Price from £27 17s.
E. Leitz (London), Ltd.

LEICA MODELS III AND IIIA.

Specification as Leica Model II, with the addition of slow speed mechanism giving shutter speeds up to 1 sec. and with optical magnifier in the range-finder to facilitate focussing. In Model

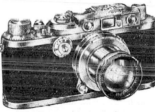

IIIa shutter is speeded up to 1/1,000th sec. These models are supplied to special order only, but Standard and Model II Leicas can be converted to Model III or IIIa.
E. Leitz (London), Ltd.

LEICA IIIB.

Specification as Leica Model II, with the addition of slow speeds ⅟₈ to 1 sec. and T., and high speed of 1/1,000th sec. Twin-sighting range- and view-finder,

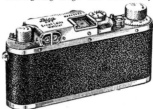

with optical magnifier in range-finder to facilitate focussing. Carrying eyelets on camera body for neck-strap. Chromium finish. Price from £34.
E. Leitz (London), Ltd.

LEICA 250.

This is a Model IIIa Leica with the addition of specially large spool-chambers that will accommodate a length of

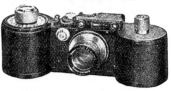

ciné film sufficient to give 250 exposures at a single loading. Price from £48 0s. 6d.
E. Leitz (London), Ltd.

NETTAX.

Takes up to 36 exposures on 35-mm. ciné film using either standard daylight-loading spools or special cassettes which can be loaded with any length of film desired. Fitted with interchangeable lenses collapsing into camera. No baseboard. 5-cm. lens fitted as normal. All-metal focal-plane shutter, speeded 1/5th to 1/1,000th sec., film being automatically wound on when shutter is set. Coupled wedge-type range-finder operating with normal and long-focus lenses. Dimensions 5⅛ × 2⅜ × 1⅜ in. Weight 17 oz. Prices from £29 5s. (Illustration below.) Zeiss Ikon, Ltd.

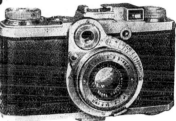

NORI.

Miniature camera making 8 exposures each 25 × 34 mm. on Selo No. 10 film. Fitted f/8 or f/6.3 lens. Dimensions 2½ × 1¾ × 1½ in. Weight 4 oz. Price from 10s.
Dr. Hopner (Seeing Camera).

RETINA.

Takes 36 pictures on 35-mm. ciné film, using standard daylight loading cassette. Baseboard type folding camera; lens-front supported on lazy-tongs. Fitted with f/3.5 lens of

5-cm. focal length in Compur or Compur Rapid shutter, with release on body of camera, except in model with Compur-Rapid shutter, priced at £12. Direct-vision tubular view-finder. Dimensions 4¾ × 3 × 1½ in. Weight 16 oz. Price from £12.
Kodak, Ltd.

RETINA II.

Takes standard 36-exposure cassettes. Self-erecting folding camera with baseboard, fitted non-interchangeable lens in Compur-Rapid shutter with release on body of camera. Focussing by helical mount to 3½ ft., movement coupled to built-in coincidence range-finder. Shutter-release and film-wind interconnected, but double exposures for trick effects can be made. Automatic

Appendix 4: Bibliography

Most of the books mentioned in this bibliography are out of print, and will therefore be found only in second-hand bookshops, on bookstalls, through classic-camera societies, dealers or advertisements, or simply by good luck as an unconsidered trifle acquired when buying a camera outfit. One or two, like the *Leica Manual* and many of the Focal 'Way' books are constantly updated, and usually available in their latest guise. However, the process of updating is not always helpful to the classic-camera user, and it will be found (for example) that a *Leica Manual* dating from the immediate pre- or post-war period will be more useful as a source of information on screw Leica equipment than a current edition, which is primarily concerned with current Leica reflex and 'M' cameras and equipment.

This is, of course, a bibliography of books consulted during the writing of this work, and is not claimed to be a complete list of books on classic cameras. Nonetheless, it will provide a classic-camera enthusiast with some useful titles to seek.

Books

ALLINSON, K.L., *35mm Photography with an Exakta*. Fountain Press, London, 1955.

AUER, Michel, *Collection Michel Auer*. Tannay, France, 1977.

BOMBACK, Edward S., *Contaflex Manual*. Fountain Press, London, 1958.

CASH, J. Allan, *Photography with a Leica*. Fountain Press, London, 1952.

DESCHIN, Jacob, *The Alpa Reflex Manual*. Kinografik Publishing Corporation, New York, 1959.

FREYTAG, H., *The Contaflex Way*. Focal Press, London, 1965.

FREYTAG, H., *The Contax Way*. Focal Press, London, 1952.

FREYTAG, H., *The Hasselblad Way*. Focal Press, London, 1972.

(Note: There have been, and in some cases still are, Focal Press 'Way' books for most of the major families of classic cameras – see *The Leica and Leicaflex Way* below).

GIEBELHAUSEN, Joachim and ALTHANN, Herbert, *Large Format Photography*. Nikolaus Karpf for Verlag Grossbild-Technik GmbH, Munich, 1967.

HASBROECK, Paul-Henry van, *Leica. A History illustrating every Model and Accessory*. Sotheby Publications, London, 1983.

HASBROECK, Paul-Henry van, *Leica. Rare and Unusual M series Cameras and Accessories*. Hasbroeck Photo-Historical Publications, London, 1978.

HICKS, Roger, *A History of the 35mm Still Camera*. Focal Press, London, 1984.

LAHUE, Kalton C., *Collector's Guide: Kodak Retina Cameras*. Petersen Publishing Co., Los Angeles, 1973.

LEA, Rudolph, *Lea's Register of 35mm SLR Cameras*. Lea's Register, Pennsylvania, 1981.

LIPINSKI, J., *Miniature and Precision Cameras*. Iliffe for Amateur Photographer, London, 1956.

MATANLE, Ivor and WRIGHT, Dr. A. Neill, *The Collector's Checklist of Contax and other Zeiss classic Miniature Cameras, Lenses and Accessories*. Thoroughbred Books, London, 1980.

MATHESON, Andrew, *The Leica and Leicaflex Way*. Focal Press, London, 1972.

MITCHELL, James (Ed.), *The Ilford Manual of Photography*. Ilford Ltd and Henry Greenwood and Co., London, 1942.

MORGAN, Willard D. and LESTER, Henry M., *The Leica Manual*. Morgan and Lester, New York, 1935, and Morgan and Morgan, New York, 1956.

PEARLMAN, Alec, *The Rollei Manual*. Fountain Press, London, 1966 and 1971.

PERMUTT, Cyril, *Collecting Old Cameras*. Angus and Robertson, London, 1976.

ROGLIATTI, G., *Leica and Leicaflex Lenses*. Hove Foto Books, Hove, UK, 1980.

ROTOLONI, Robert, *Nikon Rangefinder Camera*. Hove Foto Books, Hove, UK, 1983.

TUBBS, D.B., *Zeiss Ikon Cameras 1926–39*. Hove Foto Books, Hove, UK, 1977.

VIAL, Bernard, *Histoire et Catalogue des Appareils Français 1940–1960*. Bernard Vial, France, 1975.

VINING, Lancelot, *My Way with the Miniature*. Focal Press, London, 1945.

WOLF, Myron, *Directory of Collectable Cameras*. Myron Wolf, Lexington, Mass., 1972.

WRIGHT, Dr A. Neill, *The Collector's Checklist of Exakta and other Ihagee Cameras, Lenses and Accessories*. Thoroughbred Books, London, 1980.

WRIGHT, Dr A. Neill, *The Collector's Checklist of Voigtländer Cameras 1840–1970*. Thoroughbred Books, London, 1980.

WRIGHT, Dr A. Neill and GLANFIELD, Colin, *The Collector's Checklist of Leica Cameras, Lenses and Accessories*. Thoroughbred Books, London, 1980.

Encyclopaedias, annual publications and catalogues

British Journal Photographic Almanac, various years. This annual publication first appeared late in the nineteenth century, and was published by Henry Greenwood and Co. of London.

The Dictionary of Photography. Iliffe for Amateur Photographer, 1961.

The Focal Encyclopaedia of Photography. Focal Press, London, 1969.

General Catalogue of Photographic Equipment. Ernst Leitz, various years.

The Wallace Heaton Blue Book, various years. This catalogue was published annually in London by Wallace Heaton Ltd, then Britain's most prestigious photographic retail organization, from 1938 to the mid-seventies. All except the first edition (which had red covers) were clad in blue – hence the name.

Index

Advocate, Ilford 45
Agiflex 2 22, 52, 152-3, 155-6
Agiflex lenses 153
Agimatic 194
Akarelle 188, 193
Akarex 188, 193-4
Alpa, various models 10, 39, 52, 55, 72, 115
Alpa 6c 54, 115-6, 128-9, 206
Alpa 11el 115-6
Alpa lenses 72, 115-6
Ambiflex, Agfa 55, 124, 130
Argus C3 17, 28-9
auction houses 213

Baldina, Balda 194
Baldinette, Balda 181
balsam faults 37
bayonet adaptors, Leitz 66-7
Bertram Press 166
Bessa, Voigtländer 30-1
Bessa II 164-5
Bessamatic, Voigtländer 39, 122-3, 127, 207, 210
Bessamatic lenses 122-3
Billy Record, Agfa 166
Bolsey 108
Brilliant, Voigtländer 16, 132
Bronica, early examples 152-3

Canon, historic prices 104-5
Canon II series 104
Canon III 104
Canon IV 104
Canon VI 104-5
Canon VIT 104-5
Canon 7 105-7
Canon 7S 105-7
Canon Mirror Box 106
Canon rangefinder, origins of 100
Canon rangefinder lenses 104-6
Canonflex R2000 106, 110
Canonflex RM 110
cassettes, early types 17
Compur shutters 36, 44, 55, 136, 174-5
Contaflex, SLR system 119
Contaflex, twin-lens 11, 18, 89, 91, 92
Contaflex lenses 120-1
Contaflex Super 120
Contaflex Super B 19, 52, 60, 120-1, 124, 125, 208, 211
Contarex, 'Cyclops' 40, 53, 116-7, 203, 205
Contarex, origins of 116-7
Contarex, various 20, 39
Contarex accessories 117, 204-5
Contarex Electronic 117-8
Contarex lenses 116-7

Contarex Super Electronic 126, 204
Contax D 19, 114
Contax E 114
Contax F 114-5
Contax FB 114
Contax S 18, 114
Contax I 13, 15, 17, 23, 82-5
Contax II 85, 86, 88, 89, 95-7, 101
Contax IIA 30, 33, 86-7, 90
Contax III 85, 97-8
Contax IIIA 30, 39-40, 87, 90
Contax accessories 89
Contax shutters, faults 33
Contax viewfinders 84-6, 88
Contessa (folding), Zeiss 19, 30, 38, 179-81
Contessa LKE 57, 189-90, 199
Contina (general), Zeiss 36, 45, 180
Contina II 188-9, 196, 200, 209
Contina III 188-90
Corfield 66 29-30
custom accessory makers 213-4

dealers, classic cameras 214
Diax 188, 193, 194-5, 199

Edixa 30, 188
Ektra, Kodak 17, 107
Ensign Ranger 162
Ensign Selfix 162, 168
Exa, various models 113
Exakta, Kine 17, 18, 112-3
Exakta, origins of 112
Exakta, VP 17, 18, 28, 145-7, 156
Exakta II 112
Exakta RTL 1000 112-3
Exakta Varex IIA 30, 112, 114
Exakta Varex IIB 30, 52, 113-4
Exakta Varex V 112
Exakta Varex VX 112
Exakta VX500 113
Exakta VX1000 113-4
exposure 44, 201-2, 215
exposure, TTL 67

families of classics 216-9
film, choice of 203
film sizes, historic 160-1
film speeds, conversion 215
Finetta 88 (general) 30, 32, 188
flare, effect of 26
folding cameras, origins 160-1
Foton 155A 108
Futura 30, 32, 188

Graflex II 145

Hasselblad 500C 52, 146-51
Hasselblad 500CM 9, 147

Hasselblad 1000F 26, 42, 52, 146-9, 159
Hasselblad 1600F 146
Hasselblad lenses 26, 146-9, 151
Hasselblad Superwide 42, 148, 150

Ihagee, Dresden 18, 29
Ikoflex, Zeiss 16, 134
Ikonta, Baby, Zeiss 13
Ikonta M 58, 165
Ikonta 35 180
Ikonta 520/2 13
Ikophot, Zeiss 202
Iloca 30, 33
infinity focus, checking 38
Isolette, Agfa 30, 164-5, 170

Kamera Werkstätten (KW) 114, 153
Karat, Agfa 35, 46, 179, 181, 185
Kardon 107
Karomat (Karat 36), Agfa 179, 181
Kiev, origins of 18
Kiev 80 150
Kodak 35 17, 46, 108
Komura 500/7 lens 73

Leica, hoods and filters 75
Leica, origins and range 12, 61
Leica, viewfinders 74
Leica I (Model A) 13, 26
Leica I (Model B) 31
Leica I (Model C) 13, 62
Leica IC 63
Leica IF 64
Leica IG 65
Leica II 13, 17, 62, 65
Leica IIC 63
Leica IIF 64
Leica IIG 65
Leica III 17, 34, 43, 62, 65, 69
Leica IIIA 22, 25, 34, 63, 65, 79
Leica IIIB 18, 29, 30, 58, 63, 65, 107
Leica IIIC 18, 29, 34, 39, 58, 63, 65, 74, 76, 80, 104, 107
Leica IIIF 29, 35, 64, 65
Leica IIIG 45, 64, 65
Leica M1 66, 67
Leica M2 53, 64, 66, 67, 68, 71, 73
Leica M3 49, 53, 58, 64, 65, 66, 67, 68, 71, 73, 79, 80, 101
Leica M4 66, 67, 68, 71
Leica M4-2 67
Leica M4-P 9, 67, 73, 79
Leica M5 67
Leica M6 67, 73
Leica Standard 30, 62
Leicaflex 52, 53, 118

Leicaflex SL 118
Leicaflex SL-2 118
Leitz lenses
28/2.8 Elmarit 71
28/5.6 Summaron 70, 71
28/6.3 Hektor 14, 69, 70
35/1.4 Summilux 71
35/2 Summicron 70, 71 (M3 type), 80
35/2.8 Summaron 70, 71 (M3 type), 72
35/3.5 Elmar 14, 69, 70, 75, 76
35/3.5 Summaron 64, 66, 75
50/1.5 Summarit 70
50/1.5 Xenon 14, 70
50/2 Summar 14, 25, 29, 34, 62, 69 (rigid), 75, 79
50/2 Summicron 53, 64, 68, 73, 79, 80, 118 (Leicaflex)
50/2 Summitar 69, 70, 80
50/2.5 Hektor 13, 70
50/2.8 Elmar 45, 67, 70, 72
50/3.5 Elmar 14, 22, 26, 39, 62, 63, 65, 75, 76
65/3.5 Elmar 72
73/1.9 Hektor 14, 58, 70
85/1.5 Summarex 70
90/2 Summicron 53, 70
90/2.2 Thambar 70
90/2.8 Elmarit 70, 72, 73
90/2.8 Tele-Elmarit 71
90/4 Elmar 14, 58, 65, 69, 70, 71 (collapsible), 75, 76
105/6.3 Elmar 14
135/2.8 Elmarit 66
135/4 Elmar 53, 70, 71
135/4.5 Elmar 14
135/4.5 Hektor 14, 64, 69, 70
200/4 Telyt 72, 79
200/4.5 Telyt 14, 49, 70
400/5 Telyt 14, 70
Leitz copy stands 72, 76
Leitz MC meter 53, 71
Leitz MOOLY motor 92
Leitz NOOKY, NOOKY HESUM 74
Leitz SOOKY-M (SOOMKY) 73
Leitz VIDOM finder 69, 74
Leitz VIOOH finder (Imarect) 58, 64, 74
lens performance 203
Leotax, various models 107
Linhof Super Technika 165-6
Linhof Technika 70 9, 10, 25, 40, 166, 173
loading, screw Leica 66
Luftwaffe engravings 63, 86

Mamiya Press 166-7
Mamiyaflex C series 139

Mamiyaflex C3 48, 139, 140, 142, 144, 209, 211
Mamiyaflex lenses 139-40
Medalist, Kodak 17, 108
Minolta Autocord 134
MPP Microcord 133-4
MPP Microflex 134

Nagel Camerawerk 17
Nettar, Zeiss 36, 55, 57, 163-5, 170
Nettax (and lenses) 89, 92, 93
Nicca 107
Nikon F 8
Nikon F3 9
Nikon M 101
Nikon S 101
Nikon S2 101, 109, 110
Nikon S3 102, 103
Nikon S4 102
Nikon SP 101, 102, 103
Nikon rangefinder, origins of 100
Nikon rangefinder lenses 101-3

Paxette (various) 30, 32, 188, 195
Paxette Reflex 124
Pen EE-2, Olympus 107
Pen F 8
Pentacon, origins of 19
Pentacon F 114-5
Pentacon FM 114-5
Pentacon Six 52, 151-3
Pentax Spotmatic 8
Perfex 108
perforated 70mm film 166
Periflex, Corfield 29
periodicals, photographic 213
Perkeo II, Voigtländer 162-5, 168
Pilot 6 145
polarizing filters 204
Praktica 114
Praktina FX 114, 152
Praktisix 52, 151-3, 158-9
prices, historic 8, 17, 18, 92, 104-5, 107-8, 116, 123, 131, 151, 165
Primarflex 145
Prominent, Voigtländer 30, 179, 192, 195
Prontor shutters 36, 37, 44, 189

Record III, Agfa 167
Reflex Korelle 22, 25, 52, 145-6, 156
Regula (general) 30
Reid I 30
Reid III 29, 30
Retina, Kodak, origins of 16, 17, 174-5
Retina I 17, 28, 174-5
Retina IA 28, 174-6
Retina Ib 175
Retina IB 175-7
Retina II 17, 28, 174-6, 186
Retina IIA 28, 174-6, 181
Retina IIc 175-7
Retina IIS 192
Retina IIIc 175-6, 182, 184
Retina IIIC 176-7, 187
Retina Reflex III 121
Retina Reflex IV 122
Retina Reflex S 121
Retina Reflex system 121-2, 174
Retinette (folding), Kodak 45
Retinette (rigid) 192-3
right-angle finders 203
Robot, Luftwaffen 18, 47
Robot IIA 18
Robot Royal 18, 19
Robot Royal 36 18
Rollei, Baby, origins of 15
Rollei close-ups 137-8
Rollei TLR accessories 138
Rollei TLR loading 132
Rolleicord, origins of 15, 131
Rolleicord I 16, 17, 28
Rolleicord V 20
Rolleicord VA 133, 143
Rolleicord VB 136
Rolleiflex, filter mounts 29, 131
Rolleiflex, origins of 15, 131
Rolleiflex, prices 136-7
Rolleiflex, Standard 15, 17, 18, 28, 131
Rolleiflex, Tele 136-7
Rolleiflex, Wide-angle 29, 137
Rolleiflex 2.8E 133
Rolleiflex 2.8F 133-4, 136
Rolleiflex 3.5E 48, 142
Rolleiflex 3.5F 48, 49, 134-6
Rolleiflex 4x4 137-8
Rolleiflex Automat 28, 131-2, 141
Rolleiflex SL66 9

Rolleiflex T 132-3, 135-6
Rolleimagic 138
Rollop 134

Selecta-flex, Agfa 124
Semflex 134
servicing 205, 213-4
shutter testing 32-3, 35, 37
Silette, Agfa 30, 36, 45, 188, 190
Six-20, Kodak 15, 47
societies, classic-camera 212
Solinette, Agfa 30, 179-80
Sport (Russian) 18
Sterotar stereo devices 89
Super Baldax, Balda 165
Super Baldina, Balda 17
Super Baldinette, Balda 181
Super Dollina 17
Super Ikonta, Zeiss, various 12, 161, 172
Super Ikonta 532/16 30, 47
Super Ikonta 533/16 30, 31, 38
Super Ikonta C 17
Super Ikonta III 163, 168, 172
Super Ikonta IV 163
Super Isolette, Agfa 30, 47, 165
Super Nettel 89, 92, 93
Super Silette, Agfa 30, 46, 190, 195, 198, 208
Super Solinette, Agfa 30, 179
Superb, Voigtländer 16, 17, 132-3

Tanack 107
Taylor Hobson, 2" f/2 29, 30
Tenax (Tenax I) 92, 93
Tenax II 89, 93, 94
tolerance, shutter speeds 201
t/stop system 108

Ultramatic, Voigtländer 52, 122-3
Ultramatic lenses 122-3

Visoflex I, Leitz 70
Visoflex II 49, 73
Visoflex III 72, 73, 79
Vitessa, Voigtländer 30, 177-9, 181, 183
Vito B, Voigtländer 30, 37, 45, 57, 177, 188, 191, 195, 196
Vito BL 46, 191
Vito BR 191
Vito C 46, 191

Vito CL 191
Vito CLR 191
Vito I 29, 176
Vito II 29, 177
Vito IIA 177, 181
Vito III 177, 179
Vitomatic, Voigtländer 46, 191-2
Vitoret, Voigtländer 191

Weltini II 178
Weston Master 202
Witness, Ilford 194

Yashica 635 134-5
Yashicamat 134, 142

Zecaflex 132
Zeiss, East and West German 19, 29, 88, 114
Zeiss Ikon, origins of 12, 18
Zeiss lenses
 21/4.5 Biogon 88 (Contax), 116-8 (Contarex)
 28/8 Tessar 14, 84, 90
 35/2.8 Biogon 14, 86, 87, 88, 90
 35/4 Distagon 116
 35/4.5 Orthometar 14, 86, 91
 40/2 (42.5/2) Biotar 14, 83, 84, 90
 50/1.5 Sonnar 14, 70, 84, 88, 90, 91, 98
 50/2 Planar 116-7
 50/2 Sonnar 14, 83, 84, 85, 87, 88, 90, 91, 97, 98
 50/2.8 Tessar 14, 23, 83, 84, 90, 117 (Contarex)
 50/3.5 Tessar 14, 83, 84, 85, 87, 88, 89, 90, 91
 85/2 Sonnar 14, 83, 84, 88, 90, 91, 116 (Contarex)
 85/4 Triotar 14, 83, 85, 88, 90, 91
 115/3.5 Panflex Tessar 90
 135/4 Sonnar 14, 83, 88, 90, 91, 98, 116 (Contarex)
 180/2.8 Sonnar 14, 85, 86
 180/6.3 Tele-Tessar 14, 84, 86, 90
 300/4 Sonnar 86
 300/8 Tele-Tessar 14, 83, 84, 86
 500/8 Fern-Tessar 14, 84
Zeiss Panflex reflex housing 90
Zenith 80 150